RotoVision

For our daughters
Olivia and Gustava
who teach us
everyday, and all
mentors, especially
Philip B. Meggs and
Akira Ouchi.

A RotoVision Book

Published and distributed by RotoVision SA

Route Suisse 9

CH-1295 Mies

Switzerland

RotoVision SA

Sales & Editorial Office

Sheridan House, 114 Western Road

Hove BN3 1DD, UK

Tel: +44 (0)1273 72 72 68

Fax: +44 (0)1273 72 72 69

Email: sales@rotovision.com

Web: www.rotovision.com

10 9 8 7 6 5 4 3 2 1

ISBN: 2-88046-819-1

RotoVision Art Director Luke Herriott

Creative Directors John T. Drew and Sarah A. Meyer

Book design by John T. Drew and Sarah A. Meyer

Acuity Color System by John T. Drew and Sarah A. Meyer

Diagram Illustrations by John T. Drew and Sarah A. Meyer

Typography: Caslon 224 and Univers

Text: © 2005 John T. Drew and Sarah A. Meyer

Acuity Color System: © 2005 John T. Drew and Sarah A. Meyer. For more information about Acuity 1.0 contact John T. Drew at jdrew@fullerton.edu or Sarah A. Meyer at sameyer@csupomona.edu

Reprographics in Singapore by ProVision Pte.

Color
Management

A Comprehensive Guide for Graphic Designers

John T. Drew

Sarah A. Meyer

He

Someone, an imposter,
forged a note to the principal
and he was through the door and gone.

He resumed his trip across the country,
stopping at every bar to take a leak and have a beer,
and outside on the street when no one was looking,
he would drop his pants.

He drove a white '59 Cadillac convertible
and wore a red cowboy hat
and when he went swimming
he wore fluorescent green swim fins,
a fluorescent blue face mask
and a fluorescent orange snorkel.

Later he became famous for serving pancake breakfasts
in the municipal parks of small towns.
Though unannounced, they were well attended.

John Randolph Carter

Contents

Color Management

All the anatomical parts of this Caslon 224 Book typeface, including its beak (the back stroke of the arm of the "t") are clearly visible from a distance of 3.5ft (1m). This is assuming that the color builds are 0/75/100/0 for the letterform, and 100/50/0/0 for the background, under fluorescent light, the type size is 72pt, the vision is normal 20/20, and no glare can be found on the object. Furthermore, the "t" letterform is readable from a distance twice that of 3.5ft (1m). All parts are not clearly identifiable, but the letterform is still readable

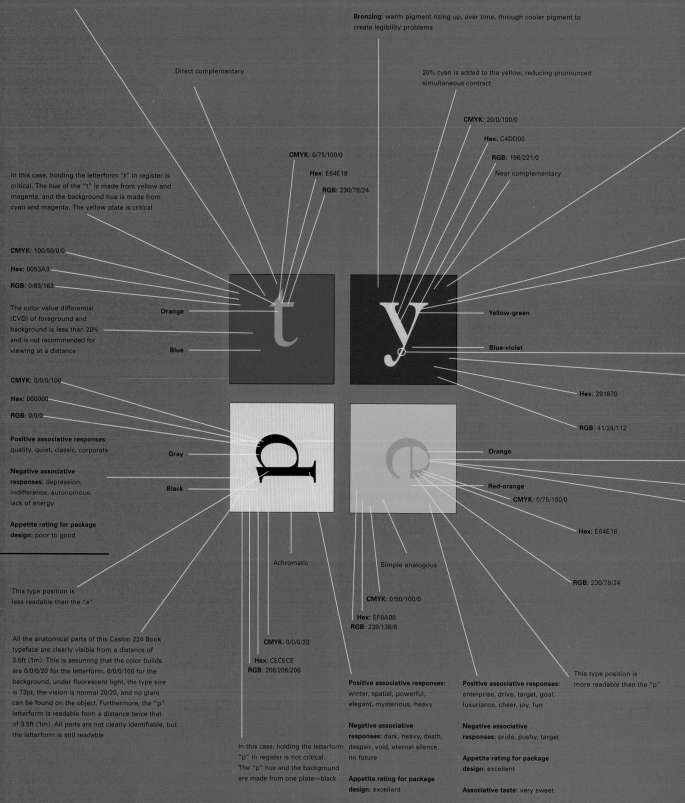

Bronzing: warm pigment rising up, over time, through cooler pigment to create legibility problems

Direct complementary

20% cyan is added to the yellow, reducing pronounced simultaneous contract

CMYK: 20/0/100/0

Hex: C4DD00

RGB: 196/221/0

Near complementary

CMYK: 0/75/100/0

Hex: E64E18

RGB: 230/78/24

In this case, holding the letterform "t" in register is critical. The hue of the "t" is made from yellow and magenta, and the background hue is made from cyan and magenta. The yellow plate is critical

CMYK: 100/50/0/0

Hex: 0053A3

RGB: 0/83/163

The color value differential (CVD) of foreground and background is less than 20% and is not recommended for viewing at a distance

Orange

Blue

Yellow-green

Blue-violet

Hex: 291870

RGB: 41/24/112

CMYK: 0/0/0/100

Hex: 000000

RGB: 0/0/0

Positive associative responses: quality, quiet, classic, corporate

Negative associative responses: depression, indifference, autonomous, lack of energy

Appetite rating for package design: poor to good

Gray

Black

Orange

Red-orange

CMYK: 0/75/100/0

Hex: E64E18

RGB: 230/78/24

Achromatic

Simple analogous

This type position is less readable than the "e"

All the anatomical parts of this Caslon 224 Book typeface are clearly visible from a distance of 3.5ft (1m). This is assuming that the color builds are 0/0/0/20 for the letterform, 0/0/0/100 for the background, under fluorescent light, the type size is 72pt, the vision is normal 20/20, and no glare can be found on the object. Furthermore, the "p" letterform is readable from a distance twice that of 3.5ft (1m). All parts are not clearly identifiable, but the letterform is still readable

CMYK: 0/0/0/20

Hex: CECECE

RGB: 206/206/206

CMYK: 0/50/100/0

Hex: EF8A08
RGB: 239/138/8

This type position is more readable than the "p"

In this case, holding the letterform "p" in register is not critical. The "p" hue and the background are made from one plate—black

Positive associative responses: winter, spatial, powerful, elegant, mysterious, heavy

Negative associative responses: dark, heavy, death, despair, void, eternal silence, no future

Appetite rating for package design: excellent

Positive associative responses: enterprise, drive, target, goal, luxuriance, cheer, joy, fun

Negative associative responses: pride, pushy, target

Appetite rating for package design: excellent

Associative taste: very sweet

Introduction

Color, unlike any other subject in visual communications—interactive, print-based, environmental, and motion graphics—is very complex and frequently misunderstood. Color, which has physical, psychological, and/or learned behavioral attributes, can shape effective visual communication. As a physical form of communication—lightwaves—color is both absorbed and reflected by the objects we look at, and meaning is transformed and translated through its use. *Color Management*, and the software application Acuity 1.0, describe how to forecast the physical, psychological, and learned behavioral effects of color, and how to use color to create more meaningful messages.

As designers, we no longer need to know how to physically mix paint pigments in order to create a certain hue. Most of us have not touched a Prismacolor Pencil, Magic Marker, Color-aid paper, or paintbrush for nearly a decade. This book aims to provide designers with a resource for understanding the dynamics of color in the context of visual communication.

The companion CD contains one-, two-, three-, and four-ink color matrices. Each matrix has the CMYK builds, and the hex numbers for hues used in Web-based, intranet, and kiosk design. For designers, these color matrices can be used to color sink client comprehensives and obtain accurate color appearance.

The Acuity 1.0 software application program scientifically determines the distance at which letterforms can be seen in any color combination, for standard visions, including normal vision, minimum U.S. Division of Motor Vehicle standards, visually impaired, and legally blind standards. It is intended to help graphic designers, architects, environmental graphic designers, and sign manufacturers gain confidence in the preparation and production of signs and signage systems that use typographic forms and color combinations.

Positive associative responses: celibacy, rage, deep nostalgia, memories, power, spirituality, infinity, dignified, sublimation

Negative associative responses: conservative, melancholia, priggishness, darkness, shadow, mourning, pompous, loneliness

Appetite rating for package design: excellent (for products other than food); poor (for food)

All the anatomical parts of this Caslon 224 Book typeface, including its serifs, are clearly visible from a distance of 3.6ft (1.1m). This is assuming that the color builds are 20/0/100/0 for the letterform, 100/90/0/0 for the background, under fluorescent light, the type size is 72pt, the vision is normal 20/20, and no glare can be found on the object. Furthermore, the "y" letterform is readable from a distance twice that of 3.6ft (1.1m). All parts are not clearly identifiable, but the letterform is still readable

Positive associative responses: lemony, tart, fruity, sharp, bold, trendy, sunlight

Negative associative responses: sickly, slimy, tacky, acidic, gaudy, tart

Appetite rating for package design: excellent (for products other than food); poor (for meats)

Associative taste: very sweet, lemony

In Caslon 224 Book this is the weakest part of the typeface for viewing at a distance

CMYK: 100/90/0/0

In this case, holding the letterform "e" in register is not critical. The hue of the "e" is made from yellow and magenta, which are the same two plates as used for the background color

All the anatomical parts of this Caslon 224 Book typeface are clearly visible from a distance of 2.77ft (84cm). This is assuming that the color builds are 0/75/100/0 for the letterform, 0/50/100/0 for the background, under fluorescent light, the type size is 72pt, the vision is normal 20/20, and no glare can be found on the object. Furthermore, the "e" letterform is readable from a distance twice that of 2.77ft (84cm). All parts are not clearly identifiable, but the letterform is still readable

Positive associative responses: enterprise, drive, target, goal, luxuriance, cheer, joy, fun

Negative associative responses: pride, pushy, target

Appetite rating for package design: excellent

Associative taste: very sweet

Monochromatic with tinting

One hue with neutrals

Analogous

Simple analogous with complementary accent

Direct complementary

Near complementary

1 The Terminology of Color

Understanding the vernacular of color, considering the color complexity we deal with on a day-to-day basis, is often overwhelming. Unlike any other art discipline, visual communication deals not only with color building (the physical mixing of ink pigment and the creation of electronic files), but also with the human perception of *hue*, and the psychological effects and interpretations of color. This chapter is concerned with the language of color, its theories, and its use as a practical form of problem-solving. The terminology found in this chapter is the building block for understanding color dynamics, including *subtractive color theory* (both *simple* and *complex color mixing*), *additive color theory*, and *3-D color theory*. Understanding the terms found within this chapter will broaden your color knowledge, thereby increasing the effectiveness of the visual messages you create.

Understanding color allows you to envision the power of visual messages, and a familiarity with color terminology will help you fully realize hue implications in the context of color theories, as well as in the context of print-based, interactive, environmental, and motion graphics. Strategies to understand effective color use are provided, including color legibility and readability using type and simple symbols, along with color matrices and paradigms. These strategies are demonstrated through exemplary professional work.

Figure 1
Art Directors Sarah A. Meyer, Ned Drew, and John T. Drew
Designer Sarah A. Meyer

Absorbed light: *Light that is absorbed by an object; the opposite of <u>transmitted</u> <u>light</u>*

All colors visible to humans are created by lightwaves. When light strikes an object, be it a rock or a printed surface, some lightwaves are absorbed by that object while others are reflected by its surface; this is what produces the object's color. This is the essence of *subtractive color theory*. The lightwaves absorbed by an object are transformed into heat. The darker the color, the more waves are absorbed and thus the more heat it produces. An understanding of this phenomenon will help you make better decisions regarding outdoor color schemes (diagram 2).

Three-dimensional color theory specifies that if all light is absorbed by an object, the "color" produced is black. If only some of the lightwaves are absorbed by the object, with the others reflected by the surface into the human eye, these reflected lightwaves are transformed into electrical impulses which are interpreted by the *primary visual cortex* as color and object. The *color value* number indicates the relative lightness as perceived by the mind. This number represents how well the human eye perceives that color (diagram 3).

Figure 1 The words "Visual Thinking," the title of this volume, are concealed by a careful examination of the color value numbers associated with green. Within this example, subtle variations of green create a color effect— the words disappear when viewed at different angles. To ensure that an object or letterform can be viewed and understood at a distance, a 20% color value differential (CVD) is recommended. In the example above, the CVD is 5%.

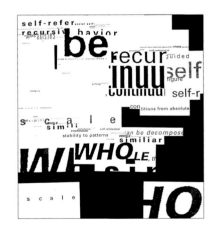

Diagram 1 Left: The black and white combination creates a CVD of more than 40%, black being 2% and white being 98%. In reality neither color is absolute—0% or 100%. Numerous hues can be found in the 2–10% and 90–98% range, dispelling the myth that black and white color combinations are the most legible.

Diagram 2 To retrieve the heat index of a color, subtract the color value rating (in this book also referred to as Y tristimulus value) from 100%. This will yield the amount of absorbed light that is transformed into heat. The larger the number, the more heat produced. The PANTONE Color Cue can retrieve the Y tristimulus values for print production colors. If using a

color not found within their systems, the Color Cue will give you the closest PANTONE Y tristimulus value. This is accurate enough to predict the color heat index.

1. 100% - 73.93% = 26.07%
2. 100% - 7.48% = 92.52%
3. 100% - 17.80% = 82.20%
4. 100% - 24.87% = 75.13%
5. 100% - 2.51% = 97.49%
6. 100% - 29.53% = 70.49%

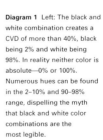

1	type C0 M0 Y0 K0
	bgd C0 M0 Y0 K100
1	type C0 M0 Y0 K100
	bgd C0 M0 Y0 K0

1	type C0 M10 Y35 K0
	bgd C0 M53 Y100 K4
1	type C0 M53 Y100 K4
	bgd C58 M6 Y80 K0
1	type C58 M6 Y80 K0
	bgd C0 M10 Y35 K0

BG Background color C0 M50 Y100 K0 30%

We visited the stadium at Indian Wells Tennis Garden for the 2003 Super 9 event. The Indian Wells Tennis Garden is located in Palm Desert, California. The daytime temperatures when we attended were in the high 90s (mid-to-high 30s °C). The stadium seats are dark blue plastic, and we quickly found that you can fry an egg on them during the day. This is a good example of architects and environmental graphic designers having little understanding of the principles of subtractive color theory.

Color is always relative to the environment in which it is used. We should understand the environment in order to select effective colors. According to *3-D color theory*, the light being reflected by an object and interpreted by the "mind's eye" determines the *color value*. It is crucial for designers to know the color value numbers, including those for all ink- and plastic-matching systems. These numbers will help you understand the heat produced by different colors, and the contrast and legibility of color as perceived by the mind's eye.

The lower the number, the more heat the object will produce. The heat of an object can be offset in many ways through manipulating the substrate. Taking the example of the Indian Wells stadium seats, two such ways of reducing the heat

could have been: to place holes in them to increase ventilation and reduce their surface area; and to increase the substrate texture in order to create more *scattering*, thereby reducing the temperature.

In the 1980s and 1990s, a plethora of studies showed that a 40 percent contrast value between foreground and background is necessary in order for the legally blind/visually impaired to navigate their way through an environment.

Achromatic: _Hues_ made from black, gray, and white
An achromatic *color scheme* can be an extremely effective communication device for the creation of visual messages. This type of color scheme is highly dramatic and, if used correctly, very emotive. Ansel Adams' black-and-white photographs of the western United States, many of Georgia O'Keeffe's paintings, and the movie ***Raging Bull*** are all fine examples of the employment of achromatic color schemes. Most contemporary designers are guilty of overlooking this particular color scheme in favor of using an array of colors. For example, few Web sites rely on an achromatic color scheme, and seldom do we see illustrations, posters, brochures, or annual reports in black and white. We tend to use black and white only

when the budget does not allow for four-color reproduction, even when achromatic hues would be the most effective choice.

To create effective visual messages using achromatic color schemes, an understanding of how the many hues of black, white, and gray are created, and how the human eye perceives them, is necessary. It is harder to create an effective visual message using achromatic colors: an achromatic color scheme is inherently more simplistic than a multicolored scheme.

In *complex color mixing*, black is made from a combination of different hues. For example, in four-color process building, 100 percent of cyan, magenta, and yellow will create a dull black; black ink is added to create a rich and saturated printed surface with a greater tonal range. In addition, many two-spot-color combinations can create a range of blacks.

Diagram 3 To the right are the Y tristimulus values for the hues above. These demonstrate the relative lightness/darkness of an individual hue within the mind.

1. 73.93%
2. 7.48%
3. 17.80%
4. 24.87%
5. 2.51%
6. 29.53%

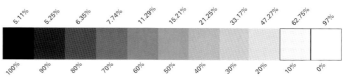

rods

Color value rating

Simple subtractive color mixing k value

Diagram 4 The rods in the eyes have the ability to detect black, white, and gray.

In print-based graphics, more often than not, white is created by the paper being used. If the paper has a high brightness rating, the white will be more brilliant, as will the other hues used. (The brightness rating for paper is always defined on the swatch provided by the manufacturer, or located on the ream itself.) If the paper is an off-white, then the inks printed on it will not have as wide a color spectrum—the colors will not be as vivid. Thus, in print-based graphics the paper used is the major building block for the color spectrum, which will be limited to the *color value* of the paper. If the paper is a light blue with a color value of 80 percent, the available range will be only 0–80 percent. In addition, all inks printed on this paper will have a tint (see *color tinting*) of blue. In some cases, white opaque ink is applied to colored paper before four-color process inks are printed on top. This links the color spectrum to the brightness rating of the white ink rather than the paper. Commercial screen-printing inks offer greater ink opacity for such use.

In environmental graphic design, white is usually created by applying a white paint, opaque white ink, or white pigment to a substrate. The same is true for any blacks or grays created for signage. It is important to know the color value of any hue, including black, white, and gray, in order

Figure 2
Photographer Jenni Goldman

Figure 2 In this photograph, black, white, and continuous tones of gray are achieved to create the main focal point. The focal point is surrounded by white to effectively communicate the visual message of serenity. In print-based graphics these hues can be achieved in three different ways. The first is to create a one-color job using black. The second is to create a two-color job with neutral gray and black. Creating a duotone in Photoshop utilizing these two hues will create a printed specimen that rivals a continuous-tone photograph. By adding a second hue (gray), more tonality can be achieved within the printing process.

Diagram 5 (a–c)
The above color wheels are examples of different color models: 5a is a four-color process wheel; 5b is a 12-step traditional color wheel that is based in subtractive color theory; 5c is a color wheel derived from 3-D color theory specific to how the eye detects color.

to understand the contrast differential for legibility purposes, no matter the standard of eyesight. Most sign manufacturers have these numbers on file. The PANTONE® Color Cue™ gives the color curve for each hue specified within their system.

In complex color mixing, gray is produced by combining multiple inks or colors. For example, in the Acuity Color System, many grays are created by equal screen percentages of cyan, magenta, and yellow. Gray can also be produced by mixing two *secondary* or *tertiary colors* located on opposite sides of the *color wheel*, in equal proportions.

In *simple color mixing*, gray is created by placing black and white side-by-side with no overlap. In print-based graphics, gray is created by using a screen percentage of black on white paper. This combines *subtractive* and simple *additive color theory* because some light is being absorbed, and *color mixing* is taking place in the brain.

According to additive color theory, black is produced by the absence of any light. To create black on a computer screen or television monitor, all light is prevented from reaching the area that is to appear black to the viewer.

According to *3-D color theory*, black and white are detected by the photoreceptor cells found in the *rods* of the eyeball, located on the *retina wall*. Gray is created by a combination of photoreceptor cells responsible for detecting black and white. In the case of black, the photoreceptor cells within the rods create a negative electrical impulse that travels to the *primary visual cortex*, where it is interpreted by the mind.

Additive color theory/mixing: *Combining lightwaves to create colors*

Additive color is used in the production of print-based, environmental, interactive, and motion graphics. However, its use in print-based media is different from that in electronic media: in the print production phase, additive color is used to simulate *subtractive color mixing*. Due to the physical properties of additive color, the available spectrum of light is greater than that available for subtractive color. For example, on a computer screen, colors are created and projected directly into the human eye. No lightwaves are absorbed or reflected in any direction, by any objects. This is why the color on a computer screen will never match print-based graphics. In print-based graphics light, whether this be from the sun, a tungsten-filament lamp, or fluorescent lighting, is *scattered* by the object; some lightwaves are absorbed by it,

leaving only a small portion to be directed into the human eye. Programming engineers have tried to simulate this phenomenon in order to create the appearance of subtractive colors on the computer screen. However, the color visible on the screen is not what appears on paper. This is due to the fact that each software application uses different programming for print-based production simulation. Since color is a product of its environment, the same spot color can look very different in different light sources, and no program can take the infinite amount of scenarios into account. Colors created according to additive color theory, for use in interactive and motion-graphic documents, are by-products of the intensity of the light they emit. A light source is measured in kelvins (K). Average daylight is measured at 5,000 K (U.S. standard) or 6,500 K (European standard). Every TV monitor, ATM, electronic kiosk, and computer screen may emit light from a different source. When designing interactive and motion graphics, it is important to make sure that the document is tested on many different models of monitors and computer systems, including those manufactured for DOS, Mac, and Unix, as the quality of the monitor and computer system will affect the color produced.

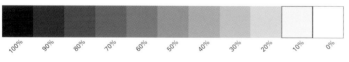

(a) Red-violet and yellow green

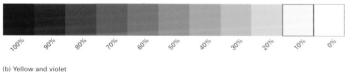

(b) Yellow and violet

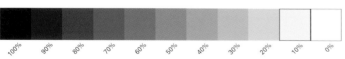

(c) Cyan, magenta, and yellow

Diagram 6 (a–c)
Left: The three gray bars are created using different color combinations: 6a creates variations of high warm gray through the use of red-violet and yellow-green; 6b creates variations of warm gray through the use of yellow and violet; 6c creates variations of a neutral gray using the process printing primaries cyan, magenta, and yellow.

Average daylight = 6,500 K

Early afternonn light = 9,300 K

Diagram 7 In the print dialog box of most ink-jet printers there are settings that incorporate average daylight (6,500 K) and early afternoon light (9,300 K). When printing, if a yellowish tint is laid down over the white areas of the paper, try one or both of these settings. By using either 6,500 K or 9,300 K the yellowish tint should be eliminated. These simulate the source of light in 3-D color theory, and most often help to render a better color printout.

Figure 3
Art Director/Designer Bas Jacobs

Afterimage: *Illusions occurring when retinal cones and neurons become fatigued or overstimulated*

Two categories of photoreceptor cells are responsible for human perception of color—red and green. (There is some debate within the medical community pertaining to another photoreceptor cell believed to be responsible for the perception of purple.) A photoreceptor cell can become fatigued if it fixates on a particular color. This will cause a false electrical impulse of the other color by the photoreceptor cell, creating what is called an afterimage. If we stare at an individual color for a minute or two and then look at a white background, we will see the color's *complementary*. For instance, if we stare first at red, we will see green. This phenomenon is known as afterimage.

Afterimage can occur with graphics produced by both *subtractive* and *additive color mixing*. In both cases, the effect can be reduced by producing a composition that is kinetic. An asymmetric composition is far more active than a symmetric one. In an asymmetric composition, the eye tends not to rest and therefore, retinal fatigue is less likely to occur. If your aim is to create an afterimage effect, then a symmetric composition is recommended, as this will encourage the viewer's eyes to rest.

Figure 3 The design of this book is an excellent example of how afterimage can be utilized to create color dynamics not found on the printed page.

Diagram 8 The use of afterimage can increase compositional movement, and at times, may alter meaning. Black, white, red, green, and blue correspond to the photoreceptor cells within the first stage of vision. When using colors that directly agree with the primaries found in 3-D color theory, afterimage will rapidly occur. The rods and cones will fire with force causing the receptor cells to become overly fatigued, hence inducing afterimage.
Designer John T. Drew and Sarah A. Meyer

3	type **C**0 **M**89 **Y**93 **K**0		
	bgd **C**90 **M**87 **Y**58 **K**63		
3	type **C**29 **M**0 **Y**73 **K**0		
	bgd **C**75 **M**36 **Y**91 **K**26		
3	type **C**90 **M**87 **Y**58 **K**63		
	bgd **C**0 **M**89 **Y**93 **K**0		

3	type **C**75 **M**36 **Y**91 **K**26
	bgd **C**29 **M**0 **Y**73 **K**0

BG	Background color	**C**30 **M**0 **Y**100 **K**0	40%

Monochromatic, achromatic, and analogous color palettes are well suited to symmetric compositions. These palettes produce a constant electronic impulse that is either negative or positive, rather than both negative and positive, and therefore help to create a fixation point. This is not to say that they can't be used for asymmetric compositions.

Analogous colors: *A color grouping in which the colors are to the near left and right of each other*

An analogous color scheme is *harmonious* in nature and can be highly effective in its subtleties. Analogous colors are harmonious because all colors within the palette have a certain percentage of each other built into them. This creates a visual lack of conflict and an exterior arrangement that is physically pleasing to the eye. As with *monochromatic* and achromatic color schemes, *analogous color schemes* are underutilized.

Within *subtractive color theory*, analogous color schemes involve *complex subtractive mixing*. Each color within the palette has a percentage of the other color, leading to complex color mixing because of the overlaying or overprinting of color in screen percentages on press.

Within *3-D color theory*, analogous color schemes are physically pleasing to the eye because very little *simultaneous contrast* takes place. *Cones* within the eye are responsible for discerning color. Cones have two types of photoreceptor cells. One type discerns red, green, and blue, and the other blue/yellow, green/red, and black/white. (There is some debate over whether another type discerns purple.) Simultaneous contrast takes place when a photoreceptor cell is responsible for two colors that appear together. This creates an intermittent electrical impulse for both colors as they travel through the *visual pathway* to the *primary visual cortex*. For example, the color combination of green and red creates pronounced simultaneous contrast. The receptor cell responsible for green and red cannot physically process the information for both colors at the same time, thereby creating an unstable juxtaposition of color. With analogous colors, the photoreceptor cells responsible for the lightwaves within the color scheme fire continuously, creating very little simultaneous contrast. There is not an intermittent electrical impulse—the impulse is constant.

Bronzing: *An effect that develops when some inks are exposed to light and air which creates a false reading in the calculation of color*

Of particular importance in environmental graphic design, bronzing causes a glare effect in 3-D color space and must be accounted for in the creation of signs and signage systems. It occurs in inks that are warm in nature: the pigments in *warm colors* begin to rise up through the cooler ink pigments. This can reduce the legibility of signs as the *color contrast*, when the signs are viewed at a 45° angle, will be affected over time. This creates an unusual amount of glare, almost equivalent to laminating or placing a sign under glass. For this reason, bronzing must be accounted for when choosing spot colors or four-color process builds that have a mixture of warm and cool colors, for example, cyan and magenta, reflex blue and rubine red. Bronzing is most apparent in the family of purples. When measuring color, a fresh color sample will ensure a correct measurement.

Diagram 9 A facsimile of how bronzing may occur and alter the purple hue.

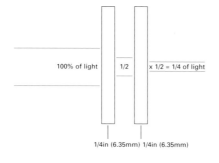

100% of light | 1/2 | x 1/2 = 1/4 of light

1/4in (6.35mm) 1/4in (6.35mm)

Diagram 10 An illustration of Lambert's law.

Diagram 11 (a and b)
In 11a, all other light not reflected off the surface is absorbed as heat. This is an example of simple subtractive color mixing. In 11b, heat absorption is less. This is an example of complex subtractive color mixing.

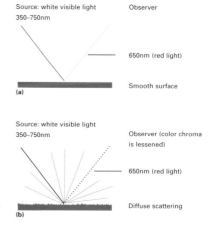

Source: white visible light 350–750nm

Observer

650nm (red light)

Smooth surface

(a)

Source: white visible light 350–750nm

Observer (color chroma is lessened)

650nm (red light)

Diffuse scattering

Rough surface

(b)

In print-based graphics, bronzing should be accounted for when creating documents that are meant to be viewed from a distance, as billboards, broadsides, posters, and food packaging are all intended to be. This is not to say that colors prone to bronzing should not be used in the creation of any sign, signage system, poster, billboard, and the like. It simply means that legibility should be increased by 10 percent to allow for this effect: the reduction in legibility due to lightwaves being *scattered* when a document is under glass is equivalent to 10 percent.

The same 10-percent rule applies to electronic media in which glare is an issue. When lightwaves reflect off of a mirrorlike or smooth surface, scattering or glare will occur. This 10 percent increase takes into account only a minimum amount of glare. There is no known equation in the calculation of color to account for severe glare. However, creating a document that is on a slightly textured substrate, equivalent to a matte finish, can sometimes cut down on glare.

Bronzing occurs only with the *subtractive color mixing. Additive color* is not affected by bronzing, however, whenever a document is to be viewed under glass, glare must be taken into consideration.

Chroma: *Color intensity. Sometimes referred to as the color's brightness, chroma is another word for the Y tristimulus value in 3-D color theory*

Chromatic colors: *A series of colors arranged in set increments*
Chromatic colors are arranged in steps, for example, a two-color matrix with an X and Y access arranged in increments of 10 percent, from 0–100 percent. In this case, a color matrix is used to determine the different hue possibilities found within the two colors by overprinting screen percentages of each color. To create the matrix, one color is placed on the horizontal (X) axis and the other on the vertical (Y) axis.

In print-based graphics, color matrices are often used to calculate color predictability. These matrices act as a visual reference for *simple color mixing*. A matrix with an X and Y access is an excellent resource for simple color mixing, or the predictability of tint (see *color tinting*) control. Overprinting or knocking out typography in each step found within the color matrix is an excellent strategy for predicting color and type legibility. This strategy can also be employed in environmental graphic design. With improved color printers, color predictability, with a little legwork, can be assured. (See Chapter 4 for predictability of color, color

calibration, and color sinking ink-jet printing for print production.)

Color matrices are also an excellent resource for color predictability in interactive and motion graphics, though since the electronic file is the final document, controlling color is an easier process. In Web design, legibility and readability with type and color combinations can be predicted by creating a color matrix in the desired font. This document should be created in Photoshop at 72dpi, in RGB mode, and saved as a JPEG or GIF. The resulting file will be platform independent, and able to be opened in a DOS, Mac, or UNIX platform. By using this strategy, legibility and readability can be assured.

Diagram 12 Chromatic colors
type = **C**65 **M**100 **Y**0

Photoreceptor cell matrix

Smallest object visible

Diagram 13 The above diagram depicts an object crossing over three photo-receptor cells, in a distinct order, for visualization to take place.

Diagram 14 (a–c)
Right: This chart illustrates the CVD for each type and color combination, and their CMYK builds. Both 14b and 14c meet the specified CVD for the visually impaired/legally blind.

a

70.03 - 50.85 = 19.18 (CVD)

type **C**8 **M**38 **Y**0 **K**0
bgd **C**8 **M**38 **Y**0 **K**0

b

70.03 - 29.88 = 40.15 (CVD)

type **C**23 **M**56 **Y**0 **K**0
bgd **C**0 **M**0 **Y**100 **K**0

c

70.03 - 9.80 = 60.23 (CVD)

type **C**65 **M**100 **Y**0 **K**15
bgd **C**0 **M**0 **Y**100 **K**0

Color contrast: *The difference between lightwaves detected by the apparatus of the eyeball*

The photoreceptive fields near and around the *fovea* are responsible for four kinds of vision:

- *motion;*
- *form/silhouette;*
- *depth; and*
- *color.*

This region is responsible for clear and sharp vision. Therefore, clear and sharp vision is determined by the density of the photoreceptive fields within the *cones,* which are found near and around the fovea. In order for an object to be detected by the eye, a lightwave must cross over a minimum of three photoreceptor cells, in a distinct order. The color, size, shape, and motion of an object or objects cannot be artificially separated. In other words, all four of these factors determine color contrast.

Figure 4
Art Director/Designer Inyoung Choi

CVR: 9.80%; 18.22%

CVR: 19.99%; 35.07%

CVR: 45.81%; 70.03%

CVR: 31.15%; 20.73%

CVR: 25.62%; 32.66%

CVR: 15.74%; 5.85%

Color value ratio (CVR)

Figure 4 Different hues of purple are utilized within the poster. When exposed to sunlight and air, bronzing will occur, creating drastic color shifts. To help slow down this process a clear UV varnish can be applied to the surface and give the ink more longevity.

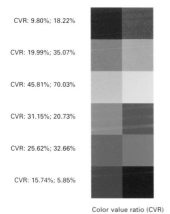

Simultanous contrast

Diagram 15 Some of the factors that need to be considered when color contrast between two objects is determined.

Warm color (top) cool color (bottom)

Complementary colors

4	type **C0** **M98** **Y2** **K0**
	bgd **C0** **M38** **Y99** **K0**

4	type **C40** **M20** **Y0** **K0**
	bgd **C0** **M98** **Y2** **K0**

4	type **C0** **M38** **Y99** **K0**
	bgd **C79** **M84** **Y23** **K25**

4	type **C79** **M84** **Y23** **K25**
	bgd **C40** **M20** **Y0** **K0**

tourism
authority of
thailand

crafts

contact:
chicago, il. 312.819.3990-5
los angeles, ca. 213.382.2353-5
new york, ny. 212-432.0433-5

Figure 5
Art Director/Designer Pornprapha Phatanateacha

To truly understand color contrast you need to grasp the factors that govern its constitution. Contrast is one of the most misunderstood aspects of color. Color contrast is dependent upon the luminosity or relative lightness of colors as perceived by the mind's eye—the difference between the *color values* of the *hues* concerned. Some combinations need only a 2 percent color value differential to be legible for normal color vision. However, for normal color vision, color value differential combinations of 15 percent are prudent. For the visually impaired—20/60 and up— a 40 percent color value differential is necessary. It is further recommended that the foreground hue have a 70 percent color value or greater, and the background hue have 30 percent or less.

When building color contrast for design purposes—whether print-based, interactive, environmental, or motion graphics— five types of contrast must be considered:

- *the differential of color value numbers;*
- *the physical effects of* <u>simultaneous</u> <u>contrast;</u>
- *the contrast of* <u>warm</u> *and cool colors;*
- *the contrast of* <u>complementary</u> <u>colors; and</u>
- *the size, shape, silhouette, depth, and motion of an object(s).*

Figure 5 An excellent example of color mixing.

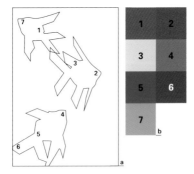

Diagram 16 (a–c) The compositional position of the parent colors (16a), the parent color swatches (16b), and their four-color process builds (16c).

(c) Color building
1. C27 M79 Y55 K37
2. C44 M54 Y65 K49
3. C7 M9 Y75 K1
4. C76 M56 Y5 K5
5. C91 M72 Y2 K1
6. C81 M68 Y18 K29
7. C100 M93 Y82 K0

5	type C64 M41 Y2 K2	5	type C1 M58 Y85 K0
	bgd C1 M58 Y85 K0		bgd C64 M41 Y2 K2

5	type C41 M63 Y50 K49
	bgd C13 M85 Y74 K3

5	type C13 M85 Y74 K3
	bgd C41 M63 Y50 K49

BG	Background color	C93 M88 Y1 K0	10%

These factors hold true for all three color theories. (See Chapters 3 and 4 for color contrast and ensuring color legibility.)

Color mixing: *The process by which different pigments, dyes, colorants, or lightwaves are mixed to create a new hue*

For print-based graphics, there are about 22 common screen-printing and offset ink manufacturers. It is easy to review these in all software applications for print. The manufacturers all have printed color-formula guides that show every *hue* they can produce. Most of these guides have base inks that produce all the variants created through mixing. For example, the Acuity Color System has four base inks from which over 10,000 hues can be created.

There are two methods of color mixing for print-based graphics. The first is to mix the ink parts of a particular color to create the spot hue. The PANTONE MATCHING SYSTEM® guides are good examples of this first type of color mixing. Each PANTONE-identified color found within their color formula guide has a number to identify the color, as well as the parts and percentage of each ink creating the specified color. In the 2004 printing edition of the PANTONE formula guide, PANTONE 152 C has 12 parts PANTONE Yellow, which is 73.9 percent; 4 parts PANTONE Warm Red, which is 24.6

percent; and one-quarter part PANTONE Black, which is 1.5 percent of the specified color. In the PANTONE MATCHING SYSTEM, each base ink is a specially formulated color unique to the system. A mixture of yellow, warm red, and black in these exact parts or percentages may look very different using base inks from another ink manufacturer. In the companion CD to this book, the inks and percentages used to create each spot color are given. This gives the printer all the information they need to mix the color for press.

The second method involves creating an electronic mechanical that produces screened percentages of each base ink to create the color. The most common screens are 150 and 133 lines per inch (lpi), in offset printing, and 75lpi in commercial screen printing. In both cases, the designer can specify the percentage used for each color when setting up an electronic mechanical. If the hue is 100 percent of color, no screen is used. The four base inks used in four-color process printing are cyan, magenta, yellow, and black; these correspond to the Acuity Color System. These four colors create one of the widest subtractive hue spectrums, including all the color variations found in full-color printing. In four-color process printing, most if not all colors are screen percentages of the four base hues.

The difference between *color mixing* and color building is the use of screen percentages of spot colors in building, in order to create new hues. In scanning a four-color photograph, the software application determines the screen percentages of each process color automatically. This is color mixing, not color building. Color building is the process by which a designer determines each screen percentage and builds the electronic mechanical accordingly. Color mixing and color building can take place in print-based, environmental, interactive, and motion graphics; architecture; interior and industrial design; printmaking; photography; and illustration.

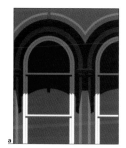 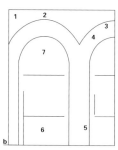

Diagram 17 (a–d) A crop of an illustration (17a), the compositional position of the parent colors (17b), the parent color swatches (17c), and their four-color process builds (17d).

(d) Color building
1. C57 M51 Y35 K35
2. C50 M41 Y29 K16
3. C69 M58 Y31 K64
4. C73 M59 Y21 K49
5. C61 M47 Y34 K32
6. C76 M58 Y18 K20
7. C91 M81 Y24 K38

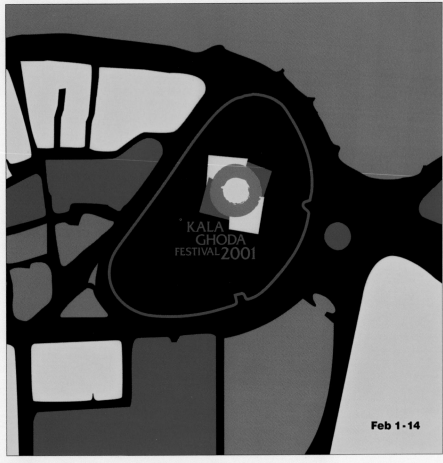

Figure 6
Studio RGD, Mumbai, India
Designers Radhika Chopra and Freddy Nagarwala

In interactive graphics, hexadecimal (hex) numbers are used in HTML coding. In many of the software applications used for interactive graphics, the designer specifies the hue by clicking on a depiction of the colors offered within the program. The program itself converts the color depiction into hex numbers. The Acuity Color System has a full library of over 10,000 colors that provides the hex numbers for each hue. This library is also useful for motion-graphics documents and internal intranet systems.

For both *subtractive* and *additive color mixing*, all ink-matching systems can be used. However, these hues will appear different depending on the environment in which the color is viewed. Additive color has a larger color spectrum than subtractive color, and this affects the appearance of the hue created. Note that when viewing colors for interactive graphics as well as motion graphics, you must bear in mind that the document in which the colors were created will be viewed on different platforms. Each platform, and every monitor, may create different tints (see *color tinting*), shades (see *color shading*), or colors of the original.

With 3-D color, it makes no difference what ink-matching or color system is used, or whether the color is additive or subtractive. The photoreceptor cells responsible for

Figure 6 An excellent example of hue use, this demonstrates how color purity can be intermingled in a working color composition.

Traditional color

Four-color process

Additive color

Subtractive color

3-D color

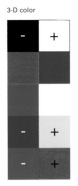

Diagram 18
Left: Primary sets within their respective color theory. When a pure hue is applied to another paradigm, some hues become semipure or achromatic. In Figure 6 these color sets were utilized to create the cover comprehensive.

6 type **C10** **M85** **Y100 K0**
 bgd **C50** **M40** **Y40 K100**

6 type **C50** **M40** **Y40 K100**
 bgd **C10** **M85** **Y100 K0**

6 type **C0** **M20** **Y100 K0**
 bgd **C100 M40** **Y0** **K0**

6 type **C100 M40** **Y0** **K0**
 bgd **C0** **M20** **Y100 K0**

BG Background color **C70** **M0** **Y100 K0** 20%

depicting color fire an electrical impulse through the *visual pathway* connecting to the *primary visual cortex*. The more light the eye can detect, the more pronounced the firing of the electrical impulse. This is what determines the mind's perception of color intensity or *chroma*.

Color purity: *The absence of white, black, or gray from a <u>hue</u>*

The majority of colors used by designers are not pure. Color purity, in a practical sense, refers to colors that are bright, e.g., colors that are made from two hues, inks, or spot colors that do not contain black or white pigment.

When working with spot colors for print-based, interactive, and motion graphics, purity is vital for color building. To create a wide range of color variation (with a great color range from light to dark), two pure or semipure colors are essential. A semi-pure color is created with no more than three inks (one of which is a small percentage of one of the hues), and with no black or white. Using two spot colors that are made from three inks consisting of four parts or more will create color matrices of earth tones or muddy colors. Muddy colors are also created when one color is pure or semi-pure and the other spot color has three inks with four parts or more creating its color.

When working with print-based graphics and the concept of color building, *complex subtractive color mixing* takes place. This is due to the overprinting of colors to create additional hues.

In interactive and motion-graphics design, color building takes place through the projection of light, which is then interpreted by the apparatus of the eye—the *visual pathway*, and the *primary visual cortex*. This constitutes *additive color theory*, and it is important to recognize that no *color mixing* takes place in physical space.

Color rendition: *The phenomenon of two colors appearing the same in one light source but very different in another*

We have all experienced the phenomenon of dramatic color shifting in photography when a film that is balanced for daylight is used under fluorescent lighting: the resultant prints have a greenish tint (see *color tinting*). All color is a product of its environment, including its light source. There are four main categories of common light sources:

- *dusk/dawn light;*
- *average daylight;*
- *incandescent light; and*
- *fluorescent light.*

For example, most fluorescent lighting emits a greenish tint that affects all colors viewed under it. This is why most printers conduct press checks under average daylight (5,000 K U.S. standard/6,500 K European standard). As this is the most common light source, it is an excellent source by which to match the press proof to the color proof.

For print-based graphics, all color proofs should be checked in daylight. Most design studios use different equipment from printers—viewing the printer's color proof under daylight conditions will give the most consistent, realistic impression possible.

Diagram 19 Left: Depending upon the light source, an individual viewing this diagram will see the color combinations as legible or not.

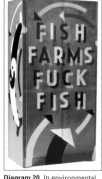

Diagram 20 In environmental graphic design, color appearance can be easily verified by placing the object in the correct light source.

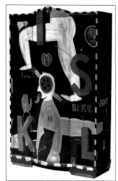

If this is not practical, a scale model should be utilized. **Designer** Carter Wong Tomlin Studio.

Figure 7
Art Director/Designer Sang-Soo Ahn

Many corporations have specialty inks made for their corporate colors. A specialty ink is a color that is not found in a standard ink-matching system but is requested by the client. In these cases, the client is likely to have strict standards as regards color accuracy. Depending on how the printer creates the specialty inks, *metameric pairs* of colors can be engendered. In such a case, two colors can look the same in one light source and different in another.

It is a much easier task to check for color rendition in environmental graphic design. From the onset of a project an environmental graphic designer will know the light source in which the signs or signage system will be viewed; at the very least, they will know before the project is completely designed. When the light source is known, the colors should always be proofed under the conditions in which the final sign will be presented.

Although color rendition affects subtractive colors, the phenomenon can be likened to the change in appearance that happens from computer monitor to computer monitor, electronic kiosk to electronic kiosk, TV set to TV set, or additive medium to subtractive substrate. Color rendition can make checking colors a tedious task, but being able to predict accurate rendition in all media in which a visual message is going to be seen is vital.

Figure 7 An effective use of color saturation. Small amounts of gray are added to help communicate a 3-D illusion on a 2-D plane. In print-based graphics this can be achieved by one of three ways. The first is by substituting gray with black to achieve the same effect. The second is to use a gray hue which will add an additional color to the print job, and the third, to add equal amounts of cyan, magenta, and yellow to create gray.

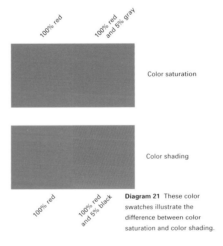

100% red 100% red and 5% gray

Color saturation

Color shading

100% red 100% red and 5% black

Diagram 21 These color swatches illustrate the difference between color saturation and color shading.

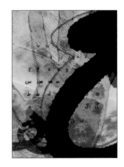

Diagram 22 Black is substituted for gray and printed on a white stock so that subtle variations in color can be achieved in the background. This is the second method mentioned in the text above (Color saturation). **Designer** Saied Farisi

7	type	C74	M93	Y84	K53	
	bgd	C10	M100	Y85	K10	
7	type	C10	M100	Y85	K10	
	bgd	C2	M33	Y95	K1	
7	type	C2	M33	Y95	K1	
	bgd	C74	M93	Y84	K53	

BG	Background color	C49	M0	Y50	K0	20%

The eye can detect subtle nuances in lightwaves, or colors. However, it can be fooled by the particles that make up an object's color. Part of a color's makeup is the substrate to which it is applied. All inks and most paints are translucent to some degree. If ink or paint of the same color is applied to different surfaces, including different materials that appear to have the same color, the likelihood of color rendition increases.

Color saturation: *The richness of a hue*
Color saturation is controlled by the amount of gray added to a particular hue. It can have a bearing on the intensity, or *chroma*, of a color. Low amounts of gray within a particular hue, for example, 100 percent red with 5 percent gray, equate to a higher level of color saturation. In four-color process printing, gray is created in one of two ways:

- *using equal portions of cyan, magenta, and yellow; or*
- *using a screened percentage of black on white paper.*

In print-based graphics, color saturation can also refer to the amount of ink printed, regardless of hue. Color saturation or ink saturation can be a concern in many low-quality print shops. Printed jobs can vary in color saturation by up to 40 percent—

the equivalent of having one sample printed at 100 percent of color and another at 60 percent.

When dealing with photographic color saturation for print production, it is a good idea to color correct all images for press. This includes checking color balance, focus, particle removal, *undercolor addition*, and/or *undercolor removal*. (See Chapter 6 for color correcting photographs.)

For interactive and motion-graphics design, images are used at a very low resolution. With Web design, most images are presented small-scale and therefore, color saturation, focus, and balance are the three most important aspects to consider; it is not necessary to check for particle removal (hickies) or to concern yourself with undercolor addition or undercolor removal as any problems caused by these will not be visible. With Web design it is perfectly appropriate to use the monotone, duotone, tritone, and quadtone features, but this is not recommended for print-based graphics. (See Chapter 6 for setting up monotones, duotones, tritones, and quadtones for print production.)

Color scheme: *The color combinations selected for a particular design*
Many designers have an intuitive sense about color and randomly select color combinations that work. For most of us it is much harder to select successful color schemes. The following three basic methods relate choosing a color scheme to the content and/or physical forms within the design.

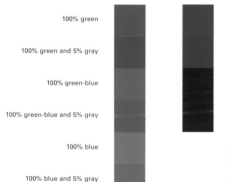

100% green

100% green and 5% gray

100% green-blue

100% green-blue and 5% gray

100% blue

100% blue and 5% gray

100% blue-violet

100% blue-violet and 5% gray

100% violet

100% violet and 5% gray

Diagram 23 The color swatches above depict the difference when small amounts of color saturation are utilized within a hue.

Diagram 24 Black is substituted for gray and blended with a teal-green to create a continuous-tone image. This is the second method mentioned in the text above (Color saturation). **Designer** Art Chantry

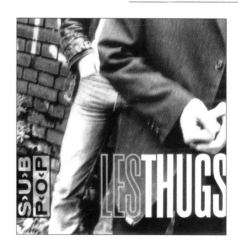

Method 1

Look at the photographs and objects to be used within the design. Most of these will have color embedded in their form. By picking two or three colors found within the original object, a color scheme can be created.

Method 2

Create a derivation of the colors found in the photographs and objects. A variety of additional colors can be created from the original color scheme using *secondary*, *tertiary*, *tints* (see *color tinting*), *shades* (see *color shading*), *chromatic*, *complementary*, *harmonious*, *monochromatic*, *neutral*, *primary*, *split complementary*, *achromatic*, and *analogous colors*. In this case the term primary refers to the colors within the original object. Each color selected from the original object becomes one of the primary color sources from which a color palette can be constructed. (See Chapter 3 for creating color schemes.)

Method 3

Examine the psychological and/or learned behavioral effects of color. An effective color scheme can be based on the message the client wants to convey, and on how they feel about their product and/or company. (See Chapter 7 for physical, psychological and/or learned behavioral effects of color.)

Color shading: *Combining a color and black*

The amount of black added to a color is usually no more than 80 percent—just a small amount of black can create a drastic difference in appearance. Many of the spot colors that are created in color formula guides have only one-quarter part or 1.5 percent black built into the overall color. In print-based graphics and environmental graphics, over 80 percent of black causes the color to appear more black than anything else. In interactive and motion graphics, up to 90 percent of black can be used to create different hues. Color shading can be used effectively with any spot color or with process printing by adding black to the other three primaries. Black is also used with six-color process (CMYOGK). The two additional colors in six-color process are orange and grass green; these intensify the cyan and magenta.

Color shading works effectively with both *warm* and cool colors. With warm colors, adding 1–20 percent of black creates an earth tone or shaded hue. With cool colors, black makes the color darker and can thus help to create a 3-D illusion on a 2-D plane. Adding 1–5 percent of black to cool colors tends not to muddy the color, however, visual verification is always necessary. The Acuity Color System uses color shading extensively.

In print-based graphics, 80 percent is prudent, especially when printing on uncoated stock, as considerable dot gain occurs on these. Dot gain can occur on coated papers or substrates, but ink swelling is not as prevalent on these, so the mark can be increased to around 85 percent. (See Chapter 6 for dot gain and color correcting.)

In interactive and motion graphics dot gain does not occur. The color spectrum is brighter because these fields utilize additive color. This allows the mark to be set at the low 90 percent mark.

One of the myths perpetuated in design is that black helps to add *color contrast*. As stated earlier, color contrast is determined by motion, form/silhouette, depth, and color. All four factors help to determine legibility and readability in color combinations. A combination can have a minimum of 2 percent contrast and still be legible simply because the motion of the object, the form/silhouette of the object, and the depth of the object are clearly visible. In a static 2-D form, the illusion of depth can still be created through size and placement, and the form/silhouette and color are still governing factors in determining legibility. The *color value* numbers constitute only one of four factors determining color contrast.

Diagram 25 In this marketing material the basic color selection was made utilizing method 1, as described above. Additional hues were added to make the material seem more springlike (see method 3). **Designers** John T. Drew and Sarah A. Meyer

Diagram 26 Right: This chart illustrates small amounts of black being added in 10% increments to the hue red.

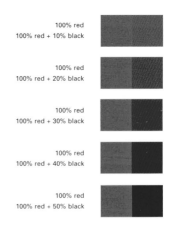

100% red
100% red + 10% black

100% red
100% red + 20% black

100% red
100% red + 30% black

100% red
100% red + 40% black

100% red
100% red + 50% black

BG Background color C0 M80 Y100 K0 80%

Color temperature: *The degree of warmth or coolness that a color suggests*

No matter the color theory or medium in which *hues* are utilized, *warm colors* appear to come forward and cool colors tend to recede. With *subtractive color mixing*, this phenomenon is due to the physical property(ies) of an object and the amount of light being reflected off its surface. The spectrum of color that humans can detect ranges from 380 to slightly over 700 nanometers (nm). The higher the number, the greater the amount of light emitted.

Cool colors range from 380nm (black) to around 500nm (blue/green), and warm colors range from 500nm (yellow/green) to 700nm (red). In this case, pure black and white are not considered colors.

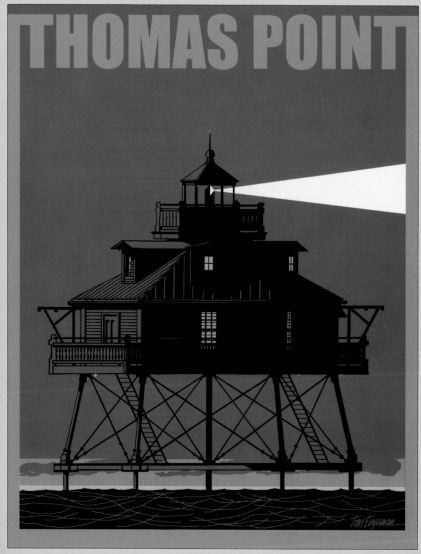

Figure 8
Illustrator/Designer Tom Engeman

Figure 8 A superior use of color temperature. The coolness of the overall color scheme relates to the physical temperatures found on the water, and the psychological effects associated with the harsh conditions. Orange is utilized to represent an oasis of warmth in a most inhospitable environment.

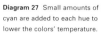

Diagram 27 Small amounts of cyan are added to each hue to lower the colors' temperature.

type C0	M85 Y70 K0	
bgd C85	M68 Y0 K0	
type C0	M45 Y100 K0	
bgd C0	M85 Y70 K0	
type C0	M0 Y0 K0	
bgd C0	M45 Y100 K0	

Figure 9
Art Director Ned Drew
Designer Brenda McManus

An object with a cool color will often appear smaller than an object of the same size with a warm color. However, this is an illusion and does not diminish the legibility of the object. In other words, the two objects can be the same size, one appearing to be larger than the other, but the physical apparatus of the eye will view them as the same. One of the myths surrounding type and color combinations is that the typography should always be a warm color and the background should be a cool color in order to increase legibility at a distance. The arrangement of these two colors makes no difference to the legibility. Hue, motion, form/silhouette, and depth are the determining factors for legibility and color contrast. Therefore, the arrangement of the type and colors makes no difference to the legibility in the example, left; all that matters is that there is a 20-percent difference between the foreground and the background color.

We do need to take into account the readability of an object. Dr. Miles A. Tinker was one of the most prolific researchers in the field of typographic legibility and readability. However, many of the studies he conducted, during the 1920s and 1930s, were based on cultural norms, and the typographic norms of his time are different from those of today. This can be said about any book dealing with typographic

Figure 9 Color temperature is used in a most effective manner. In each case a warm color is juxtaposed with two cool colors, making the images pop. By setting up the color composition in this manner, a 3-D illusion on a 2-D plane is achieved.

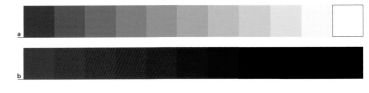

Diagram 28 (a and b)
The color swatches above depict two color techniques: 28a illustrates color tinting in 10% increments, and 28b illustrates color shading. Both techniques are methods to control color temperature.

readability issues published over 10 years ago. The readability of an object depends upon how normal the object appears. Under abnormal conditions, the speed at which we read will be reduced. When dealing with the color temperature of type and color combinations, changing the foreground color to the background and vice versa will not have any effect on legibility, but it may affect the speed at which the combination can be read. If speed of reading is part of the design requirement, then you should look for culturally normal type and color combinations. If the intent is to slow down the reader, look for abnormal combinations.

In print-based, motion, interactive, and environmental graphics, warm colors can have a cool tint and cool colors can have a warm tint (see *color tinting*). Depending on the amount of color being added to the original warm or cool hue, the intensity or relative lightness as perceived by the mind's eye may not be diminished to any great degree. Changing color temperature is a very effective way of creating *color schemes*. If used correctly, color combinations can create a 3-D illusion on a 2-D plane. The darker the color, the more it recedes. The warmer the color, the more it comes forth. Depending on how these color categories are used, a minor or major 3-D illusion can be created.

With a knowledge of color temperature, you can create more effective visual communications through illusions. We know that the photoreceptor cells found within the eye respond to amounts of light. Lightwaves are interpreted according to the relative lightness or brightness perceived by the mind's eye. The more light that enters the eye, the brighter, more intense, and more pure the color will appear until the apparatus of the eye is overwhelmed and glare occurs. Warm colors have a longer wavelength than cool colors. The physical property of lightwaves may have some bearing on the creation of *simultaneous contrast*. Researchers have determined that when viewing an object that possesses warm and cool colors, the iris focuses back and forth from a long wavelength to a short wavelength. This phenomenon may exacerbate simultaneous contrast by causing the iris to adjust back and forth rapidly.

Color tinting: *Adding a small amount of one color or white pigment to another color*
A color tint can also mean a screened percentage of a color, which allows the white of the paper to show through. The practical application of color tinting is usually 3–30 percent of one color or white pigment added to the other, or a percentage of color less than 100 percent printed on a substrate. When dealing with electronic files, color

tinting takes place when the opacity is set less than 100 percent and the background color is white, or a small amount of one color is superimposed on another. If used correctly, color tinting can create a wide variety of color effects that can complement the overall message.

Color tinting can be a highly effective strategy for creating efficient messages within visual communications. Since most offset inks are very transparent, the substrate on which the ink is placed plays an important role in color tinting. In fact, the substrate plays an important role in controlling the outcome of color appearance. Screen-printing inks are more opaque than offset inks, but they are still transparent.

Diagram 29 (a–d)
The two squares 29a and 29b utilize warm and cool colors to create an illusion of the type coming forward or popping. The color combination in 29c creates the illusion that the type recedes. The combination in 29d is perceived as flat because the warm color is in the background and the cool color in the foreground.

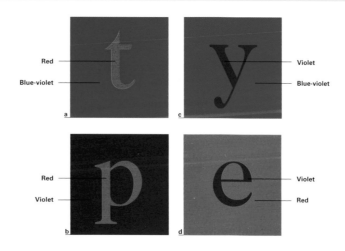

Red — Blue-violet (a)

Red — Violet (b)

Violet — Blue-violet (c)

Violet — Red (d)

In screen printing, pigment can be added to increase the opacity of an ink, but the ink's appearance may be affected. Since most offset and screen printing is produced on white paper, it can be said that all colors used have a certain percentage of color tinting taking place. When using a colored paper or a substrate that is already colored, all inks placed on top will "contain" a certain percentage of the substrate's color; this is also considered color tinting. In other words, color tinting takes place by using a colored substrate or paper that modifies the overall appearance of the inks.

Color tinting is one of the most common techniques used throughout the design industry, whatever the medium. Color tinting can be used for film; video; traditional photography (in which case it is usually done by hand); digital photography; illustration; printmaking; and print-based, interactive, motion, and environmental graphics. An important factor to consider when using color tinting is the type of inks or monitors being used. The first consideration for print-based graphics should be the type of printing to be used: this will dictate how you set up the electronic file for a press-ready mechanical. Within the media and color schemes mentioned above, many different color tinting techniques can be created.

In print-based graphics, the most common techniques involve the use of different screens—mezzotint, vertical or horizontal parallel line, steptone, double dot, crossline, etc.—and different screen numbers (lpi). However, the tonal distribution of color tinting can be affected by the highlights, midtones, and shadows of an image. If the tonal range of an image for print production is from 3–98 percent of color, then the color tinting taking place will have an overall effect on the image.

If a higher-contrast image is being utilized, then the color tinting may not appear to apply to the whole image. With high-contrast images, the tonal range or continuous tone of an image is diminished. The spectrum range of a continuous-tone image is no longer from 0–100 percent. In most high-contrast images, the continuous tonal range is from 20–100 percent. The higher the contrast, the less tonal range the image has: the contrast causes areas of 0–30 percent to drop out to white or the color of the substrate, and areas from 70–100 percent to fill in black. Black equals 100 percent and white equals 0 percent. When using color tinting with images, the darker areas of a photograph, illustration, and painting may not be affected by the tinting, or the effect may be so slight that it is hard for the human eye to detect the shift in color.

In this book, color tinting is utilized on an array of colors following one simple rule— if the *hue* is made from a cool color, then it is tinted 20 percent or less; if it is made from a *warm color*, it is tinted from 20 percent and above. Warm, pure or semipure colors (see *color purity*) are used at 100 percent of color.

As mentioned above, screens and their percentages are a highly effective way to create color tinting. Each type of screen, the corresponding percentage, and the corresponding dpi/lpi being used can have a different effect upon color tinting.

Many different screens are available, among them continuous tone, dot, square, oval, brick, concentric circle, crossline, cutline, double dot, engraving, etch tone, fine grain, linen, mezzotint, vertical and horizontal parallel line, steptone, and wavy line. In many of the photo manipulation programs available today, the manipulation of screens, their corresponding percentages, and their dpi and lpi are relatively easy to control. The lower the lpi number, the coarser the screen produced. In offset printing, the two most common lpi numbers are 133 and 150. Work that is printed at 300lpi looks similar to a continuous-tone photograph. With 300lpi it is hard to see the screens utilized within the photograph without magnification.

Yellow-orange 100%

Yellow-orange 100%

White 100%

Yellow-orange 100% + blue-violet 10%

Yellow-orange 70%

Yellow-orange 10%

Diagram 30 Left: Two methods of color tinting.

Diagram 31
Different screen effects that can be utilized to alter hue appearance. This includes color tinting.

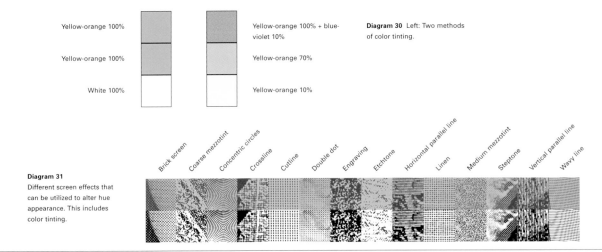

Brick screen · Coarse mezzotint · Concentric circles · Crossline · Cutline · Double dot · Engraving · Etchtone · Horizontal parallel line · Linen · Medium mezzotint · Steptone · Vertical parallel line · Wavy line

For interactive graphics, images are generally saved at 72dpi, and screen effects can also be utilized efficiently within this medium. Consideration should be given to the amount of compression applied by the file format the image is saved in (most commonly JPEG or GIF). In order to compress an image or graphic, some information is thrown away. Typically, this results in a loss of tonal and/or color range. Screening effects can create a dynamic color palette by creating a *color scheme* that utilizes the opposition of light to dark, and ghosted to fully saturated images. The same can be said for motion graphics, film, video, illustration, and photography.

Figure 10
Art Director/Designer Ned Drew

Figure 10 When printing on colored stock, purity of the original hue specified must be taken into consideration. This poster is a good example of pure and semipure colors being utilized to offset the effect that a colored stock will have on each hue printed.

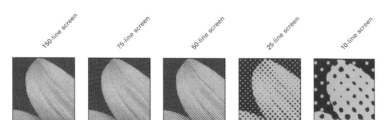

Diagram 32 Color tinting through the use of line screen per inch—all round dot.

10	type	C25	M33	Y50	K2
	bgd	C69	M49	Y99	K18

10	type	C15	M79	Y99	K6
	bgd	C77	M73	Y60	K80

10	type	C77	M73	Y60	K80
	bgd	C15	M79	Y99	K6

10	type	C69	M49	Y99	K18
	bgd	C25	M33	Y50	K2

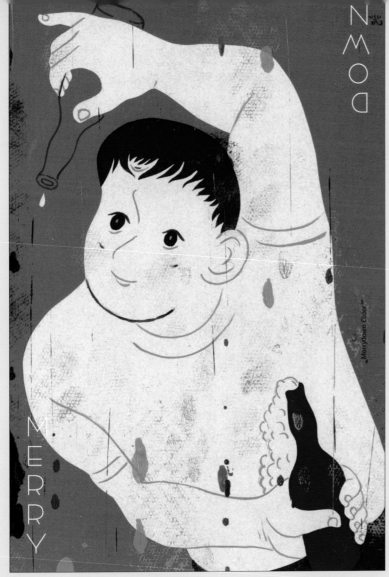

Figure 11
Creative Director David Dye
Typographers David Wakefield and Mike Pratley

Color toning: *Adding one <u>complementary</u> <u>color</u> to another*

Color toning is the most effective strategy for decreasing *simultaneous contrast*. This occurs when there is an imbalance, or unequal proportion, of complementary colors and becomes pronounced when the colors are traditional *primaries*. In such cases, typographic color combinations are all but impossible to read as the strobing effect makes it physically impossible for the eye to fixate.

By adding one complementary color to the other, a more balanced color proportion occurs, thus lessening the simultaneous contrast—the overstimulation and fatigue of the photoreceptor cells, and the resultant *afterimage* effect. The more color toning created, the less simultaneous contrast will occur. Simultaneous contrast occurs with all color processes, disciplines, and media, so toning is an excellent strategy for design in print, interactive, environmental, and motion graphics.

Color value: *The relative lightness or darkness of the color as perceived by the mind's eye*

The color value rating, or *chroma*, is also known as the *Y tristimulus* value. Numerous *hues* have the same or nearly the same color value. We often confuse the screen percentage of the color with its color value.

Figure 11 In this Merry Down poster, the red has a CVR rating of 18.22% and the purple a CVR rating of 10.37%. This is a CVD of less than 8%.

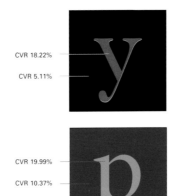

CVR 18.22%

CVR 5.11%

CVR 19.99%

CVR 10.37%

Diagram 33 Left: A person possessing normal eyesight, with or without corrective eyewear, can easily detect objects that have a CVR differential of less than 9%.

Diagram 34 Right: In this C/Z records cover, two hues are being utilized—a dark purple and a pinkish red. Each is used at 100% of color. The pinkish red has tonal variance, however, this is achieved through a coarse screen pattern. **Designer** Art Chantry

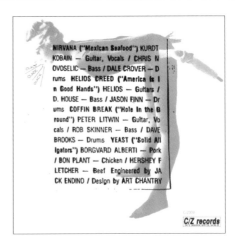

	type				
11	type	C96	M84	Y22	K33
	bgd	C13	M99	Y91	K1
11	type	C13	M99	Y91	K1
	bgd	C12	M11	Y15	K0
11	type	C12	M11	Y15	K0
	bgd	C96	M84	Y22	K33

BG Background color C20 M0 Y100 K0 70%

The screen percentage of a color and the color value operate independently; one does not affect the other. Color percentage and color value are distant cousins, but for ease of comprehension we should view them as entirely different. For example, a color can have a color value rating of 3 percent and be 100 percent of color, or the color can have a 98 percent color value rating and be 100 percent of color. The percentage of a color is the amount of color being utilized either in an electronic environment or on a printed substrate. The color value rating tells us how well the human eye perceives the color either as a positive electrical impulse (*warm color* value) or a negative electrical impulse (cool color value). (See Chapter 5 for color value and color contrast.)

The association of color value and *color contrast* with legibility is frequently misunderstood. Many designers confuse the two. Color contrast is determined by the physical way the eye perceives hues and objects, whereas color value is how the mind interprets what the eye perceives.

Color value is one of the contributing factors in distinguishing three-dimensionality. The lighter the color, the closer the object appears to be; the darker the color, the further away it appears. This does not mean that the eye perceives a lighter color more

clearly than a darker color, or that a light color must be combined with a dark color to create legible type and color combinations.

By changing the value of a color, numerous *primary*, *secondary*, and *tertiary colors* can be created. Adding black to a color will affect its purity (see *color purity*); if the color created is to be used for building and you want to achieve a high color *chroma*, use only very low percentages of blacks.

Color value is one of the factors that determines typographic legibility. When using a white substrate, the standard rule of thumb for black text type on a background color is to use 5–20 percent for dark, cool-colored backgrounds. Most warm primaries and secondary colors can be used at a much higher percentage of color, including 100 percent of color as a background. For example, 100 percent of red with a color value of 18.22 percent can be used as a background for 100 percent black text type. As black has a color value of 5.11 percent, the differential between the two is only 13.11 percent, so the type and color combination is perfectly legible. The same applies for 100 percent purple (with a 6.9 percent color value) and 100 percent red (with an 18.22 percent color value): the differential is only 11.32 percent, and the type and color combination is perfectly

legible. The distance at which a human with normal color vision can see this type and color combination is identical if the type is purple and the background is red or vice versa. The same is true for the red and black text and color combination. It makes no difference which color is the background and which is the foreground for typographic legibility and viewing distance.

The color value rating for any physical sample can be determined. Included in the Appendix are visual samples and other color value ratings for woods, metals, plastics, bricks, cinder block, and stucco—all commonly used material for signage. Using these values will ensure color compliance with any legislation.

Diagram 35 Right: A person possessing normal eyesight, with or without corrective eyewear, can easily detect objects that have a CVR differential of less than 9%.

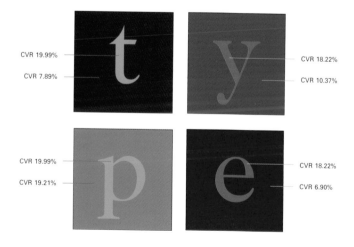

CVR 19.99%
CVR 7.89%

CVR 18.22%
CVR 10.37%

CVR 19.99%
CVR 19.21%

CVR 18.22%
CVR 6.90%

Color wheel: *A matrix comprised of <u>primary</u>, <u>secondary</u>, and <u>tertiary</u> <u>hues</u> or <u>colors</u>*

Different forms of color wheels generate a multiplicity of hues. The Munsell System has 10 basic recognized hues defining the color wheel, while in the PANTONE MATCHING SYSTEM® some 13 basic hues make up the color wheel. In the Acuity Color System, there are four basic hues, and some 10,000 spot colors. Most color wheels and their respective systems start with a few basic colors. These colors tend to correspond to the receptor cells found within the *cones* of the eye (yellow/blue, red/green, white/black, red, blue, green, and purple). Most of the color spectrum that humans can see can be created through either *subtractive* or *additive color mixing*, from these basic colors.

Color wheels that do not utilize the entire human color spectrum can also be created. Such wheels are offbeat and usually specific to the job in hand. They are generally set up to meet the objectives of the client through the utilization of corporate colors, and physical, psychological, and/or learned behavioral effects. A basic color wheel that utilizes primary, secondary, and tertiary colors coordinated with a specific job provides a highly effective tool for creating articulate visual messages. (See Chapter 3 for creating color wheels.)

In print-based graphics, subtractive primaries (cyan, magenta, yellow, and black) are used to create the color spectrum. In interactive and motion graphics, including film and video, additive color is used to create the color spectrum. With additive color mixing, the hues are projected from their source. This means that the color intensity or *chroma* is greater than that produced in print-based graphics, and this creates a larger color spectrum. Most of the wheels provided by contemporary application programs do not distinguish between subtractive and additive color spectrums. Many of these programs distinguish only the color ranges that are outside of the subtractive color spectrum, flagging the color chosen with a "!."

Complementary colors: <u>Hues</u> *that are found on opposite sides of the <u>color</u> <u>wheel</u>*

Complementary colors can be *primary*, *secondary*, or *tertiary*, as well as tints (see *color tinting*) and shades (see *color shading*). With *subtractive colors*, mixing two complementary colors in equal parts will create a neutral gray or black. White pigment can be added to lighten a neutral gray. Black pigment can be added to darken a neutral gray. Mixing slightly more of one complementary color to the other will create a gray with a color tint of the "larger" complementary color.

With *additive color mixing*, complementary colors mixed in equal parts (using all three primaries) create a neutral gray or white. Computer screens and television monitors use additive color. However, the contemporary application programs used by designers, photographers, and illustrators for interactive and motion graphics and film use *subtractive color mixing* (both *simple* and *complex*) for the creation of color palettes. The color information is still created in the color gamma range of additive colors, but designers tend to be more familiar with subtractive color mixing palettes. Color gamma is the intensity of light generated, in this case by the computer screen. Macintosh operating systems usually use a gamma value of 1.8 while Windows systems use 2.2; the higher the value, the darker the midtones produced. Neither of these systems accurately reflects what would be seen on paper.

Complementary colors create highly effective *color schemes* and, usually, pleasing color combinations. However, using primary and secondary hues at full saturation within complementary color schemes creates pronounced *simultaneous contrast*. This effect, in the right context, can create successful visual communications. A color scheme utilizing simultaneous contrast creates highly kinetic hue interplay.

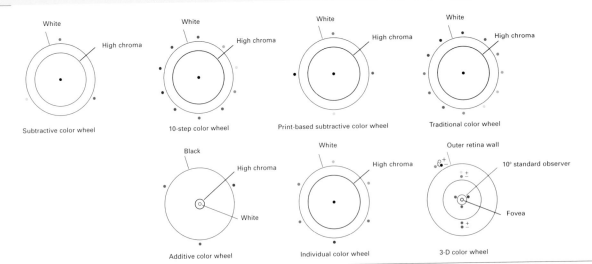

Diagram 36
These are a few of the color wheels/models that designers use on a day-to-day basis.

Subtractive color wheel

10-step color wheel

Print-based subtractive color wheel

Traditional color wheel

Additive color wheel

Individual color wheel

3-D color wheel

The strobing interplay can be intriguing. However, you do need to exercise caution when using complementary colors that create pronounced simultaneous contrast with type and color combinations—small text set in a complementary color scheme at full saturation creates unreadable text.

Complementary colors that are primary and coincide with the photoreceptor cells found within the *cones* of the eye (blue/yellow, green/red, red, blue, green, and purple) can create a 3-D illusion on a 2-D plane. Eyewear such as 3-D glasses that utilize the same complementary colors as the printed page produce a 3-D effect; the transparent, colored gels through which the audience views the printed piece must be the same or near-same *hue* and *chroma* as the colors on the printed page.

Figure 12
Art Director/Designer John Malinoski

Figure 13
Illustrator/Designer Tom Engeman

Figure 12 Red and green are utilized as parent colors to form a complementary color palette.

Figure 13 Blue and orange are employed to form a complementary color palette. Both shading and tinting are utilized within the blue hue. Magenta is utilized with blue to create an array of red-violet. When combined, the three hues create an incongruent color palette.

Diagram 37 Parent colors from Figure 12.
● ● Complementary colors (12-step color wheel)

Diagram 38 Parent colors from Figure 13.
● ● Complementary colors (12-step color wheel)

Diagram 39
● ● Complementary colors (10-step color wheel)

| | type C0 M91 Y87 K0 | | |
| | bgd C65 M0 Y100 K9 | | |

| **12** | type C0 M0 Y0 K0 |
| | bgd C0 M91 Y87 K0 |

| **12** | type C65 M0 Y100 K9 |
| | bgd C0 M0 Y0 K0 |

| **13** | type C17 M28 Y0 K0 |
| | bgd C89 M29 Y13 K15 |

| **13** | type C89 M29 Y13 K15 |
| | bgd C17 M28 Y0 K0 |

| **13** | type C89 M29 Y13 K15 |
| | bgd C2 M33 Y36 K0 |

ITALIAN MARKET FESTIVAL, 17TH STREET FARMERS' MARKET, SATURDAY, JUNE 23, 2001, 10 AM TO 6 PM, RAIN OR SHINE, ADMISSION FREE, FEATURING: DIVAS, ACCORDIONS, BOCCE BALL, ITALIAN SPIRITS, GRAPE STOMPING, ITALIAN CHEFS, PASTA MAKING, PIZZA TOSSING, PONY RIDES, MAGICIANS, JUGGLERS, CHILDREN'S ACTIVITIES, A WEDDING AND MUCH, MUCH MORE! FOR MORE INFO: 804 646 0477 OR WWW.17THSTREETFARMERSMARKET.COM

Complex fields of vision: *The mechanics of perceiving the location and orientation of an object*

Complex fields are located in the *primary visual cortex* of the brain. They work best when an object is properly oriented but contains no "on" and "off" component. Complex fields are responsible for defining moving slits, edges, and/or dark bars, and help humans to interpret the shape, contour, and mass of an object.

For example, complex fields play an important role in how humans see and understand typographic anatomy. Without them we would see color, but no distinct shapes. Color and shape perception are intertwined—they should not be viewed as independent entities. They have a symbiotic relationship best viewed as a dynamic, ongoing visual process.

With the complex fields of vision, it makes no difference whether the *color value* rating of a background/foreground color combination has a 2 percent or a 98 percent differential. The issue is whether these fields can detect form or not. With regard to the perception of form, the choice of color combination has to do with learned behaviors—it has nothing to do with the way humans perceive objects physically, through the apparatus of the eye.

A general lack of understanding about how humans "see" color has led to myths about *color contrast*. The colors chosen for type and background can have the same value rating and the type be clearly legible. Type and background can even have a yellow and yellow/orange combination and be clearly legible. Legibility depends on the shape, color, depth, and size of the form. If the object under examination crosses over the *simple, hypercomplex,* and *complex fields*, the object can be seen. These three fields are found within the *visual pathway*. An object must be big enough to make an impression that is larger than three of these receptor cells; if it is not, the object will not be seen.

Complex subtractive mixing: The process of removing lightwaves through absorption and scattering

Complex subtractive mixing occurs when light bounces off an object. The lightwaves are then either reflected back in the direction of the viewer, absorbed by the object as heat, and/or *scattered* in various directions. When creating objects for viewing at a distance, the effects of complex subtractive color mixing should always be considered. In print-based graphics this process will have an effect whenever a varnish is used or an object is viewed under glass or laminate. In many cases, glare is a by-product of the object created. Minimum glare must be taken into account because it decreases the distance at which objects can be read by up to 15 percent. In cases where intense glare is generated, the object can no longer be seen.

In environmental graphic design, many materials and substrates are utilized in signs and signage systems. Each material has its own molecular structure and texture. Both the structure and the texture influence scattering. The rougher the texture, the greater the scattering; the smoother the texture, the less likely it is that scattering will occur. However, in certain conditions, if the object is smooth intense glare will occur. Both scattering and glare have a direct impact on the distance at which we can see objects—both reduce it. On a rougher object, glass, laminate, and varnish, whether matte finish or not, all produce scattering, and/or glare. Scattering and glare occur in interactive and motion graphics because the object is under transparent glass when the design is viewed. No matter how transparent the glass appears, some scattering will occur. With interactive and motion graphics the phenomena of projected light and ambient light occur simultaneously. Depending on the environment, one lighting condition may be dominant over the other, and this must be accounted for in the design.

Diagram 40 (a and b)
The difference in appearance when hypercomplex photo-receptor cells are used in the process of perception and when they are not: 40a shows the appearance without the use of the complex photo-receptor field; 40b shows the appearance with the complex photoreceptor field.

CVR 10.37%

CVR 19.99%

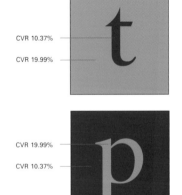

CVR 19.99%

CVR 10.37%

20/20 = 5ft 4^{6}/$_{16}$in (1.7m)
20/25 = 5ft 3^{12}/$_{16}$in (1.6m)
20/30 = 3ft 3^{12}/$_{16}$in (1m)
20/40 = 2ft 7^{15}/$_{16}$in (0.8m)
20/50 = 2ft 3^{8}/$_{16}$in (0.67m)
20/70 = 1ft 6^{10}/$_{16}$in (0.47m)
20/100 = 1ft 15/$_{16}$in (0.3m)
20/200 = 8/$_{16}$in (0.16m)

Diagram 41 The visual distance is the same in both type and color combinations. For typographic legibility it makes no difference which color is the foreground and which is the background.

BG Background color C50 M90 Y0 K0 15%

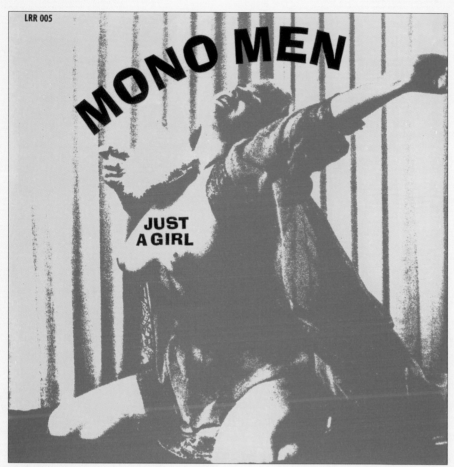

Figure 14
Art Director/Designer Art Chantry

Cones: *The receptor cells responsible for our perception of bright light and color*

Cones receive their name from their shape. They are primarily responsible for daylight perception. Cones are most dense near and around the fovea of the eye. They diminish in density as they move outward on the retina wall. There are two types of color perception within the cones of the eye. The first type corresponds to the *primaries* of *additive color theory* (red, green, and blue), and the second corresponds to the color opponent theory, with color primaries of red/green, blue/yellow, and black/white. Each set of primaries seems to correspond to the location of the cone's photoreceptor cell matrix on the retina wall.

Figure 14 In this example, both complex subtractive mixing and simple subtractive mixing occur. In the photographic process, complex subtractive mixing is utilized, and simple subtractive mixing is used to reproduce the photograph in the printing process.

Diagram 42 In these two examples, simple subtractive mixing takes place. In order for complex subtractive mixing to occur, the substrate in which these images are printed would have to have a textured surface. **Designer** Linda Y. Henmi

14	type **C0**	**M95**	**Y100**	**K0**
	bgd **C2**	**M6**	**Y80**	**K0**

14	type **C0**	**M95**	**Y100**	**K0**
	bgd **C2**	**M6**	**Y80**	**K0**

Cones corresponding to the color primaries of red, green, and blue seem to be located near and around the fovea. As the cone field decreases in density and moves outward to the perimeter of the retinal field, the receptor cells within the cones tend to respond to the opponent process theory (blue/yellow, green/red, and black/white). The receptor cells found within the cones in this location operate in pairs of three.

Understanding the basics of color perception and how we process and interpret color—both physically and psychologically—will help you create superior visual communication. It is hard to create compelling solutions without a comprehension of how color works.

Electromagnetic radiation: *The transfer of radiant energy as heat and light, through air, water, or vacuums*

Electromagnetic radiation is produced by a light source, either artificial or natural. With artificial light, the radiant energy transferred as heat can be easily controlled. When radiant energy is produced by a light source, it is the responsibility of the designer to understand the degree of heat produced.

Electromagnetic radiation and the radiant energy produced as heat are issues in *additive*, *subtractive*, and *3-D color mixing*.

Print-based, interactive, and motion-graphics designers need not be concerned with this phenomenon, but it must be taken into account in the fields of architecture, interior design, industrial design, lighting (for television and motion pictures, etc.), and environmental graphic design.

Fixation points: *Discrete points at which the eye is in focus*

The eye moves along the printed line in a succession of small, rapid jerks, from one point to another. These points are called fixation points, and it is only at these that the eye is in focus.

Fixation points play an important role in our understanding of the relationship between an object and its color. If the human eye were unable to fixate, the viewing of clear, vivid, colored objects would be impossible. The process of viewing what is around us is similar to the construction of a movie. Each fixation point is like a single frame, and by combining these images one after another, the environment around us is understood.

We can increase the perception of good compositional balance by carefully placing fixation points. Many typographic configurations do not lend themselves to inducing a fixation point. The same can be said for many type and color combinations

and two-color combinations. For example, structuring a column of text that is over 24 picas long will create a protracted horizontal scan that results in poor fixation, thus making it hard to pick up the next line within the column of text. Simultaneous contrast, which is caused by an over-stimulation of the photoreceptor cells within the eye also prohibits fixation. When this occurs, the result is poor fixation, which leads to reduced viewing comprehension.

Within any design field, some typographic anatomy is better for viewing at a distance than others. For an image to be "seen," an object must cross over, in a distinct order, three cells positioned in the simple field matrix of the *primary visual cortex*. If, for example, part of the typographic anatomy of a specimen is too thin to cross over these cells, the totality of the anatomy will go unseen. This is not to say that only monoweight typefaces should be used for typography that will be viewed at a distance. This is a misperception of many researchers in the field of environmental graphic design. By understanding the factors that determine whether an object will be visible or not in *3-D color theory*, adjustments to create a better viewing experience can be made. Fixation points constitute part of the overall calculation for clear, vivid viewing. The software program Acuity 1.0 makes these

Diagram 43 In both examples, fixation is hard to achieve due to pronounced simultaneous contrast, induced by the photoreceptor cells of the eye which are responsible for color.

Each has a line length of almost 29 picas, a contributing factor in poor fixation. If a line length less than 18 picas is used for body copy, the leading must be increased to improve fixation. For body copy the standard amount of leading is 3pts. In this example, 2pts of leading has been added, increasing the amount to 5pts.

"The process of viewing what is around us is similar to a movie. Each fixation point is like a single frame found within hundreds of thousands of movie frames, and by combining these images one after another the environment around us is understood."

"Designers creating structure need to take fixation into account. Many typographic configurations do not lend themselves easily to inducing a fixation point. The same can be said for many type and color combinations and two-color combinations."

0 picas 14.5 picas 18 picas 24 picas

calculations and determines the distance at which clear perception takes place. (See Chapter 4 for color legibility.)

Many color combinations make it very difficult for the eye to fixate on an object. When printed or viewed at 100 percent, many *complementary color* combinations can create pronounced *simultaneous contrast*, which makes the object appear to vibrate. This can be more aggressive and advanced with *additive color mixing* due to its greater color spectrum. With *subtractive color*, lightwaves strike an object before being projected into the apparatus of the eye. Subtractive lightwaves appear less intense, or bright, to the human eye, and therefore, the effect of simultaneous contrast is lessened. However, some complementary color combinations and *primary color* combinations create *hue* dynamics that are not conducive to stabilizing an object. For both additive and subtractive color mixing, this phenomenon should be corrected, unless it is specifically desired, to make the composition more kinetic.

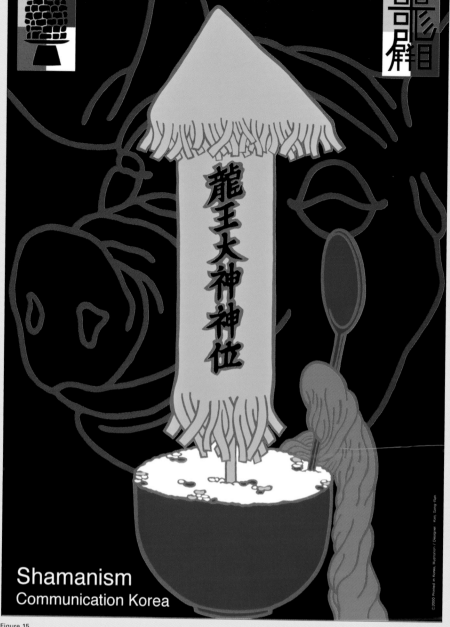

龍王大神神位

Shamanism
Communication Korea

Figure 15
Art Director/Designer Sang-Rak Kim

O O O O O

Old style: Garamond (1617)
Stroke width-to-height ratio: 1:7
Stroke width-to-width ratio: 1:7.33
Width-to-height ratio: 1:1
Stroke width-to-counterform ratio: 1:5.3

Transitional: Baskerville (1757)
Stroke width-to-height ratio: 1:5.33
Stroke width-to-width ratio: 1:5.5
Width-to-height ratio: 1:1
Stroke width-to-counterform ratio: 1:3.5

Modern: Bodoni (1788)
Stroke width-to-height ratio: 1:6.25
Stroke width-to-width ratio: 1:5.25
Width-to-height ratio: 0.84:1
Stroke width-to-counterform ratio: 1:3.25

Egyptian: Century Expanded (1894)
Stroke width-to-height ratio: 1:6.15
Stroke width-to-width ratio: 1:5.5
Width-to-height ratio: 0.89:1
Stroke width-to-counterform ratio: 1:3.5

Contemporary: Helvetica (1957)
Stroke width-to-height ratio: 1:7.5
Stroke width-to-width ratio: 1:7
Width-to-height ratio: 0.93:1
Stroke width-to-counterform ratio: 1:5

Figure 15
With this poster, prolonged viewing will create retina fatigue, making it hard for the eye to fixate. Such color combinations are very effective when creating a dynamic composition like this.

Diagram 44 Left: This example illustrates the typographic specifications for each typeface shown. The stroke width-to-height, width-to-width, and width-to-counterform ratio, and the character width-to-height ratio are critical when designing a typeface for maximum viewing distance. (For more information see Chapter 4.)

					
15	type	C0	M0	Y0	K0
	bgd	C0	M0	Y0	K100
15	type	C0	M0	Y0	K100
	bgd	C0	M30	Y100	K0
15	type	C0	M0	Y0	K0
	bgd	C80	M90	Y0	K0

Fovea: *A small spot on the <u>retina</u> that provides our narrow, central field of focused vision*
The location of the fovea is critical in detecting sharp, vivid images. This area of the eye also has a high concentration of *cones* sensitive to color. The region around the fovea performs the primary role in the calculation of color and sharp, vivid images. It represents a 10° angle of vision that can be projected in an outward direction. At a distance of 18in (45.7cm), this area would be equivalent to a 3⅜in (8.5cm) circle (the 10° *standard observer*). The other areas located on the retina wall are responsible for our peripheral vision. This does not provide us with sharp, vivid images, but it does play an important role in helping us navigate through our environment.

Fugitive colors: *Colorants, pigments, or dyes that change or lose color rapidly when exposed to light and air*
Fugitive colors are used in print-based graphics, product design, and environmental graphic design. Colorants, pigments, and dyes are not used for interactive and motion graphics.

Most colorants, pigments, and dyes are sensitive to light and air, which causes fading of the original, specified color(s). For print-based graphics, many different colorants and pigments are used in the creation of an ink, and some inks are more sensitive than others. Most ink-jet printers do not offer stable inks. A proof from such a printer should be treated in the same manner as a blueline. (A blueline is a proofing system for press-ready mechanicals that is extremely sensitive to light. In certain conditions a blueline can be ruined within 20–30 minutes.) Although ink-jet inks are more stable than bluelines, an ink-jet proof should be protected from light. Proofs from a dye sublimation proofing system should also be protected. When using any electronic color proofing system for final output (as with digital photography), the manufacturer or service bureau should be contacted to discuss the stability of their inks or dyes.

The same applies to printed samples from any commercial printer using offset, spot-color, four-color process, silk-screen, and Day-Glo inks. Day-Glo inks are extremely sensitive to light; exposure to full sunlight will cause the design to fade completely within a week. Most printers can offer an ultraviolet (UV) coating to help protect the ink from fading rapidly. Such a coating helps to protect the colorant, pigment, or ink from the sun's harmful UV rays and will also protect the proof from exposure to air. UV rays are shorter than the lightwaves visible to humans and can physically alter the particles within colorants, pigments, or dyes for print-based graphics.

Harmonious colors: *Two or more colors that have a sameness about them*
Harmonious colors can be defined in many ways. Each *color scheme* outlined in this book can produce a harmonious or a dissonant color palette. Sameness must be applied to the palette to create a harmonious color scheme. For example, to create a harmonious color scheme in a *primary color* palette, the *color value* rating for each color must be the same. If *color tinting* is to be used within the primary color palette, the color tinting must be applied uniformly across all *hues*.

Some color schemes are harmonious in nature, e.g., *monochromatic*, *achromatic*, *analogous*, and *neutral colors*. They have a characteristic sameness in their palettes and therefore, the individual hues found within each scheme harmonize well. In monochromatic color palettes, harmony is achieved by the use of one color. The variation in the palette is achieved by color tinting and *color shading* to lighten and darken the color scheme. With achromatic colors, harmony is achieved by limiting the color palette to black, gray, and white. Color tinting and color shading are also

2° standard observer

10° standard observer

Diagram 46 All colors fade when exposed to light. The higher the chroma rating, the more likely the color will fade/change when exposed to light. Day-Glo colors are the most sensitive and will fade rapidly in direct sunlight. With all colorants, pigments, and dyes, additives and coatings can be utilized to protect a hue, giving the color greater longevity. **Designer** Yokoyama Yoshie

Diagram 45 The amount of space the 2° standard observer and the 10° standard observer project at a distance of 18in (45.7cm).

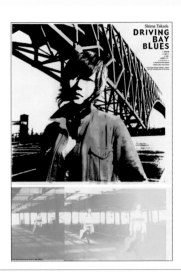

utilized here. Neutral color schemes use a percentage of a complementary color or black to develop a palette. A harmonious color palette is created if the percentage of the complementary color is uniformly applied and the percentage of black is varied or vice versa. This ensures that one of the two aspects that make up a neutral color scheme has a sameness within the palette. (See *harmony of analogous colors*.)

RECORDING

REPRODUCING

SOUND

"Restlessness is discontent - and discontent is the first necessity of progress.
Show me a thoroughly satisfied man - and I will show you a failure."

Figure 16
Art Director Ned Drew
Designer Rick Bargmann

Diagram 47 (a–c)
This three-part diagram depicts the methods mentioned under harmonious colors above.

(a) Harmony of scale: within this example, colors take up the same amount of space, creating harmony of analogous colors through scale.

(b) Harmony of dominant color: within this example, harmony of analogous colors is created through color tinting by the dominant color, and through color contrast—color, size, and shape.

Figure 16 Magenta and yellow run throughout the color palette with the exception of white. White is a type reversal in which the color of the paper shows through.

CVR 27.14% CVR 25.75% CVR 25.95%

(c) Harmony of hue: here, harmony of analogous colors is achieved through the relative lightness of each hue to the mind's eye. All three colors have a very similar CVR in fluorescent lighting.

White

High chroma

Diagram 48
The complex analogous color palette utilized in Figure 16. This type of color palette is inherently harmonious.

16	type **C22**	**M71**	**Y96**	**K9**		
	bgd **C75**	**M68**	**Y67**	**K90**		

16	type **C22**	**M71**	**Y96**	**K9**
	bgd **C10**	**M25**	**Y100**	**K0**

16	type **C28**	**M100**	**Y80**	**K31**
	bgd **C22**	**M71**	**Y96**	**K9**

16	type **C75**	**M68**	**Y67**	**K90**
	bgd **C28**	**M100**	**Y80**	**K31**

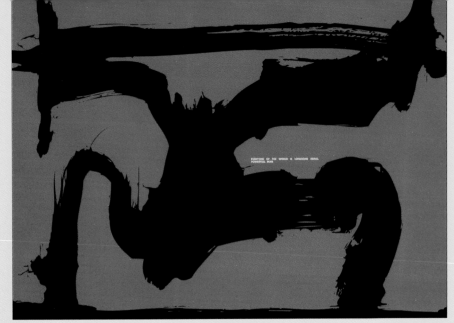

Figure 17
Illustrator/Designer Koshi Ogawa

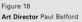

Figure 18
Art Director Paul Belford

Harmonious hues create a visual impression that lessens the kinetic energy normally attributed to asymmetric design and most color schemes. This phenomenon is both psychological and physical. With *3-D color*, harmonious color palettes create fewer variants within the electrical stimuli that are processed and sent along the *visual pathway* to the *primary visual cortex*. When color palettes are narrowed by a contributing factor of sameness, the psychological effects that can be attributed to the palette are also reduced. Any strategy employed to achieve harmonious color relationships creates a stabilizing force upon the viewer that acts as a consonant color scheme, both physically and psychologically. A consonant color scheme is one that has an inherent agreement within the arrangement.

For print-based, interactive, environmental, and motion graphics, harmonious color schemes are highly effective in promoting stability within the given palette. This sense of stability can be incorporated into the visual messages created by designers to ensure soundness, security, and balance. Harmonious color relationships can build visual messages intended to convey particular information, and leave the viewer with a desired emotive response.

Figure 17 Red and black are specified to amplify the power of the illustration. Between the two colors, black is an excellent choice for the figure, giving it mass and weight.

Figure 18 (a and b)
In these typographic posters, black is specified to help create dynamic compositions.

Diagram 49 A simple analogous color palette that utilizes tinting.

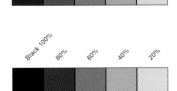

Monochromatic

Achromatic

Diagram 50 Two different color schemes utilizing tinting.

17 type C75 M68 Y67 K90 **18** type C0 M0 Y0 K100
bgd C0 M94 Y82 K0 bgd C0 M0 Y0 K0

17 type C0 M94 Y82 K0 **18** type C0 M0 Y0 K0
bgd C75 M68 Y67 K90 bgd C0 M0 Y0 K100

BG Background color C0 M56 Y99 K0 30%

Harmony of analogous colors: *Of scale: <u>color</u>* *<u>tones</u> that are produced through a single scale* *Of hue: colors that have the same relative* *lightness to the mind's eye (<u>color value</u> rating)* *Of dominant color: <u>hues</u> that are related to the* *factors involved in color contrast*

Harmony of *analogous colors* is defined as the pleasing arrangement of colors that have a lack of conflict within the hue palette. This harmony is brought about by an aspect of sameness within harmony of scale, harmony of hue, and harmony of dominant color. Harmony, an aspect that is generally applied to symmetric designs, can also be integrated into asymmetric compositions. By doing so, an asymmetric composition can have both a kinetic structure and a harmonious color scheme. Analogous colors in general are harmonious so long as the color scheme applies to one of the three factors in the above definition. Harmonious analogous colors create a sense of rest and therefore, when used with an asymmetric composition, retard the kinetic energy to some degree, creating a navigable, pleasing pace. With symmetric composition, harmony of analogous colors helps to anchor a lack of motion. It can be used as a conceptual primer to control the visual pace or lack thereof.

Harmony of contrast: **Of scale:** *Two colors with* *the same or near same <u>color value</u> rating but* *different <u>hues</u>* **Of hue:** *<u>Chromatic</u> <u>colors</u> with distinctly* *different color value ratings mixed together in* *stepped increments* **Of color temperature:** *Two colors with the same* *or near same color value rating but different* *color temperatures*

Harmony of contrast occurs where colors have one aspect in contrast, but share a sameness in another. This sameness creates a lack of conflict and most often a pleasing arrangement of color. When these factors are used correctly, harmony of contrast can create a conceptual model for understanding effective color use. In *subtractive*, *additive*, and *3-D color schemes*, harmony of contrast can be applied; in 3-D color schemes, the perception of harmony of contrast is paramount. Both harmony of scale and harmony of color temperature can create *simultaneous contrast*. You must verify the palette visually to avoid unwanted simultaneous or pronounced simultaneous contrast.

Hue: *A classified or specified color*

An example of a specified color is Acuity 00385. This is made up of 80 percent yellow and 80 percent cyan. In architecture, and in interior, industrial, packaging, print-based, Web, motion-graphics, and environmental graphic design, specified colors or colorants are used to create a color palette that can be reproduced anywhere in the world. All of these specified colors can be referred to as hues. Hues can be found in paint, plastic, laminate, and ink-matching color systems including Pittsburgh Paint, Pantone, Inc., Toyo, and Acuity colors.

Hue application must be understood before specifying any color. Many of the ink-matching/color-matching systems available for architecture, and for electronic press-ready, Web, motion-graphics, interior, and environmental graphic design have different color-matching systems. These vary not only from industry to industry, but also within each field. Having a broad understanding of the matching systems, color and otherwise, will help you make informed decisions about how best to use color.

Diagram 51 (Acuity 00385)
A hue sampled from the Acuity Color System.

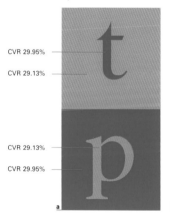

CVR 29.95%
CVR 29.13%

CVR 29.13%
CVR 29.95%

Diagram 52 (a–c)
Three methods for achieving harmony of contrast: 52a shows harmony of contrast achieved through temperature, 52b through scale, and 52c through hue.

CVR 23.52% CVR 23.27% CVR 23.36%

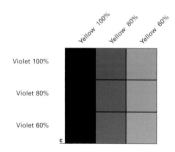

Yellow 100% Yellow 80% Yellow 60%

Violet 100%

Violet 80%

Violet 60%

For example, the Acuity Color System can build any of its hues using CMYK and hex numbers. Each color-matching system is unique and therefore, has potentially different uses depending upon the circumstances and the expertise of the user.

Figure 19
Art Director Ned Drew
Designer Jeff Wiazlowski

Hypercomplex fields of vision: *Matrix fields of photoreceptor cells within the brain that respond most favorably to moving objects which behave with a set direction and definite position/pattern*

Hypercomplex, *simple*, and *complex fields* process visual information that is sent to the *primary visual cortex* by the eye. The photoreceptor cells found within the hypercomplex field respond to any moving stimuli that are large enough for the mind's eye to perceive. Simple and hypercomplex fields are responsible for determining if an object is visible or not. With hypercomplex photoreceptor cells, the position and length of a moving object and the pattern it forms while moving are critical for detecting the object and its motion. Hypercomplex photoreceptor cells respond best when moving objects are on a predictable path. For an object to be visible, it needs to cross over three photoreceptor cells in a distinct order. If it does not cross over the cells in the required order, or does not cross over at least three cells, then the object and its motion will not be visible.

The problem for designers has always been how small, big, near, far, and in what color an object should be in order for it to be legible. All design disciplines have developed rules of thumb for placing an object in an environment for viewing at a distance.

However, these are highly inaccurate and can leave a designer with a nonfunctional structure. For instance, a standard rule of thumb in environmental graphic design is that 1in (2.54cm) of letter height equals 50ft (1.5m) of viewing distance. This rule has become institutionalized in many industries, but it is inaccurate. The distance at which humans with 20/20 vision can read a sign that is made up of a monoweight typeface is totally different from the distance at which they can read a sign with a typeface that has thick and thin strokes. The distance at which we can see an object depends upon that object's unique structural characteristics and nothing else.

In 1862 Herman Snellen, MD, devised a system for determining the accuracy of human perception. As one of the pioneers of ophthalmology, he is credited with inventing a field test known as the Standardized Eye Chart. This chart takes into consideration how human perception takes place, including how the hypercomplex, complex, and simple photoreceptor cells respond to visual stimuli. This test is still used to determine whether an individual needs corrective eyewear. The Standardized Eye Chart has been deemed scientifically accurate by the field of ophthalmology, and millions of individuals see normally, with corrective eyewear, due its accuracy.

Figures 19 and 20
Typographic readability and legibility are different. Readability is the speed at which an object is recognized, and legibility is how clearly an object can be seen. In figures 19 and 20 readability is intentionally manipulated to slow down the viewer.

Diagram 53 (a–e) The CVR for each hue, the typeface, and the viewing distance for standardized eyesight. Note that the New Baskerville Italic, when typeset at the same size as Helvetica 55, is less visible at a distance. The two main factors that contribute to this phenomenon are the colors used and the typographic anatomy. Parts c, d, and e show the crude approximation used in the past, and the precise viewing distance of the letterforms used in 53a and 53b.

CVR 50.21%
CVR 35.07%

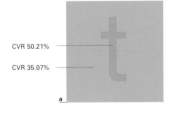

 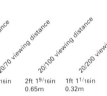

20/20 viewing distance	20/25 viewing distance	20/30 viewing distance	20/40 viewing distance	20/50 viewing distance	20/70 viewing distance	20/100 viewing distance	20/200 viewing distance
10ft 9 2/16in	0ft 5 14/16in	7ft 5 14/16in	5ft 3in	4ft 4 9/16in	3ft 11/16in	2ft 1 9/16in	1ft 1 1/16in
3.3m	3.2m	2.3m	1.6m	1.3m	0.9m	0.65m	0.32m

CVR 10.41%
CVR 17.54%

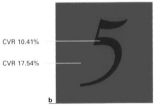

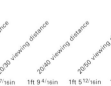 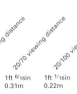

20/20 viewing distance	20/25 viewing distance	20/30 viewing distance	20/40 viewing distance	20/50 viewing distance	20/70 viewing distance	20/100 viewing distance	20/200 viewing distance
3ft 7 9/16in	3ft 6 8/16in	3ft 4 7/16in	1ft 9 4/16in	1ft 5 12/16in	1ft 6/16in	1ft 1/16in	6/16in
1.1m	1.08m	1.0m	0.54m	0.45m	0.31m	0.22m	0.1m

 type **C**0 **M**0 **Y**0 **K**0
bgd **C**76 **M**22 **Y**2 **K**6

 type **C**76 **M**22 **Y**2 **K**6
bgd **C**78 **M**67 **Y**64 **K**83

19 type **C**78 **M**67 **Y**64 **K**83
bgd **C**0 **M**0 **Y**0 **K**0

BG Background color **C**100 **M**0 **Y**50 **K**0 10%

Using the mathematical equations Snellen devised for determining human perception, it is now possible for interior, packaging, Web, and environmental graphic designers to predict the distance at which an object can be seen for normal vision and for any other defined vision. Other mathematical equations for determining environmental factors, such as light source, color, and motion, are used to calculate the distance at which objects should be placed for viewing. The software program Acuity 1.0 uses these mathematical equations to predict the distance at which typefaces should be placed for viewing at a distance. Within this program each condition—individual typeface, color, light source, size, motion—is considered to determine the optimal viewing distance.

We do not need to know how to mix paint pigment to create a certain hue, but we do need to understand how humans perceive color, shape, depth, form, and motion under many different conditions. These conditions include the application of *additive* and *subtractive colors* on different substrates. Hypercomplex photoreceptor fields are just one of the visual dynamics that constitute human perception.

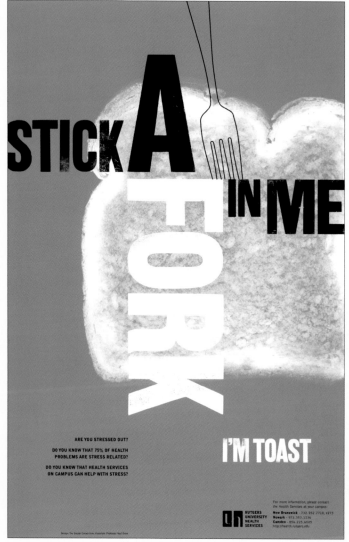

Figure 20
Art Director/Designer Ned Drew

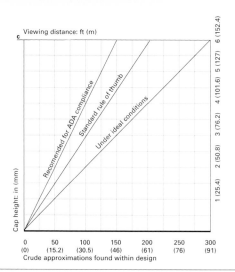

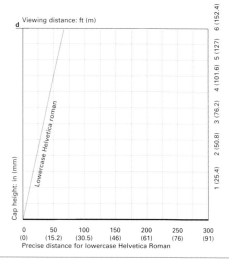

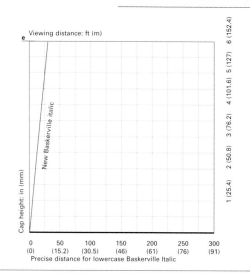

20	type C0	M0	Y0	K0
	bgd C76	M22	Y2	K6
20	type C76	M22	Y2	K6
	bgd C75	M68	Y67	K90
20	type C75	M68	Y67	K90
	bgd C0	M0	Y0	K0

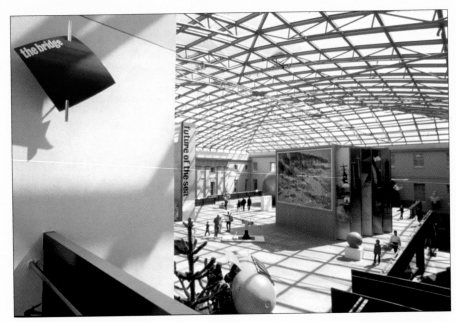

Figure 21
Studio Pentagram
Partner/Art Director David Hillman

Figure 22
Studio Pentagram
Partner/Art Director David Hillman

Figure 21 Numerous factors must be considered in order to create a functional signage system. Most important are the lighting conditions found within the environment. Once the lighting conditions, within operational hours, are confirmed, testing for legibility can take place. For any environment a photographer's light meter would be most helpful: they measure light in kelvins. This would allow the environmental graphic designer to plot the different lighting conditions throughout the day, and to verify the overall legibility of the system.

Figure 22 With any signage system, typographic legibility at prescribed distances, and for different standardized eyesights, must be realized. The National Maritime Museum in Washington D.C. is an excellent example of both a conceptual and practical signage system that meets the regulations concerning the visually impaired (20/200 vision) and their normal eyesight audience (20/20 vision).

Illuminant: *Light, physically realized or not, defined by spectral power distribution*

In the process of measuring light and its by-products, color-standardized light sources have been established in order to predict outcome. Plotting wavelength found within the standardized light sources gives the spectral power distribution (SPD) curve. Each standardized light source or illuminant has its own SPD curve—without standardized sources, color predictability would be impossible. Each standard illuminant is configured to create a different form of basic white light. The three most standard illuminants are daylight, incandescent light, and fluorescent light. Each can create a full spectrum of color.

With *additive color*, the combination of all colors creates white light. In 1730, Sir Isaac Newton conducted an experiment in which light was directed through a glass prism in order to break apart the white light and show the visible spectrum of colors found within the source. Although humans encounter standardized light sources every day (D65, average daylight; A, incandescent lighting; CWF, fluorescent lighting), these sources do indeed have unique SPD curves and therefore, the colors they create differ from source to source. In other words, a red that is seen under average daylight may differ greatly in appearance when viewed

21	type C46 M28 Y18 K0 / bgd C100 M91 Y24 K10
21	type C12 M6 Y3 K0 / bgd C66 M71 Y65 K80
22	type C0 M0 Y0 K0 / bgd C78 M66 Y62 K71
22	type C47 M24 Y41 K0 / bgd C15 M85 Y55 K0
21	type C100 M91 Y24 K10 / bgd C12 M6 Y3 K0
22	type C59 M43 Y45 K10 / bgd C0 M0 Y0 K0
22	type C15 M85 Y55 K0 / bgd C47 M24 Y41 K0
21	type C66 M71 Y65 K80 / bgd C46 M28 Y18 K0
22	type C78 M66 Y62 K71 / bgd C59 M43 Y45 K10
BG	Background color C100 M0 Y0 K0 10%

under fluorescent or incandescent lighting. Color shifting should be taken into consideration when creating a display for which multiple light sources will be constructed or be inherent in the environment. If, for example, we have a bank of lights, five of which have lightbulbs that are balanced for average daylight and one that is not, color shifting will take place. If the light is distributed evenly, the colors under a light source that is something other than average daylight will differ.

This may not be a problem if the *hues* change within each region of light, but if there is a standardized color that is going to be utilized throughout the display, then more than likely the color will change as the light changes.

The same can be said when dealing with computer screens, electronic kiosks, and television sets; these need to be calibrated in order to create the correct illuminant. There are two basic ways to do this, one easy and one hard.

The easy way is to set up a display that utilizes, for example, computer screens that are of the same model, manufacturer, and year. To facilitate ease of set-up, they should be purchased new and at the same time: the efficiency of electronic equipment that

projects light diminishes over time. The lighting conditions should also be set up in a consistent way. The hard way is to try to set up a bank of monitors of different makes and models: these produce an environment that is all but impossible to calibrate.

A problem within the design industry today is that there are no accurate standards for illuminants created for computer screens, electronic kiosks, and television sets. For example, in electronic stores, multiple television sets are tuned to the same channel yet the color shifts from set to set. This can be controlled to some degree by adjusting each set to match the other. However, many cannot be calibrated simply because they are created by different manufacturers.

Web-site designers face the problem of color standards. For example, DOS computers and Macintosh computers use different programming and electronics to set up their color spectra. Although both computer systems are capable of creating millions of colors, only a small fraction of the hues available on each will match closely. In fact, when designing a Web site, only 216 colors on either system will equate to a fairly accurate color appearance capable of being achieved on both. This is the

highest common denominator for browsers that take into consideration Macintosh and Window capability. This limited palette is referred to as the Web-safe color cube.

D65: Average daylight CWF: Fluorescent lighting A: Incandescent lighting

Diagram 54
The examples above illustrate the color shifting that takes place when viewing objects under different light sources.

Figure 23
Studio Thonik

Incongruous colors: *Colors that make a discordant combination*

A color used with another *hue* that is to the right or left of its complement (for example, yellow-orange as one color and reddish-purple, or bluish-green as another) creates an incongruous combination. Incongruous color combinations have one color that runs through each hue, and one that does not. They possess little or no color harmony, and tend to create lively compositions due to the inherent kinetic found within them. In general, incongruous color combinations are well suited to asymmetric design: they are more "active" to the eye. However, if used incorrectly, they can clash and create an unpleasant effect.

The best way to guard against an unwanted incongruous combination is to create color swatches in the proportions in which they are to be used. In today's design environment it is easy to simply click and place the desired color in a document, but this may not be the best solution. There is something to be said for slowing down the process of choosing colors by, for example, using a color swatch book. Hold a color swatch book in hand, and move the colors around until the color proportions create a visually intriguing piece. This type of exercise allows optical verification of simultaneous contrast. With an incongruous

Figure 23 This book design is an excellent example of an incongruous color scheme.

Diagram 55
Right: When using incongruous simultaneous colors, contrast must be considered. Shown here are three techniques for managing simultaneous contrast.

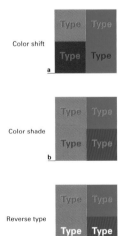

Color shift

a

Color shade

b

Reverse type

c

Diagram 56 In this figure, red-violet and yellow-orange are used in the background. Cyan is added to the yellow-orange color to muddy the hue, lessening the chroma (the fourth technique).
Designers John T. Drew and Ned Drew

| 23 | type **C**31 **M**10 **Y**88 **K**0 |
| | bgd **C**89 **M**98 **Y**48 **K**47 |

| 23 | type **C**89 **M**98 **Y**48 **K**47 |
| | bgd **C**31 **M**10 **Y**88 **K**0 |

| **BG** | Background color **C**20 **M**0 **Y**100 **K**0 50% |

color combination, pronounced *simultaneous contrast* may occur if the combination does not have a portion of at least one of the colors throughout.

In interactive graphics it is unnecessary to worry about how many colors are used in order to create an effective incongruous color combination. In any Web design, 216 colors can be effectively used on multiplatforms. The concern here is the creation of a combination so complex that it impedes dissemination of information. Setting color delimitations based on sound reasoning and not on subjective criteria is the most effective way of creating color combinations suitable for the subject matter. This holds true for *additive*, *subtractive*, and *3-D color* combinations for architectural sites, interior environments, exterior signage systems, interactive graphics, package design, and print-based graphics.

Integrated sphere: *A hollow sphere used to collect all of the light reflected from the surface of a color sample*
With today's technology it is commonplace for a color sample to be measured for reproduction. Many printers and paint dealers employ this technology. House paint, for example, can be mixed to match the customer's favorite shirt. The integrated sphere is part of the machine used to

measure the lightwaves bouncing off a color sample, in nanometers. The printing industry uses this equipment in order to create standard colors using other manufacturers' inks. For example, it is quite common to use base inks that are not Pantone products to create a color that is a match for one of the PANTONE MATCHING SYSTEM® colors. The equipment that uses the integrated sphere includes a software program that tells the printer how to mix other ink products, including waste ink.

The integrated sphere or drum has other uses related to quality reproduction. A drum scan uses an integrated sphere to achieve high-end reproductions of photographs, illustrations, paintings, and any other artwork that can be attached to a cylinder. This is the highest quality scan used on the market today. Unlike handheld, slide, and flatbed scanners, including leaf scanners, a drum scanner has the ability to capture the original quality of the image—its color and form—at a much higher dpi that is not interpolated.

The artwork is taped to the drum, which then revolves at high speed. The image is captured on a photomultiplier tube, which gives the image a greater color spectrum (including grayscale levels found within the

artwork). Most drum scans are connected to an integrated computer system that allows the image to be captured, and in most cases little color correcting remains to be done. This cannot be said for any other type of scanner. Drum scans are typically used for print-production purposes because of cost considerations.

A low-end digital camera or video capturing device is the minimum needed for Web purposes. A flatbed scanner can be used for both Internet and print-production purposes, but the dpi should be set differently. A leaf scan is necessary only for print production. It is one level below a drum scan, but the quality is greatly diminished. The drum scan uses *additive color mixing* to scan and reproduce the images. If an image is going to be used for print production, the software program attached to the integrated computer system will reconfigure the artwork for CMYK production—*subtractive color mixing*.

Diagram 57 This color scheme, violet and orange, is an excellent example of an incongruous color scheme. The orange hue has been tinted and the violet utilizes shading. Tinting with white is the second technique.
Designers John T. Drew, Sarah A. Meyer, and Pornprapha Phatanateacha

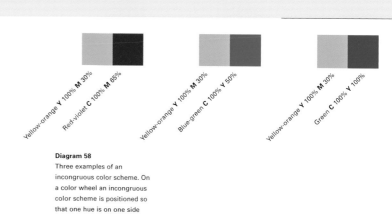

Yellow-orange **Y** 100% **M** 30% Red-violet **C** 100% **M** 65%

Yellow-orange **Y** 100% **M** 30% Blue-green **C** 100% **Y** 50%

Yellow-orange **Y** 100% **M** 30% Green **C** 100% **Y** 100%

Diagram 58
Three examples of an incongruous color scheme. On a color wheel an incongruous color scheme is positioned so that one hue is on one side and the other hue is two steps away from its complementary.

Invariant pairs: *Color samples or objects having an identical spectral reflectance curve and the same color coordinates*

The phenomenon of invariant pairs means that, in *3-D color mixing*, one *hue* can occupy the same space as another. In other words, the colors in question match mathematically in all standard light sources, but they look different. This happens with very few hues within ink-matching systems, but it is the reason you must always visually verify the color specified. Invariant pairs can occur with any equipment that measures samples for color reproduction purposes. For example, three colors that look very different to the naked eye can possess the same color coordinates within 3-D color theory—the same X, Y, and Z *tristimulus values*. These tristimulus values are used to help map the ink or paint mixture needed to produce a certain color. This applies only to print-based graphics, environmental graphic design, interior design, and architecture—any field that uses colorants and pigments for the production of product—and in this context, are of concern only with *subtractive color mixing* and mapping out paint, ink, and other materials such as wood, stone, metal, and plastic, for the reproduction or perception of color. The tristimulus values are also used to predict human perception of hue.

Iris: *The portion of the eye that helps to focus an image, adjust the amount of light passing through the pupil to define depth of field, and give eyes their color*

The iris is much like the lens on a camera; the greater the aperture, the smaller the depth of field, and the smaller the opening, the greater the depth of field. The iris is the part of the human eye that gives individuals blue, green, brown, hazel, or black eyes. It should not be confused with the *pupil*, through which light travels to strike the *retina* on the back wall of the eyeball. The two irises working in tandem define depth of field and enable us to accurately perceive our 3-D environment. The iris also governs the amount of lightwaves that enter the eye, thus controlling how an image is exposed to the retina and *fovea* located on the back portion of the eyeball.

Light energy: *Light distinguished by the human eye as colors*

Light energy from the sun or any other artificial source starts the process of perceiving color within the human mind. In fact, a person's perception of any colored object is either composed of reflected light sources or of light transmitted directly from the source itself. The type of light energy cast by the source affects a color's appearance. For example, most fluorescent lighting gives a greenish tint to any of the

colors perceived by humans. For the accurate representation of an individual color, average daylight is required. Light energy is measured in kelvins (Ks), and average daylight is measured at 5,000 K (U.S. printing standard), or 6,500 K (European printing standard). In order to achieve average daylight, the object must be placed under a corrected light source that is balanced to achieve average daylight, or placed outdoors.

The individual colors humans perceive are created by the source of light and the molecular structure of an object. For example, if an object appears to be red, the light that strikes the object, and that is of the exact molecular structure and size found on the object's surface, will appear to be red. The light energy that does not match the surface structure will be absorbed by the object as heat.

As designers, our main concern is how the object we are creating will appear and feel to humans. Understanding the light energy that is transmitted from the surface of the objects we create will enable us to predict appearance. In addition, light that is directly transmitted into the human eye (for example, from television, Web sites, electronic kiosks, etc) has the potential to fatigue the eye. The quality of the surface

Pupil Iris

Twilight

Diagram 59 This illustration depicts how the pupil and iris operate in different levels of light.

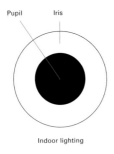

Pupil Iris

Indoor lighting

The lens on a camera is like an iris: it opens and closes to adjust the amount of light that passes through the pupil and defines the depth of field.

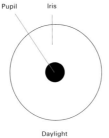

Pupil Iris

Daylight

Diagram 60
This two-part diagram illustrates the effects that motion has upon eyesight, and the eye's ability to fixate on objects.

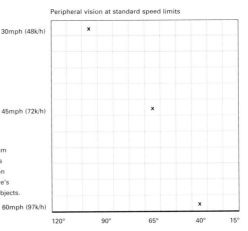

Peripheral vision at standard speed limits

30mph (48k/h)

45mph (72k/h)

60mph (97k/h)

120° 90° 65° 40° 15°

the light strikes also can influence the way we see the object. If the object has a rough texture then diffuse *scattering* will take place. In other words, the light energy reflected off the textured surface will scatter in numerous directions, thereby lowering the intensity or *chroma* of the object's appearance.

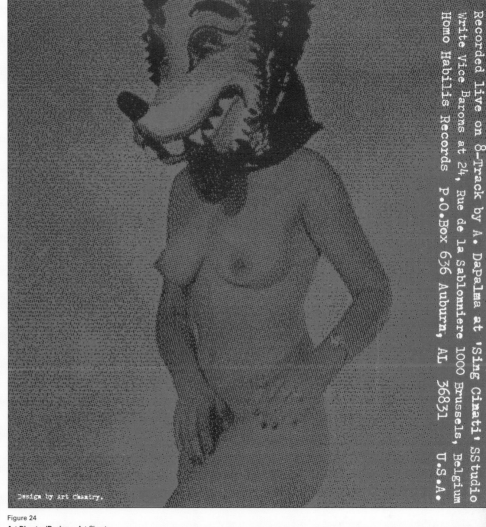

Recorded live on 8-Track by A. DaPalma at 'Sing Cimati' SSStudio Write Vice Barons at 24, Rue de la Sablonniere 1000 Brussels, Belgium Homo Habilis Records P.O.Box 636 Auburn, AL 36831 U.S.A.

Design by Art Chantry.

Figure 24
Art Director/Designer Art Chantry

Fixation vision at standard speed limits

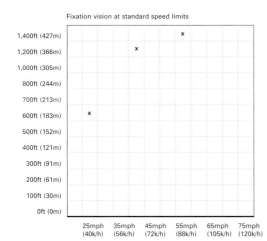

Figure 24 For this example, a flatbed scanner is all that is required for print production purposes. When creating artwork that has a gross screen pattern, a high-end drum scan is not necessary (see Chapter 6).

Diagram 61 Right: Three substrates and their corresponding information (CVR, grayscale equivalent, and four-color process builds).

Satin soild copper
CVR 33.22%
Grayscale 35%
C11 **M**69 **Y**72 **K**4

Bamboo
CVR 44.77%
Grayscale 38%
C10 **M**44 **Y**75 **K**3

Anodized aluminum
CVR 52.25%
Grayscale 24%
C9 **M**16 **Y**37 **K**1

24	type	**C**41	**M**96	**Y**54	**K**40
	bgd	**C**0	**M**95	**Y**100	**K**0
24	type	**C**0	**M**1	**Y**11	**K**0
	bgd	**C**41	**M**96	**Y**54	**K**40
24	type	**C**0	**M**95	**Y**100	**K**0
	bgd	**C**0	**M**1	**Y**11	**K**0

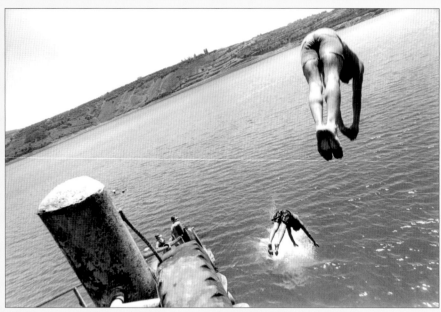

Figure 25
Photographer Jenni Kolsky

Metameric pairs: *Pairs of colors with different spectral reflectance curves (see <u>spectral</u> <u>power</u> <u>distribution</u> <u>curve</u>) that have the same appearance in one light source but not in another*

All colors are created by light. Lightwaves, whether from the sun or an artificial source, bounce off an object and enter into the field of perception through the human eye, or are directly transmitted into the human eye, starting the process of color perception. Objects that are metameric pairs have the ability to change their appearance from one another as they travel through one light source into another. This rare occurrence is caused by the object's molecular structure. In such cases the anatomy of the object is more complex than an object made from one material, and therefore the object has a greater ability to change its appearance.

If a structure is planned for an environment with different lighting conditions, a scale model should be placed in the proposed environment in order to predict outcome. This will ensure the color predictability of the materials being utilized as a safeguard against an unwanted color effect. For example, in food packaging fluorescent lighting needs to be considered, especially when dealing with red meats. As stated, typical fluorescent lighting imparts a

greenish tint. If the color yellow is placed under fluorescent light, the color will appear to the viewer as a greenish yellow. Instead of having a clean yellow next to the red meat, we now have a greenish yellow, which diminishes the appearance of freshness associated with yellow, possibly indicating spoiled meat. Green is not advised when creating food packaging for red meat products because red meats, when spoiled, turn shades of green.

The greater the number of materials used to create a structure, the more likely the phenomenon of metameric pairs is to occur. In such cases, a consistent light source is advised. In other words, if matching color is critical, using a structure made of numerous materials and passing it through different light sources is ill-advised: it is more than likely that the phenomenon of metameric pairs will occur. In interior, industrial, and environmental graphic design, metameric pairs are more likely simply because

Figure 25 In the above photograph, different substrates are present, a condition of 3-D space. As can be seen, different materials reflect and absorb different amounts of light.

Diagram 62 Right: For any 3-D object that is exposed to different lighting conditions, a scaled model should be created to better understand how lighting affects the surface space and the corresponding substrates. **Designer** Brian Cantley

Diagram 63 Far right: In the heat of the day sunlight is around 6,500 K to 9,300 K. At this temperature light is a true white. **Photograph** Jenni Kolsky

25	type	C0	M0	Y0	K97
	bgd	C0	M0	Y0	K48
25	type	C0	M0	Y0	K15
	bgd	C0	M0	Y0	K97
25	type	C0	M0	Y0	K48
	bgd	C0	M0	Y0	K15

BG Background color C0 M27 Y100 K0 30%

different materials and light sources are used more often than not. In print-based graphics, motion graphics, and Web design this phenomenon is not as likely to occur.

The phenomenon of metameric pairs does occur with *subtractive color mixing*, but is more likely to occur in a 3-D environment. If, for example, an environmental site is going to be constructed from different materials having the same color, visual verification of these materials in different sunlight sources is necessary. If an artificial light source will be used to illuminate the site at night, then the materials should be tested under these conditions as well.

Figure 26
Art Director/Designer Inyoung Choi

Figure 26 In this example, metameric pairs will not occur. The substrate that the poster is printed on is singular, and the pigments are the same throughout the piece. However, in diagram 62, metameric pairs are more likely to occur.

26	type	C22	M14	Y0	K0
	bgd	C75	M68	Y67	K89
26	type	C75	M68	Y67	K89
	bgd	C69	M7	Y9	K0
26	type	C69	M7	Y9	K0
	bgd	C22	M14	Y0	K0

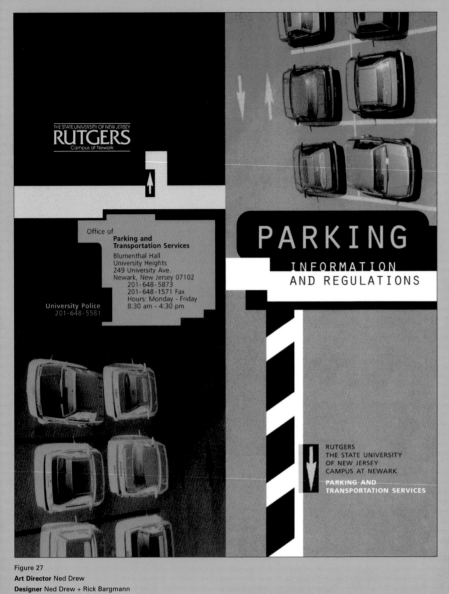

Figure 27
Art Director Ned Drew
Designer Ned Drew + Rick Bargmann

Monochromatic colors: _Hues consisting of one color, including screen percentages of tints, shades, and combinations of tints and shades_ (see _color_ _tinting_ and _color_ _shading_)

In the past it was much cheaper to print one- and two-color jobs than four-color. With advances in printing technology and the globalization of the industry, this is no longer always the case, although there is a definite tendency for high-end design to use four-color process mixing. On top of this, designers often opt for a _color scheme_ that will show off their abilities to use color effectively; in fact, sometimes less is truly more. With monochromatic color schemes, one color can be employed effectively to solve a design problem.

Monochromatic color schemes can work effectively for _additive color_ documents, _subtractive color_ documents, and 3-D objects. Unlike many complex color schemes, monochromatic palettes can be utilized in many media.

Neutral color: _A _hue_ with a near equal screen percentage of one or more colors, including its _complementary__

A truly neutral color is perceived as neither warm nor cool. Near-neutral colors are easily created and are built mainly of equal percentages. Typically, there is little contrast in neutral combinations, and a

Figure 27 This monochromatic study utilizes shading as a technique to create a multitude of hues. The color white is created by an absence of pigment—it is the paper that the impression is printed on.

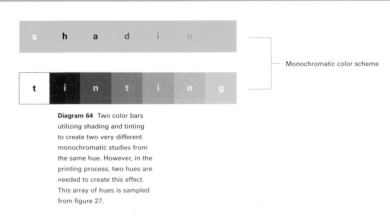

Monochromatic color scheme

Diagram 64 Two color bars utilizing shading and tinting to create two very different monochromatic studies from the same hue. However, in the printing process, two hues are needed to create this effect. This array of hues is sampled from figure 27.

27	type C0	M1	Y15	K19	27	type C6	M44	Y99	K93
	bgd C0	M33	Y100	K37		bgd C0	M51	Y100	K19

27	type C0	M33	Y100	K37
	bgd C6	M44	Y99	K93

27	type C0	M51	Y100	K19
	bgd C0	M1	Y15	K19

BG	Background color	C0	M85	Y100	K0	80%

harmonious relationship is therefore created when using them. Contrast creates the appearance of tension, and neutral color combinations create harmony. Neutral colors can be effective for creating environments of quiet reflection.

Many hues found within the spectrum of neutral colors have an earthy appearance. The more colors there are blended together, the darker and earthier the color. Intensity or *chroma* is diminished through this blending process, thereby creating unpure colors. However, this does not diminish a neutral color's effectiveness in certain circumstances. It may be that a designer uses a neutral *color scheme* except for one color. The visual sensation of a pure hue used within such a scheme makes the hue "pop." Pop is a term used when a hue within a color scheme has the appearance of suddenly moving forward.

Neutral schemes are used mostly in interior design, fashion design, rug and other textile design, and environmental graphic design—any type of 3-D environment lends itself to a neutral color scheme. However, this does not mean that they are limited to such environments. Exploratory use of any color combination, including neutral colors, can only add to the effectiveness of your ability to solve visual problems.

With the continuing advances in high-resolution screens, neutral color schemes can be utilized more effectively: higher color intensity ratings and subtleties between colors can be created in additive color environments such as Web design and interactive graphics, than *subtractive color* applications.

Parent colors: *Two or more <u>hues</u> that are used to create or build an array of colors*
Parent hues are those colors that form the base structure for all colors, shades, and tints (see *color shading* and *color tinting*) created within a color palette, e.g., a two-color print job where the mixing or building of these two colors through screen percentages creates other hues and tints. Designers have long used parent hues to create color palettes. Parent colors are created according to the defined needs of the client, the emotive and psychological effects outlined for their particular use, and from preexisting products, materials, and subjective and objective criteria.

The use of parent colors to create and define a spectrum of hues, shades, and tints is not limited to print-based graphics. Motion graphics, Web, interior, fashion, industrial, and environmental graphic design all use parent colors to imbue the environments and products they create. Some fields and

individuals use parent colors more successfully than others. By choosing two or more parent colors according to objective criteria, delimitations intrinsic to the content and context of the given problem are set forth. This can be said about any color strategy that is objectively defined, but parent colors encompass a broader context of color, including many individual color strategies such as *primary, harmonious, analogous, chromatic, monochromatic, achromatic, complementary,* and *incongruous colors.*

The final appearance of a hue can also be determined by the context in which the parent colors are used. Typically, designers use parent colors to help attract attention to a given environment or product. No matter the medium, whether digital, film, video, print, 3-D, built interior environments, or a built environment made of different materials, properly chosen parent colors imbue the surroundings with a visual language that can be easily understood.

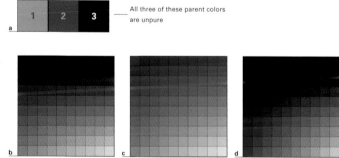

Diagram 65 (a–d) Right: The three parent colors in 65a create an array of 330 hues in 10% increments. These color matrices—in 65a, 65b, and 65c—are an excellent way to create an in-depth color palette for any design problem. Thousands of hues can be created by just using these three parent colors.

All three of these parent colors are unpure

Diagram 66 Left: An excellent example of a neutral color scheme. **Designer** Inyoung Choi

Four basic principles govern color building:

- *Mixing or building two colors that are pure and have a high brightness rating will yield the widest array of colors from light to dark*
- *Mixing two colors, one that is pure and bright, and the other that is pure or semipure and dark (having a <u>color</u> <u>value</u> rating of 50 percent or less), will create a color palette from light to dark, but the array will not be as great*
- *Mixing one pure and bright color with an unpure color will create an array of light to dark from a pure to earth tone family*
- *Mixing two unpure colors, regardless of their <u>chroma</u>, will create an array of earth tones.*

Primary colors: *Pure <u>hues</u> that create the foundation of all color spectrums*

Subtractive, *additive*, and *3-D color* media are based on different primaries. Each set is constructed to create the widest possible color spectrum for the given medium, and each has a particular use within the fields of design. The three sets of primary colors are:

- *Subtractive: cyan, magenta, yellow, and black (CMYK)*
- *Additive: red, green, and blue (RGB)*
- *3-D: blue, yellow, green, red, white, black, and purple.*

Subtractive primaries

Cyan, magenta, yellow, and black are used to create a full color spectrum for print. This is known as four-color process mixing. Cyan, magenta, and yellow can create a wide color spectrum, including black; the black is added as a fourth primary to ensure *color saturation* and richness. Without this black, it would not be possible to create many of the darker colors on press.

Recently, a new set of primaries has been created for print-based media in order to widen the color spectrum. Two new primaries, a lime green (very similar to PANTONE 355) and an intense orange (similar to PANTONE 151, but brighter) have been added to the four traditional primaries (CMYK). These hues are intensely bright, almost fluorescent, and create a wider chroma within the traditional color spectrum for press, allowing the subtractive color spectrum to compete with that of additive color.

Additive primaries

Traditionally, *additive color* primaries have created a wider color spectrum than their print-based counterparts because transmitted light is conveyed directly from its source into the human eye. Typically, there is no outside interference in the transmission of lightwaves and therefore,

color intensity is increased. Lightwaves are visible to humans from a range of 350–750nm. They are created with the color primaries red, green, and blue. These three primaries create the full spectrum of color, including black and white. Black is created by the absence of light and is not considered a color within additive color theory. White is created by the combination of all three primaries at 100 percent intensity. Within any software application, this combination will create white. To create additive *secondary colors* (yellow, cyan, and magenta), two of the three primaries must be combined at 100 percent of color intensity (red 255 and green 255 will give yellow; green 255 and blue 255 will give cyan; and red 255 and blue 255 will give magenta). Additive color primaries are modeled after the first stage of color vision, and 255 represents the maximum amount of stimuli the corresponding receptor cells receive.

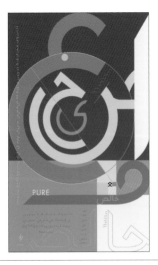

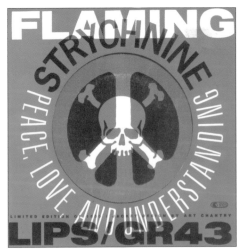

Diagram 67 Far left: The analogous color scheme with complementary accent is an excellent example of parent colors. In this case, they are hues that constitute the predominant use of color within the composition. **Designer** Saied Farisi

Diagram 68 Left: Overprinting and type reversals are utilized to create two additional colors. **Designer** Art Chantry

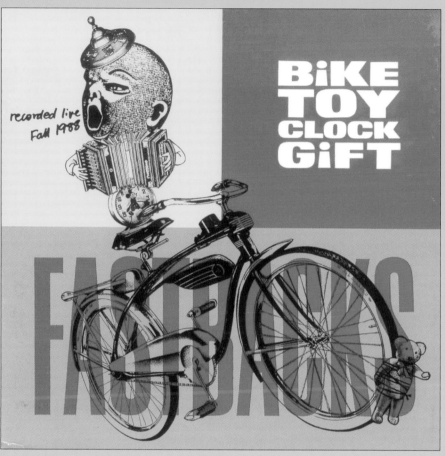

Figure 28
Art Director/Designer Art Chantry

3-D primaries

Three sets of primaries constitute subsets of *3-D color theory*. The International Commission on Illumination (CIE) primaries are red, green, and blue, with light sources of average daylight (the U.S. standard, known as Source D50 is set at 5,000 K and the European standard, known as Source D65, is set at 6,500 K), tungsten filament lamp (Source A; 2,854 K), and noon sunlight (Source C; 4,800 K). There is no Source B. The Young-Helmholtz theory, also known as the trichromatic color theory, includes three sets of primaries (blue-/yellow+, green-/red+, white-/black+-), and the opponent-process theory, developed by Ewald Hering, has four sets of primaries (blue-/yellow+, green-/red+, white-/black+, purple). In both theories, negative and positive stimuli are used in the calculation of color perception.

Figure 28 Pure and semipure colors are utilized to create a vivid color composition.

Diagram 69 Below and right: A few of the primary color sets used by designers.

Four-color process

Diagram 70 Left: Semipure and pure colors are utilized in a step/bar pattern to create a kinetic color composition.
Designer Jannuzzi Smith

Subtractive color

Additive color
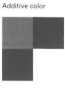

Traditional color
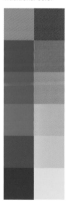

3-D color
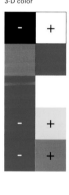

28	type **C**73 **M**55 **Y**85 **K**71
	bgd **C**0 **M**95 **Y**82 **K**0

28	type **C**0 **M**95 **Y**82 **K**0
	bgd **C**4 **M**0 **Y**96 **K**0

28	type **C**4 **M**0 **Y**96 **K**0
	bgd **C**31 **M**9 **Y**81 **K**0

28	type **C**31 **M**9 **Y**81 **K**0
	bgd **C**73 **M**55 **Y**85 **K**71

These three theories constitute color in a 3-D environment. However, it is now known that the photoreceptor cells near the *fovea* respond to the additive primaries red, green, and blue. Within CIE theory, other light sources are available, for example, fluorescent lighting (Source CWF) and dusk (there is no Source appellation for dusk). In fact, Sources D50, D65, A, and CWF are the most common light sources used for measuring colors.

All three theories have in common the predictability of color appearance within a 3-D environment. CIE theory is concerned with measuring colors to predict how to reconstruct them in numerous environments, while the trichromatic color and opponent-process theories are concerned with describing how color perception takes place within humans.

At first glance, 3-D color theory may seem a bit esoteric for designers, but a knowledge of it is essential to understanding how humans perceive color and for predicting the appearance of a color within any given medium or environment. We need a working knowledge of 3-D color theory to know how big, small, bright, or dark an object should be in what lighting conditions, with what type of contrast values, and at what distance, in order to make the object legible.

Primary visual cortex: *A portion of the brain located at the end of the visual pathway, devoted to the input for and interpretation of sight*

The primary visual cortex is responsible for phrasing information in the areas of color, motion, depth perception, and form. As part of both the visual pathway and the human brain, this cortex acts as a conduit through which visual information is interpreted. As part of a complex visual system, it collects the information, or electrical impulses, groups them into the categories listed above, interprets them, and communicates with other regions within the brain to create a holistic visual interpretation of the object(s) under examination by the mind's eye. The electrical impulses are sent by the photoreceptor cells in the *rods* and *cones* of the eye, along the optic nerves, to the primary visual cortex. The ganglion cells, positioned just behind the rods and cones and attached to the visual pathway, receive electrical impulses and help start the process of classification by dividing the information into two major categories: motion and fine detail. This information travels along the visual pathway into the primary visual cortex where further classification and interpretation take place. Each lightwave within the spectrum of human sight has its own unique bandwidth;

this triggers an electrical impulse that is decoded through the process of human sight. The interpretation of sight is both an external and an internal phenomenon. However, the object under examination must be large enough to cross over, in a distinct order, three photoreceptor cells found within either the cones or rods of the eye. If the object is not large enough to cross over at least three photoreceptor cells in a distinct order, the object goes unseen, and therefore no electrical impulse is created.

Pupil: *The pupil is the black point in the center of the eye through which light travels in order to strike the retina. It operates like the leaf shutter of a camera, opening and closing in a circular pattern*

The cornea, located in front of the pupil, is responsible for the first stage of human perception. The cornea, a clear, protective coating that covers the pupil, is a protein-rich, flexible crystalline tissue located on the outside of the eyeball. As light travels through the cornea and pupil, it strikes the lens of the eye and is inverted backwards on the retina wall. At this point light is converted, or not, to electrical impulses that travel through the *visual pathway*, ending up at the *primary visual cortex* where it is interpreted and translated to other regions found within the human brain. The pupil is

Diagram 71 The field of vision interpreted by the primary visual cortex. As an individual scans their surroundings, multiple images are processed through the visual pathway and interpreted/transmitted through the primary visual cortex and other parts of the brain.

Primary visual cortex —————————————— Pupil

the portal to human perception. Without it light, or color, would not reach the inner workings of the mind's eye.

To understand how and why the eye works is to understand how and why we should create objects that operate in a certain way. Knowing how humans perceive color—how the eye works—is as critical as knowing how to use the psychological and/or learned behavioral effects of color and how to use color through building processes. Understanding the apparatus of the human visual pathway and how best to create designs to exploit human physiology is just one more step in the architecture of color.

The physiology of the eye is directly linked to *3-D color theory* and the *standard observers* specified by it (y bar 10 and y bar 2).

Figure 29
Art Director/Designer John Malinoski

Figure 30
Art Director Babette Mayer
Designer Leonardo Popovic

Figure 29 In this poster, excellent examples of color use and symbolism are combined to create a powerful message.

Figure 30
An excellent use of a reductive color palette, and a compositional balance that is highly kinetic. This is achieved primarily by stimulating the receptor cells responsible for an object's distinctive shape.

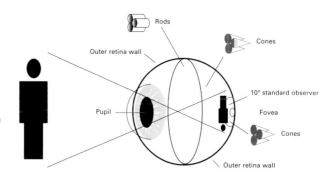

Diagram 72 The above illustration depicts how an object is viewed on the back of the retina wall.

29	type C0 M0 Y0 K0
	bgd C0 M30 Y0 K0

	type C0 M30 Y0 K0
	bgd C0 M0 Y51 K0

	type C0 M0 Y51 K0
	bgd C0 M0 Y0 K0

30	type C0 M0 Y0 K0
	bgd C0 M0 Y0 K100

30	type C0 M0 Y0 K100
	bgd C0 M0 Y0 K0

Figure 31
Art Directors Saied Farisi, John T. Drew and Sergio Lizarraga
Designer Saied Farisi
Type Designer Saied Farisi

Retina: *The region at the back of the eyeball where the ganglion cells, <u>cones</u>, and <u>rods</u> are located*

When an object is perceived by humans, the lightwaves representing the image are either reflected into the eye or transmitted directly from a source. The light first passes through the cornea and *iris*, right-side up, and is then inverted and flipped backwards as it passes through the lens of the eye to make an impression on the *retina* wall. If the lightwaves are intense enough, the stream of light activates the photoreceptor cells. These electrical impulses, created by light stimulation, are then processed and sent through the optic nerves to the *primary visual cortex.*

Rods: *Photoreceptors responsible for night vision*

Rods are highly sensitive to light and operate effectively in dim light. They are responsible for distinguishing blacks, grays, and variations of white, but do not distinguish color.

Rods are most concentrated around the perimeter of the *retina*. They decrease in number toward the *fovea*, becoming integrated with an increasing concentration of *cones*. Rods derive their name from their shape. They are associated with three types of vision in the *primary visual cortex* of

Figure 31
In viewing this example, the cones and rods are being utilized to process the impression on the retina wall. In four-color process, a form of print-based graphics, the color array found within this design is limited in comparison to the original. On a computer screen, the viewer easily comprehends vivid details.

Diagram 73 For this example, rods are primarily used to interpret the impression on the retina wall. **Designer** Inyoung Choi

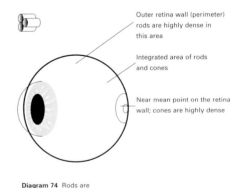

Outer retina wall (perimeter) rods are highly dense in this area

Integrated area of rods and cones

Near mean point on the retina wall; cones are highly dense

Diagram 74 Rods are responsible for processing black, white, and grays.

31	type C0 M0 Y60 K0			
	bgd C60 M0 Y71 K0			
31	type C0 M0 Y60 K0			
	bgd C60 M0 Y0 K0			
31	type C0 M0 Y60 K0			
	bgd C0 M0 Y0 K26			

BG Background color C0 M45 Y100 K0 80%

the brain: movement, form/silhouette, and depth. The corresponding photoreceptor fields—termed simple, complex, and hypercomplex—are located near the back of the brain. (See *simple*, *complex*, and *hypercomplex fields of vision*.) Simple fields "contain distinct 'on' and 'off' regions that are parallel rather than concentric to one another, making the position of the stimulus within the receptor field important. Moving stimuli are more effective than stationary ones." Complex fields "respond best to a properly oriented moving slit, an edge, or dark bar. However, stimulus position within the receptor field is not critical (contains no distinct 'on/off' regions). Cells with complex fields receive binocular input from simple cells." Hypercomplex fields "respond best to stimulus with a particular orientation and direction, and the length of the stimulus pattern within the field is critical. (The stimulus must cross over three photoreceptor cells in order to register.) Hypercomplex cells receive binocular input from many complex cells."

Scattering: *A phenomenon that occurs when light strikes an object with a rough surface, causing lightwaves to reflect in many directions*
Light absorbed by an object is converted to heat. As rough surfaces cause more scattering, there is less absorption of light, and the object does not get so hot. When designing an environment for human interaction, understanding the conditions in which the object will be placed is critical. If the objective is to create a comfortable environment in which, for example, seating takes place in an atmosphere where high temperatures occur, creating a rough texture that will cause diffuse scattering will help keep the temperature of the seats down.

Another solution is to select a color that has a 50 percent value rating or higher (see *color value*). Before placing any object in an environment in which high temperatures occur, the reflective index of the object should be measured in order to understand the amount of absorption that will take place. An outside vendor should be contacted if the manufacturer does not provide this information.

Secondary colors: *A <u>hue</u> formed by adding equal amounts of two <u>primary</u> <u>colors</u> to one another*
The method of creating a secondary color depends upon the method of color mixing being used.

Subtractive mixing
In the *subtractive color* wheel, each secondary color is located between its parent primaries. For example, the secondary color created by mixing cyan and magenta is purple, and cyan and magenta are found to the left and right of purple in the *color wheel*.

When mixed together in equal parts the subtractive primaries cyan/magenta, magenta/yellow, and yellow/cyan create true secondary colors. The secondary color created by mixing magenta and yellow is red, and that created by cyan and yellow is green. These primaries, which are used for traditional four-color process printing, create a large color spectrum that allows for color diversification. A six-color process printer is also available. This adds two more color primaries to the traditional four-color process: fluorescent orange and lime green.

Diagram 75
The effect a surface structure has on color.

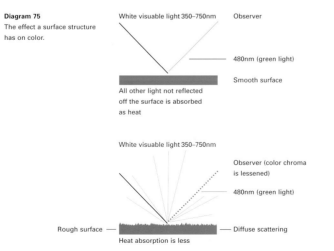

White visuable light 350–750nm Observer

480nm (green light)

Smooth surface

All other light not reflected off the surface is absorbed as heat

White visuable light 350–750nm

Observer (color chroma is lessened)

480nm (green light)

Rough surface — — Diffuse scattering

Heat absorption is less

a

b

Diagram 76 (a and b) The area over which large amounts of light will be absorbed. It is also noteworthy that both the type and color combinations are equally legible at a distance.

(a) The background color (violet) is absorbing large amounts of light (92.29%), and will create considerable heat if exposed to sunlight.

(b) The background color (yellow) is absorbing a small amount of light (26.40%), and will not generate any sizable heat.

Figure 32
Art Directors Ned Drew and John T. Drew
Designer Ned Drew

Additive mixing

The three traditional additive primaries are red, green, and blue. When combined, these three create white. In *additive color theory*, the absence of any light creates black. In other words, any black on the computer screen is created by blocking out light. The secondary color created by mixing red and green is yellow, green and blue make cyan, and blue and red make magenta.

These secondary colors are primary colors in subtractive color theory, which adds black as a fourth primary.

3-D mixing

The primary colors in *3-D color theory* are blue-, yellow+, green-, red+, white-, and black+. The receptor cells of the eye are grouped in pairs of three types: blue/yellow,

green/red, and black/white. Each of these receptor cells has a negative or positive color sensor, blue, green, and black being negative, and yellow, red, and white positive. Each of these primaries appears pure to the receptor cells, meaning that they contain no other color. Receptor cells cannot stimulate a response for both of the colors in its pair at the same time, except for black and white; gray is created by a combination of positive and negative stimulation by both white and black at the same time. However, the secondary colors created by blue and yellow and green and red are transmitted as pure primaries. The process of color mixing begins in the *primary visual cortex*. Further interpretation is then processed in the brain or mind's eye.

Nontraditional color wheels

In both additive and subtractive color theory, regardless of the medium and discipline, numerous secondary colors can be created by altering the initial *color wheel*. For example, if the color palette of an individual project is converted into a color wheel, the secondary colors created derive from the original palette. If, for example, the palette is made up of orange, red, and purple, the secondary colors created from this color palette differ from both the traditional additive and subtractive

Figure 32 On a 12-step color wheel red is a primary color and green is a secondary color. However, on a four-color process wheel both red and green are secondary colors.

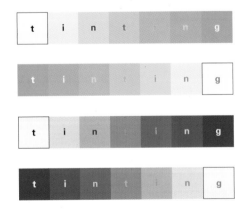

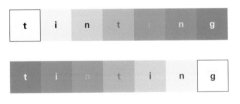

Diagram 77
Color combinations using secondary hues with tints are utilized to demonstrate which type and color combination is most legible.

| 32 | type C66 M42 Y55 K94 |
| | bgd C0 M17 Y16 K0 |

| 32 | type C0 M17 Y16 K0 |
| | bgd C1 M92 Y100 K0 |

| | type C1 M92 Y100 K0 |
| | bgd C66 M42 Y55 K94 |

| BG | Background color C0 M27 Y100 K0 50% |

color wheel. The same can be said for *tertiary* colors and any other traditional *color schemes.*

Simple fields of vision: *Photoreceptive fields that are parallel to one another and work best with moving stimuli*

The simple photoreceptive fields contain clear "on" and "off" regions, and are responsible for producing 25 percent of the color contrast perceived by humans. However, simple fields do not work as an independent entity. Simple cells produce binocular input for complex photoreceptive fields. *Complex photoreceptive fields* are responsible for the perception of another 25 percent of the color contrast perceived by humans (moving slits, edges, and dark bars), and they produce binocular input for *hypercomplex photoreceptive fields.* Although the three photoreceptive fields— simple, complex, and hypercomplex— do not interpret color, they are intricately intertwined and give color shape.

If the object under examination crosses over the simple, complex, and hypercomplex fields, the object can be seen. If not, the object will have no distinct form. At a minimum, an object must cross over three cells in a distinct "on" and "off" order.

Simple subtractive mixing: *The process of removing lightwaves through the absorption process*

Simple subtractive mixing takes into account the phenomenon of absorption, or a loss of visible light. This phenomenon occurs whenever we observe an object of color, whether it is back lighting or a light source that reflects off the object. The lightwaves that are transmitted back or through the object are those that are not absorbed. The process of absorption is directly related to the size of the pigment particles in the colorant or object. These particles help to impart color to the human eye. The sun emits white light onto a colored object, let us say red; the object absorbs most of the light and for the most part reflects the wavelengths in the range of red. This is true for any visible color.

In print-based graphics the majority of inks are translucent, including four-color and six-color process inks. This strategy is intentional and takes into account the phenomenon of light absorption—it is considered simple subtractive mixing.

Figure 33
Studio Concrete Pictures
Creative Director Jeff Boortz

White

High chroma

Nontraditional color wheel

Diagram 78 Primary and secondary colors are created to develop an individualized color wheel. This type of color wheel is easy to create and yields unique color schemes.

Figure 33 (a–c) In the above motion-graphics piece, the moving elements are highly effective. This is due to the anatomy found within human perception. Innately, the eye is attracted to moving objects with a distinct shape and a directional orientation.

Diagram 79 On a 12-step wheel, orange and violet are secondary colors. Blue-green, and yellow-orange are tertiary colors. **Designers** Ned Drew and John T. Drew

Primary color	C 0	M 31	Y 94	K 0
Primary color	C 100	M 0	Y 15	K 6
Primary color	C 7	M 91	Y 100	K 1
Secondary color	C 0	M 60	Y 94	K 0
Secondary color	C 77	M 0	Y 94	K 0
Secondary color	C 77	M 91	Y 0	K 5

33	type C58	M58	Y51	K85
	bgd C0	M0	Y0	K0
33	type C4	M75	Y69	K0
	bgd C58	M58	Y51	K85
33	type C0	M0	Y0	K0
	bgd C4	M75	Y69	K0

CELEBRATE ILLUMINATE

Richmond's Downtown Holiday, The Evening of Friday November 30, 2001
James Center Grand Illumination, magic, music and entertainment, 6 to 7 pm 17th Street Farmers' Market, a holiday shopping extravaganza 5 to 9 pm
and Saturday, December 1, 9 am to 4 pm Historic Shockoe Slip, glowing, charming Victorian style, shopping and dining, 5 to 9 pm La Différence, fun, funky,
contemporary style, cider and caroling, 5 to 8 pm Library Park Story Time, 7:30 pm VMI Marching Band, 6 pm at James Center, 7 pm at Shockoe Plaza
Sponsors: Austin's Christmas Décor, The Industrial Development Authority, James Center, nTelos, The River Lofts

Department of Economic Development, City of Richmond; Design: Malinoski 51

Figure 34
Art Director/Designer John Malinoski

Simultaneous contrast: *A strobing effect resulting from the use of unequal portions of colors*

Simultaneous contrast is most pronounced with an imbalance of large and small areas of color. A pronounced simultaneous contrast of color opposites causes an unpleasant strobing effect.

To some degree, simultaneous contrast occurs with all colors, but it is most pronounced when pure complementary colors are juxtaposed. This phenomenon is caused by retinal cone fatigue. The photoreceptor cells found within the *cones* near the *fovea* of the eye become overworked because each cell can process only one color at a time. The resultant switching back and forth overstimulates the photoreceptor cell, for example, the cell responsible for green− and red+, thereby creating the visual phenomenon of simultaneous contrast.

This is a natural phenomenon, regardless of the medium used. However, we can use it to our advantage. As stated above, pronounced simultaneous contrast is predictable when using pure complementary colors. As the complementary colors become less pure, the effect lessens, which means we can control the degree of the strobe. Learning to utilize this effect can lead to innovative

Figure 34 An outstanding illustration of how to use simultaneous contrast effectively. The poster communicates both the blinking of Christmas lights, and running/jumping reindeer.

Diagram 80
Pronounced simultaneous contrast occurs most visibly in the dorsal and tail fin of the fish, causing a back-and-forth motion as if the fish were swimming. **Designer /illustrator** John T. Drew

Coruscation:
 a. A sudden burst of light
 b. A flash of light

| 34 | type C0 M0 Y0 K0 |
| | bgd C100 M65 Y0 K30 |

| 34 | type C100 M65 Y0 K30 |
| | bgd C0 M0 Y0 K0 |

| 34 | type C0 M79 Y91 K0 |
| | bgd C43 M0 Y79 K0 |

| 34 | type C43 M0 Y79 K0 |
| | bgd C0 M79 Y91 K0 |

| BG | Background color C30 M0 Y100 K0 20% |

color work. For example, we can create a poster that utilizes this back and forth motion, or design a room utilizing simultaneous contrast to create an illusion of a surreal environment in which people walking through feel unsteady or off balance. The possibilities are tremendous.

In print-based, interactive, and motion graphics, simultaneous contrast must be considered every time letterforms are used within a color field. It is all but impossible to read any information when pronounced simultaneous contrast occurs. If you are creating a Web site, you need to check the work on Mac, Windows, and UNIX platforms to make sure that no unpleasant color shifting has taken place. Some software programs have built-in features that simulate what the Web site will look like in each one of the platforms mentioned.

In print-based graphics it is much harder to predict the outcome of simultaneous contrast. Due to the design process and the production phases associated with print-based graphics, it is far more complicated to visualize the final outcome without viewing the finished work. However, the first stage in guarding against unwanted simultaneous contrast is to print out a color proof full-size. The quality of the printer will have an affect on the result. If the area in question

is made up of four-color process builds, it is more predictable than simulated spot colors. If the area in question is made up of spot colors, the color printout should be checked against, for example, the PANTONE® formula guide for color accuracy. If the colors are accurate, the outcome of simultaneous contrast can be predicted easily. (An Iris, Cromalin, Matchprint, Fuji Final Proof, Agfa Print, Waterproof, or Kodak Approval color proofing system should be used for spot color work. An Iris proof matches most spot color for the lowest price.) If the colors do not visually represent the specified spot hues, you can create a color matrix to color sink the spot hues. (See Chapter 4 for color sinking.)

Today, application programs for graphic design have a color component built in. This feature allows designers to retrieve the color builds of any hue used within the document. As we know, pronounced simultaneous contrast occurs when pure complementary colors are juxtaposed. By reading builds of the hues in question, we can predict the amount of simultaneous contrast that will occur and then make the appropriate adjustments.

Several strategies can be employed to adjust the amount of simultaneous contrast occurring within a piece:

1. Add a portion of one color to the other by setting up a color matrix with 10-percent increments. This matrix allows you to determine the point at which simultaneous contrast does not affect the readability or legibility of the type and color combination in question. (See Chapter 5 for creating color matrices.)

2. Tint the type and color combination in question with a third color; this also requires the building of a type and color matrix.

3. Shade the type and color combination with black to lessen the amount of simultaneous contrast, again building a type and color matrix.

4. Combine all of the above.

5. Switch the type and color combination to a *harmonious color palette*—one that has an equal portion of one color running through both the type and color fields (for example, yellow type on a green background). This is harmonious because the amount of yellow is stable in both the foreground and the background.

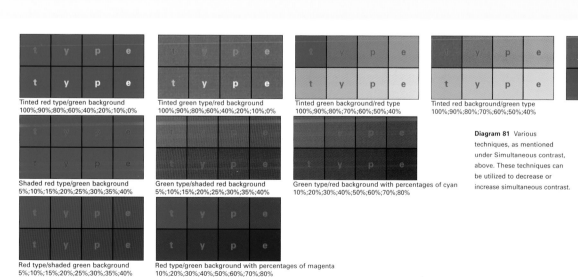

Tinted red type/green background
100%;90%;80%;60%;40%;20%;10%;0%

Tinted green type/red background
100%;90%;80%;60%;40%;20%;10%;0%

Tinted green background/red type
100%;90%;80%;70%;60%;50%;40%

Tinted red background/green type
100%;90%;80%;70%;60%;50%;40%

CVR 19.04%
CVD 11.99%
CVR 30.13%

Shaded red type/green background
5%;10%;15%;20%;25%;30%;35%;40%

Green type/shaded red background
5%;10%;15%;20%;25%;30%;35%;40%

Green type/red background with percentages of cyan
10%;20%;30%;40%;50%;60%;70%;80%

Diagram 81 Various techniques, as mentioned under Simultaneous contrast, above. These techniques can be utilized to decrease or increase simultaneous contrast.

Red type/shaded green background
5%;10%;15%;20%;25%;30%;35%;40%

Red type/green background with percentages of magenta
10%;20%;30%;40%;50%;60%;70%;80%

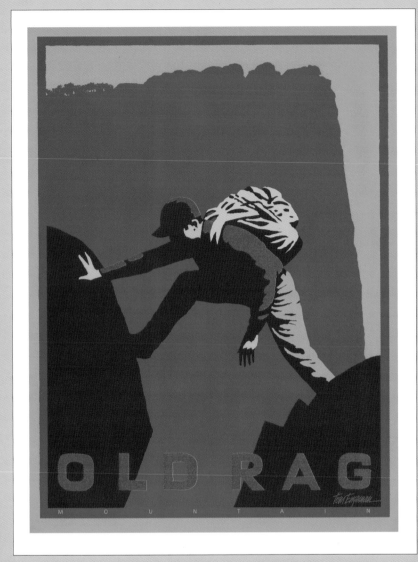

Figure 35
Illustrator/Designer Tom Engeman

In print-based graphics, techniques 1, 2, and 5 will still create a two-color combination, and no additional ink is necessary to complete the job. In other words, if the paper is white, this is still considered a two-color and not a three-color job. When tinting or shading one or both of the colors, select a color swatch that has additional white, black, or another color. You can also create a color percentage of one of the two hues found within the combination, and this would still be considered a two-color job.

Spectral power distribution curve: *The spectrum of color seen by the human eye; when combined this makes white light*
A light source can take the form of the sun or a lightbulb and can be interrupted by its energy or power x time. The wavelength giving the spectral power distribution curve is plotted as a function of power for a given light source. Examples of light sources giving different spectral power distribution curves are clear daylight, incandescent lighting, and overcast daylight.

Three light sources are commonly used within all industries involving designers: D50 or D65 (5,000 K or 6,500 K), the U.S. and European standards for average daylight; A (2,854 K), incandescent lighting; and CWF (4,800 K), fluorescent lighting. There are other standard light sources

Figure 35 In this example, white light is reflected down on to the illustration and all lightwaves are absorbed except for the hues seen by the viewer.

Diagram 82 The following CVR ratings were measured under D65 (average daylight).

Metals
Silver-plated aluminum
CVR 6.01%
Gold-plated aluminum
CVR 4.51%
Nonoxidized aluminum
CVR 47.17%
Nonoxidized copper
CVR 10.28%
Nonoxidized brass
CVR 10.92%
Nonoxidized steel
CVR 11.16%

Plastics (Acrylite gp sheets)
015-2gp white
CVR 77.90%
015-2 white p-95
CVR 77.03%
047-2gp ivory
CVR 62.95%
199-0 black p-95
CVR 3.60%
199-ogp black
CVR 0.57%
202-ogp red
CVR 12.00%
205-ogp red
CVR 7.33%
207-ogp red
CVR 7.71%
209-ogp red
CVR 4.68%
211-ogp red
CVR 5.13%

216-4gp red (white bgd)
CVR 26.45%
262-ogp rust
CVR 6.50%
278-ogp red
CVR 7.01%
303-ogp orange
CVR 21.72%
324-ogp brown
CVR 2.39%
324-0 brown p-95
CVR 5.28%
406-igp yellow
CVR 42.59%
407-2gp yellow
CVR 57.16%
411-5gp yellow (white bgd)
CVR 43.01%
424-3gp yellow
CVR 58.12%

506-ogp green
CVR 3.41%
507-ogp green
CVR 5.37%
605-ogp blue
CVR 2.40%
606-ogp blue
CVR 2.12%
607-igp blue
CVR 10.22%
693-ogp blue
CVR 15.83%

available, but these three fit the majority of scenarios found within the marketplace. You should specify the light source emitting from a backlit sign or signage system as 6,500 K or greater: this will ensure that the spectral power distribution curve is the same as or greater than that of source D65. As Source D65 represents average daylight, a source that is the same or greater than D65 will be visible from a greater distance. If the light source were less than D65, the sign would not be visible from as far.

The same applies to neon signs. If the standard source is emitting light greater than D65, the tools available within this book and the application program Acuity 1.0 can be used. If the source is less than any of the three standard sources mentioned above—D50 or D65, A, or CWF—you cannot predict the distance at which the backlit or neon sign can be viewed clearly.

Split complementary colors: *Two or more <u>hues</u> on or near the opposite sides of the <u>color</u> <u>wheel</u>* For example, the split *complementary colors* of red-orange are blue and green, which are to the left and right of blue-green (the complementary color of red-orange) on the color wheel. Depending on the color wheel used, split complementary hues can take the form of almost any color. When using the traditional *additive* or *subtractive color* wheel, split complementary colors are predictable and limited in number. However, a nontraditional color wheel will yield different results. If, for instance, a color wheel is derived from nontraditional means (for example, the client's product), nontraditional split complementary colors will result. Color is the most powerful tool we have within our arsenal. Traditional *color schemes* implemented through nontraditional color wheels can create innovative color palettes. A color wheel and its color schemes can be derived from almost anything, including indexical, iconic, or symbolic references.

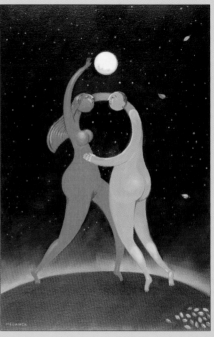

Figure 36
Illustrator Robert Meganck

Figure 36 The black area of this illustration is absorbing 100% of the light. To the eye black is the absence of light. This absence of light creates a negative impulse that is as forceful as a pure hue with a high chroma rating.

Stones
Rose quartz
CVR 25.13%
Onyx
CVR 68.45%
Turazo
CVR 43.34%
Red sandstone
CVR 14.37%
Blond sandstone
CVR 30.65%
Brown sandstone
CVR 27.02%
White sandstone
CVR 53.17%
White quartzite
CVR 57.25%
Gray quartzite (30–40%)
CVR 28.02%
Gray quartzite (10%)
CVR 40.50%
Sunrise sandstone

CVR 29.99%
Crushed black granite
CVR 6.99%
Granite (speckled black/white)
CVR 16.97%

Stones (Contempo ceramic tile)
Juparana colombo
CVR 27.50%
Almond mauve
CVR 38.55%
Luna perla
CVR 30.93%
Absolute black
CVR 1.25%
Empress green
CVR 3.44%
Bargello
CVR 28.23%
Trani/fiorito
CVR 57.75%
Nero marquine
CVR 3.00%
Carrara
CVR 55.89%
Botticino
CVR 67.16%
Olympus white

CVR 58.03%
Salone
CVR 18.96%
San Francisco verde
CVR 14.94%
Breccia damascata
CVR 52.80%
Classico
CVR 50.98%

Fake stone-laminants
(Wilson art international)
Graphite nebula 4623-60
CVR 6.27%
Dakota ridge 4557-60
CVR 19.10%
Dove moraine 4640-60
CVR 43.94%
Confetti 4205-60
CVR 74.86%
Clay 4658-60
CVR 28.88%
Saffron tigris 4673-60
CVR 45.11%
Gray moraine 4641-60
CVR 33.57%
Brune slate 1763-60
CVR 23.42%
Gray glace 4142-60
CVR 42.41%
Neutral glace 4143-60
CVR 55.40%

36	type C0	M67	Y85	K0
	bgd C87	M63	Y74	K61

36	type C87	M63	Y74	K61
	bgd C0	M67	Y85	K0

36	type C83	M44	Y64	K36
	bgd C0	M100	Y87	K0

36	type C0	M100	Y87	K0
	bgd C83	M44	Y64	K36

Figure 37
Art Director John T. Drew
Designer/Photographer Haleh Bayat

Standard observer: *A set angle of observation which affects the response of normal color vision*

The standard observer angle is like a flashlight beam shining on a wall at close range. The light travels out of the flashlight at a 2° or 10° angle (the two recognized standard observer angles, referred to as y bar 2 and y bar 10) and exposes that part of the *retina* wall to light or color. For designers, understanding the size of the area in which sharp, vivid objects can be seen aids in the creation and structuring of a document. For example, the most readable column width for text type is 18–24 picas in length. This measurement corresponds to the 10° standard observer and is capable of producing sharp, vivid images. There are 6 picas in an inch (2.54cm), so 18–24 picas in length is roughly 3–4in (8.5–10cm). Any greater length/width will lie outside the 10° standard observer, with the result that readers will be reliant on their peripheral vision to pick up the next line of type within the column. Peripheral vision is neither sharp nor vivid, but it does give us a general sense of our surroundings. Extending the copy line length over 4in (10cm) will make it harder for readers to pick up the next line of text, and creating body copy line lengths that are less than 3in (8.5cm) does not provide sufficient horizontal clues for our clear and sharp vision to utilize.

Figure 37 and Diagram 83
Right: In both figure 37 and diagram 83, well-defined focal points are implemented to create superior compositional balance. In diagram 83 an asymmetrical design is achieved, and in figure 37 a symmetrical balance is achieved.

Diagram 84 Center and far right: In both posters repetition of form and a reductive color palette creates a unique and wonderful image. The 2° and 10° standard observer are utilized to help create superior compositional balance.
Designer Hiroyuki Matsuishi

37	type	C0	M13	Y25	K0
	bgd	C29	M92	Y93	K5
37	type	C29	M92	Y93	K5
	bgd	C85	M49	Y100	K5
37	type	C85	M49	Y100	K5
	bgd	C0	M13	Y25	K0

| BG | Background color | C0 | M95 | Y100 | K0 | 10% |

For asymmetric and symmetric designs, the 10° standard observer can be utilized to create compositional balance that is more effective and pleasing to the eye. With 2-D asymmetric composition, three points are utilized to create a kinetic compositional balance. This balance usually takes the form of a 2-D triadic relationship. In other words, the viewer's eye is pulled from one focal point to another within this type of compositional balance.

When designing objects that are meant to be viewed at a reading distance of 18–24in (46–61cm), the 10° standard observer can be utilized to determine focal points within the compositional balance. These areas can be structured in such a way that the visual message created in each focal point is encapsulated or nearly encapsulated within a 3–4in (8.5–10cm) diameter. This will ensure that the *fovea* is being utilized to its fullest extent, guaranteeing sharp, vivid objects for better comprehension.

With 3-D color, the 2° standard observer can also be utilized. At a distance of 18in (46cm) from the object being viewed, the 2° standard observer is 4 picas or ²⁄₃in (1.7cm) in diameter. At 6ft (1.83m), the 2° standard observer is the size of 16 picas or 2²⁄₃in (6.77cm). The 2° standard observer seems to coincide better with the eye's natural

fixation points for greater viewing distances. For example, in the design of a poster, both the 10° and the 2° standard observers can be utilized in the creation of a hierarchical structure suitable for viewing at a distance. The 10° standard observer at 6ft (1.83m) would be an area 12in (30cm) in diameter. Both can be intertwined with the compositional balance and hierarchical structure of any given design, whether for a computer screen, television monitor, or printed sample.

In 1976 the International Commission on Illuminations (CIE) modified the 1931 standard observer to create today's standard (X bar 10, Y bar 10, and Z bar 10). This mathematical system measures the response of the tristimulus values (X, Y, and Z). The tristimulus values correspond mathematically to the way color is seen by subjects with normal color vision. The *Y tristimulus value* measures the relative lightness to the mind's eye, the amount of color or light detected by humans possessing normal color vision.

Standard source: *A light source for which the characteristics—wavelength, intensity, etc.— have been specified*

Within all fields of design, we should be concerned with standard light sources. By understanding the source of light we can predict the color of an object, as well as the distance at which letterforms and simple symbols can be seen clearly. For example, a color that is made up of 95 percent yellow and 30 percent magenta will appear a bright yellow-orange in average daylight. However, this same color will appear to have a greenish tinge in fluorescent lighting. The intensity or brightness of the color also will be drastically reduced because the light source is considerably less (2,845 K).

In 3-D color theory, there are three common standard light sources:

- *average daylight: D50 (5,000 K) is the U.S. standard, and D65 (6,500 K) is the European standard;*
- *incandescent lighting: A (2,854 K); and*
- *fluorescent lighting: CWF (4,800 K).*

CVR 70.03%
CVR 15.26%

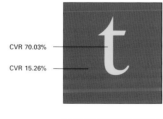

CVR 77.26%
CVR 21.11%

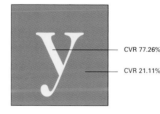

CVR 15.11%
CVR 75.61%

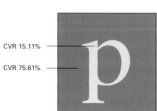

Diagram 85 The color shift in the three squares is the equivalent of viewing one hue under three different light sources: the upper left square is average daylight, the upper right square incandescent lighting, and the lower left square fluorescent lighting.

The way in which we see color under different lighting conditions influences the distance at which we can see objects. In this case, the visual distance of the upper left square, under average daylight and at 20/20 vision, is 5½ft (1.7m); the visual distance of the upper right square, under incandescent lighting and at 20/20 vision, is 4¾ft (1.6m); the visual distance of the lower left square, under fluorescent lighting and at 20/20 vision, is 5¹⁄₆₄ft (1.5m). The variance in distance grows exponentially as the object increases in size.

Most color samples are measured using one of these three standards. These can be used to determine *color value* ratings for both foreground and background. They can also be used to help determine the distance at which type and color combinations can be seen. The software application Acuity 1.0 presents such a system for determining the distance at which letterforms can be seen clearly for any standard eyesight, including 20/20, minimum DMV standard, visually impaired, and legally blind. Visually impaired can mean 20/60 and higher vision, or 20/200. Opthalmologists generally consider 20/60 and higher to be the minimum standard for those who are visually impaired. Some legislation considers 20/200 to be visually impaired, but the mainstream medical community dealing with individuals with limited eyesight considers 20/200 to be legally blind.

A color sample will appear drastically different when viewed in one light source or another. This is why printers, sign manufacturers, legislation, and any business that caters to the design industry uses D50 or D65 as the standard source in verifying colors. For example, all press people check their printed samples under a lit booth that emits the standard source D50 or D65.

Figure 38
Art Director/Designer Mihoko Hachiuma

Figure 38 In this package design, simple and complex subtractive color mixing takes place. A superior use of form and color this package design is highly kinetic.

Diagram 86 An excellent use of color and form. This package design series illustrates a superior command of the medium. Both simple and complex subtractive color mixing take place. When viewing the packaging design on the shelf, complex subtractive mixing occurs. When viewing the designs in this book, simple subtractive mixing takes place.

| 38 | type **C7** | **M18** | **Y30** | **K0** |
| | bgd **C64** | **M61** | **Y55** | **K38** |

| 38 | type **C64** | **M61** | **Y55** | **K38** |
| | bgd **C7** | **M18** | **Y30** | **K0** |

| 38 | type **C64** | **M61** | **Y55** | **K38** |
| | bgd **C5** | **M4** | **Y4** | **K6** |

| BG | Background color | **C100** | **M90** | **Y0** | **K0** | 10% |

This booth is specifically balanced for average daylight so that clarification of color can take place, both at the printing facility and at the client's residence. By simply placing the printed sample and spot color specified under daylight, a designer or printer can easily check for accurate color appearance. Depending upon the type of color specified, the same color may look very different under average daylight and fluorescent lighting.

Subtractive color mixing: *The process of removing lightwaves or matter in physical space to create additional colors*
Architecture, graphic and interior design, and any other industry that produces a physical object that does not have its own light source uses subtractive color mixing. This can be broken down into two categories: simple subtractive, and complex subtractive mixing. Simple subtractive mixing is the process of removing lightwaves through absorption. Complex subtractive mixing is the process of removing lightwaves through absorption and *scattering*. Both of these processes hold clues as to how humans see colors in 3-D space. Color is a by-product of lightwaves emitted from a source, for example, the sun. When these lightwaves strike an object, depending upon the molecular structure of that object, some lightwaves are absorbed by the object as

heat and the rest are reflected off its surface as a particular color. When the lightwaves are detected by humans, the process of 3-D color space is completed. If, in the process described above, scattering takes place, the same color will appear to have less *chroma*. Scattering is a by-product of texture. The greater and rougher the surface area, the more scattering will take place.

Subtractive color is inherently less brilliant and produces a smaller color spectrum than additive color. The color spectrum or gamma of these two types of color rendering is fundamentally dissimilar and therefore creates a different color array. For example, in subtractive and *3-D color theory*, there must be a source of light, an object, and an observer. These three factors are what describe 3-D color space. These factors are also fundamental in *subtractive color theory*.

In *additive color mixing*, there is only a source and an observer. Additive color mixing is more direct as the lightwaves do not bounce off an object before entering the observer's eye. The source emits light in a straight path to the eye, thereby reducing any loss of light and making color more vivid. With this said, many computer color printers use additive ink primaries (see *primary colors*) to produce subtractive color mixing. Used in this way, the *additive*

primaries will produce a smaller color spectrum than the *subtractive primaries* if the inks are pigment based. For color printers, the primaries used to produce color printouts should be subtractive and/or four- or six-color process.

Additive color primaries should be used when creating work for a television monitor or computer screen. Additive primaries are also used with color printers that employ dye-based primaries, such as an Iris, however, such dyes are unstable in light and are therefore not suitable for jobs that require longevity. Additive, dye-based primaries, when used in a subtractive mixing process, create a greater color spectrum than their pigment-based subtractive counterparts.

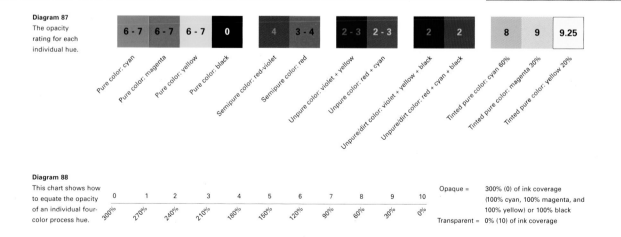

Diagram 87
The opacity rating for each individual hue.

| 6 - 7 | 6 - 7 | 6 - 7 | 0 | | 4 | 3 - 4 | 2 - 3 | 2 - 3 | | 2 | 2 | | 8 | 9 | 9.25 |

Pure color: cyan · Pure color: magenta · Pure color: yellow · Pure color: black · Semipure color: red-violet · Semipure color: red · Unpure color: violet + yellow · Unpure color: red + cyan · Unpure/dirt color: violet + yellow + black · Unpure/dirt color: red + cyan + black · Tinted pure color: cyan 60% · Tinted pure color: magenta 30% · Tinted pure color: yellow 20%

Diagram 88
This chart shows how to equate the opacity of an individual four-color process hue.

0	1	2	3	4	5	6	7	8	9	10
300%	270%	240%	210%	180%	150%	120%	90%	60%	30%	0%

Opaque = 300% (0) of ink coverage (100% cyan, 100% magenta, and 100% yellow) or 100% black
Transparent = 0% (10) of ink coverage

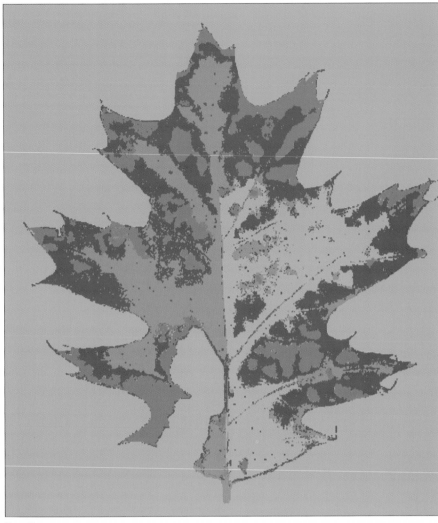

Figure 39
Illustrator John T. Drew

The company Pantone, Inc., the world leader in ink-matching systems for print and textile products, has developed a six-color process system that challenges traditionally held beliefs about the gamma arrangement of subtractive versus additive color theory. With the PANTONE Hexachrome® Color System, the color array of subtractive color mixing has been expanded to rival the chroma and color spectrum of additive color theory. These types of color systems (which in the past have involved up to eight process colors) have been around for decades, but are neither standardized nor cost efficient. With advances in printing technology it is becoming more common for printers to have six-color presses. Pantone produces a plug-in extension for common software applications used in the industry to accommodate the Hexachrome System.

Tertiary colors: *Colors produced by mixing equal amounts of a <u>primary</u> and a <u>secondary color</u>*

With both traditional and nontraditional *color wheels*, tertiary hues have infinite color possibilities. Knowing how to get the most from a color wheel is crucial for understanding color dynamics. To make sound color choices, we must understand the principles employed through cogent color practice; the inner workings of a

Figure 39 In this illustration the color palette is comprised of two tertiary colors, one secondary color, and one primary color.

Diagram 89 The parent colors used within the design and their classification. **Designer** Ned Drew

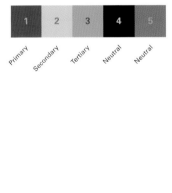

1	2	3	4	5
Primary	Secondary	Tertiary	Neutral	Neutral

type **C**27 **M**18 **Y**100 **K**0
bgd **C**53 **M**49 **Y**0 **K**0

type **C**76 **M**33 **Y**0 **K**0
bgd **C**27 **M**18 **Y**100 **K**0

type **C**27 **M**18 **Y**100 **K**0
bgd **C**76 **M**33 **Y**0 **K**0

BG Background color **C**20 **M**0 **Y**100 **K**0 10%

color wheel independent of the colors being utilized. These principles have been empirically proven. (Note that in *3-D color theory*, three of the color primaries correspond to *additive color theory*, and one of the color primaries corresponds to *subtractive color theory*.) No doubt traditional color wheels were derived through empirical research, but through medical endeavors, scientists have come to realize that the color wheels used in additive and subtractive color theory correspond neatly with the way our eyes and brain perceive and interpret colors. What does this have to do with tertiary colors? Understanding human physiology and how it connects with additive and subtractive color theory demonstrates how powerful these theories, methodologies, and processes are for developing dynamic and communicative color palettes. (See *secondary colors* for setting up nontraditional color systems.)

Transmitted light: *Light that is reflected*
Transmitted light occurs in *subtractive* and *3-D color mixing*. Since light is emitted directly from the object to the source in *additive color mixing*, transmitted light does not occur. In order for transmitted light to occur, it must happen in 3-D space through the process of light emitting from a source, striking and reflecting off an object, and entering the eye of the observer.

Transparent: *If light travels through an object uninterrupted, the object is said to be transparent*
Ink has different levels of transparency, depending on the printing process. In offset litho printing, four to six inks are usually laid down one on top of the other, to generate a full color spectrum. Due to the nature of this process, inks need to be transparent, viscous, tacky, and concentrated, with high levels of pigment. Ink is laid down in very thin layers so that light will either travel through each layer, striking the pigment surface and reflecting back its color, or be absorbed as heat. In commercial screen printing, there is more latitude in the possibilities of ink characteristics. Silk-screen ink can be opaque, translucent, or virtually transparent depending on the type of ink and the way it is formulated. Silk-screen inks also need to be viscous and sticky but, depending on the job, a thicker layer can be laid down at one time, creating a virtually opaque surface. (This also depends on the transparency of the color itself and the surface on which it is printed.) To understand how this works we need only look at an ink matching system's spot colors and their formulas.

For printing purposes, the system of mixing is referred to as subtractive. This is an important clue to understanding how ink transparency or opacity is created. The fewer inks used to create a color, the higher its transparency; the more inks used, the greater its opacity. This includes using black and white ink in the formulation of a color. For example, pure yellow, cyan, and magenta are all equally transparent. If we combine yellow and cyan to make green, the green is more opaque. Green, however, is still a very transparent color, but if we add magenta to it the color loses more transparency. If we add white ink, black, or white and black to this formula, it loses even more transparency. In this example we can continue to add colors until the ink formulation creates black. To create a black color with *subtractive color mixing*, all light is absorbed, or subtracted, creating an area on which no light is reflected back to the observer. When creating a design for which overprinting is planned, the right colors for the job should be determined beforehand, including trapping in the screen-printing process. Trapping is a prepress term that refers to the slight overprinting of one color on another, around the edges, to compensate for misregistration on press.

a

Diagram 90 (a and b) All ink is inherently transparent, however, some inks are more transparent than others. This example uses process colors—cyan, magenta, yellow, and black—to create the spectrum of hues found on the page. These inks are highly transparent. With these four process colors, laid down one on top of the other, and in different percentages of density, different hues can be achieved. In 90b, the parent colors are indicated along with their opacity rating. **Designers** Brenda McManus and Skouras Design

6.25	8.75	3.80
6.75	7.90	1.15

b

Figure 40
Illustrator/Designer Koshi Ogawa

To understand an object's transparency, and how transparency influences color appearance, we need to consider the illuminant (the source of light), *scattering* (how the light reflects off a surface texture), the properties of the substrate (how opaque or transparent the object is and its brightness rating), and *standard observer* Y 10. The standard observer Y 10 calculates the *Y tristimulus*. These elements are the major factors in understanding color appearance. Each factor plays an important role in influencing the color's intensity and thus the readability and legibility of the object. For example, if diffuse scattering takes place, the color's intensity or *chroma* will diminish, possibly creating readability and legibility problems. If an object is placed under glass, or is made from it, the thickness of the surface itself plays a role in how much light or color can be seen through it. Lambert's law states that equal amounts of absorption result when light passes through equal thicknesses of material. If ³/₈in (1cm) of material absorbs half the light, another ³/₈in behind it will absorb half the amount passing through the first layer, so that one-quarter of the original light energy will pass through ³/₄in (2 cm) of material, and so on. If each wavelength is considered separately, Lambert's law is always true in the absence of scattering. If the substrate is made of paper or is

Figure 40 In this example, diffuse scattering does not take place, therefore the chroma level of the hues being utilized is not diminished. The red and dark blue have nearly the same Y tristimulus value.

Diagram 91 Left:
The dimensionality of the form causes lightwaves to scatter off the object in different directions (diffuse scattering). Diffuse scattering and lighting conditions influence hue chroma. This is evident in the photograph. The side of the bag appears to be a different hue (different Y tristimulus value) from the front, and is a good example of why we need to understand how objects interact with their environment.
Designer ModernArts

Diagram 92 In this example, the Y tristimulus values of the foreground and background have a CVD of over 80%.
Designer Tanya Ortega

40	type	C20	M90	Y76	K9	
	bgd	C25	M20	Y19	K0	
40	type	C25	M20	Y19	K0	
	bgd	C20	M90	Y76	K9	
40	type	C0	M0	Y0	K0	
	bgd	C90	M70	Y19	K4	

40	type	C0	M0	Y0	K0	
	bgd	C90	M70	Y19	K4	

BG	Background color	C98	M54	Y0	K0	10%

opaque, the brightness rating plays an important role in the color appearance. If the substrate has a low brightness rating, the color's intensity will be greatly diminished to the point that the color specified no longer appears to be the same, no matter the light source. Finally, the light intensity has by far the greatest influence on color appearance. The source of light operates in the same manner as the brightness rating of materials. The lower the amount of light in a given environment, the less color spectrum and intensity will occur, including the object's properties of transparency.

Tristimulus values: *X, Y, and Z tristimulus values refer to the amount of light the eyes see from the three primaries—red, green, and blue—of 3-D color theory. These values are determined by the power (light source) x the reflectance x the standard observer (the equivalent of normal color vision within humans). The three most typical standard light sources are Source A (tungsten filament lamp), Source D50 and/or D65 (U.S. and European standards for average daylight), and Source CWF (fluorescent lighting)*

The *Y tristimulus value* should be taken into account for color use. The Y value gives the relative lightness of the color as perceived by the mind's eye and relates directly to our response to the color in question. The tristimulus values can be compared to the reflective values found in some paint sample books, but as we all know, a color looks very different under different light sources. The reflective value of a color is not the sole cause of the difference; the efficiency of the human eye in converting reflective values into electrical impulses is also a factor.

In much legislation, the Y tristimulus has played an important role in calibrating signage for the visually impaired. This is the standard by which all *color values* are represented. For environmental graphic designers to meet legal requirements, they must calculate the Y tristimulus for both the foreground and the background color. For U.S. requirements, there must be a 40 percent contrast differential between the two numbers. The foreground number must have a 70 percent value rating or higher (up to 100 percent), and the background must have a rating of 30 percent or lower to ensure that the visually impaired can distinguish between the two. Understanding the standard observer's visual acuteness is necessary to determine the distance at which type and color combinations are legible. Within all other fields of design, a 20 percent Y tristimulus differential is needed for normal vision, including corrected 20/20 or near-normal vision.

There are some color combinations with a contrast differential of lower than 20 percent that are clearly visible, however, this number provides a prudent guideline when dealing with any type of signage or printed material meant to be read at a distance.

The X, Y, and Z tristimulus values are measured in nanometers (1/1,000 of a millimeter) by a data color machine. Tristimulus values represent a mathematical transformation of physical lightwaves and cannot be reproduced by any physical light source, such as a lightbulb. Tristimulus values are commonly referred to as the X, Y, and Z primaries. Combining these measurements with specially adapted software allows printers to retrieve ink formulas from the companies they use.

	X	22.93%
Tristimulus values:	Y	27.51%
	Z	06.07%

	X	09.55%
Tristimulus values:	Y	10.02%
	Z	08.77%

Diagram 93 The primary hue used within diagram 91 and the corresponding Y tristimulus values.

Diagram 94 The primary hue used within diagram 92 and the corresponding Y tristimulus values.

Performing
Arts 2004–05

Figure 41
Art Director/Designer Myung Jin Song

Figure 42
Art Director/Designer Halim Choueiry

For example, a customer may bring in a color sample that is not within any standard ink-matching system. With the use of a data color machine with color-matching software, a press person can retrieve the ink formulas for many different brands to match the customer's color sample. In other words, designers are no longer limited to standard ink- and paint-matching systems. Specialty colors tailored to a client's taste can now be easily created and matched from printer to printer.

Nanometers are both indirectly and directly related to 3-D and *subtractive color theory*. In the process of measuring lightwaves or color, light is fired at the object and its refractive index is measured. In other words, the light is bounced off an object under examination and then measured in nanometers. The lightwaves representing the color are then translated into the X, Y, and Z primaries, which represent the tristimulus values in 3-D color theory. The refractive index for the Y tristimulus value also represents the relative lightness to the mind's eye. This book includes the Y tristimulus values for common woods, plastics, metals, and building materials such as different colored stones, polished marbles, bricks, cinder blocks, and stucco. (For the Y tristimulus value for each of the materials mentioned above, see pages 64/65.)

Figure 41
In this stage performance the lighting conditions have been devised to achieve an environment of consistent hue.

Figure 42 (a and b) In 42a, undercolor addition (UCA) would occur in the cyan plate, and could easily be adjusted on press. In 42b, UCA, if needed, would occur in the magenta plate, and could easily be corrected on press. Percentages of the magenta plate run throughout all hues, making it very easy to adjust on press. However, if the purple were on the bluish side, the document would be difficult to adjust on press: the orange would become muddy with the addition of any cyan.

41	type C72 M66 Y68 K86	bgd C31 M1 Y87 K0
42	type C54 M100 Y0 K0	bgd C0 M43 Y100 K0
42	type C56 M12 Y8 K1	bgd C78 M68 Y33 K81

41	type C1 M70 Y25 K0	bgd C72 M66 Y68 K86
42	type C64 M58 Y44 K95	bgd C54 M100 Y0 K0
42	type C14 M12 Y8 K17	bgd C56 M12 Y8 K1

41	type C31 M1 Y87 K0	bgd C1 M70 Y25 K0
42	type C0 M43 Y100 K0	bgd C54 M100 Y0 K0
42	type C78 M68 Y33 K81	bgd C56 M12 Y8 K1

BG Background color C60 M0 Y100 K0 60%

Undercolor addition (UCA): *A method of adding color to improve image quality*

In four-color process, small amounts of color added to the cyan plate (no more than 10 percent) will improve color density. Undercolor addition is achieved through the CMY plates, but the cyan plate is used most often as it is the least efficient primary of the three—yellow is the most efficient. For example, to create a 50-percent neutral gray using cyan, magenta, and yellow, the color builds would most commonly be set at 53 percent cyan, 30 percent magenta, and 30 percent yellow for press. In this case the cyan plate would be printed beneath the black plate for trapping purposes. This method can be utilized through channels in Photoshop when color correcting a four-color process image. The user simply clicks on the channel desired or the plate to be altered. After selecting the plate, the user can pull down any of the adjustment features in Photoshop under Image in the main menu (Auto Levels, Levels, Curves, Brightness and Contrast, Replace Color, and Variations). Any of these features will allow control of additional density. In some cases it may be necessary to add color to the yellow and magenta plates as well. However, the density of a color for press, including black, should never exceed 98 percent. This is because, on press, dot gain occurs as the ink is absorbed into the paper

and begins to swell. There is a minimum of 2 percent dot gain. When color correcting an image, use the information palette under Windows in the main menu of Photoshop. This will allow you to scroll over the shadow areas within the image to detect if any of the four plates has a color density over 98 percent. Undercolor addition is most typically used to improve flat shadow areas.

In four-color process, each plate or channel is separated and RIPed out (raster image processed) to clear film in the form of tiny halftone dots with a certain line frequency, 133 or 150 lines per inch (lpi). Halftone dots come in many different shapes, but typically are oval, circular, or square. For color correcting images for digital media purposes, the same process should be followed. When scrolling over the shadow areas, add more density to the cyan channel to improve the color spectrum.

When conducting press checks, additional color can be added in the printing process. The press person has control over adding and subtracting the amount of ink flow, thus altering the final appearance. However, most craftsmen, including press operators, do not like to be told how to run their equipment. The press person knows the equipment better than anyone and has a superior understanding of how much

to dial the equipment up or down. It is perfectly appropriate to tell a press person that the job has too much or not enough of one or more colors, but the press person needs to make the decision on how much to dial the machine.

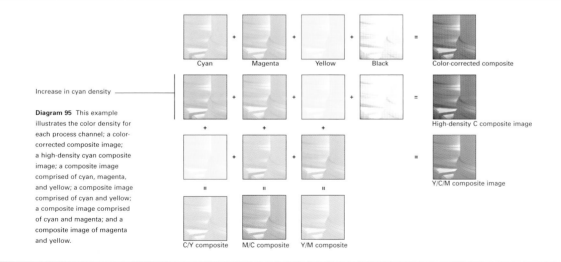

Increase in cyan density

Diagram 95 This example illustrates the color density for each process channel; a color-corrected composite image; a high-density cyan composite image; a composite image comprised of cyan, magenta, and yellow; a composite image comprised of cyan and yellow; a composite image comprised of cyan and magenta; and a composite image of magenta and yellow.

Cyan + Magenta + Yellow + Black = Color-corrected composite

= High-density C composite image

+ + +

= Y/C/M composite image

C/Y composite M/C composite Y/M composite

Undercolor removal (UCR): *A method of removing color to improve image quality*

In four-color process printing, the removal of cyan, magenta, and yellow from the black shadow areas will compensate for ink buildup by replacing it with black ink. This process cuts down on the amount of ink used and improves trapping. Most printers do not allow for more than 300 percent total ink coverage at any given point within a photograph; 400 percent is the equivalent of 100 percent total ink coverage of all four process colors.

In the process of color correcting images, you have the option of removing color density through Photoshop by going through any of the adjustment features under Image in the main menu or through an individual channel. In either case, activate the information dialog palette so that you can scroll through the image and determine the areas where color removal is needed. Avoid dropout. The term dropout is used to describe the areas within an image that should have color density but, due to the printing process, lose their color completely. This usually occurs in highlighted areas. To guard against this phenomenon, highlighted areas should be no less than 2–3 percent of color. This will account for the 2–3 percent dropout that occurs on press. For example, in the area of a

Figure 43
Art Director/Designer Ned Drew

Figure 43 Warm and cool colors are juxtaposed, allowing the human form to come forth. The shading technique within the human form allows for subtle variations of tonal texture on the surface of the skin.

Diagram 96 Right: Undercolor removal is used to create a black hue that has less than 300% total ink coverage.

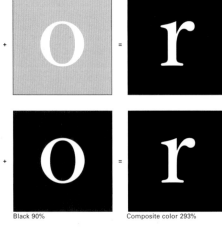

Cyan 98% Magenta 30% Yellow 75% Black 90% Composite color 293%

	type C0	M0	Y0	K0
43	bgd C11	M96	Y71	K1

	type C75	M68	Y67	K90
43	bgd C0	M0	Y0	K0

	type C11	M96	Y71	K1
43	bgd C75	M68	Y67	K90

BG Background color C0 M43 Y100 K0 70%

photograph where highlights are most pronounced, the color build should be close to 3 percent cyan, 3 percent magenta, 3 percent yellow, and 1 or 2 percent black. Using the method described above will ensure that a four-color process image will be color corrected properly for press. (See Chapter 6 for controlling color for press.)

Visual pathway: *The pathway from the eyes to the back of the brain, the* <u>primary</u> <u>visual</u> <u>cortex</u>, *to which the electrical impulses travel to be recognized and interpreted in the mind's eye, instantly and right side up*

With normal eyesight, a person sees the world like a 120° photograph. The eye does not move in a smooth manner, but rather in rapid, jerky movements. The eye peruses what is in front of it, one *fixation point* after another. The mind's eye pieces still frames together into a seamless choreograph of images. Each electrical impulse created by lightwaves striking the photoreceptor cell matrices, located within the visual pathway, travels to the primary visual cortex, where it is organized and interpreted in the mind's eye instantly. The visual pathway consists of lightwaves penetrating the cornea, traveling through the *iris* and lens, and striking the *retina* wall. The image at this point is upside-down and backward. The lightwaves are then processed by the *rods* and *cones*, which in turn pass the information to the

ganglion cells, where the electrical impulses travel along the optic nerve through the optic chiasm and onto the right and left lateral geniculate body. From these stations, the information is transmitted to the primary visual cortex for further categorization and interpretation by this region of the brain and many others. Any defect along this complex pathway will decrease the visual acuity of the observer.

When the lightwaves are processed into electrical impulses, the intensity with which they fire creates not only the *chroma* of a color but also the color itself. For example, to create red, the type of retinal cone that is sensitive to red has to fire with force while the other two types of cone fire faintly. With the photoreceptor cell primaries, all the colors of both *subtractive* and *additive mixing* can be seen. The color spectrum in which humans can see is from 380–750 nanometer (nm) wavelengths. By altering the amount of electrical impulses generated when the retinal cones fire, different hues are created to generate the array of colors visible to humans. This array includes the identification of *color value*, chroma, saturation (see *color saturation*), and many other color characteristics.

Warm colors: *Colors that produce the appearance of an object being nearer the observer than it is*

Warm colors are derived from yellow, orange, and red. Any *hue* comprised of a majority of one or more of these colors is said to be warm, including half of all specified purples. In most ink-matching systems, numerous warm purples contain more than 50 percent of red; any color that contains more than 50 percent of yellow, orange, or red is said to be warm.

If warm and cool colors are used appropriately, they can influence the appearance of a design. If cool colors are placed behind warm colors, this will give the design the appearance of a 3-D format, while if warm colors are placed behind cool colors, the design will appear 2-D. This phenomenon, combined with scale and placement, creates kinetic composition.

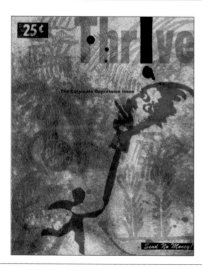

Diagram 97 Right: In this example a 2-D and 3-D color effect is created.

Diagram 98 Left: In this example the intense red background will cause the cones within the eye to fire with force. The stimulation within the eye and visual pathway is an excellent example of how color can be utilized to help create kinetic compositions. **Designer** Theron Moore

Diagram 99 Right: To create the color red the cone that is sensitive to the light wave must fire with force while the other two fire faintly.

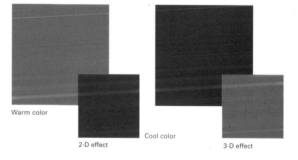

Warm color

2-D effect

Cool color

3-D effect

Figure 44
Art Director/Designers Brenda McManus and Skouras Design

Figure 44 This book cover design shows an excellent use of warm, earth-tone colors, or colors with a warmish tint. The black hue is surrounded by warm colors, causing an optical illusion that casts a warmish tint.

When a hue is comprised of near-equal proportions of warm and cool colors, other factors that influence color appearance need to be understood. In addition to the formula of the ink, there are four major factors that influence appearance:

- *the translucence of the ink;*
- *the substrate on which the ink is printed;*
- *the lighting conditions in which the object is placed; and*
- *the order in which the inks are laid down on press in order to build the color.*

The transparency of an ink depends upon the type of printing being used. With commercial screen printing, inks will be more opaque. The amount of ink commercial screen printers can lay down on press is far greater than what can be laid down for commercial offset and web printing. Commercial screen printers can also place agents, or pigments, in their inks to increase opacity without altering color to any great extent. The drawback with commercial screen printing is that it provides only limited resolution. Most commercial screen printers have a hard time holding anything over 75 lines per inch, but the saturation, the amount, and the quality of ink laid down on press at one time are unlike that possible with any other commercial process.

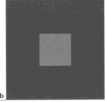

a

b

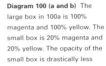

Diagram 100 (a and b) The large box in 100a is 100% magenta and 100% yellow. The small box is 20% magenta and 20% yellow. The opacity of the small box is drastically less (80%), and in this facsimile the white of the paper is coming through to create pastel pink. In 100b, the small box has 80% of color and therefore is 20% less opaque than the large box.

44 type C0 M45 Y100 K7 44 type C38 M53 Y58 K37 BG Background color C33 M12 Y82 K0 10%
 bgd C38 M53 Y58 K37 bgd C0 M45 Y100 K7

 type C0 M0 Y0 K94
 bgd C30 M100 Y100 K20

 type C30 M100 Y100 K20
 bgd C0 M0 Y0 K94

As most inks are translucent, the substrate on which the color is printed will influence its appearance. In commercial screen printing, many different materials other than paper can be utilized. Each of these substrates has its own characteristics which will influence the hue unless the ink is 100 percent opaque. For example, if you print on blue plastic and don't add any agents to increase the opacity of your ink, the imprinted area will be drastically influenced by this blue. This holds true for commercial offset printing. Although offset printers use paper only, paper is available in many different textures and colors, each of which can influence the outcome for the imprinted area. There are many different manufacturers of paper, each using a slightly or drastically different process. White paper should be selected under daylight conditions in order to determine whether it has a warm or a cool tint. All paper sold commercially is given a brightness rating, which subtlely or drastically influences the appearance of color. The higher the brightness rating, the more vivid or chromatic the color will appear. Also, paper can be purchased either coated or uncoated. Coated paper comes in many different forms—matte finish, gloss finish, clay coated, etc.—each of which influences color appearance. Coated paper does not absorb as much ink or color as uncoated, so more light passes through the ink and bounces off the white surface of the paper, creating more vivid colors than on uncoated stock.

In printing, the order in which color is laid down on press in order to build a hue influences color appearance. For example, if we create a purple by adding 100 percent magenta and 100 percent cyan, the color will be either warm or cool depending upon which ink is laid on top of the other. The usual order for laying down in the four-color process is black, cyan, magenta, then yellow. Changing this order by asking the press person to print yellow first will create a warm, greenish tint on any printable surface. However, understanding how trapping works, and if an area can be held in registration within the printing process, is crucial in order to determine whether the order can be arranged to cast the desired tint, or whether back trapping is necessary (changing the printing order of cyan and magenta) to obtain maximum image quality.

a

b

Figure 45
Art Director/Designer Halim Choueiry

a b

Diagram 101 (a and b)
Printing order has an influence on color appearance. In these two examples, the printing order has been changed. In 101a, magenta is laid down last, while in 101b, cyan is last.

Figure 45 (a and b) In both examples above, warm colors are utilized with various degrees of shading. These childlike drawings are more psychologically effective using warm color schemes to communicate the intended message. (See Chapter 7 for psychological and/or learned behavioral effects.)

	type	C0	M60	Y100	K0		type	C0	M35	Y15	K0
45	bgd	C1	M6	Y85	K0	45	bgd	C91	M61	Y19	K2
45	type	C7	M12	Y45	K0	45	type	C1	M6	Y85	K0
	bgd	C0	M60	Y100	K0		bgd	C30	M87	Y96	K12
45	type	C91	M61	Y19	K2						
	bgd	C7	M12	Y45	K0						

Figure 46
Art Director/Designer Ben Hannam and Peter Martin

Wavelength range: *The visual range within which humans can distinguish the color spectrum*

This range is 380–750 nanometers (nm). The purple family falls between 380 and 480nm, the blue family between 450 and 500nm, the green between 500 and 560nm, the yellow between 560 and 590nm, orange between 590 and 610nm, and red between 610 and 750nm. Combinations of these colors are found near the borders of each color range.

Websafe Color Cube: *An arrangement of the 216 hues, at 20 percent intervals, that can be depicted accurately with most common computer platforms. This includes black and white and their shades and tints (see color shades and color tints).*

Although most platforms and their corresponding monitors can detect millions of colors, all but 216 individual hues will differ from one to another. The two most common platforms—Macintosh and Windows Operating Systems—both have the ability to detect millions of colors, but because of the difference in the way they operate, only 216 individual colors correspond. The Websafe Color Cube is considered a browser-safe color palette. The Websafe Color Cube ensures color reliability and accuracy for designers working on the Internet regardless of the

platform or browser in which the design will be viewed. Working outside this color matrix will cause the design to differ greatly in both its color and texture, from platform to platform.

The cube is designed so that the *additive color primaries* (red, green, and blue) and their secondary colors (cyan, yellow, and magenta) are arranged at each corner of the nine-sided cube. The *primary* and *secondary colors* are placed on different corners, depending on the platform. Most programs used for the construction of Web sites and photo manipulation have a default color palette made up of 216 colors. These color swatches represent Websafe colors. For example, Photoshop allows users to load Websafe colors from their 2-D color palette feature.

In the creation of the Websafe Color Cube, or any other Websafe color-swatch library, the primary colors, secondary colors, shades, and tints, including black and white, are created according to the tenets of *additive color theory*. Since these color libraries are meant to be viewed only by projecting light directly into the human eye, *subtractive color theory* does not apply. However, these application programs do use subtractive color mixing (operator interface only) in the creation of hues.

Figure 46 (a–c) This conference Web-site design demonstrates a subtle use of hue. The predominant use of pastel yellows and oranges relates to the environment in which the design conference was held (Doha, Qatar).

Diagram 103 Right: This two-part diagram illustrates both the DOS and Mac color cubes that create a total of 216 Websafe colors.

Websafe Not Websafe

CC3300 D84020

Diagram 102 Each of the colorsafe hues has six digits that are paired. Any Web color that is not paired is not a Websafe color.

Netscape (DOS) color cube

Netscape (Mac) color cube

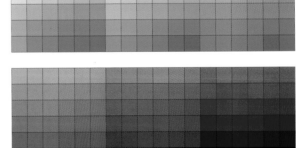

Websafe color swatch

 type **C0** **M20** **Y69** **K0** type **C73** **M67** **Y66** **K83**
bgd **C73** **M26** **Y5** **K0** bgd **C1** **M0** **Y24** **K0**

type **C73** **M26** **Y5** **K0**
bgd **C0** **M20** **Y69** **K0**

 type **C1** **M0** **Y24** **K0**
bgd **C73** **M67** **Y66** **K83**

BG Background color **C0** **M20** **Y100** **K0** 20%

The hues that are created through these Websafe color libraries have more intensity or *chroma* than their subtractive color counterparts. Photographs for Web design have to be saved in RGB mode (additive primaries) prior to manipulation to ensure an accurate depiction of the color chroma used within the photograph.

Most photographs set up for Web design are saved as either a Joint Photographic Experts Group (JPEG) or a Graphics Interchange Format (GIF) file. Both of these file formats compress files that then decompress when they are opened. JPEG format works well with a continuous-tone photograph, and GIF format works well for line art such as illustrations, graphic-based images, and typography, or for any graphic elements, including flat colors used on a Web site. Venturing outside the Websafe Color Cube or Websafe color palette will create color appearance problems and textural anomalies in the site.

Y tristimulus value: *A measure indicating the relative lightness of a color to the mind's eye*
In *3-D color theory*, the tristimulus values X, Y, and Z plot the power of the light source x the reflectance value x the *standard observer*, but it is the Y value that is meaningful to designers. With the Y value (the *color value* number), designers can

predict the legibility of type and color combinations, no matter what the medium utilized. In the past, color legibility for normal color vision was based solely on the experience of the designer. The Y tristimulus value is the first building block in understanding the architecture of human color perception. These values tell the designer how well humans can perceive a color, color combination, image, symbol, logo mark, or type and color combination, for any substrate, including brick, cinder block, stone, metal, plastic, fabric, wood, glass, etc.

Motion, form, and depth play important roles in determining visual acuity. This is why legislation mandates other visual factors for legibility for the legally blind. Depending upon the lighting conditions at the location of the sign, one of the three standard sources should be used. With each standard source, the Y tristimulus value will change.

The Y tristimulus value used, along with the principles of color contrast, color value, and simultaneous contrast outlined in Chapter 2 and Acuity 1.0, will help to ensure color legibility, the clear human perception of color, in any given situation.

Figure 47
Art Director Hiroyuki Ueno
Designers Hiroyuki Ueno and Mayumi Izumino
Illustrator Hiroyuki Ueno

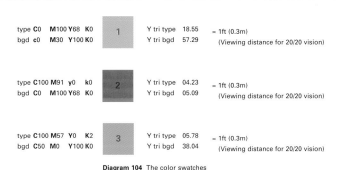

	type						Y tri type		
type	C0	M100	Y68	K0	1		Y tri type	18.55	= 1ft (0.3m)
bgd	c0	M30	Y100	K0			Y tri bgd	57.29	(Viewing distance for 20/20 vision)
type	C100	M91	y0	k0	2		Y tri type	04.23	= 1ft (0.3m)
bgd	C0	M100	Y68	K0			Y tri bgd	05.09	(Viewing distance for 20/20 vision)
type	C100	M57	Y0	K2	3		Y tri type	05.78	= 1ft (0.3m)
bgd	C50	M0	Y100	K0			Y tri bgd	38.04	(Viewing distance for 20/20 vision)

Diagram 104 The color swatches above create a visual testing range for viewing at a distance of no greater than 1ft (0.3m). This will ensure absolute visual clarity of all anatomical parts found within the letterform.

Figure 47 White, black, and grays are utilized to create this dynamic composition. The Y tristimulus values for these hues (subtractive color theory) will help you to understand the legibility issues concerned with compositions including grayscale.

47	type	C0	M0	Y0	K36
	bgd	C0	M0	Y0	K91
47	type	C0	M0	Y0	K91
	bgd	C0	M0	Y0	K36

2 Basic Color Theories

In 1730 Sir Isaac Newton wrote, "Color is to the eye as music is to the ear." This profound statement recognizes the relationship between human expression and color. Color resonates through the environment we look at and the objects we create. Full of life, color stimulates the mind to wander in new directions. It is unquestionably the strongest emotive dynamic we can use to create compelling form. Within design, color is always both an outward and an inward expression of visual creativity. When used correctly, color becomes the catalyst through which visual communication is expressed and a response evoked.

The theories of color used by designers on a day-to-day basis are related to the way in which human perception takes place. We will compare these theories to demonstrate the interrelationships between interactive, print, and environmental graphic design. They can be categorized into three major groups: additive, subtractive, and 3-D color. Each theory holds part of the answer to how color is formed, used, and perceived by humans.

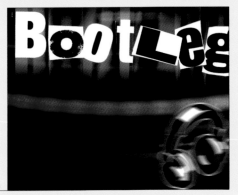

Figure 1
Studio Rosie Lee

Additive Color Theory

Additive color theory is usually more familiar to those who study the hard sciences, but this is changing. To understand additive color theory, it is helpful to understand a little of the physiology involved in the human perception of color.

Additive color theory explains the process of adding lightwaves to one another, either in physical space or in the brain, to create additional colors, hence its name. Any standard light source—including television monitors, computer screens, electronic kiosks, lightbulbs, and the sun—uses this process.

Additive color theory is based on three basic primaries: red, green, and blue. These colors are used because of their location in 3-D space. They offer the widest triadic relationship, or spectrum, possible for mixing or viewing.

The wavelength measurement of red is 700 nanometers (nm), of green 546nm, and of blue 436nm. When mixed together, red and green create a spectrum of yellow lights (hues). Adding green and blue lights yields a spectrum from blue-greens to pure cyan, and adding blue and red lights results in a spectrum from purples to pure magenta.

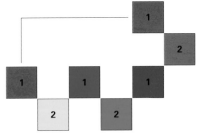

Diagram 1 There is no color on earth. All color seen by man is a result of light that is reflected off the surface of objects. The higher the chroma, the more intense the light. The sun is the most naturally intense light source.

Red, green, and blue are additive primaries, and are considered the first stage of color vision.

Figure 1 (a–i) Primary and secondary colors are used in this piece to take advantage of the chroma values found in additive color theory. These intense colors are used to activate the work, and provide continuity throughout the motion graphics.

Diagram 2 The hues that are marked "1" are the primaries for additive color theory, and those marked "2" are the primaries for subtractive color theory.

Yellow, cyan, and magenta—subtractive primaries—are the secondary colors for the additive primaries. Additive primaries relate to the Young-Helmholtz (trichromatic color) theory and offer the largest color spectrum.

type C94 M66 Y37 K10	type C0 M0 Y0 K0	
bgd C1 M16 Y99 K0	bgd C0 M87 Y99 K0	
type C21 M100 Y95 K0	type C40 M0 Y17 K0	BG Background color C0 M30 Y100 K0 30%
bgd C94 M66 Y37 K10	bgd C84 M57 Y1 K0	
type C1 M16 Y99 K0	type C0 M87 Y99 K0	
bgd C94 M66 Y37 K10	bgd C40 M0 Y17 K0	

There are three basic types of additive color mixing: lightwaves added together by direct transmitted light; lightwaves emitting from a spinning disk of different primary colors; and dotted areas of pure additive primaries that create the appearance of a mixed color in the mind's eye.

Direct Transmitted Light

The first type of additive mixing is commonly used in the production of stage performance, film, and video; the second in print and television. Everyone has been to a musical concert where the use of colored spotlights was apparent. In this process, if two different light sources of different colors are beamed down simultaneously, the wavelengths create an additive mix. However, when the lightwaves strike the performer, the color mixing becomes subtractive.

In print-based production, additive color mixing takes place simultaneously with simple or complex subtractive mixing only when the illusion of one color is created by a combination of primaries that are mixed together within the mind's eye. This process is additive color mixing used within a subtractive context and should not be confused with additive color theory. For example, if a four-color photograph is built from four 133-line screens and the primaries

do not overlap, the color mixing is additive. If the colors do overlap, it becomes simple or complex subtractive color mixing. In other words, if there is an area where the primaries do not overlap, but are laid down side by side (one dot next to the other), the color mixing is an additive process if additional hue(s) are created within the mind's eye: color mixing that takes place through the visual pathway of humans is additive. If color mixing takes place through the overlapping of two colors in physical space before entering the human eye, it is a subtractive mixing process.

a

b

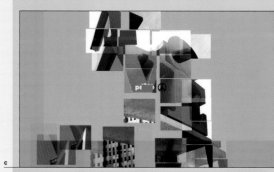

c

Figure 2
Studio Concrete Pictures
Segment Lead/Designer Jeff Boortz

Diagram 3 In the diagram above red and blue are laid down side-by-side, creating the appearance of a third color assimilated within the mind's eye.

Figure 2 (a–c) This Brutha Love piece was designed with a push/pull use of color. A warm, high-chroma color field flattens the space. The higher the chroma, the more intensified the effect. This color effect is amplified when viewed on a computer monitor.

2	type C0 M96 Y100 K0 bgd C0 M56 Y99 K0		type C67 M57 Y0 K0 bgd C75 M0 Y100 K0
	type C67 M57 Y0 K0 bgd C0 M96 Y100 K0		type C0 M96 Y100 K0 bgd C82 M21 Y31 K15
2	type C0 M56 Y99 K0 bgd C67 M57 Y0 K0		

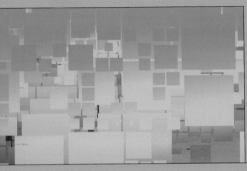

Figure 3
Studio Concrete Pictures
Segment Lead/Designer Jeff Boortz

Projected Light

The second type of additive mixing is commonly used in the technology behind color television tubes. Electrons in these tubes transport the information that agrees with the three primaries, red, green, and blue. These electrons pass through a filter (by striking phosphor dots on the mask of the television tube that corresponds to that primary color) and project the colors as lightwaves, in an outward direction. When these dots are juxtaposed in the right combination, a spectrum of color is created. No overlapping of dot or hue takes place, and therefore the process is considered additive color mixing. This same color mixing process is used for both computer monitors and kiosks. It is important to understand that the process of color mixing takes place in the mind, not in physical space (the environment from television tube to human). It is a physical and psychological effect taking place in the visual pathway and primary visual cortex of the brain.

With signs and signage systems, additive color mixing takes place for any sign that uses projected light. Examples of such signs include those illuminated through backlighting or a neon process. Either type can be calibrated for the amount of light the sign projects in order to predict typographic legibility. However, signs of these types do not normally use traditional additive primaries for the projection of color.

Additive color theory relates directly to the Young-Helmholtz theory, also known as the trichromatic color theory, in the sense that the photoreceptor cells located closest to the fovea respond to the same primaries—red, green, and blue. Primaries that are printed do not have the full spectrum range that the eye can detect. This is why the sky looks bluer in reality than in a photograph. In the case of a television set, the primary lights function in the opposite way to the eyes. The set receives electronic impulses and transmits them outward to be interpreted.

Additive color theory offers the greatest color spectrum due to the amount of chroma inherent in projected light. This color spectrum, or color gamma, is far greater than the chroma offered in traditional subtractive theory. However, this is now being challenged: the PANTONE MATCHING SYSTEM® offers a print-based color system that can match the chroma produced through additive color theory.

Figure 3 (a–c) In this motion-graphics piece, an effective use of color is being utilized. The high chroma values in frames 1 and 2 are outside the CMYK color spectrum, and are highly intensified on the computer monitor. The intensification of hue is caused by light being projected directly into the human experience—the source of light is not reflected off of an object, but transmitted directly into the eye. When viewing work on the computer screen, the second type of additive color mixing, through projected light, occurs.

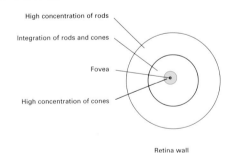

Diagram 4 This diagram illustrates the makeup of the back of the retina wall. Note that the fovea is off center.

	type					type			
3	type C1	M92	Y20	K0		type C59	M0	Y21	K0
	bgd C59	M0	Y21	K0		bgd C8	M65	Y100	K1
	type C8	M65	Y100	K1	3	type C61	M0	Y100	K0
	bgd C61	M0	Y100	K0		bgd C82	M73	Y0	K0
3	type C82	M73	Y0	K0	3	type C28	M2	Y100	K0
	bgd C28	M2	Y100	K0		bgd C1	M92	Y20	K0

BG Background color C100 M0 Y0 K0 30%

Subtractive Color Theory

When learning about color, graphic designers are usually exposed to subtractive color theory only. This is why most designers find it difficult to understand, for example, why the colors on a computer monitor do not match those printed on paper. It is useful for designers and architects to understand additive, subtractive, and 3-D color theory.

The typical primaries for subtractive color are cyan, yellow, and magenta. These primaries function neatly with the additive primaries of red, green, and blue as they are the complementary and secondary colors of the additive primaries. When all three subtractive primaries are combined at 100 percent, all lightwaves are absorbed, or subtracted, leaving black.

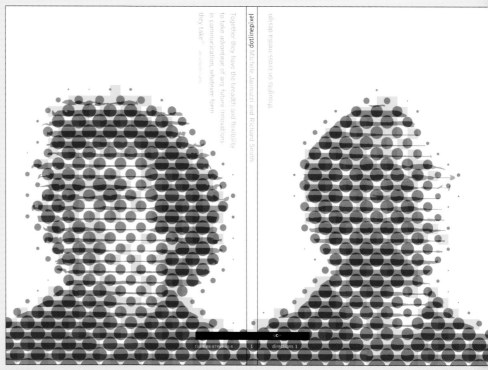

Figure 4
Art Director/Designer Jannuzzi Smith

High-chroma chart

- Additive chroma
- PANTONE® color formula guide
- PANTONE® Hexachrome colors
- Four-color process

Diagram 5 This illustration depicts the high-chroma line for additive, PANTONE® formula guide, PANTONE® Hexachrome colors, and four-color process spectrum.

Figure 4 A book cover design using a gross screen pattern of 2lpi with dots. A typical computer monitor has the capacity to display 72lpi with pixels that are square in shape.

	type				
4	type	C85	M85	Y0	K0
	bgd	C0	M0	Y0	K0
4	type	C0	M0	Y85	K0
	bgd	C0	M85	Y85	K0
4	type	C0	M0	Y0	K0
	bgd	C85	M85	Y0	K0
4	type	C0	M85	Y85	K0
	bgd	C0	M0	Y85	K0

Black is detected by the human eye when no light is transmitted into it. Yellow and cyan mixed together in different proportions yield an array from yellow-green/blue-green to a pure green color; yellow and magenta added together in different proportions yield an array from yellow-orange/orange-red to a pure red; and cyan and magenta added together in different proportions yield an array from cyan-blue/blue-purple/reddish-purple to a pure purple.

When dealing with print-based graphics, more often than not, printing takes place on white stock. Printing inks are very translucent and therefore black is added as a fourth primary in subtractive color theory to create color density and color shading, and to broaden the color spectrum. In print-based, interactive, environmental, and motion graphics, black is considered a color, as is white.

Figure 5 When creating artwork for reproduction purposes color shifting will take place. No matter the monitor, the software, or the hardware devices used, color appearance will shift from medium to medium, from software to software, and from printing device to printing device. However, understanding how subtractive color theory and additive color theory work within a 3-D environment will help you manage hue outcome. In this example, simple subtractive color mixing takes place—there is no scattering involved.

Diagram 6 This three-part diagram demonstrates how additive and subtractive primaries interrelate. Subtractive primaries are secondary on the additive color wheel, and additive primaries are secondary on the subtractive wheel.

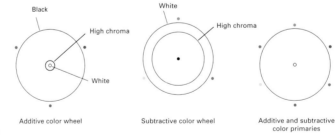

Additive color wheel Subtractive color wheel Additive and subtractive color primaries

Simple Subtractive Mixing

In subtractive color theory, color mixing can be subdivided into simple and complex subtractive mixing. Simple subtractive mixing is the process of removing lightwaves through absorption. The phenomenon of absorption results in a loss of visible light. If all the light is absorbed by the color/object, the radiant energy is transformed into heat and the object appears black. If the substrate absorbs only part of the light that strikes the surface, it will appear to have a color other than black and the temperature will be less than its black counterpart. This occurs whenever we observe an object of color, regardless of the light source. The lightwaves transmitted back or through the object are those that have not been absorbed. The effect of this process can be directly related to the size of the pigment particles in the color, which help impart color to the eye. The sun emits white light onto a colored object, let us say red—the object absorbs most of the light and reflects mainly the wavelength in the range of red. This is true for any visible color.

Complex Subtractive Mixing

Complex subtractive mixing is the process of removing lightwaves through both absorption and scattering. Scattering results when wavelengths interact with matter, causing light to be reemitted in various directions rather than reflecting off in one direction, as with simple subtractive mixing. Scattering accounts for the sky being blue and the clouds white. If all of the lightwaves falling on an object scatter, the object appears white; if partial absorption takes place, the object appears colored; and if all the lightwaves are absorbed, the object appears black.

In reality, neither scattering nor absorption are absolute. The appearance of color depends upon the size of the pigment's particles. Lighter colors are produced by smaller particles, and darker colors by larger ones. If the pigment and resin of the object have extremely small particles, it will appear transparent. In other words, the size of the matter and the molecular structure of the object determine the object's color.

a

b

c

Figure 6
Studio Magnetic North

Figure 6 (a–c) In the above motion-graphics piece, additive color theory applies for the original medium, however, within this book, simple subtractive color mixing occurs.

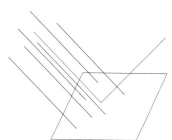

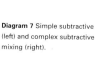

Diagram 7 Simple subtractive (left) and complex subtractive mixing (right).

	type C5	M18	Y86	K0		type C6	M68	Y31	K0
	bgd C67	M78	Y21	K4		bgd C0	M0	Y0	K0
	type C67	M78	Y21	K4		type C67	M0	Y89	K0
	bgd C6	M68	Y31	K0		bgd C5	M18	Y86	K0
	type C0	M0	Y0	K0		type C11	M94	Y67	K1
	bgd C11	M94	Y67	K1		bgd C67	M0	Y89	K0

Figure 7
Art Director/Designer Danielle Foushée

3-D Color Theory

Traditionally, the term "3-D color theory" has been used to describe how color reacts and behaves in our external environment. However, this book broadens the definition to include theories from the field of ophthalmology that pertain to the human internal environment. By broadening the definition, an important triadic relationship between the source of light, the object, and the observer is completed. This relationship provides the foundation for making informed color choices based specifically on how the audience will visualize the work.

How the Eye Works

The eye works in some ways like the lens and aperture of a camera, and the process by which the receptor cells transmit color to the mind's eye can be likened to the use of different screen percentages in order to create an unpure color in subtractive, four-color process printing.

First, lightwaves pass through the cornea, which covers and protects the iris as a clear filter protects a camera lens. On striking the cornea, the lightwaves are bent; this starts the process of exposing the image to the retina. The iris, which gives us our sparkling green, blue, brown, or black eyes, works much like the focusing ring and leaf

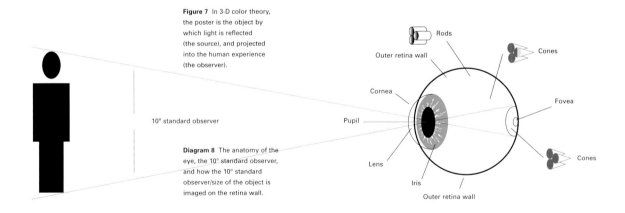

Figure 7 In 3-D color theory, the poster is the object by which light is reflected (the source), and projected into the human experience (the observer).

10° standard observer

Diagram 8 The anatomy of the eye, the 10° standard observer, and how the 10° standard observer/size of the object is imaged on the retina wall.

Rods

Outer retina wall

Cones

Cornea

Fovea

Pupil

Cones

Lens

Iris

Outer retina wall

	type	C67	M57	Y0	K0
	bgd	C70	M0	Y100	K0
7	type	C14	M0	Y100	K0
	bgd	C67	M57	Y0	K0
7	type	C70	M0	Y100	K0
	bgd	C14	M0	Y100	K0

| **BG** | Background color | C75 | M0 | Y100 | K0 | 30% |

shutter of a camera lens. It helps to focus the image and adjust the amount of light passing through the pupil to define the depth of field. The pupil, which operates like the aperture of a camera, is located at the midpoint of the eye. It is through the pupil, the black part in the center of the eye, that light travels in order to strike the retina, which is located in the back of the eyeball. The lens of the eye is like the camera's glass lens. It is a curved piece of protein-rich, flexible crystalline tissue that forms a clear image on the retina, thus completing the focusing process of the eye. At this point, the lightwaves have made their way through the focusing pathway and emerged upside down and backwards. This phenomenon takes place between the cornea and the lens of the eye, with the lightwaves bending and inverting as they travel.

With normal eyesight, a person sees the world as in a 120° photograph. The eye scans a scene in small, rapid jerks rather than in a smooth manner, and impressions are created by fixation points. When the eyes move, for example when they pan right, they fix on an individual object and then move right to fix on the next object. They focus only at these fixation points. This process occurs so rapidly that vision seems to be smooth. At each fixation point, a focused image is flashed on the fovea,

creating an impression. In turn, this impression generates electrical impulses through several photoreceptor cell matrices located in the visual pathway. This organizes the image into color, motion, form/silhouette, and depth. The visual pathway links the eyes to the back of the brain—the primary visual cortex. Electrical impulses travel along this path to be organized and interpreted in the mind's eye, instantly and right side up.

Figure 8
Art Director Babette Mayer
Designer Leonardo Popovic

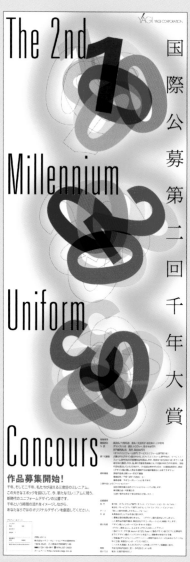

Figure 9
Art Director/Designer Ganta Uchikiba

Diagram 9 Size and location of typical fixation points found within figure 9. In design, the compositional balance found within a given piece is the primary determinant of fixation points.

Fixation points

Figure 8 For this image, only a small amount of fixation is needed to comprehend the total composition. Simplistic compositions do not need a great deal of fixation in order for the totality within the mind's eye to be comprehended.

Figure 9 The greater the complexity, the greater the amount of fixation points needed to comprehend the total composition. The larger the number of fixation points, the longer it takes to comprehend. If there is a viewing time limit, graphics should be more simplistic to enable faster comprehension. This includes all media.

	type			
8	type C0	M0	Y0	K0
	bgd C11	M77	Y66	K2
8	type C11	M77	Y66	K2
	bgd C0	M0	Y0	K0

	type			
9	type C1	M96	Y91	K6
	bgd C3	M24	Y84	K1
9	type C3	M24	Y84	K1
	bgd C1	M96	Y91	K6
9	type C43	M31	Y29	K13
	bgd C0	M0	Y0	K100

	type			
9	type C0	M0	Y0	K100
	bgd C43	M31	Y29	K13

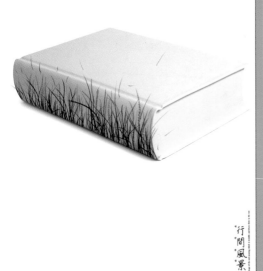

Located off-center on the retina wall is the area called the fovea. In this area, the cone receptor cells are extremely concentrated. Cones are responsible for our perception of bright light and color. This type of vision is used primarily in daylight. The other photoreceptor cells are called rods; they are responsible for our night vision, which operates efficiently in dim lighting. Rods do not distinguish color, but they are highly sensitive to light. The most concentrated area of rods is around the perimeter of the retina. They diminish in number toward the fovea, becoming integrated with an increasing concentration of cones.

Cones and rods derive their names from their shape. They are associated with three types of vision in the primary visual cortex: motion, form/silhouette, and depth. The corresponding photoreceptive fields—simple, complex, and hypercomplex—are located near the back of the brain. The simple photoreceptive fields lie parallel to one another and work best with moving stimuli. They contain clear "on" and "off" regions. Simple cells give binocular input to the complex field cells. Complex fields react most favorably to stimuli that are oriented properly across the field. They contain no distinct "on/off" regions, so stimulus length is not critical. Complex field cells give binocular input to the

hypercomplex cells. Hypercomplex fields react most favorably to stimuli that are moving in a particular direction and orientation. Within these fields, the length of the stimuli pattern is critical.

Cones are responsible for one more dimension of vision—color. The capability to see and value color is one of the most important functions in the visual process. Three types of cone, each sensitive to one of the three additive primaries (red, green, and blue), mediate the color visual process. These primaries correspond to those used by the Commission Internationale de l'Eclairage (CIE), the international commission on illumination, which also uses red, green, and blue. The optic nerve and middle area of the retina wall seem to be governed by the color opponent theory, with the three different cells responding either to red/green, blue/yellow, or black/white. Blue and green input yields yellow if there is a lack of yellow-sensitive cones.

To summarize, wavelengths of color are focused and inverted through the cornea and lens of the eye, forming an image on the retina wall. Cones and rods catch the lightwaves, organizing and categorizing them through their receptor cells into electrical impulses. These impulses travel through the

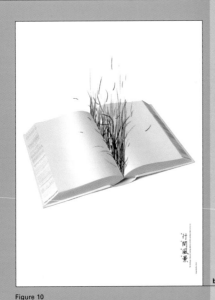

Figure 10
Art Director/Designer Gi-Heun Suh

Figure 10 (a and b) In both examples the compositional balance is simplistic and induces a strong concentrated area of fixation points. There are numerous fixations due to the complexity found within the grass.

3-D color

Additive color

Diagram 10
This two-part illustration depicts how 3-D color primaries and additive color primaries interrelate.

visual pathway, where they are interpreted
by the primary visual cortex of the brain
instantly and right side up, as an object or a
scene. The visual process ends at this point,
and the mind's eye, or brain, begins the
interpretive and/or recognitive procedure.
Having a fundamental understanding of how
the human eyes work in relationship to the
source, object, and observer, we can begin
to grasp how color theories are interrelated.

Figure 11
Art Director/Designer Jannuzzi Smith

Figure 11 In an empirical
color study of 16 individuals,
the pink/red squares and the
purple squares were perceived
first. Nine individuals saw
the pink/red squares, six
saw the purple squares, and
one individual saw the blue
squares first. It is interesting to
note that purple and red
are at either end of the color
spectrum perceived by humans.

Diagram 11 The cones that
are sensitive to red, blue,
and green can detect any
combinations of the three
primaries. Above is the
spectrum of visible light
that humans can see.

Diagram 12 Rods are sensitive
to white, black, and shades of
gray. The gradation of grays
are extremely sensitive to any
variation detected by the rods.

11	type C80 M90 Y0 K0		11	type C0 M100 Y50 K0
	bgd C50 M0 Y30 K0			bgd C0 M0 Y0 K0

11	type C0 M0 Y0 K0
	bgd C80 M90 Y0 K0

11	type C50 M0 Y30 K0
	bgd C0 M100 Y50 K0

Figure 12
Art Director/Designer Akio Okumura

The Young-Helmholtz Theory

Two theories of color vision, the Young-Helmholtz theory (or trichromatic color theory) and the opponent-process theory, developed by Ewald Hering, provide further clarification. Each of these theories holds part of the key to understanding color vision.

The function of the three retinal cones' primaries (red, green, and blue) is described in the Young-Helmholtz theory by sets of cones. Each type of cone is predominantly sensitive to one color or wavelength and minimally sensitive to another color or wavelength. To create red as the eye sees it, the type of retinal cone that is sensitive to red has to fire with force while the other two types of cone fire faintly.

With the three primaries, all the colors of the spectrum, from 380–750nm wavelengths, can be seen by humans through alterations to the amounts of electrical impulses generated when the retinal cones fire. For example, white is created when all three types of retinal cone fire at once with force, while to produce yellow, the red and green cones have to be stimulated to an average extent and the blue retinal cones to a lesser extent. All three types of cone function simultaneously; no one type can operate alone.

In 1964, two research teams, working independently of one another, discovered that light-sensitive photoreceptor cells respond to three types of pigment wavelengths—red, green, and blue—which is consistent with the Young-Helmholtz theory. These receptor cells are located in the region adjacent to the fovea.

The Young-Helmholtz theory also explains the illusion of complementary afterimages. These occur when the retinal cones and neurons become overstimulated and fatigued. If we stare at an individual color, say red, for a minute or two and then look to a white background, we will see its complementary, green. Green placed within a larger field of red of the same intensity appears to be brighter because the red retinal cones become overstimulated, creating their complementary afterimage, green. This effect is called simultaneous contrast, and it occurs with every hue to some extent, depending on its amount of color, combination of color, and amount of chroma. Pronounced simultaneous contrast is produced by an imbalance between small and large areas of color. A more pronounced simultaneous contrast of color opposites causes an unstable juxtaposition or unpleasant strobing effect. Again, these effects are all forms of color illusion caused by retinal cone fatigue.

Figure 12 After staring at this color field for two minutes, then looking at a blank white wall, an array of afterimage colors will emerge.

Diagram 13 Stare at the green or red color for a minute or two, then look at the white squares. These will appear to have the afterimage of the two hues (green having red and red having green).

| 12 | type | C0 | M0 | Y0 | K0 |
| | bgd | C76 | M70 | Y66 | K87 |

| 12 | type | C81 | M93 | Y19 | K4 |
| | bgd | C0 | M0 | Y0 | K0 |

| 12 | type | C76 | M70 | Y66 | K87 |
| | bgd | C81 | M93 | Y19 | K4 |

| BG | Background color | C90 | M53 | Y0 | K0 | 50% |

Opponent-process Theory

Ewald Hering's opponent-process theory explains the function of the cones, rods, and optic nerves found around the fovea in the middle of the retina wall. No rods are located in the area of the fovea itself, but they become highly concentrated as we move outward to the perimeter of the retina. The mid-area of the retina, between the fovea and perimeter, has equal amounts of rods and cones. The receptor cells located in this area function differently from those found in the fovea or the perimeter of the retina wall, as explained by Hering's theory. The receptor cells are grouped in pairs of three types: blue/yellow, green/red, and black/white. Each of the cells has a negative and a positive color sensor—blue, green, and black are negative, and yellow, red, and white positive. These colors do not contain any proportions of other colors and are therefore pure to the eye. The receptor cells do not have the capability of stimulating a response for both colors at once, except for black and white. Both the Young-Helmholtz and the opponent-process theories hold that white is created by the presence of a sensation and black by the absence of one; any type of gray would be created by a partial absence of light according to the Young-Helmholtz theory, and a combination of positive and negative responses according to the opponent-process theory.

Figure 13
Art Director/Designer Akio Okumura

Figure 13 In viewing this image, all the photoreceptor cells within the cones are being utilized in order to process the array of color found on the bag. Constantly firing with different degrees of force, the photoreceptor cells will quickly become fatigued, causing simultaneous contrast and its by-product, afterimage.

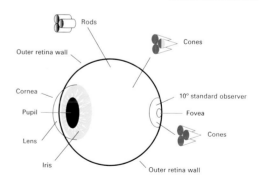

Diagram 14 The mechanics of the eyeball, illustrating how and where the opponent-process theory takes place.

13	type	C65	M58	Y38	K7
	bgd	C94	M96	Y48	K37
13	type	C94	M96	Y48	K37
	bgd	C65	M58	Y38	K7
13	type	C71	M7	Y58	K0
	bgd	C2	M2	Y75	K0

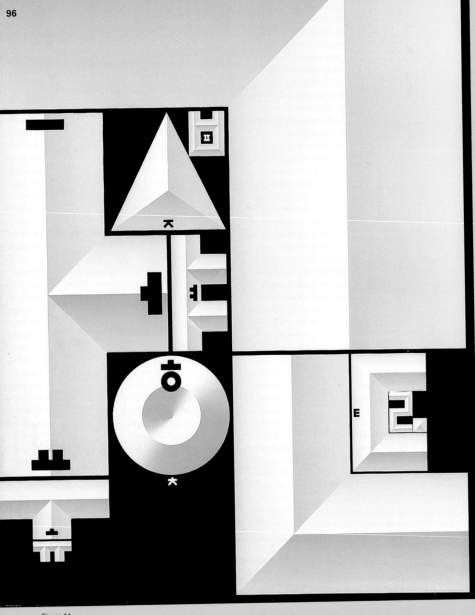

Figure 14
Art Director/Designer Myung-Sik Rhoo

Illumination: The Source

The first of the triadic components of color is the light source. In 1730, Sir Isaac Newton created an experiment in which light was broken into visible colors by the use of a prism. This experiment led to the discovery of the visual spectrum of wavelengths, known as color, that can stimulate the human eye. The full spectrum of color as seen by the human eye makes white light. A light source can be in the form of the sun or a lightbulb, and can be interpreted by its energy, or power x time. Plotting the wavelength power x time will give the spectral power distribution curve of a light source. Examples of sources having different spectral power distribution curves are daylight, incandescent light, or an overcast day.

Daylight, and any source of light, is described by its wavelength (or wavelength range), which is measured in nanometers (nm), 1nm being 1/1,000,000 of a millimeter. The wavelengths of light that are visible to the human eye range from 380—750nm. The color purple lies at the bottom of the spectrum (380nm); and is followed by blue (480nm), green (500nm), yellow (560nm), orange (590nm), and red (650nm), which lies at the top of the spectrum. The human eye perceives as visual light (or color) only a small fraction of the whole

Figure 14 The photoreceptor cells within the rods are actively utilized to process this image. As the light source decreases, the gray tones will gain darker values, and as light increases, the tones will lighten.

Diagram 15 A representation of the visual spectrum of colors that humans can see.

Diagram 17
Three hues seen in average daylight, and the same three hues seen in poor lighting conditions. As bright light fades (daylight), the cones become less effective and the rods take over processing all visible light.

Diagram 16
Examples of light sources
D65 = Average day
9,300 K = Early afternoon light
4,800 K = Noon sun

14 type **C**11 **M**8 **Y**7 **K**0
 bgd **C**23 **M**23 **Y**27 **K**0

14 type **C**100 **M**100 **Y**100 **K**85
 bgd **C**11 **M**8 **Y**7 **K**0

14 type **C**23 **M**23 **Y**27 **K**0
 bgd **C**100 **M**100 **Y**100 **K**85

BG Background color **C**0 **M**75 **Y**100 **K**0 50%

array of electromagnetic radiation. In measuring wavelengths by instrumentation, the CIE has established a number of standard light sources. These are identified as Sources A, B, C, and D50/D65. Source A operates at a temperature of 2,854 kelvins (K) and is the equivalent of light produced by a tungsten-filament lamp; Source C operates at a temperature of 4,800 K and approximates noon sun; Source D operates at a temperature of 6,500 K and approximates average daylight; Source D65, the European standard, has alternate color temperatures of 5,500 K and 7,500 K, but is averaged to 6,500 K. The U.S. standard, Source D50, operates at 5,000 K.

Each of these standard sources emits a different spectral power distribution, influencing the color being measured by changing its appearance. For example, two colors that look the same as each other in Source C may look very different from one another in Source A. This phenomenon is called color rendition. It is important to use the right standard source to achieve the proper amount of stimulation of the eye at a given distance. In other words, do not use Source D (daylight) to calculate the eye's response to incandescent lighting. Within color rendition, the phenomenon of two colors with different spectral reflectance curves appearing the same under one light

source but not under another can occur. Such colors are called metameric pairs. Colors that have the same spectral reflectance curves are known as invariant pairs. This means that in 3-D form, one color can occupy the same space as another. Because of this phenomenon, colors cannot be matched by their reflectance curves (tristimulus values), but the stimulation of the color to the eye in different light sources can be predicted.

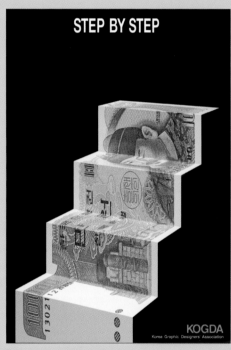

Figure 15
Art Director/Designer Myung-Sik Rhoo

Figure 15 In this poster the colors and their corresponding values will change in different lighting conditions. This applies to both the highlight, midtones, and shadow areas of the photograph and typography. Color shifting in the shadow areas will be minimal, and in standard light sources will be imperceptible in the black area. In poor lighting conditions all color is eradicated, turning the poster into a grayscale composition.

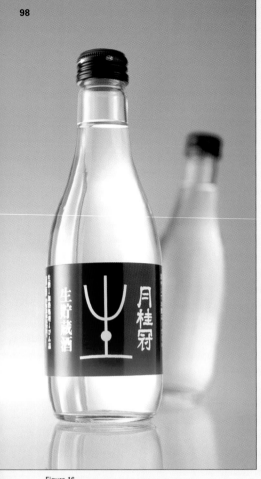

Figure 16
Art Director/Designer Akio Okumura

Reflectance: The Object

The second of the triadic components of color is the object. What happens when lightwaves strike different surfaces? A lightwave travels through the air in a straight line. Only when interrupted by an object can it change its course, and the surface of the object determines the extent to which this will change. If light travels through an object uninterrupted, the object is said to be transparent. All light passes through transparent objects, except for a small amount that is reflected off their surface. Scattering occurs if light strikes an object with a rough surface: this causes the wavelengths to reflect in many directions. When scattering is excessive, light is said to be diffusely reflected. If the object is smooth and mirrorlike, reflecting all of the light back in the opposite direction, the object is said to be opaque. If you hold a flashlight at a 45° angle to the face of a vertical mirror, the lightwaves will reflect back in another 45° angle. If the object is transparent and the source of light striking the glass is at a 45° angle, 90 percent of the light transmits through the glass at an angle of 28° off the vertical plane, and 10 percent of the light is reflected back at a 45° angle, in the opposite direction. This accounts for the glare often encountered with glass, varnish, and some inks. The rougher the surface, the more scattering will occur.

The opposite of transmitted light is absorbed light. If all of the light is absorbed by an object, the object appears black. On sunny days a black top conducts heat by absorbing the energy of light. Lambert's Law states that equal thicknesses of material will produce equal amounts of absorption. If no scattering takes place, a little over 3/8in (1cm) of material will absorb one half of the light. If another one half of the remaining light is absorbed by another 3/8in (1cm) of material, only one-quarter of the original light will be left.

Another important law in light absorption is Beer's Law. This states that equal amounts of absorbing material will produce equal amounts of absorbed light. This is important in understanding how the pigment in ink works in printed material, including translucent material. The size of the pigment particles directly influences which wavelengths are absorbed and which are transmitted or reflected back; this is called the refractive index.

If there is no absorption and all wavelengths are reflected back, the pigment is said to be white. If there is partial absorption, the pigment particles will reflect back only the wavelengths compatible to their size and will absorb the others, creating the appearance of a color.

Figure 16 Although the label has a smooth surface, diffuse scattering will occur due to the bottle's shape. The shape of an object will influence color appearance whether the object is smooth or rough. In this example the glare that occurs is caused by the total amount of white light reflecting off the object.

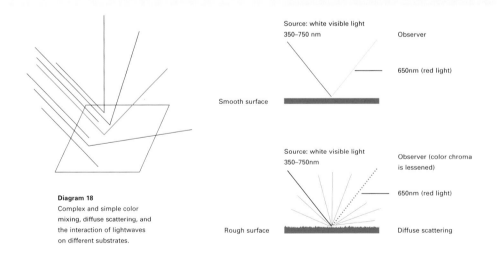

Diagram 18
Complex and simple color mixing, diffuse scattering, and the interaction of lightwaves on different substrates.

Smooth surface

Rough surface

Source: white visible light 350–750 nm

Observer

650nm (red light)

Source: white visible light 350–750nm

Observer (color chroma is lessened)

650nm (red light)

Diffuse scattering

16 type C86 M89 Y36 K16
 bgd C37 M41 Y22 K0

16 type C29 M28 Y16 K0
 bgd C86 M89 Y36 K16

16 type C5 M0 Y4 K0
 bgd C29 M28 Y16 K0

16 type C37 M41 Y22 K0
 bgd C5 M0 Y4 K0

BG Background color C54 M25 Y19 K8 20%

The spectral characteristics of materials can be described by a spectral transmittance or reflectance curve. Spectral refers to the total quantity of variants within a light's wavelength, not to be confused with specular, which refers to the reflection caused by smooth surfaces. The refractive index varies with the type of surface—gloss, matte, or rough (in the case of printed materials, uncoated). With printing inks, an interesting and common phenomenon occurs. Most inks are translucent and the surface under them opaque. Together, they create a diffuse reflection surface. This occurs with inks that are applied to a surface coated with a clear varnish; it can also occur with matte and nonglossy surfaces if there is a degree of unevenness or roughness.

The spectral transmittance or reflectance curve describes the characteristics of the object just as the spectral power distribution curves describe the characteristics of the source of light. Material that is colored absorbs complementary hues and reflects light of its own hue. With this knowledge alone, you cannot accurately or even generally predict the legibility of colors in relationship to distance. In order to do this, you must look at all three components of 3-D color (source, object, and observer) in conjunction with one another.

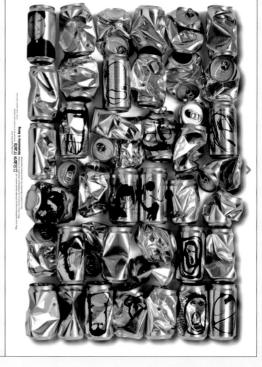

b

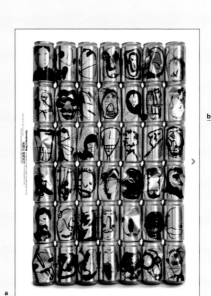

a

Figure 17
Art Director/Designer Gi-Heun Suh

Figure 17 (a and b)
An excellent example of diffuse scattering caused by the unusual shapes found within each object.

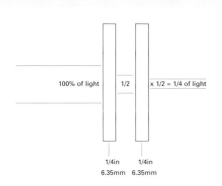

100% of light | 1/2 | x 1/2 = 1/4 of light

1/4in 1/4in
6.35mm 6.35mm

Diagram 19 Lambert's law states that equal thicknesses of material produce equal amounts of absorption.

17 type C100 M100 Y100 K99
bgd C33 M27 Y31 K0

17 type C0 M0 Y0 K0
bgd C100 M100 Y100 K99

17 type C65 M50 Y56 K1
bgd C0 M0 Y0 K0

17 type C33 M27 Y31 K0
bgd C65 M50 Y56 K1

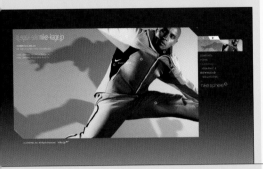

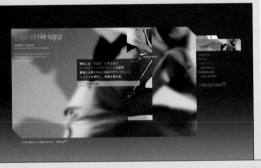

Figure 18
Art Director/Designer Shun Kawakami

Standard Observers
(x bar, y bar, and z bar)

The standard observer is a term used to describe the response of normal color vision. The standard was established in 1931 and modified in 1976. This third component completes the triad that makes up 3-D color in our environment.

The source, object, and observer must be considered together in order to calculate the response of the human eyes. The relative light source is described as the spectral power distribution, or the relative power (P). In the CIE system it will be one of the standard sources, A, B, C, D50, and D65. The object is described by the spectral reflectance (R), which is the reflectance or the transmittance value of the color. The standard observer, or spectral response, is determined by a mathematical equation in the CIE system and given as x bar 10°, y bar 10°, and z bar 10°. The stimulus for color, given as tristimulus values X, Y, and Z and described as the relative stimulus, represents the amount of color seen by subjects with normal color vision.

Before 1931, the tristimulus values were a combination of the three primaries with the use of a fourth light source as subtractive light to create all the colors that can be seen by the human eye. This method was

Figure 18 (a–c) The intensity of light has a direct bearing on color chroma or brightness of hue. The more intense the light source, the more the receptor cells will fire with force, causing a stronger electrical impulse within the mind's eye. Typically, viewing color on the computer screen will cause the receptor cells to fire with more force. This is caused by light (source) being directly transmitted into the eye (observer) and thereby bypassing the object as we know it in 3-D color theory.

| 18 | type C29 M12 Y13 K1 | | 18 | type C57 M18 Y20 K6 |
| | bgd C65 M42 Y29 K30 | | | bgd C26 M58 Y68 K22 |

| 18 | type C26 M58 Y60 K22 |
| | bgd C29 M12 Y13 K1 |

| 18 | type C65 M42 Y29 K30 |
| | bgd C57 M18 Y20 K6 |

BG Background color C1 M5 Y91 K0 20%

considered cumbersome and unnecessarily complex so, in 1931, the CIE adopted a new set of tristimulus values called X, Y, and Z. This new set is a mathematical transformation of physical lightwaves and can only be determined theoretically—it cannot be reproduced in physical form.

According to the CIE's mathematical system, which is based on the tristimulus values, the standard observer (x bar 10, y bar 10, and z bar 10) measures the response of the tristimulus values (X, Y, and Z). This mathematical calculation is directly related to the way color is seen by humans with normal color vision. The tristimulus values relate to the amount of light the eyes receive from the three primaries—red, green, and blue. In the CIE system, these primaries are translated into numbers describing each test color. For instance, PANTONE 250 C would have, for a standard observer of 10° and a light source of D65 (daylight), tristimulus values of X = 70.90, Y = 68.11, and Z = 79.93. Each individual sees color in a slightly different way. The CIE standard observer accounts for this fact, taking the average of test subjects to create the standard.

Figure 19
Studio Pentagram
Partner/Art Director Fernando Gutierrez

Figure 19 In this case the observer primarily recognizes red. This is caused by the size of the pigment particles, which match the size of the lightwave (red). The red lightwave bounces off the pigment particles found within the ink and is seen by the viewer. The color red absorbs all other light waves found within white light.

Source + Object + Observer

Diagram 20 This illustration depicts the three factors that must be in position according to 3-D color theory.

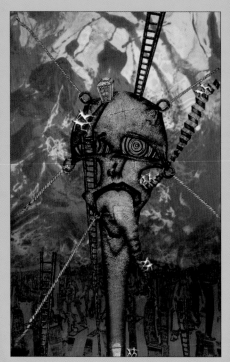

Figure 20
Illustrator Leny C. Evangelista

The standard observer y bar 10 represents the eye's response to the total amount of energy or lightwaves we call color. The y bar 10 describes the Y of the tristimulus values, giving information on the lightness of a specific color to the eyes. The y bar curve, or spectral luminous efficiency, determines how effectively the eye converts light into human electrical stimuli. The Y of the tristimulus values and the y bar curve of the spectral luminous efficiency are two different entities. The y bar is part of the mathematical equation that calculates the Y tristimulus value, or the response to the amount of energy/lightwaves we call color. This equation is: the power x the reflectance x the standard observer = the tristimulus values.

The number 10 of y bar 10 represents the 10° angle of vision that is the small field of color vision in the eye. This area is located in and around the fovea on the retina wall and is suitable for testing large areas for color vision. There is also a 2° standard observer, but this observer should not be used to determine distances for legibility: when viewing from a distance of 18in (45.72cm), the 2° standard observer is an area the size of a dime (2⁄3in/17mm). The data presented throughout this chapter are based on the 10° standard observers.

In this book, three types of light source are referred to. Source A is a tungsten-filament lamp, Source D65 is average daylight, and Source CWF is fluorescent lighting. These three types of light source should engender more effective solutions to visual communication problems.

The mathematical equations used to calculate the tristimulus values are not presented in this book, but can be found in ***Billmeyer and Saltzman's Principles of Color Technology*** by Roy S. Berns. The tristimulus values for each PANTONE MATCHING SYSTEM® color are now available with the use of the PANTONE® Color Cue.

Figure 20 The parent colors found within this illustration are listed in the small color swatches below. To truly understand color contrast between hues, the Y tristimulus values must be identified. The PANTONE® Color Cue identifies the X, Y, and Z tristimulus values of any hue under examination.

Diagram 21 Right: The factors for calculating the Y tristimulus value. The observer is calculated with normal eyesight, including normal color vision.

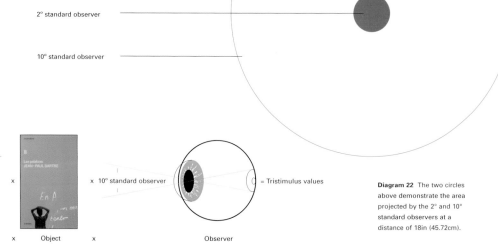

2° standard observer

10° standard observer

Source x Object x Observer

x x 10° standard observer = Tristimulus values

Diagram 22 The two circles above demonstrate the area projected by the 2° and 10° standard observers at a distance of 18in (45.72cm).

20 type **C**59 **M**39 **Y**3 **K**0
 bgd **C**50 **M**90 **Y**100 **K**19

20 type **C**24 **M**27 **Y**21 **K**0
 bgd **C**59 **M**39 **Y**3 **K**0

20 type **C**50 **M**90 **Y**100 **K**19
 bgd **C**24 **M**27 **Y**21 **K**0

BG Background color **C**0 **M**75 **Y**100 **K**0 70%

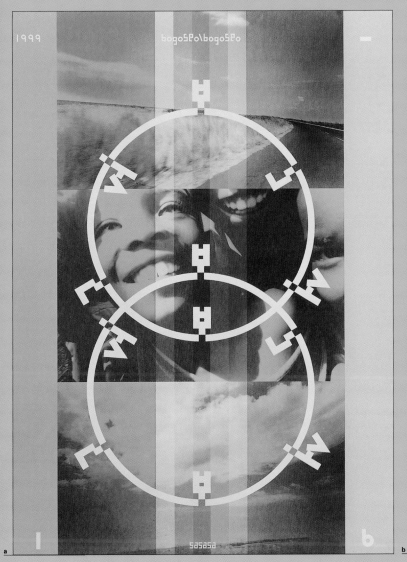

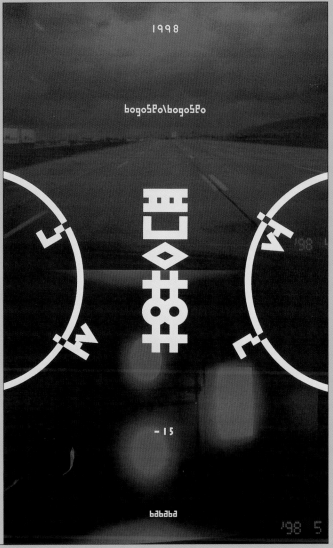

Figure 21
Art Director/Designer Sang-Soo Ahn

Figure 21 (a and b) The Y tristimulus values for each hue used within the posters above can be identified using the PANTONE® Color Cue. There are two basic ways to do this. If you have a printed sample, use the Color Cue as directed. If the file is digital, convert the document into CMYK mode. In Photoshop, sample a hue and choose the PANTONE® formula guide—coated or uncoated—in the color dialog box. Photoshop will automatically select the nearest Pantone color. Once the color is selected, use the PANTONE® Color Cue and measure the hue from the Printed PANTONE® formula guide.

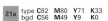

| 21a | type | C56 | M49 | Y9 | K0 |
| | bgd | C25 | M41 | Y10 | K0 |

| 21a | type | C25 | M41 | Y10 | K0 |
| | bgd | C13 | M21 | Y63 | K0 |

| 21a | type | C13 | M21 | Y63 | K0 |
| | bgd | C82 | M80 | Y71 | K33 |

| 21a | type | C82 | M80 | Y71 | K33 |
| | bgd | C56 | M49 | Y9 | K0 |

| 21b | type | C82 | M81 | Y80 | K41 |
| | bgd | C25 | M89 | Y84 | K11 |

| 21b | type | C25 | M89 | Y84 | K11 |
| | bgd | C82 | M81 | Y80 | K41 |

3 The Creation of Color Wheels

To play a musical note is one thing. To know how long, how loudly, or how softly to play it is another. The basic intonations found in color, their universal translation, and how these inflections are brought about, changed, and recorded into the architecture of color are explored in this chapter.

Numerous types of color wheel and their practical applications help us to gain a broader understanding of how gamma, or spectral ranges, and their respective media complement and influence color appearance. Conventional and unconventional color wheels and their color schemes, including secondary, tertiary, tints, shades, chromatic, complementary, harmonious, monochromatic, neutral, parent, primary, split complementary, achromatic, and analogous colors, help to explain how humans perceive color and how colors can vary from medium to medium. These wheels include ink-matching systems, additive systems, and 3-D color theories.

Each color theory has its own set of color primaries, and each set holds a clue as to how color works in 3-D space as perceived by humans. Without an overall understanding of how these sets of color primaries operate, both independently and together, color dynamics cannot be predicted.

Figure 1
Art Director/Designer Myung-Sik Rhoo

The Spectral Range of Color Wheels

Subtractive Color

Subtractive color theory has three traditional color primaries: cyan, magenta, and yellow. If all three overprint at 100 percent of color, they create black, which involves the subtraction or absorption of all visible light. In subtractive color theory, white is created when no light is absorbed or subtracted from the object the lightwaves strike. In print-based graphics, these same traditional primaries function differently. Cyan, magenta, and yellow are still intact but black is added as a fourth color primary to create a wider color gamma or spectral range and to cut down on the amount of ink utilized. In four-color process printing, undercolor removal is commonly practiced so that blacks within an object are created primarily from the black primary and not a buildup of the other three primaries. In printing, black and white are generally considered colors. White is created by the substrate, e.g., paper, or the addition of white ink or foil stamp. The color spectrum created by cyan, magenta, and yellow is quite small in the subtractive process. With the addition of black, the color gamma range is increased in the lower range, but is still the smallest gamma out of the three color theories discussed within this book.

Figure 1 A fine example of a simple subtractive color palette. Stunningly bold, the illustration is counterbalanced with red letterforms that pop off the page. The juxtaposition of warm and cool colors is a highly effective technique. Black is created through one plate only.

Diagram 1 The three traditional primaries of subtractive color theory.

Diagram 2 (a and b) Left: In 2b, the black plate is removed and color balanced using cyan, magenta, and yellow. The image in 2a is color balanced using the traditional subtractive primaries cyan, magenta, and yellow, with the addition of a black plate (CMYK).
Designers John T. Drew and Sarah A. Meyer

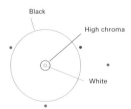

Diagram 3 The three color wheels above illustrate additive and subtractive color primaries, and how they relate to one another in a six-step color wheel.

	type			
1	type **C0**	**M0**	**Y0**	**K100**
	bgd **C0**	**M0**	**Y0**	**K0**
	type **C1**	**M82**	**Y71**	**K0**
	bgd **C15**	**M38**	**Y67**	**K1**
1	type **C15**	**M38**	**Y67**	**K1**
	bgd **C0**	**M0**	**Y0**	**K100**

BG Background color **C11 M32 Y64 K1 20%**

The Acuity Color System shows how the three/four primaries overprint each other to create an array of over 10,000 hues. Although these primaries create a small color gamma, the number of hues The Acuity Color System provides is quite large.

Some color printers, affordable for home use, use a six-color (dark cyan, light cyan, dark magenta, light magenta, yellow, and black) ink-jet system. These color primaries produce a smaller color gamma than the PANTONE MATCHING SYSTEM® produced using the PANTONE Hexachrome primaries because of their location in 3-D space. However, the six-color primaries allow for a greater tonal range within the standard four-color process spectrum. Dark cyan, light cyan, dark magenta, and light magenta operate in the same manner as a duotone that is made from black and gray. This type of duotone does not increase the color spectrum range, but it does increase the fineness of the tonal range, which makes an image appear of higher quality than it actually is.

In 1963, Pantone created the PANTONE formula guide and expanded the subtractive primaries to include yellow, warm red, rubine red, rhodamine red, purple, violet, reflex blue, process blue, green, black, and transparent white. This increase in primaries enlarges the color spectral range by over 40 percent in comparison to traditional four-color process printing. However, the intensity of these primaries limits the gamma range to well below the additive primaries (red, green, and blue) when used through the process of projected light, e.g., a computer monitor.

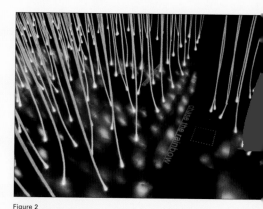

Figure 2
Studio Imagination, Ltd.
Art Director Stuart Jane
Designers Caroline Wilson, Natalie Gibb, Lisa O'Neil and Tony Rimmer

Figure 3
Art Director/Designers Brenda McManus and Skouras Design

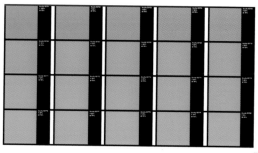

Diagram 4 The Acuity Color System is demonstrated above to show the subtleties derived from a color matrix using 5% increments. Included in this color system are the CMYK and hexadecimal numbers required to reproduce the colors in multiple media.

Diagram 5 The six-color process involves altering/ subdividing the traditional primaries cyan and magenta. This creates a finer degree of tonal variation than the four-color process, without increasing the color spectrum.

Figure 2 This photograph demonstrates how effectively color/light can be used within 3-D color theory (source, object, and observer).

Figure 3 Undercolor removal is used within the black areas of the illustration to alleviate ink buildup on press.

In 1998, Pantone released the Hexachrome Color System, which broadens the subtractive color gamma considerably. This system uses six primary colors to create a color wheel, and through this process PANTONE can create a color spectrum that is almost as broad as that produced by additive color mixing. The six primaries are yellow, orange, magenta, cyan, green, and black. The PANTONE MATCHING SYSTEM offers a software plug-in that works with the commonly used software applications for print-production purposes. This color system can duplicate close to 95 percent of all the PANTONE formula guide colors. With the four-color process primaries—cyan, magenta, yellow, and black—about 60 percent of all the PANTONE spot colors can be reproduced. This is why specifying a spot color from the PANTONE MATCHING SYSTEM and then printing does not print as the correct hue on a home ink-jet over 40 percent of the time.

The traditional subtractive primaries —cyan, magenta, and yellow—fit neatly as the secondary colors for the additive color primaries. However, subtractive primaries do not produce as much chroma or intensity within their respective color wheels. Additive color primaries (red, green, and blue), when used through additive color

mixing, create a larger color gamma or spectrum. This is due to the fact that the colored lightwaves are projected directly into the human eye, which greatly increases stimuli within the human eye. In other words, because the wavelengths have not reflected off any objects when they strike the retina wall, the intensity of the lightwave is greater. This causes the photoreceptor cells to fire with more force, which creates a stronger electrical impulse to be interpreted by the mind's eye as color.

Figure 4
Art Director/Designer Aidan Rowe

Figure 4 (a–c) In this motion-graphics piece, light is directly transmitted into the eye where the lightwaves are inverted to form an impression on the back of the retina wall. This light is then processed and interpreted by the mind's eye in the final stage of color vision (primary visual cortex and other parts of the brain).

Diagram 6 The PANTONE® color library is a comprehensive color system that makes easy work of the color issues faced by graphic designers on a day-to-day basis. **Designers** John Rushworth and Daniel Weil of Pentagram.

type **C**25 **M**87 **Y**100 **K**22
bgd **C**75 **M**68 **Y**67 **K**90

type **C**75 **M**68 **Y**67 **K**90
bgd **C**25 **M**87 **Y**100 **K**22

BG Background color **C**80 **M**46 **Y**13 **K**17 10%

Additive Color

In additive color theory, one lightwave is added to another to create additional colors from a starting point of red, green, and blue. These three primaries offer the greatest color gamma range and therefore are used to produce colors on computer monitors, television screens, electronic kiosks, film, and video. With any of these products, there is some color variance due to each manufacturer's limitations. These primaries relate directly to the Young-Helmholtz, or trichromatic color theory (see Chapter 2).

The color gamma produced in both the Young-Helmholtz theory and Hering's opponent-process theory (see Chapter 2) are the largest possible for human perception. The color spectrum range is from 380–750 nanometers (nm). The opponent-process theory primaries can be likened to the PANTONE solid in Hexachrome guide primaries, except that the orange is replaced with white. This is why the color spectrum in the PANTONE Hexachrome Color System has been dramatically improved in color gamma for a subtractive process. However, this process produces less chroma than a direct light experience.

The International Commission on Illumination (CIE) reflects the color primaries found in both the additive color and Young-Helmholtz theories —red, green, and blue. However, this system operates to reproduce an approximated mathematical variable representing the human visual response to a particular color. This response is represented through the Y tristimulus values, from 0–100 percent, and approximates the relative lightness to the mind's eye, that is, the human response.

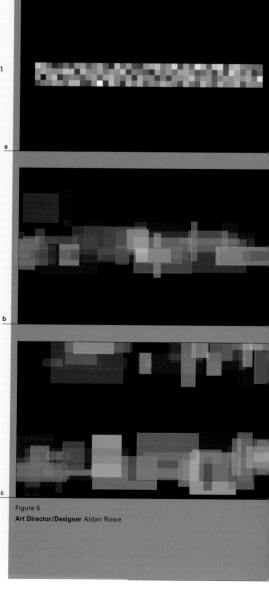

Figure 5
Art Director/Designer Aidan Rowe

Figure 5 (a–c) In additive color theory the hue black is created by a total absence of light. This can be likened to a black hole that stimulates a negative impulse interpreted by the mind's eye as black.

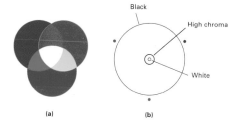

(a) (b)

Diagram 7 (a and b) The location of the three primary colors, red, green, and blue, for additive color theory (7b), and the secondary colors they create when added together in equal portions (7a).

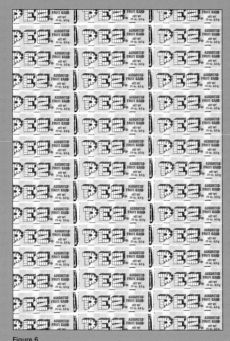

Figure 6
Art Director John T. Drew
Designer Iwao Hashimoto

Expanding
the Color Wheel

When most designers talk about tints
and shades, secondary, tertiary, primary,
complementary, split complementary,
or analogous color palettes, they think of
color as fixed. We tend to imagine color
possibilities through one color wheel. When
we talk about primary colors are we talking
about the traditional subtractive primaries
(cyan, magenta, yellow), the four-color
process primaries (cyan, magenta, yellow,
and black), Epson's six-color primaries
(dark cyan, light cyan, dark magenta, light
magenta, yellow, and black), the PANTONE
Hexachrome primaries (Hexachrome Yellow,
Hexachrome Orange, Hexachrome Magenta,
Hexachrome Cyan, Hexachrome Green, and
Hexachrome Black, and the color wheel they
create), or the PANTONE formula guide
primaries (PANTONE Yellow, PANTONE
Warm Red, PANTONE Rubine Red,
PANTONE Rhodamine Red, PANTONE
Purple, PANTONE Violet, PANTONE Reflex
Blue, PANTONE Process Blue, PANTONE
Green, PANTONE Black, and transparent
white), the additive color primaries (red,
green, and blue), or the opponent-process
theory primaries (blue, yellow, green, red,
white, and black)? Or are we talking about
something else, such as devising a color
wheel based on parent colors within a

photograph, or colors derived from the
psychological response of a client?
Color is light. It lives, it moves, and without
it nothing can grow. To view color in a static
form is to miss out on an infinite number of
color combinations, including color wheels
made of primary, secondary, tertiary,
complementary, split complementary,
analogous, harmonious, and achromatic
colors, as well as tints and shades.

All color wheels must have a starting
point. The color palettes for the examples
of professional work shown here are
demonstrated through a traditional
four-color process wheel. Each example
demonstrates how to derive other color
wheels and the color palettes they create,
based on the original work and the color's
psychological and/or learned behavioral
effects. For each example, the subsequent
color wheels and palettes use simple
subtractive mixing. While additive color
mixing is not used, its primaries are
used to create color wheels and their
palettes through simple subtractive mixing.
Since this book is in printed form, it is
impossible to demonstrate additive color
theory, as this requires the absorption, or
subtraction, of wavelengths.

Figure 6 The color swatches
for this Pez poster are listed
below in CMYK values;
diagram 8a indicates the
secondary/overprinting hues
created by the primary colors.
By interpreting color in this
manner, the color wheel can
be expanded to include
nontraditional colors. In other
words, the three primary
colors and the three secondary
colors create a six-step color
wheel. By adding hues created
by the primary and secondary
colors, tertiary colors that will
expand the steps within this
color wheel can be created.

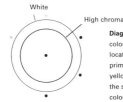

White

High chroma

Diagram 8 A nontraditional
color wheel depicting the
location of the four-color
primaries, cyan, magenta, and
yellow (used in figure 6), and
the secondary overprinting
colors they create.

	type C4	M2	Y16	K6
	bgd C3	M28	Y7	K0

6	type C3	M28	Y7	K0
	bgd C100	M94	Y1	K1

	type C0	M31	Y45	K0
	bgd C4	M2	Y16	K6

6	type C100	M94	Y1	K1
	bgd C0	M31	Y45	K0

BG	Background color	C0	M95	Y100	K0	80%

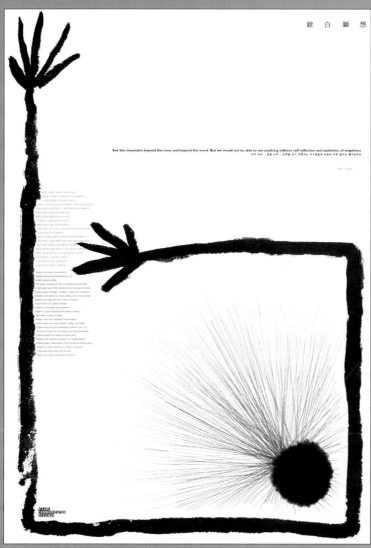

餘 白 斷 想

See the mountains beyond the trees and beyond the wood. But we would not be able to see anything without self-reflection and aesthetics of emptiness

Figure 7
Art Director/Designer Gi-Heun Suh

Figure 8
Art Director/Designer Akio Okumura

Figure 7 The hues found in this poster form the basis of the nontraditional color wheel in diagram 9.

White

High chroma

Diagram 9
The black, gray, and white tones found in figure 7, and their overprinting hue.

Figure 8 The hues found in this poster form the basis of the nontraditional color wheel in diagram 10.

White

High chroma

Diagram 10
The location of the three hues, orange, red, and green, found in figure 8, and the secondary overprinting colors they create.

7	type	C0	M0	Y0	K0	
	bgd	C30	M25	Y24	K99	
7	type	C30	M25	Y24	K99	
	bgd	C0	M0	Y0	K0	

8	type	C98	M32	Y83	K13	
	bgd	C0	M84	Y85	K0	
8	type	C0	M84	Y85	K0	
	bgd	C0	M31	Y95	K0	
8	type	C0	M31	Y95	K0	
	bgd	C98	M32	Y83	K13	

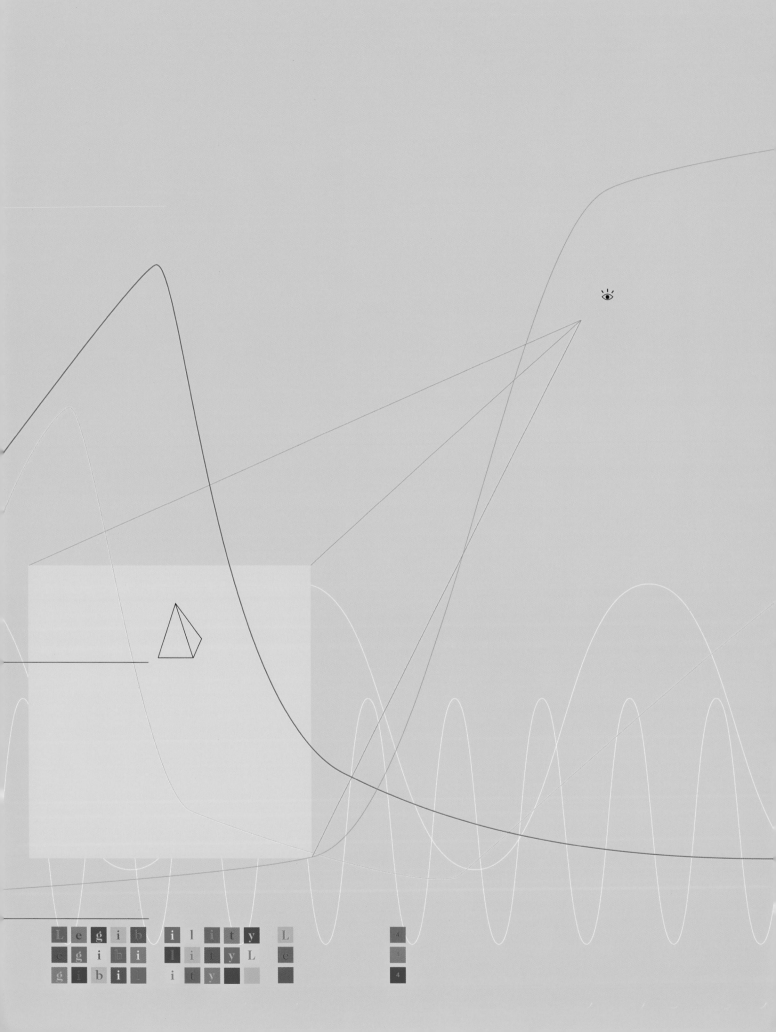

4 Color Legibility

The theory behind color legibility and the practical application
of color begins and ends with understanding color in 3-D form.
Within 3-D color theory are triadic relationships between the
source, the object, and the observer. To accurately predict color
legibility, these three components must be considered both
individually and in their totality. Each of these components
involves numerous factors. Understanding how to account for
naturally occurring situations or man-made environments will
enable you to ensure color appearance and legibility.

With additive color theory, the source changes with each
scenario depending on the intensity of light. Scientists have been
conducting experiments to discover what light is visible to humans
since the early 1700s. Through these endeavors, basic principles
governing the nature of lightwaves (color) have been revealed:
the intensity of light has a direct impact on the chroma and value
of color, and the wavelength of light has a direct bearing on color
appearance (hue). These factors help shape the way humans see
color, and affect color legibility.

In the past, designers were taught how to work with the object,
following subtractive color theory, for good reason. This theory
teaches us how to mix paint pigment, dyes, and colorants to create
an array of color. On the computer, using traditional software
applications, simple subtractive color mixing is simulated to
demonstrate how objects will appear when paint, dyes, or colorants
are applied. However, there is more to subtractive color theory than
just mixing paint. Pigments, dyes, and colorants possess no color;
the process of mixing paint involves altering which wavelengths are
absorbed, which are subtracted, and which are scattered by
manipulating the paint pigments. Changing the object's physicality,
whether it is apparent to the naked eye or not, alters the object's
appearance through its effect on the absorption, reflection, and
scattering of wavelengths.

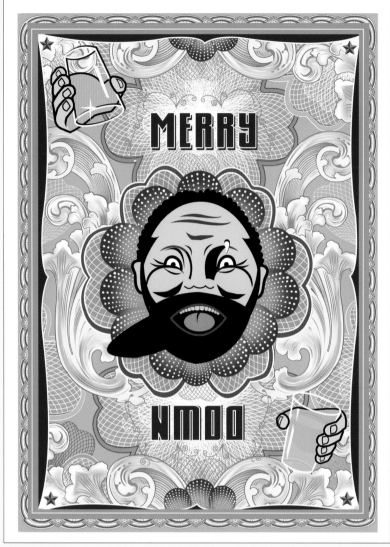

Figure 1
Creative Director David Dye
Typographers David Wakefield and Mike Pratley

Readability

Defining readability as opposed to legibility is not a simple task. The printed word is composed of symbols. For the observer to understand their meaning, visual perception, identification, and recognition are necessary. A word need not be legible to be identifiable—there need only be enough visible information for it to be recognized as a word picture.

Readability enables us to quickly understand, both visually and mentally, the complex codes and structures composing written and visual language. Written language has physical properties that help speed up the process of cognition, including: the position of letterforms on a page or screen; the structure of individual letterforms, regardless of font characteristic; and the total word structure, which creates its silhouette and internal patterns (i.e., the word picture).

Figure 1 Form/silhouette and position of image and type play an important role in cognition of message. In this example, "down" is inverted and typeset in capital letterforms to intentionally slow the reader. The illustration is designed so that a different message is communicated depending upon the position of the poster—right side up or inverted.

Diagrams 1–5 Position, color, size, spacing, and line length of type all play a role in its readability and legibility.

Diagram 1

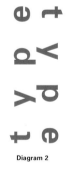

Diagram 2

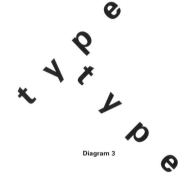

Diagram 3

Diagram 4 Type is **typographical** in nature. (9 pt.)

	type					type			
1	type	**C79**	M94	Y100 K0	1	type	**C49**	M1	Y36 K0
	bgd	**C49**	M1	Y36 K0		bgd	**C0**	M83	Y0 K0
1	type	**C0**	M83	Y0 K0	1	type	**C0**	M27	Y100 K0
	bgd	**C0**	M27	Y100 K0		bgd	**C72**	M0	Y0 K0
1	type	**C72**	M0	Y0 K0					
	bgd	**C0**	M0	Y0 K100					

BG	Background color	C24	M9	Y99	K1	30%

Position

The position of typographic forms on the printed page can either help the process of reading, or hinder it. The eye moves along the printed line in a procession of small, rapid jerks called fixation points. It is only at these points that the eye is in focus. Movement continues or regresses, depending upon the complexity of the information, and on its position. About 94 percent of the time spent reading is dedicated to these pauses. If there is a time limitation for viewing, it makes sense that, as designers, we understand how best to use position to reduce the time needed to recognize the intended message. The following points describe and illustrate factors that promote or impair readability.

- *Type aligned vertically is all but impossible for Westerners to read. This arrangement should be avoided for signage, for a Western audience, with a time limitation (diagram 1).*

- *Type that is positioned at a 90° angle is less readable in an upward than a downward direction (diagram 2).*

- *Type that is positioned at smaller angles, for example, 45°, is more readable in an upward direction than in a downward one (diagram 3).*

- *The optimum reading distance for type set in traditional book format (i.e., 8–12pt type) is around 12–14in (30.48–35.56cm). At this distance, the fovea is capable of focusing clearly on a space that is about four letterforms in length. With our peripheral vision, we can see about 12–15 letterforms at each fixation point (diagram 4).*

- *The optimum line length for 9–12pt type is 18–24 picas, which translates to 10–12 words per line. It is particularly helpful to know the number of words per line for exhibition design. This word count should be maintained for any viewing distance, with the appropriate adjustment made to the size of the type.*

- *For optimal results, leading should be 3pt, though if the line is longer than 24 picas, more leading seems to promote the readability of information. Difficulty in reading long lines of type is attributed to inaccuracies in relocating the next line. Difficulty with short lines (18 picas or shorter) is attributed to the eye's inability to utilize horizontal line cues, and therefore more leading is appropriate.*

- *The format of body copy has no effect on good readers, but many readers find justified type more difficult read.*

Figure 2
Art Director/Designer Linda Y. Henmi

Diagram 6 The body copy in this book has two additional points of leading to promote ease of reading. The body copy line length is shorter than the optimal, justifying the use of additional leading.

Diagram 7 In this example, the letterforms are tracked out equal to the stroke width, providing ample white space for viewing at a distance. If the letterforms are less than a stroke width apart, they will converge when viewed at a distance.

Figure 2 Here type is positioned at a 90° angle, reading from bottom to top, to intentionally slow the speed of reading. The artists' names and contact information for the event are placed on different axes to call attention to the information as well as keep the viewer's eye on the page for longer.

Diagram 5 Knowing the number of words per line is helpful for **exhibition design.**

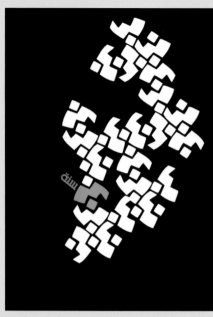

Figure 3
Art Director/Designer Halim Choueiry

- *In signage, generous white space (tracking) around individual letterforms or numbers aids in their recognition.*

- *Generous white space in a typographic treatment has always served to "activate" the page and increase the attention of the viewer. Filling the page with information creates a psychological aversion to the point where some individuals will not bother to read it.*

Structure of Individual Letterforms

The structure of individual letterforms has a significant impact on readability, as is well documented. This section concentrates on structural factors that enhance or contribute to the readability of the printed page. Letterforms fall into four major groups, based on their structure: vertical strokes, curved lines, both vertical strokes and curved lines, and oblique strokes. Some letterforms have a more dominant role than others in the readability of a word.

- *Words comprised of ascenders and descenders perform the most important role in the creation of a word picture.*

- *Letterforms with no ascenders or descenders provide few visual cues.*

- *In both capital and lowercase letterforms, the right half of the form provides greater cues for cognition than the left half (diagram 9).*

- *The upper halves of lowercase letterforms are more readable than the lower halves (diagram 10).*

- *With capital letterforms, the lower half of the form provides more cues for cognition than the upper half of the form (diagram 10).*

- *Uppercase letterforms have a distinct order of ranking for cognition. In 1930, the Council of British Opthalmologists advised that some letterforms are difficult to read, whereas other letterforms are easy. Numbers and capital letterforms have an inherent order of cognition and can be categorized into four groups:*

 - *easily recognized: A C J L D V O U 7 1 4;*
 - *intermediate: T P Z I G E F K N W R 6 2 3;*
 - *difficult: H M Y X S Q B 5 8 9; and*
 - *letterforms that can be confused with one another: C D G O Q H K M N W.*

Ascender

picture　　no cues　　56 56

Descender

Diagram 8 The ascender and descender in "picture" provide visual cues to ease the reading of the word, whereas "no cues" lacks a defined word picture. The spelling of the word or the design of the typeface can determine the amount of ascenders and descenders. For example, the Helvetica numerals above lack ascenders and descenders, making the number more difficult to read than when set in the old-style face to the right.

Diagram 9 The right half of a letterform is easier to recognize than the left half.

3	type	C0	M0	Y0	K100
	bgd	C0	M70	Y100	K0

3	type	C0	M0	Y0	K60
	bgd	C0	M0	Y0	K100

 Background color　　C0　　M70　Y100　K0　　30%

- *Copy set in all capital letterforms interferes with the speed of reading. In fact, using all capital letters decelerates the process of reading more than any other factor, by slowing the activity to a letter by letter process.*

- *Many researchers have found that italic letterforms reduce the speed of reading by up to 15 percent.*

- *Old-style numerals are more easily recognized than those of modern typefaces. This is because they are constructed with ascenders and descenders, which give the word picture identifiable cues for recognition.*

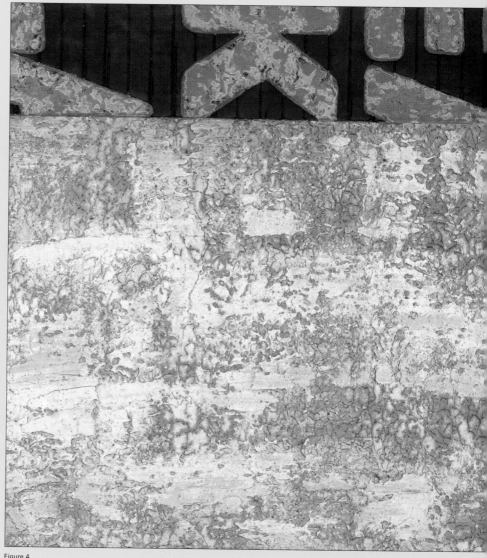

Figure 4
Illustrator Clinton MacKenzie

a

The format of body copy has no effect on good readers, but many readers find justified type more difficult to read.

b

The format of body copy has no effect on good readers, but many readers find justified type more difficult to read.

c

COPY SET IN ALL CAPITAL LETTERS DECELERATES THE PROCESS OF READING MORE THAN ANY OTHER FACTOR.

d

Italic letterforms reduce the speed of reading by up to 15 percent.

Figure 4 The textural quality of the letterforms is highlighted through cropping to the essential elements of the form. The K and E are clearly readable while the remaining letterforms are questionable, hinting at all of A, M, N, V, or W.

abcdefghijklmnopqrstuvwxyz

abcdefghijklmnopqrstuvwxyz

ABCDEFGHIJKLMNOPQRSTUVWXYZ

ABCDEFGHIJKLMNOPQRSTUVWXYZ

Diagram 10 The upper halves of lowercase letterforms provide more cues for cognition, but the reverse is true of capital letterforms.

Diagram 11 (a–d) Notice the effect the word picture and alignment have on readability in the above boxes. Diagram 11a shows optimal conditions. The justified type in 11b degrades readability through disproportionate kerning and equal line lengths. The irregular kerning destroys the word picture and the equal line length provides the reader few visual cues as to the start of the next line. Set in all caps, 11c eliminates the word picture and significantly hinders readability. Diagram 11d, in italics, also slows readability by distorting the letterform and manipulating the clarity of the word picture.

| 4 | type | C0 | M87 | Y89 | K0 |
| | bgd | C1 | M14 | Y63 | K0 |

| 4 | type | C78 | M36 | Y40 | K6 |
| | bgd | C0 | M87 | Y89 | K0 |

| 4 | type | C68 | M65 | Y61 | K59 |
| | bgd | C78 | M36 | Y40 | K6 |

| 4 | type | C1 | M14 | Y63 | K0 |
| | bgd | C68 | M65 | Y61 | K59 |

Figure 5
Art Director/Designer Sang-Soo Ahn

Word Pictures

A word picture is a combination of typographic forms having an external and internal pattern that is recognized by the reader at a glance. The reader need not see all parts of the letterforms within a word for the word to be recognized. The eye can recognize a word as fast as a single letterform, and with memorization, mature readers can familiarize themselves with the total characteristic shape of individual words. The following points will influence the readability of a design.

- *Longer words are more apt to be recognized at a glance than shorter ones because they provide more cues for the reader.*

- *The prefix and first half of a word provides more cues—or a better word picture—for recognition than the second half does. Words to the right of the fixation point furnish meaningful cues for perception and further fixations.*

- *Words that are set in headline type, with upper- and lowercase letterforms, retain their word pictures and are therefore easy to read.*

- *Under normal reading conditions, reversing black letterforms on a white background to white letterforms on a black background will decelerate the process of reading by up to 14.7 percent. This is caused by a loss of word pictures.*

- *With any one of the factors mentioned above, adding color that is preconceived as abnormal will decrease the speed at which the letterform, word, line of text, paragraph, column, or document is read by up to 14.7 percent. However, this may be a desirable effect.*

Figure 5 (a and b) The posters above use stacked type and word pictures to slow or speed up the readability in relation to the viewing distance. In this way the type activates the composition and attracts the eye to more complex details of information as the viewer approaches the space.

Diagram 12 In the example above, the word is easily recognized by its identifiable prefix. The suffix increases the amount of visual cues and provides grammatical context, but is indistinguishable from many other words.

Diagram 13 As exemplified above, words set in all lowercase are easily read due to their identifiable word picture. A word set in upper- and lowercase will retain its word picture to some degree, but a word set in all uppercase will completely disintegrate the word picture.

| 5 | type **C71** **M71** **Y85** **K40** bgd **C11** **M26** **Y91** **K0** | 5 | type **C76** **M75** **Y53** **K51** bgd **C9** **M69** **Y100** **K0** | BG | Background color | **C11** **M26** **Y91** **K0** 50% |

| 5 | type **C9** **M69** **Y100** **K0** bgd **C76** **M75** **Y53** **K51** |
| 5 | type **C11** **M26** **Y91** **K0** bgd **C71** **M71** **Y85** **K40** |

Legibility

Now that we have delineated some of the factors that help or hinder reading, we can turn to those that contribute to legibility. These include visual clarity of printed words, letters, numerals, and simple symbols as defined by the scientific standardization of visual acuity. There is a considerable difference between readability and legibility. Readability is concerned with the speed of reading, whereas legibility is more concerned with visual clarity. We have already stated that in order for something to be readable, only enough information need be visible for it to be recognized as a word picture. In order for something to be legible, errors of communication must be avoided. Some letterforms and numerals are more apt to be misread than others. This is of great importance to us as designers in the creation of signage systems. Your first concern should be with legibility and clarity of communication. You do not have to look far to find signage that does not serve the purpose for which it was intended.

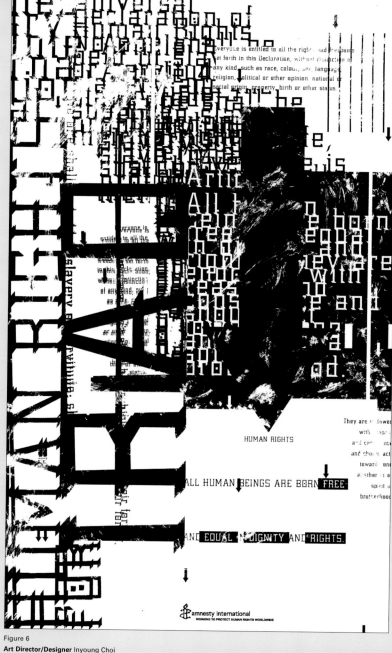

Figure 6
Art Director/Designer Inyoung Choi

Black letterforms on a white background produce the usual speed of reading, and set the standard by which all other deviations are measured.

White letterforms on a black background will decelerate the process of reading by up to 14.7 percent.

Adding color that is preconceived as abnormal will decrease the speed at which the letterform, word, line of text, paragraph, column, or document is read.

Diagram 14 The type set in the boxes above illustrates the effect that type and background color can have on readability.

Figure 6 Legibility and readability are pushed to the extreme. Words come in and out of clarity creating a jarring effect that gives visual representation to the desecration of human rights.

readability

legibility

legibility

legibility

Diagram 15 Readability defines that a word, such as that above, can be read even though every part of the letterform is not revealed. Legibility defines that every element of the word must be distinguishable in the prescribed usage. In this case, each variation of "legibility" is completely legible for the viewing distance of a book.

6	type C0	M0	Y0	K95
	bgd C0	M0	Y0	K0
6	type C0	M0	Y0	K0
	bgd C0	M0	Y0	K90
6	type C0	M0	Y0	K0
	bgd C0	M0	Y0	K95

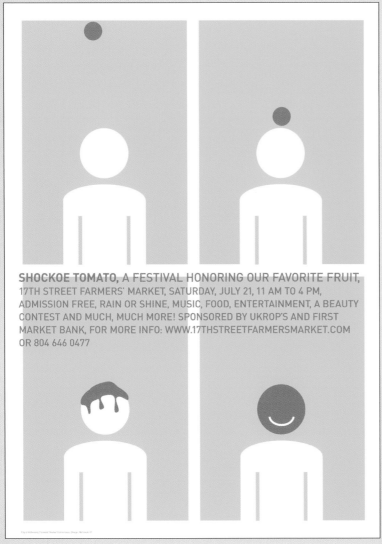

SHOCKOE TOMATO, A FESTIVAL HONORING OUR FAVORITE FRUIT, 17TH STREET FARMERS' MARKET, SATURDAY, JULY 21, 11 AM TO 4 PM, ADMISSION FREE, RAIN OR SHINE, MUSIC, FOOD, ENTERTAINMENT, A BEAUTY CONTEST AND MUCH, MUCH MORE! SPONSORED BY UKROP'S AND FIRST MARKET BANK, FOR MORE INFO: WWW.17THSTREETFARMERSMARKET.COM OR 804 646 0477

Figure 7
Illustrator/Designer John Malinoski

There is a formula for determining the distance at which a letterform is legible: for every 1in (2.54cm) of letterform height add 42in (1.28m) of viewing distance. This formula is accurate for typefaces that are monoweight, with a width of line similar to that of the typeface Helvetica 75. Most typefaces, however, have a wide ratio of thick to thin strokes, making this formula too broad to accurately predict the visual outcome.

Scientific Standardization of Visual Acuity

Dr. Herman Snellen, M.D., a professor of ophthalmology at the University of Utrecht, developed the scientific standardization of visual acuity in 1862. This standard remains the basis for all visual testing in the medical field today.

In Snellen's development of letterforms, it was necessary to contain the shape within a square matrix five times the thickness of the width of the letterform itself. The formula allows for a visual angle of 5° on the surface of the retina wall when the letterforms are placed at the proper distance. The visual angle of 5° is the proper angle for standard 20/20 vision. If the angle decreases or increases by moving the object in space, the object is no longer presented at the proper distance for standard 20/20 vision.

Figure 7 The clarity of the typography in this poster reiterates the highly graphic language of the imagery. Neither type nor image is sacrificed to create impact. From a distance the piece is legible and easily accessible.

Diagram 16 Dr. Snellen's letterforms are comprised of a square matrix in which the width and height of the letterform is five times the thickness of the stroke and counterform. The stoke of the letterform is 1° and the entire letterform is 5° of visual angle on the retinal wall at a predefined distance. In this way, Dr. Snellen's letterforms are used to establish standardized eyesight.

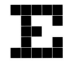
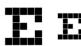

The image on the retina wall becomes either too small to be seen or it becomes larger on the retina wall and, therefore, easier to see.

The density of the photoreceptor cell matrix within humans governs the visual acuity test. Two visually stimulated cells within the matrix must be separated by one unstimulated cell to create an electrical impulse that represents an object. Diagram 16 depicts Snellen's monoweight typeface as viewed at different distances.

The time needed to recognize an individual letterform is less than a fraction of a second, if the letterform is clear and sharp. If we have 20/20 vision, recognition of the first letterform within the line of type occurs almost instantaneously. The process of recognition occurs letter by letter, in rapid succession, until we reach the point at which legibility is hard to define and readability begins to take over.

The receptor cell matrix, or simple matrix, is one of three matrices found within the eye (the other two being the complex and hypercomplex matrices). The simple matrix works by a system similar to a string of binary numbers: on-off-on, or stimulated-unstimulated-stimulated. At a minimum, a wavelength needs to cross over three cells of the simple matrix in the specific order

of stimulated, unstimulated, stimulated, in order to register as an object seen by the mind's eye.

Snellen's letterforms were created mathematically so that the entire form operates at the same visual angle. The font is a perfect monoweight typeface, with its counter and positive shapes equal in size. This allows for the rate of convergence at a distance to be equal as well. For example, if we view Snellen's typeface at distances

further than that used for testing 20/20 vision, at each distance, the counter and positive shapes move closer to one another until the form converges on itself. The typeface is designed so that when viewed at any distance, the size of the counterforms is the same as the width of the lines composing the letterforms.

Figure 8
Studio Underware
Art Director/Designer Bas Jacobs

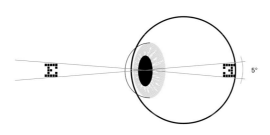

Diagram 17 If the letterform is increased or the viewing distance decreased, more than 5° of the retina wall will be covered and the legibility will increase. Likewise, if the letterform is decreased or the distance of the letterform is increased, less than 5° of the retina wall will be covered and the legibility will decrease. If the observer does not have 20/20 vision, the visual angle will increase or decrease as though the scale and distance of the letterform has been increased or decreased.

Figure 8 This spread from a book created in a typography workshop explores the limits of visual acuity through size, cropping, and zoning. The optimum reading distance for type set in traditional book format (i.e., 9–12pt type) is, on average, 12–14in (30–35mm). In this case, the violation of optimum readability and legibility reinforces the hierarchy, navigating the viewer through complex layers of information, and thus, activating the page and holding the reader's interest.

8	type	**C**38	**M**81	**Y**75	**K**47
	bgd	**C**2	**M**2	**Y**3	**K**0
8	type	**C**2	**M**2	**Y**3	**K**0
	bgd	**C**93	**M**50	**Y**73	**K**60
8	type	**C**93	**M**50	**Y**73	**K**60
	bgd	**C**38	**M**81	**Y**75	**K**47

In condensed typefaces, convergence usually occurs with the countershapes of the letterforms whereas, with other types of fonts, it occurs at the thinnest part of the line composing the letterform, which converges to the color of the background. Most type designers vary both the thickness of the lines composing the letterforms and the sizes of the countershapes. Thus, convergence occurs in different areas at different rates with most typefaces, and therefore, typefaces have more than one visual angle when presented at a distance. For most typefaces, the possibilities for convergence are numerous. Like human fingerprints, each font is unique, having certain characteristics that make up its structure. Some letterforms are inherently more visible than others if they are of equal size. By using the system described in Acuity 1.0, we can quantify typographic forms and determine the outcome for viewing distance, allowing designers greater flexibility.

The following factors affect legibility:

- *Kerning letters tighter than the width of the line composing the typeface will result in a decrease in the distance at which the letterforms can be deciphered. In this case, the word or words become one long ligature, decreasing legibility and readability.*

- *The thin part or countershape of a letterform, numeral, or font determines its visual clarity as it is the weakest part for viewing at a distance.*

- *The optimum legibility of type in relationship to distance will occur when letterforms are of a consistent width. A medium-to-bold extended letterform should be used so that the line width will be one-fifth the size of the letter squared, to allow for ample counterspace. This is mathematically correct if all typefaces are of the same letter height.*

Figure 9
Studio Thonik

Figure 9 (a and b) This book makes use of discrete changes in font to increase hierarchy while maintaining optimal legibility and increasing the overall readability.

optimal
tight kerning

Stroke width

Diagram 18 For optimal legibility, the kerning of a word should not be less than the stroke width of the letterform. Tight kerning will decrease the legibility of a word viewed at a distance.

Diagram 19 Not all letterforms are equally legible. The legibility of a letterform is hindered by different factors for each face. For example, the counterform in this condensed typeface will appear to converge to black at a distance, while the thins of this Old Style typeface will converge to white at a distance. In addition, different letterforms at the same point size have significantly different proportions. For instance, in this case, both "g's" are set in 163 points.

Contrast

Myths about color contrast have persisted in the arts and within subtractive color theory for some time. These myths pertain to the perceived color differential between, for example, a color presented to the viewer from 100 percent of color to 0 percent of color in 10° increments, or two different colors, side-by-side, presented for viewing. In either case, color contrast does not exist, only the color value rating, or to be more accurate, the Y tristimulus values and their corresponding differential numbers. Color contrast is determined by form/silhouette, motion, depth, and color. In order to obtain color legibility, these factors must be clearly defined. Diagram 20 illustrates how an individual would see the world if color perception were the only factor that he or she had to determine color contrast. Without form/silhouette, motion, and/or depth, objects are unrecognizable and there tends to be a multitude of colors varying in hue, value, chroma, and shade, with no clear distinction of form. Simply put, any discussion of color contrast must include all the factors that determine it.

Figure 10

Art Director/Designer/Illustrator Lanny Sommese

Diagram 20 (a and b) Under normal conditions the black type can be easily determined due to the distinguishable color contrast including form/silhouette. However, if color perception or the y tristimulus value were the only method of determining color contrast, the type would appear to be a hazy field of color.

Figure 10 This poster shows an excellent use of color contrast through form/silhouette and color perception. The silhouette of the tree creates an illusionary form in which other objects can be seen, and the complementary colors, red and green, create the strobing effect through pronounced simultaneous contrast. (The gradation is achieved through an ink fountain.) Color contrast, in its purest definition, heightens dimensionality.

		C	M	Y	K
10	type	C18	M74	Y92	K6
	bgd	C74	M13	Y52	K1
10	type	C74	M13	Y52	K1
	bgd	C75	M68	Y67	K90
10	type	C75	M68	Y67	K90
	bgd	C18	M74	Y92	K6

Figure 11
Studio Pentagram
Partner/Art Director Angus Hyland

Form/Silhouette

Humans have the ability to use and determine readability and legibility. However, readability is universally and culturally defined—most of this interpretive function takes place in the mind. As a viewer matures, recognition quickens even though the object is not seen in its totality. This is due to the storage bank of imagery a mature viewer has built up. Legibility deals with visual clarity, with how well the visual pathway detects, in this case, form/silhouette. This function of human perception is attributed to the simple matrix field located at the end of the visual pathway. It is responsible for detecting properly oriented moving slits, edges, and dark bars. The simple matrix field receives binocular input from both eyes.

When dealing with type and color combinations, clarity of form/silhouette is just as important as any of the other three factors determining color contrast. When discussing viewing color and type at a distance, several rules of thumb have been devised, some more accurate than others. Three published rules apply to viewing type and color combinations at a distance. However, two of these rules are grossly inaccurate.

Figure 11 The application of the type has impact and it is easily readable in a wide variety of applications—on stationary signage, moving uniform graphics, and package design.

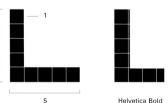

Helvetica Bold

Diagram 21 This example shows the optimal legibility in Dr. Snellen's "E" and its prescribed relationship to the Americans with Disabilities Act. Dr. Snellen's "E" falls within this law, while the Helvetica Bold "L" narrowly misses the constraints of the mandate. In addition, as we have seen previously, the counterform has significant impact on the legibility of a letterform. The Americans with Disabilities Act does not take into account the width of the counterform, as exemplified in the "M."

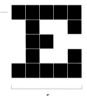 type **C20 M45 Y80 K0**
bgd **C75 M75 Y85 K0**

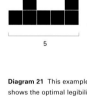 type **C75 M75 Y85 K0**
bgd **C20 M45 Y80 K0**

 type **C0 M0 Y0 K0**
bgd **C75 M75 Y85 K0**

 type **C0 M0 Y0 K0**
bgd **C20 M45 Y80 K0**

BG Background color **C20 M45 Y80 K0 20%**

The first rule of thumb—for every 1in (2.54cm) of letter height add 42in (1.28m) of viewing distance—is inaccurate for several reasons, the first of which is the assumption that form/silhouette is the only factor that determines type and color legibility at a distance. It does not take into account the factors that determine the source, the object, and the viewer, nor does it factor in motion, depth, and color. Without having a full understanding of these factors and how they fit a particular scenario, accurate type and color prediction for viewing at a distance is impossible.

United States federal law, via the Americans with Disabilities Act of 1990 and subsequent amendments, mandates the second rule: "Letters and numbers on signs shall have a width-to-height ratio between 3:5 and 1:1 and a stroke width-to-height ratio between 1:5 and 1:10." However, just because the rule is law does not mean it is effective. The law is based on several assumptions/decisions that were made regarding color contrast and form/silhouette that are unsound. The most damaging of these is the width-to-height ratio and the stroke width-to-height ratio. When we apply these ratios to a site, some configurations will work better than others, and illegible type and color configurations will emerge. In the case of the width-to-height ratio, the

document fails to specify from what part of the typographic anatomy the measurement should be taken (arm, stem, terminal, stroke, shoulder, tail, ascender, leg, eye, spine, hairline, crossbar, fillet, apex, bowl, ear, link, descender, loop, serif, counter, spur, etc.). The importance of specifying a designated location within the font anatomy is twofold. First, the location assures that the visual angle of 20/200 vision (legally blind) is guaranteed, thereby producing the proper density within the photoreceptor cell matrix. Second, density is produced through both size and mass. In order to achieve 20/200 vision, the visual angle must be displayed at the proper size on the retina wall, thereby creating enough density for the object to be seen at the specified eyesight.

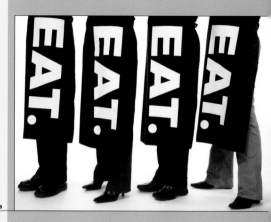

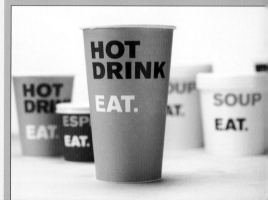

b

Figure 12
Studio Pentagram
Partner/Art Director Angus Hyland

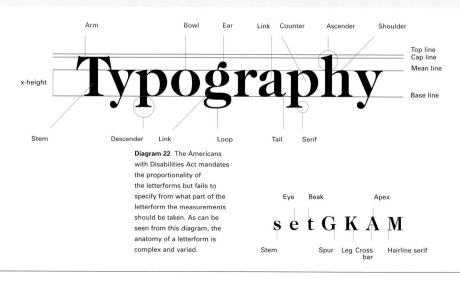

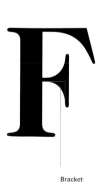

Diagram 22 labels: Arm, Bowl, Ear, Link, Counter, Ascender, Shoulder, Top line, Cap line, Mean line, Base line, x-height, Stem, Descender, Link, Loop, Tail, Serif

Typography

setGKAM labels: Eye, Beak, Apex, Stem, Spur, Leg, Cross bar, Hairline serif

Diagram 22 The Americans with Disabilities Act mandates the proportionality of the letterforms but fails to specify from what part of the letterform the measurements should be taken. As can be seen from this diagram, the anatomy of a letterform is complex and varied.

F

Bracket

Figure 12 (a and b) This work uses generous white space to activate the audience's eye and increase legibility.

	type					type			
12	type C0	M0	Y0	K0	12	type C20	M45	Y80	K0
	bgd C0	M0	Y0	K100		bgd C75	M75	Y85	K0
12	type C75	M75	Y85	K0					
	bgd C20	M45	Y80	K0					
12	type C10	M70	Y100	K0					
	bgd C0	M0	Y0	K0					

Summer visits to the Type Museum. typemuseum.org

Figure 13
Art Director/Designer/Illustrator Paul Belford

The width-to-height ratio between 3:5 and 1:1 is too broad in some respects and too narrow in others. The premise of the width-to-height ratio and the stroke width-to-height ratio is flawed. Snellen's standardized eye chart is the basis for all visual form sense testing worldwide. In this, the width of the lines comprising the letterform "E" is five times squared (1:1). This produces the correct visual angle when presented at the proper distance for both 20/20 and 20/200 vision (legally blind). In fact, when presented at the proper distance, the 1:1 ratio produces the correct visual angle and density for all standardized visions. Use of the 3:5 ratio or anything in between 3:5 and 1:1 will produce an inferior angle, thus reducing the size and density of the image when displayed on the retina wall and interpreted by the photoreceptor cell matrix. In other words, when letterforms from different fonts that meet the current standard are presented at 3in (7.62cm) letter height, they will all have different visual distances at which someone possessing 20/20 or 20/200 vision can see them. Some of the fonts will vary little in distance whereas others will vary drastically.

The stroke width-to-height ratio between 1:5 and 1:1 allows for condensed letterforms to be used for the purpose of signs and signage systems. Because of the way in

Figures 13–15 These three posters utilize a wide variety of letterforms to signify conceptual elements. In this case, the type is primarily defined as image. Although in most cases the letterforms are legible, the viewer does not automatically read the elements until context is given through the tag line of the poster.

3:5

3.75:5.2
Helvetica Bold

5:5
Snellen

Diagram 23 In order for the Helvetica Bold "E" to meet the strict definition of the Americans with Disabilities Act it would have to appear more uniform—like the "E" to the left.

| 13 | type | **C61** | **M0** | **Y0** | **K0** |
| | bgd | **C0** | **M0** | **Y0** | **K0** |

| 13 | type | **C0** | **M0** | **Y0** | **K0** |
| | bgd | **C61** | **M0** | **Y0** | **K0** |

| 13 | type | **C40** | **M0** | **Y70** | **K0** |
| | bgd | **C0** | **M97** | **Y95** | **K0** |

| 13 | type | **C0** | **M97** | **Y95** | **K0** |
| | bgd | **C40** | **M0** | **Y70** | **K0** |

| **BG** | Background color | **C40** | **M0** | **Y70** | **K0** | 50% |

which the Americans with Disabilities Act is written, some condensed fonts that meet the requirements will converge before the specified distance. In other words, the anatomy of these fonts and their countershapes will collide before the proper distance is achieved, thereby making legibility and readability impossible. If condensed letterforms are to be used, the measurement should not be taken from the stroke width but from the smallest counterform within the font: this part of the typographic anatomy is the weakest for viewing at a distance. With the majority of condensed letterforms, the counterforms are narrower than the stroke. The 1:5 ratio is in keeping with Snellen's visual form sense testing, but the 1:1 ratio creates an inferior angle for the object to be displayed on the retina wall.

The third published guideline for visual acuity can be found in the Acuity 1.0 CD. For this guideline, specific typographic anatomy within each font specified was measured under 7° magnification in order to ensure that the visual angle for all standardized eyesight, including 20/200 vision, would be met. In doing so, the proper density within the photoreceptor cell matrix is assured. Other mathematical equations were used in order to make the proper translation of Snellen's visual form sense

testing to incorporate the form/silhouette component of the complex receptor field matrix and the other factors that define color contrast (motion, depth, and color).

Figure 15
Art Director/Designer/Illustrator Paul Belford

Figure 14
Art Director/Designer/Illustrator Paul Belford

Diagram 24 The above "Ms" are set in 28pt and show the variety of stroke width-to-height ratios that occur in diverse typefaces.

	type	C11	M0	Y6	K56
14	bgd	C0	M0	Y0	K0

	type	C0	M0	Y0	K0
14	bgd	C11	M0	Y6	K56

	type	C0	M78	Y93	K0
14	bgd	C0	M0	Y100	K18

	type	C0	M0	Y100	K18
14	bgd	C0	M78	Y93	K0

	type	C93	M0	Y97	K0
15	bgd	C0	M0	Y0	K0

	type	C0	M0	Y0	K0
15	bgd	C93	M0	Y97	K0

**Dali Universe Film Festival
Trafalgar Square, London
July 2003**

dalifilmfest.com

**Facilitating a platform for
unprecedented excellence**

Figure 16
Studio Sauce
Creative Director Adam Softley

Figure 16 This broadside makes use of foreshortening, minimal foreground details, and two-point perspective to increase the sense of motion in the graphic elements. This effect conceptually links the content of a film festival to the context of a stationary broadside. In contrast, the important typographic information is made readable through the use of a bold typeface. This choice of font would be appropriate for viewers moving at speeds from walking pace to approximately 15mph (25k/h).

Diagram 25 The mind's eye detects oriented moving slits, edges, and dark bars. Visual perception and legibility deals with visual clarity, and how well the visual pathway detects this form/silhouette.

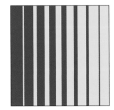

| 16 | type | C10 | M47 | Y76 | K4 |
| | bgd | C22 | M93 | Y93 | K16 |

| 16 | type | C22 | M93 | Y93 | K16 |
| | bgd | C10 | M47 | Y76 | K4 |

| 16 | type | C17 | M7 | Y31 | K0 |
| | bgd | C24 | M90 | Y93 | K55 |

| 16 | type | C24 | M90 | Y93 | K55 |
| | bgd | C17 | M7 | Y31 | K0 |

| BG | Background color | C0 | M19 | Y100 | K0 | 70% |

Motion

All three of the photoreceptor fields—simple, complex, and hypercomplex—respond to moving stimuli. (See Chapter 2, How the Eye Works.)

When dealing with type and color combinations in static form, as in a sign, simple and hypercomplex photoreceptor fields do not play an important role in color legibility. However, when motion graphics is applied, they play a crucial role. Motion is one of the most effective forms of visual communication. The human eye naturally gravitates toward anything that is moving, most particularly objects moving in a distinct orientation and pattern. Objects that move in a seemingly random order do not hold the viewer's attention. This is due to the way in which the receptor fields physically operate. These photoreceptor cell matrices are a product of evolution. The development of a receptor field that detects random movement was not necessary in daily life.

Reaction time must be accounted for when dealing with objects that are static and a viewer who is in motion. The motion factors detailed here deal with ensuring that messages are decipherable to a motorist traveling at standard speeds of 15–55+mph (25–90+km/h). Although the information

deals with fixed messages perceived by the eyes of a moving motorist, the research could be applicable to messages intended to move on a screen and be perceived by a fixed human being.

In the field of architecture and design, there is a standard rule of thumb for environmental signage created to be seen by motorists: 3in (7.62cm) of letter height for every 100ft (3m) of viewing distance. This formula is a crude attempt to account for the factors involved in motorized travel. The process of deciphering messages takes time, and when time limits are placed on viewing an object, as is the case with billboards, details evaporate. The visual acuteness of the viewer, the placement of the object, and the pattern it forms in motion or static representation have a direct bearing on color legibility. This statement only hints at the complexity encountered when motion enters the equation.

a

b

c

Figure 17
Studio Concrete Pictures
Creative Director Matt Hall

Diagram 26 In the natural environment the slits can consist of the whole gamma of color. However, in motion graphics the slits are primarily comprised of the additive color gamma attributed to red, green, and blue. Pure red type on a split complementary or near split complementary will strobe, due not only to simultaneous contrast, but also to the eye's inability to keep pace with slits and edges.

Figure 17 (a–c) Spacious kerning increases the readability of type in motion. Sequencing will increase recognition where tight kerning is utilized. For example, this motion-graphics piece builds the letterforms one by one, from the outside inward, forcing the viewer to build the word letter by letter.

17	type	C1	M75	Y94	K0	
	bgd	C0	M19	Y100	K0	

17	type	C2	M2	Y11	K0
	bgd	C39	M41	Y93	K49

17	type	C0	M19	Y100	K0
	bgd	C1	M75	Y94	K0

17	type	C39	M41	Y93	K49
	bgd	C2	M2	Y11	K0

Figure 18
Studio Redcow Creative Consultancy
Creative Directors Graham Ogilivie and Adam Softley

Time Limits

The process of reading takes time. The more information we have to comprehend, the longer it takes. This is one reason we have posted speed limits. The more information to perceive, the slower the posted speed limit. A Baltimore County study seems to confirm existing research which reveals that, on average, a motorist can perceive only 7–10 items. Mandelker and Ewald (authors of *Street Graphics and the Law*) define an item as an initial, abbreviation, phone number, address number, or more than one geometrical shape, syllable, symbol, logo mark, or logotype. Long proper names should be counted as four items. A sign containing a word with more than one syllable should not include more than six other items.

The limited number of items is related to our inability to store large amounts of details in our short-term memory. In a limited amount of time we can decode and store in long-term memory only limited amounts of information. Moments of stress further impede this process. Formally, these items must also fit within the constraints of a 2° standard observer. Therefore, the length of each designed item is critical. The process of perception is both a mental and a physical endeavor.

Figure 18 This poster should be viewed at walking speed but utilizes the perceptual effects of greater speed to increase the sense of motion inherent in interactive design. For instance, notice that the peripheral vision is foreshortened by the blurring of type and image outside the main area of focus. In addition, as when viewing an object at high speed, approximately 12 letterforms can be clearly seen at each fixation point, and the words on the right half of the poster appear to be slightly more readable than those on the left.

Diagram 27 With our peripheral vision, we can see about 12–15 letterforms at each fixation point while standing still. Our peripheral vision decreases as speed increases. In addition, as the eye scans forward, words to the right of the fixation point furnish meaningful cues for perception and further fixations, and words to the left fade from view. This, in combination with the fact that, on average, a motorist can perceive only 7–10 items, must be considered when designing for motion.

 point furnish mean**ingful clues for perception and further fixations.**

Diagram 28 As driving speed increases, foreground details begin to fade and the clear silhouettes of letterforms diminish. Because of this, elaborate detail in highway signage is meaningless.

Reaction Time

Reaction times, which are relative to the speed of a motorist, are based in part on the number of items contained in a graphic or sign. Information first presented in *Human Limitations in Automobile Driving*, Hamilton and Thurstone, is summarized in *Man-made America: Chaos or Control*, Tunnard and Pushkarev, and abstracted in *Street Graphics and the Law*, Mandelker and Ewald. This valuable information bears reiteration. (All quotes from Mandelker and Ewald, *Street Graphics and the Law*, 1988.)

1. "As driving speed increases, the driver's concentration increases."

2. "As driving speed increases, the driver's point of concentration recedes. His or her eyes feel their way ahead of the wheels. At 25mph (40k/h), their natural focusing point lies approximately 600ft (180m) ahead of the car; at 45mph (70k/h), it lies some 1,200ft (365m) ahead of the car."

3. "As driving speed increases, the driver's peripheral vision decreases."

4. "As driving speed increases, foreground details begin to fade. At 40mph (65k/h), the closest point of clear vision lies about 80ft (25m) ahead of the car. At 60mph (100k/h), the driver can see clearly only that detail which lies within an area 110–1,400ft (35–430m) ahead of the car and within an angle of 40°. Since at that speed the distance between 110 and 1,400ft (35 and 430m) is traveled in less than 15 seconds, it follows that elaborate detail in highway graphics is totally meaningless."

5. "As driving speed increases, the driver's perception of space and speed deteriorates, and his or her judgment becomes more dependent on visual clues picked up along the highway."

Diagram 29 illustrates the decrease of peripheral vision at speeds from 30–60mph (50–100k/h).

Figure 19
Illustrator/Designer Leny C. Evangelista

60mph (100k/h)

45mph (70k/h)

30mph (50k/h)

Diagram 29 Left: As the speed of the viewer increases, the peripheral vision decreases and the need for additional distance and thereby time to view the object increases. For example, a person moving at 60mph (100k/h) will need signage to be legible at a greater distance than a person moving at 30mph (50k/h). In addition, the peripheral vision of a person moving at 60mph (100k/h) will be approximately half that of a person moving at 30mph (50k/h).

Figure 19 This visual representation of information overload makes use of the sensory deprecation experienced in motion. For example, not all of the type is readable and only 7–10 items per line are in the foreground at one time. Increased concentration is necessary to decipher all the information, while the perception of space and peripheral vision deteriorates.

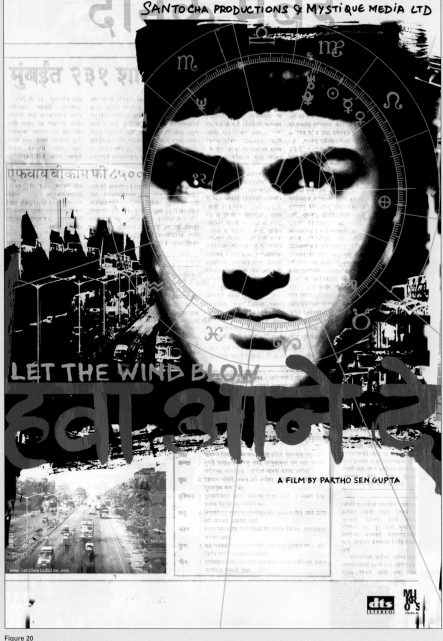

Figure 20
Studio RGD, Mumbai + India
Art Director/Designer Rabia Gupta

It is safe to say that the more information in an area, the more reaction time the driver will need. For example, if we are driving down a city block that has numerous signs and pedestrians, the competition for our attention becomes so great that it is impossible to decipher all that is around us. Therefore, we must design the message so that it emerges from the sea of signage to be clearly legible. How large must a sign be to be legible while the viewer is in motion? This depends on the speed of travel, the visual acuteness of the viewer, the reaction time of the viewer, and the amount of illumination.

Through research and field testing, Mandelker and Ewald have devised a method for determining the reaction times needed, taking into account driving speeds, surroundings, and number of lanes. To compile the reaction times, the researchers took into consideration how long the driver took to see the sign, read it, and respond to it.

With the data on motion provided by Mandelker and Ewald, we can compute the required size and color of a message intended to be seen by a motorist traveling at a certain speed. For example, if we intend to create a sign to a corporate complex for a two-lane entry and exit road, with a posted

Figure 20 The intensity of the eyes in this poster attracts the viewer's attention, thereby effectively competing with other signage in the environment. Large-scale, minimal type succinctly communicates the message.

Diagram 30 Table listing the number of lanes, speed of travel, reaction time needed, and the distance traveled during reaction time.

Type of lane	Speed		Reaction time (seconds)	Distance traveled	
2	15–25mph	(25–40k/h)	8	234ft	(71m)
2	30–40mph	(50–65k/h)	8	410ft	(125m)
2	45–55mph	(70–90k/h)	8	586ft	(178m)
4	15–25mph	(25–40k/h)	10	293ft	(90m)
4	30–40mph	(50–65k/h)	10	510ft	(155m)
4	45–55mph	(70–90k/h)	10	733ft	(223m)
6	5–25mph	(25–40k/h)	11	322ft	(98m)
6	30–40mph	(50–65k/h)	11	564ft	(172m)
6	45–55mph	(70–90k/h)	11	806ft	(246m)
Expressway	50–55+mph	(80–90k/h)	12	1,056ft	(322m)

These data take into account the surroundings, including commercial/industrial or institutional/residential/rural surroundings.

20	type C4 M2 Y6 K6
	bgd C61 M46 Y56 K100

20	type C9 M94 Y100 K10
	bgd C4 M2 Y6 K6

20	type C61 M46 Y56 K100
	bgd C9 M94 Y100 K10

BG Background color C49 M27 Y27 K0 30%

speed limit of 15mph (25k/h), the sign must
be legible on average, for standard 20/20
vision, at 234ft (71m). Referring to Acuity
1.0, we see that, for example, Futura Heavy
capital letterforms in a point size of 502
can be seen at a distance of 259ft (79m) in
a color combination of black and white. If
we add colors other than black and white,
we must specify the coated PANTONE
colors in Acuity 1.0. For example, to use
PANTONE 072 C for letterforms on a white
background, we would enter the distance in
feet (259), for the capital letterforms set in
502pt, by the color value number of the
PANTONE spot color 072 C (.9264) to get
240ft (73m). This color combination allows
6ft (1.8m) more than needed.

While this distance may seem excessive,
a great deal of research on signage for
motorists has been done over the past 50
years, the results of which confirm these
reaction times. You must remember,
however, that each situation is unique; the
dimensions of a particular site must also be
considered. Obviously, if a signage system
for motorists was to be installed in a parking
lot that had a viewing distance of only
100–50ft (30–15m), modifications would be
called for. A traveling speed of 15mph
(25k/h) may be excessive for this particular
circumstance, and in a situation such as
this, field testing would be of value. For

example, if you found that 7.5mph (12k/h)
was the average speed of a car in this lot,
you would then divide the distance and/or
reaction time in half. This would give you
the new distance of 117ft (36m), a more
reasonable figure for the size of the lot.

Figure 22
Art Director Hiroyuki Ueno
Designers Hiroyuki Ueno and Mayumi Izumino
Illustrator Taimei Hori

Figure 21
Art Director/Designer Paul Middlebrook

Figure 21 When designing
for T-shirts, the aspect of
motion is rarely considered.
However, to legibly
communicate information at
walking speed, the graphics
must be bold and concise.

Figure 22 Complexity can
be utilized to slow down
the viewer. This poster uses
a highly detailed image and
the eyes of the geisha to
engage the audience from a
distance, and draw them in.
As the viewer approaches,
more typographic details
come into focus.

21	type C0	M0	Y0	K0		22	type C49	M27	Y27	K0		22	type C0	M0	Y0	K0
bgd C0	M80	Y100	K0			bgd C11	M2	Y5	K0			bgd C84	M67	Y4	K0	
21	type C0	M80	Y100	K0			type C31	M32	Y68	K8						
bgd C0	M0	Y0	K0			bgd C49	M27	Y27	K0							
21	type C0	M80	Y100	K0		22	type C11	M2	Y5	K0						
bgd C100	M100	Y30	K0			bgd C31	M32	Y68	K8							

Figure 23
Studio Pentagram
Partner/Art Director Fernando Gutierrez

Depth

The perception of depth is created by binocular input from both eyes; their corresponding rods and cones, including ganglion cells; the optic pathway, including the right and left lateral geniculate bodies; simple, complex, and hypercomplex fields located in the primary visual cortex; and many other parts of the brain. Without binocular input from both hemispheres of the visual pathway, depth perception would be very limited. For example, we could still see a sign in the distance, but we could not tell the distance at which the sign was located. This phenomenon increases as the visual acuity rating of the viewer deteriorates. In other words, someone possessing data from only one eye with 20/200 vision has less depth perception than someone possessing 20/20 vision out of one eye. Depth perception gives us the ability to judge time and space as we move through our environment. Without it, depth and varying distances become difficult to navigate and judge.

Figure 23 These book covers for Faber and Faber's poetry series utilize color to communicate the mood of each book. As a series, the Perpetua typeface holds the work together while the limited palette for the author's name, title, and ground reiterates the emotional content of each book.

Diagram 31 The color combinations for additive (RGB) and subtractive (CMYK), as well as the secondary colors, orange, purple, and green, are exhibited in a multitude of foreground and background combinations. Notice the pronounced simultaneous contrast in the pure color combinations: colors with a common color in their build, such as red with orange (red + yellow) are less likely to exhibit pronounced simultaneous contrast.

23 type C75 M67 Y67 K80 **23** type C24 M100 Y100 K22
 bgd C4 M26 Y100 K0 bgd C2 M1 Y8 K6

23 type C2 M1 Y8 K6
 bgd C75 M67 Y67 K89

23 type C4 M26 Y100 K0
 bgd C24 M100 Y100 K22

BG Background color C83 M53 Y0 K0 30%

Simultaneous Contrast

With a knowledge of how color is created within the human experience, you can measure and manage pronounced simultaneous contrast (see The Young-Helmholtz theory in Chapter 2). Simultaneous contrast occurs most often with pure and semipure colors. Because they induce a forceful conal firing of electrical impulses, they fatigue the receptor cells quickly. As colors become muddy or dirty, simultaneous contrast is less likely to occur. A pure color is made up from one ink or lightwave; a semipure color is made from two pure colors or lightwaves. Two pure colors and a small percentage of shading (no more than 10 percent black, or less than 10 percent of a third pure hue) can also create a semipure hue. As discussed in Chapters 2 and 3, the purity of color depends upon the primary colors that create the individual color wheel. For example, in a four-color process there are four primaries, but with most ink-matching systems additional primaries are used in order to create a much larger color gamma. Pronounced simultaneous contrast most often occurs with complementary or near-complementary colors. Using a color scheme that has one pure or semipure color juxtaposed to a muddy or dirty color will not create pronounced simultaneous contrast. Several steps to reduce simultaneous contrast are outlined in Chapter 1; in this section the mathematics behind simultaneous contrast is explored to give you the tools for full comprehension and predictability.

A recent color study investigated how simultaneous contrast operates. Out of the 1,701 pure and semipure type and color combinations created, 200 of these color studies produced pronounced simultaneous contrast or simultaneous contrast. This means that simultaneous contrast occurred 12 percent of the time, or with 1 combination in 9. Using this study as a model, designers have a high risk of creating simultaneous contrast within their work every time they set out to solve a client's problem (Drew, Pure and Semipure Color Study, 2001).

Figure 25
Studio Pentagram
Partner/Art Director Fernando Gutierrez

Figure 24
Studio Thonik

Figure 24 In this example, simultaneous contrast is used to call out layers of additional meaning and to change the sentence structure. The back-and-forth shift of foreground and background continually restructures the grammatical hierarchy.

Figure 25 Pronounced simultaneous contrast on this cover design creates a jarring effect and attracts the viewer's eye. The strobing forces them to concentrate in order to read the type.

24	type C1 M1 Y1 K0 bgd C30 M1 Y0 K99	**24** type C98 M2 Y97 K0 bgd C1 M1 Y1 K0	**25** type C0 M0 Y0 K0 bgd C83 M53 Y0 K0
24	type C30 M1 Y0 K99 bgd C0 M100 Y99 K0		type C83 M53 Y0 K0 bgd C14 M100 Y44 K1
24	type C0 M100 Y99 K0 bgd C98 M2 Y97 K0		

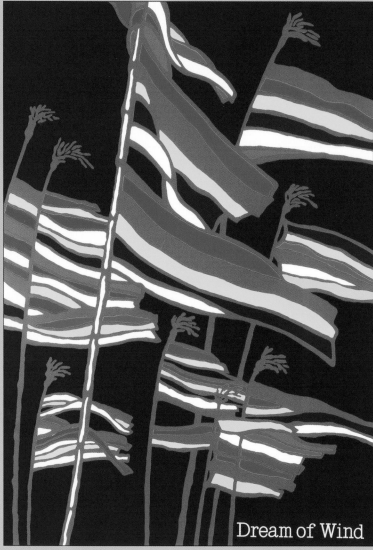

Dream of Wind

Figure 26
Illustrator/Designer Sang-Rak Kim

Several results from the Drew (2001) study help in predicting and measuring the amount of simultaneous contrast that might occur. One is that simultaneous contrast will occur when the background and foreground color value differential is 35 percent or less. If a color combination has a color differential of 35 percent or higher, simultaneous contrast does not occur. With a differential of less than 15 percent, there is a 1 in 1.5 chance of simultaneous contrast occurring. (Of the 200 color studies that produced some kind of simultaneous contrast, 133 had a differential of less than 15 percent). With a color value differential of 15–20 percent, there is a 1 in 13 chance of simultaneous contrast occurring. (Fifteen of the 200 color studies that produced some kind of simultaneous contrast had a differential of 15–20 percent.) The color studies that produced pronounced simultaneous contrast or simultaneous contrast and fell within the 20–35 percent color differential range were very predictable. The majority of these color combinations (48 in total) were produced with red and green as color combinations. Within the 48 total, color tints of red and green were used as well. A small percentage of these color combinations produced pronounced simultaneous contrast when a process cyan or tints of sky blue were used with a magenta, red, or orange-red with a high chroma factor.

Figure 26 This poster shows a superior use of simultaneous contrast. In daylight, the strobing effect caused by this moves the flags back and forth as though flapping in the wind.

Diagram 32 The color combinations for additive (RGB) and subtractive (CMYK), as well as the secondary colors orange, purple, and green, are exhibited at 80% and 60% background tint. As the background color becomes more muted with white, the simultaneous contrast decreases.

Many of the color studies did not follow the preconceived idea that simultaneous contrast occurs when there is a color combination of complementary or near-complementary colors. The study suggests that if there is less than 2.5 percent color differential between foreground and background, simultaneous contrast will most likely occur, no matter what the color combination, if the typefaces used have a thick-to-thin anatomy and are at their maximum legibility range. The study also suggests that, with the exception of color combinations that are made of red and green, or light blue and red, the amount of simultaneous contrast will diminish as more color value differential between foreground and background is implemented.

Simultaneous contrast will occur with a combination of yellow/purple or yellow/blue only if the purple or blue has a similar color value rating as the yellow. In many of the color theories covered in this book, yellow and blue are direct or near-complementary colors. However, a color combination created with PANTONE 293 C and PANTONE Process Yellow C will not create simultaneous contrast. PANTONE 293 C is a medium-range blue made from 50 percent Reflex Blue and 50 percent Process Blue—a semipure color. PANTONE Process Yellow C is a pure color. The color value for

PANTONE 293 C is 13.47 percent and for PANTONE Yellow C, 72.80 percent— a color value differential of 59.33 percent. To create simultaneous contrast using yellow and another pure or semipure color, a large amount of color tinting must take place in order to bring the color value rating to the same or nearly the same as the yellow. This color combination phenomenon—that the complementary or near-complementary primaries do not induce simultaneous contrast unless color tinting is used—is unique to yellow. In other words, a fully saturated cyan with a fully saturated process yellow will not induce simultaneous contrast. For pronounced simultaneous contrast to occur, the process cyan must be made lighter by infusing the color with white. The above process applies to any of the pure or semipure colors if lighting is desired.

Figure 27
Art Director/Designer Inyoung Choi

Figure 27 Shades of complementary colors will mute simultaneous contrast and decrease the strobing effect between foreground and background. In this poster the shade of green clearly recedes, however, the semipure red on the side of the face increases the radial effect of flower petals. In addition, the red on the bridge of the nose creates depth in the skull's eye socket.

27	type	C0	M89	Y89	K0
	bgd	C82	M46	Y99	K55
27	type	C82	M46	Y99	K55
	bgd	C0	M89	Y89	K0

Figure 28
Art Director Lanny Sommese
Illustrator/Designer Lanny Sommese

Test for Print-based Graphics

For print-based graphics, a crude and easy system for determining the color contrast with Photoshop is described below. The size and number of divisions given are for a two-color document; for more than two colors, create a larger document with more divisions. This system should not be used to comply with any legislation or other set standards.

1. In Photoshop, open a 72dpi CMYK document that is no less than 1 x 1in (2.5 x 2.5cm).

2. Pull down a guideline on the background layer to divide the document in two.

3. Using the rectangle marquee tool, fill in one half of the document with one of the spot or four-color process colors.

4. Fill in the other half in the same way with the second specified color.

5. Convert the Photoshop document to grayscale.

6. Open the Information palette under Windows in the main menu of Photoshop. This will yield a crude estimate of the color value rating and the contrast between the color through the black percentage indicator.

Figure 28 This series of posters creates a slight shift in foreground and background through simultaneous contrast and form/silhouette.

Diagram 33 The color combinations for additive (RGB) and subtractive (CMYK), as well as the secondary colors orange, purple, and green, are exhibited at 20% and 40% background shade. As the background color becomes more muted with black, the simultaneous contrast decreases.

28 type **C**75 **M**68 **Y**67 **K**90
bgd **C**2 **M**55 **Y**1 **K**0

28 type **C**2 **M**55 **Y**1 **K**0
bgd **C**75 **M**68 **Y**67 **K**90

BG Background color **C**0 **M**0 **Y**100 **K**0 40%

These numbers vary greatly from the true color value rating, or Y tristimulus value. However, if the contrast is 20 percent or greater, the legibility of the two colors is assured, providing there will be no simultaneous contrast within the color combination. For normal, 20/20 vision, 20 percent is a prudent estimation. Some color combinations need only a 2–5 percent color contrast differential in order for the combination to be clearly legible. For red, green, and blue colors designed for a digital environment, the color contrast differential for normal 20/20 vision can be decreased drastically. However, researchers have not compiled enough scientific data to give a guideline for color and type legibility combinations.

Due to the color intensity created by computer monitors, the electrical impulses stimulated by the cones and rods in the eye are greater, or fire with more force, creating an environment where a decrease in color contrast is reasonable.

Light-measuring equipment (available for less than $300 U.S./£170 U.K.) can be connected to either a DOS- or a Mac-based computer. This equipment can measure the color value rating of any standardized ink source, such as Pantone, Toyo, Trumatch, Focoltone, or Acuity. In fact, this equipment can measure any physical color made from paper and ink, plastic, metal, wood, ceramic, etc. The PANTONE Color Cue measures the Y tristimulus values for all PANTONE colors and also costs less than $300 U.S. (£170 U.K.).

Figure 29
Art Director Lanny Sommese
Illustrator/Designer Lanny Sommese

Figure 29 This poster shows an excellent use of form/silhouette and contrast to create dimension on a 2-D surface. Notice that even though one of the clowns does not have a head, the shift from foreground to background helps increase the sensation of juggling and the disorientation of standing on the hands.

29	type	C75	M68	Y67	K90
	bgd	C25	M2	Y1	K0

29	type	C25	M2	Y1	K0
	bgd	C75	M68	Y67	K90

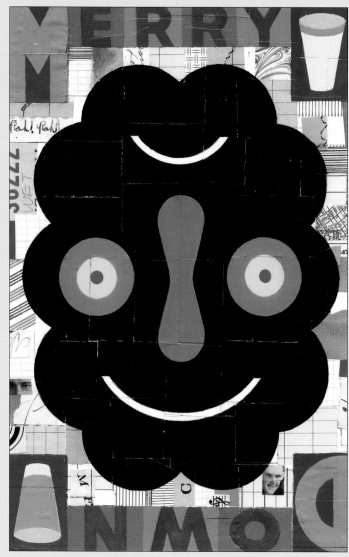

Figure 30
Creative Director David Dye
Typographers David Wakefield and Mike Pratley

Warm and Cool Colors

When warm and cool colors are juxtaposed on a 2-D surface, be it print-based, interactive, or any other 2-D surface, a 3-D illusion is created. This illusion can also be utilized in a 3-D environment in order to enhance the dimensionality of the surroundings. This dramatically affects the design options for architecture, and for packaging, industrial, landscape, interior, and textile design. The environments in which we live shape this color illusion.

The cones located outward on the retina wall, which are physically different from those near the fovea (near midpoint), correspond to cool and warm colors. Blue, bluish-green, and black (cool colors) emit lightwaves that measure from 380–500 nanometers (nm) and send a negative electrical impulse to the primary visual cortex and other parts of the brain. Yellow, yellow-green, red, and white (warm colors) emit lightwaves that measure from 500–700nm and send a positive electrical impulse. A fully saturated purple has the unique ability to move up and down the nanometer light spectrum a great deal, depending upon the individual primary color build. In other words, if purple is perceived to be a warm color, the majority of the color build that makes up the color

Figure 30 The black face on top of the warm background flattens the image to a 2-D plane by contradicting our learned perception of color. The 2-D plane accentuates the dramatic change in meaning that occurs when the image is rotated 180°.

Diagram 34 (a–e)
The juxtaposition of warm and cool colors can be used to increase the illusion of 3-D space. For example, the full-color pyramids (b–e) allude to deeper space than the black-tinted pyramid (a). In addition, a cool purple (d and e) may recede more than a warm purple (b and c) due to the perception of colors in the distance as diffused. Tints of a color may further help to increase the sense of depth by defining a greater shadow area (a and d).

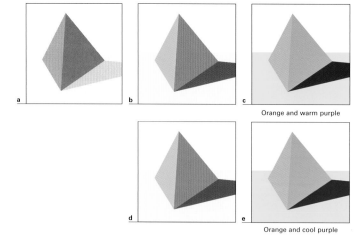

Orange and warm purple

Orange and cool purple

| 30 | type C0 M2 Y47 K0
 bgd C59 M55 Y50 K89 | | type C59 M65 Y5 K0
 bgd C72 M6 Y94 K1 |

| 30 | type C59 M55 Y50 K89
 bgd C59 M65 Y5 K0 |

| 30 | type C72 M6 Y94 K1
 bgd C0 M2 Y47 K0 |

| BG | Background color C1 M28 Y87 K0 50% |

is created by magenta in subtractive color mixing. For a purple to be perceived as cool, the majority of the color build is made up from cyan.

An object colored black or dark blue that is placed in the sun will be much hotter than the same object colored white. This statement (cool colors are hotter than warm colors) may seem an oxymoron at first, but the notion of colors appearing warm and cool is to do with a psychological response, cultivated by our past understanding of how objects appear in our environment. For example, fire has a warm color, and the ocean a cool color. Both of these examples contradict the above example; viewing color is a different experience than touching it.

Objects that are in the distance appear to the eye to be tinted blue. This perception is the result of an atmospheric condition that creates diffuse scattering, lowering the intensity of light reaching the observer, and bringing these colors into a cooler range. Objects that are in the foreground of our environment are more apt to have a much higher chroma rating because diffuse scattering does not take place. This creates the appearance of a warmer color, and there is more of the object for the eye to behold. For example, if we hold a brightly colored object in our hands, irrespective of its color,

the object will appear to the eye as warmer in color than if the object is placed at a distance. The chroma of a color has a great deal to do with the "cool" or "warm" response of the viewer. Therefore, when using cool and warm colors on a 2-D plane to create a 3-D illusion, chroma can be utilized to create the scale of volume found within the illusionary space.

Figure 32
Illustrator/Designer Tom Engeman

Figure 31
Illustrator Tom Engeman

Figures 31 and 32 An intense orange on a vibrant blue background will have a shortened depth of field in comparison with a tint of orange on shades of blue. For example, figure 31 appears to have a shallower depth of field than figure 32.

Diagram 35 (a and b)
Experience dictates that a dark object (a) placed in the sun will appear to be hotter than a light object (b) under the same conditions. Sometimes cool colors are hotter than warm colors in reality—the perception of color is relative to our psychological response and the context.

Diagram 36 (a and b) Both pyramids are equal in scale, however, the blue pyramid (36a) may be perceived as slightly smaller than the orange pyramid (36b) due to our learned perception of color. Due to an atmospheric condition that creates diffuse scattering, objects in the distance appear to be cooler in

color and therefore, objects that are equally scaled may appear unequal due to their color. Likewise, objects that are of the same color will appear different when placed at a distance.

| 31 | type | C1 | M65 | Y74 | K0 |
| | bgd | C74 | M60 | Y4 | K2 |

| 31 | type | C74 | M60 | Y4 | K2 |
| | bgd | C1 | M65 | Y74 | K0 |

| 32 | type | C1 | M1 | Y1 | K0 |
| | bgd | C98 | M75 | Y12 | K5 |

| 32 | type | C54 | M61 | Y17 | K24 |
| | bgd | C1 | M1 | Y1 | K0 |

| 32 | type | C68 | M42 | Y10 | K10 |
| | bgd | C54 | M61 | Y17 | K24 |

| 32 | type | C98 | M75 | Y12 | K5 |
| | bgd | C68 | M42 | Y10 | K10 |

Lucite International

Going further than you think

Corporate Review

Figure 33
Art Director/Designer Paul Middlebrook

When using warm and cool colors to create a 3-D illusion on a 2-D plane, we must always take into consideration simultaneous contrast. If using a warm and a cool color of the same chroma, or color value rating, simultaneous contrast will most likely occur. If it does, the 3-D illusion will cease to exist due to the strobing effect associated with pronounced simultaneous contrast. This effect causes the background color to jump in front of the foreground color and then back again as long as the viewer is beholding the object. When a 3-D illusion on a 2-D plane is desired, understanding which color combinations create pronounced simultaneous contrast, and how their corresponding differential ratings can be managed to create an acute color effect is essential to great design.

With subtractive color mixing, warm and cool colors are traditionally created through the four primaries—cyan, magenta, yellow, and black. Other subtractive color mixing systems are available, for example, Pantone, Toyo, and TRUMATCH. The primaries of these systems all differ. Whether a warm, cool, or neutral color is created depends upon the amount of each primary used.

To create a neutral color, including neutral black or gray, an equal proportion of hues must be utilized to build the color. To create

Figure 33 The warmth of magenta is increased with yellow in this piece. Although the depth of field is narrow, hierarchy and legibility is established through subtle increases in the warmth of each color.

Diagrams 37 (a–d) Pronounced simultaneous contrast will diminish the dimensionality of an object as the background color attempts to jump in front of the foreground color and then back again. The cyan and magenta pyramids (a and b) vibrate to maximum effect because each is composed of the pure printing colors (CMYK). The red and green (c and d) would strobe more effectively in an additive environment such as motion graphics. In this book, magenta and yellow create red, and cyan and yellow create green. The impurity of these colors with subtractive color theory will decrease the degree of simultaneous contrast.

a b
Cyan and magenta

c d
Red and green

| 33 | type C0 | M0 | Y0 | K0 |
| | bgd C0 | M100 | Y43 | K0 |

| 33 | type C0 | M100 | Y43 | K0 |
| | bgd C0 | M100 | Y67 | K35 |

| 33 | type C0 | M100 | Y67 | K35 |
| | bgd C0 | M0 | Y0 | K0 |

| BG | Background color | C0 | M100 | Y43 | K0 | 50% |

a neutral secondary color, equal amounts of two primary colors must be utilized. In other words, if a color matrix is used to create neutral colors, the incremental steps of both primaries must be proportionately identical. For example, neutral green and its tints are created from equal amounts of yellow and cyan. To create a neutral tertiary color, equal proportions of two secondary colors must be utilized. If these proportions are not equal, the hue created will be either a warm or a cool tint.

Black or shades of neutral grays are created in one of two ways. The first, to use only black in a four-color process printing, will create a neutral black and neutral grays.

The second way to create a neutral black and gray is to use cyan, magenta, and yellow, in equal proportions. If each of these three primaries is used at 100 percent of color, a neutral black will result. However, this black will not be as vivid as the fourth primary—black—used in four-color process printing. In addition, this second way of creating black for four-color process printing is not recommended due to the amount of ink that will be placed on the paper. This will create excessive dot gain and will therefore diminish any tonal qualities within the area where black and dark gray are created.

Figure 34
Art Director/Designer Paul Middlebrook

Figure 35
Designer Clinton MacKenzie

Diagram 38 To create a warm color using a four-color process there must be:

- a high percentage of magenta, yellow, or magenta/yellow;

- a high percentage of magenta and yellow with a low percentage of cyan;

- a high percentage of magenta and yellow with a small percentage of black;

- a high percentage of magenta with a lower percentage of cyan;

- a high percentage of magenta with a small percentage of black;

- a high percentage of yellow with a smaller percentage of cyan; or

- a high percentage of yellow with a small percentage of black.

Diagram 39 To create a cool color using a four-color process, there must be:

- a high percentage of cyan or black;

- a mixture of cyan and black;

- a large percentage of cyan with a slightly smaller percentage of magenta or yellow;

- black with a slightly smaller percentage of cyan and an even smaller percentage of magenta, yellow, or magenta/yellow; or

- a large percentage of cyan with a smaller percentage of either magenta, yellow, or magenta/yellow.

Figure 34 The cool colors in this interior spread are created through a large percentage of cyan and black. The black adds depth to the images.

Figure 35 The red in this image is relatively cooled by the addition of cyan to the ink build.

34	type	C52	M16	Y1	K2
	bgd	C81	M56	Y19	K44
34	type	C67	M74	Y27	K82
	bgd	C52	M16	Y1	K2
34	type	C1	M32	Y18	K5
	bgd	C67	M74	Y27	K82

35	type	C1	M95	Y80	K0
	bgd	C71	M67	Y58	K57
35	type	C71	M67	Y58	K57
	bgd	C49	M3	Y23	K0
35	type	C49	M3	Y23	K0
	bgd	C1	M95	Y80	K0

144

Environmental Destruction
Can a breath be done?

Black is a highly underutilized color. If used correctly, it can be altered to shift the mood of a piece. Oftentimes we overlook the fact that black can have either a warm or a cool tint. Depending upon the circumstance, a black can be tinted warm by the utilization of magenta, yellow, or magenta/yellow. A cool black can be created by tinting the color with cyan. When using the fourth primary black, an excessive amount of color tinting will also create dot gain, whether by adding a large percentage of a second primary, or two equal amounts totaling a large percentage—over 50 percent.

Figure 36
Illustrator/Designer Hiroyuki Matsuishi

Figure 36 The neutral black of this poster produces a cold foreshadowing effect accomplished through the use of line and a scattered dot pattern.

Diagram 40 Black and its shades of neutral gray are created using the four-color process, printing black at 10% incremental screens.

Neutral black and tints

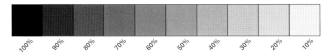

100% 90% 80% 70% 60% 50% 40% 30% 20% 10%

Diagram 42 (a–d) In this example, a neutral black is created through 100% black (a) or 100% cyan, 100% magenta, and 100% yellow (b). A cool black is created through 100% black and 100% cyan (c). Warm blacks are created through 100% black and yellow, 100% black and magenta, and 100% black, magenta, and yellow (d).

36 type C0 M0 Y0 K0
 bgd C0 M0 Y0 K98

36 type C0 M0 Y0 K0
 bgd C0 M0 Y0 K85

BG Background color C51 M40 Y38 K22 50%

The Color Matrix

A color matrix is a highly effective tool. Using a color matrix will help you understand how well the human eye can see colors in juxtaposition, and to predict the appearance of an individual hue or hues. Understanding how color combinations will interact with one another before you build the electronic mechanical is crucial. This may seem an obvious statement, but there are plenty of examples produced that appear to violate this rule.

Using Photoshop is a good way to create a color matrix with 10-percent increments from 0–100 percent. To create a two-, three-, or four-color matrix, follow the steps below. When creating the matrix, leave the first inch (or centimeter) clear of color: this will give you room to type in the screen percentages for the x and y coordinates of each color field.

1. Open Photoshop, and create a document that is 11 x 11in (28 x 28cm), 72dpi, and with the background white.

2. For four-color reproduction, make sure the document is in CMYK mode; for spot-color matrices and Web/interactive projects, it should be in RGB mode.

3. Place guidelines both horizontally and vertically every inch (or centimeter).

4. Depending upon how many hues are used within the matrix, create corresponding layers.

Depending upon the medium specified, a two-color matrix can be created using any spot colors, including a mixture of two different color systems, four-color process, and additive colors, or a combination of the two. Each time one of the vertical strips is created and filled, change the opacity setting within the Fill dialog box, starting with 10 percent and moving up in 10-percent increments until 100 percent of color is used, then repeat the process for the other colors. Change the direction of the strips from vertical to horizontal, from layer to layer. Once you have completed the hues and tints, use the multiply feature in the Layers dialog box to flatten the document for printout. Do not use the multiply feature in the Fill dialog box: it can create a false color appearance if both multiply features are used at the same time.

a
Cyan

b
Magenta

c
Yellow

Diagram 43 (a–c) The above fields show cyan, magenta, and yellow in 10% increments from 0–100%. In diagrams 44–46, each color is overprinted in varying combinations displaying a wide array of color possibilities.

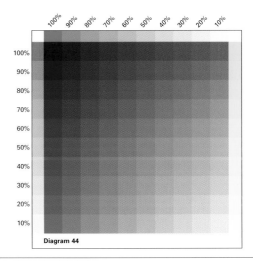

Diagram 44

Figure 37
Illustrator/Designer Sang-Soo Ahn

A document created in this way can be used as a comprehensive press proof. To do so all we need to know is the printer on which the color proof will be pulled. Several color-sinking programs are available, but due to the variables involved in the process not all work well. If, for example, the color printer is old, has not been cleaned, is using generic inks, or is using a paper with a low brightness rating (including colored paper), the color printout will be off. The programs are not set up to take anything but the ideal into account. The same can be said for those books that are published to simulate ink-jet colors. These books yield inaccurate color appearance. The only way to get what you see is to first pull a high-end proof. Set up a color matrix, in the program being utilized for the final proof, and send it to the printer who will create the final comprehensive. The color matrix should be printed on the same paper that will be used for the final proof. If you are using duotones and tritones, include a sample strip from each, from an area on the image that shows full color and tonal range. It is a good idea to have examples of one image set up three or four times with different color densities to simulate ghosted images. This will give you an idea of what to expect so that the repro house can make adjustments based on the color matrix and sample images to accurately predict what is on screen.

When utilizing a color matrix, you must always consider color value differential to determine a color combination or combinations. If you juxtapose colors from a color matrix, skip every other cell within a 10-percent matrix at a minimum. To be prudent, two colors in a row in a horizontal, vertical, or diagonal fashion should be skipped. This will ensure that there is enough color value differential for clear distinction between colors.

Figures 37 (a and b) and 38
The depth of field between foreground type and background color can be increased or decreased by color choice. In this poster series, black type on a cool background (figure 37a) appears to have a large depth of field in comparison with black type on a warm background (figure 37b). The red-orange background of figure 38 contains no shades of black, therefore the type is easily readable in the foreground.

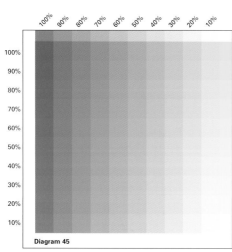

Diagram 45

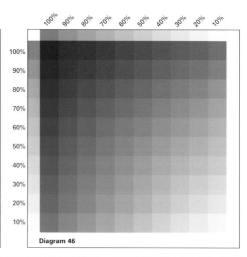

Diagram 46

	type			
37a	type	C91 M99 Y99 K65		
	bgd	C38 M59 Y67 K1		
	type	C46 M18 Y58 K0		
	bgd	C22 M56 Y36 K0		
	type	C22 M56 Y36 K0		
	bgd	C46 M18 Y58 K0		

	type	
37a	type	C38 M59 Y67 K1
	bgd	C91 M99 Y99 K65

	type	
37b	type	C71 M70 Y71 K26
	bgd	C34 M42 Y73 K0
37b	type	C34 M42 Y73 K0
	bgd	C14 M12 Y11 K0
37b	type	C14 M12 Y11 K0
	bgd	C71 M70 Y71 K26

BG	Background color	C34 M42 Y73 K0 50%

Utilizing Field Colors with Text Type

When creating a background color with text type, two rules apply: the opacity of the background hue must be no more than 20 percent when using black type as body copy, or when using a dark, cool color with 15 percent Y tristimulus value or less, on top of a color field. This is a safe and prudent rule whether the color is warm, cool, or neutral. If the body copy is black or a dark, cool color, 15 percent color value or less, a warm primary or secondary color can be utilized at 100 percent of color, including red. Many designers tend to believe that black type on a red background is not legible. This is a misconception. Black on red is perfectly legible if the red is either a pure or semipure color with no black.

If using colored body copy that is warm, neutral, or of a color that has 15 percent color value or greater, these rules do not apply. In this case, you must consider simultaneous contrast. Create a color matrix to incorporate a sample of the body copy and the varying colored backgrounds to achieve your desired color effect.

Figure 38
Illustrator/Designer Sang-Soo Ahn

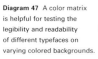

Diagram 47 A color matrix is helpful for testing the legibility and readability of different typefaces on varying colored backgrounds.

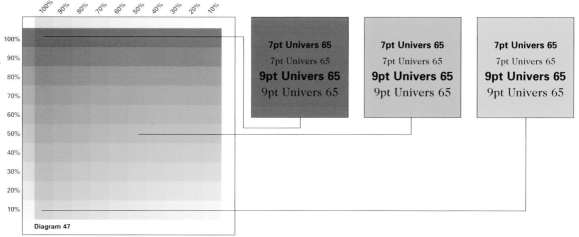

Diagram 47

7pt Univers 65
7pt Univers 65
9pt Univers 65
9pt Univers 65

38 type C87 M95 Y98 K65 / bgd C14 M68 Y89 K0
38 type C14 M68 Y89 K0 / bgd C30 M31 Y45 K0
38 type C30 M31 Y45 K0 / bgd C87 M95 Y98 K65

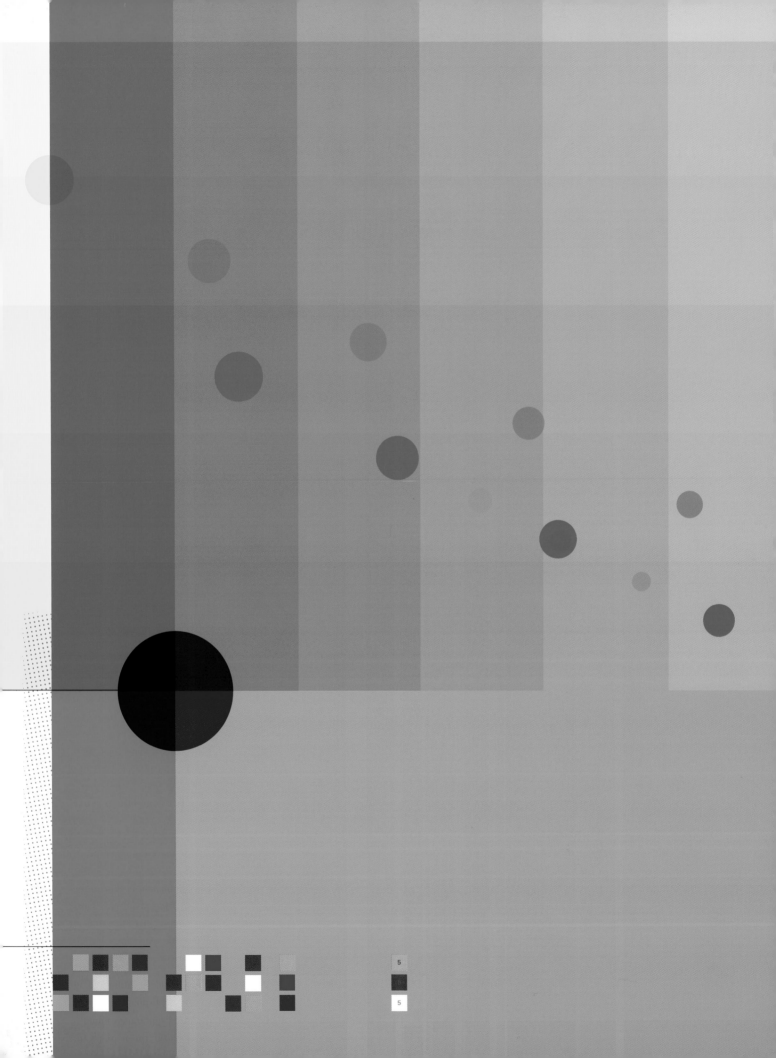

5 Color Calibration and Overprinting

Since the 1980s a technological explosion has transformed the way in which designers manage, process, and produce color. This explosion has had both benefits and drawbacks in the way color is visually communicated. Since the introduction of the computer as a tool and medium, designers have found it frustrating to color calibrate and color sink their monitors to printing devices. Many color swatch books, monitor devices, and application programs are overly complex and do not yield effective results. Due to the physical nature of color, these devices are not accurate enough in the presentation of color.

The first step in color sinking a monitor to a color printer is to create a color matrix comprised of 5-percent increments, from 0–100 percent. (See Building a Spot Color Matrix for Overprinting.) Such a matrix is appropriate for ink-jet, plotter, color laser, Fiery, Iris, and Color Key proofs. It can be used for any six-color ink-jet printer. For high-end color proofs, a color matrix comprised of 2.5-percent increments is warranted. This type of matrix is appropriate for eight-color and 12-color ink-jet printers, Cromalins, Matchprints, and press proofs.

There are many different color matrices on the market, some having finer steps than others. All of these matrices are used to simulate color appearance, and for good reason: this is by far the most accurate way of determining the subtle differences found within the spectrum of hues created using set primaries. However, some of these color matrices are worth owning and others are not.

Figure 1
Illustrator Robert Meganck

For color proofs and color sinking, a color matrix must be created as an electronic file to be printed to the printing device that will be used for the finished project. This is the only way in which to create accurate color appearance and to color sink what is on the screen to what appears on paper. The Acuity 1.0 Color System has over 485 pages of color matrices built in 5-percent increments, creating over 12,000 individual hues. These matrices have been saved as a PDF file (300dpi).

When dealing with low-end color proofs, the software application in which the file is printed out influences color appearance. This means that the same file printed out in QuarkXPress will have a different color appearance than when printed out in Adobe Photoshop, Painter, Macromedia FreeHand, or any other software program. The color appearance also changes when, for example, the color swatches are saved in EPS format versus TIFF format in QuarkXPress.

Each of these manufacturers uses different coding/technology to simulate colors for low-end printers, thereby creating different color appearances. QuarkXPress is used specifically for print production; both the PDF files and the Adobe Photoshop files are universally compatible with most software programs.

Figure 1 This illustration is an excellent example of color use fully realized through four-color process printing.

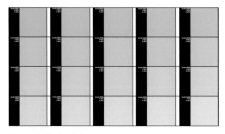

Diagram 1 The Acuity Color System is an extensive four-color process library. The matrices found within this system allow the designer to color calibrate their printer with ease.

type **C58 M31 Y32 K1**
bgd **C28 M10 Y38 K1**

type **C75 M100 Y32 K66**
bgd **C58 M31 Y32 K1**

type **C28 M10 Y38 K1**
bgd **C75 M100 Y32 K66**

BG Background color **C40 M0 Y80 K0 30%**

We can obtain an accurate representation of the colors our printers can produce either by using the files supplied on the Acuity Color System or by generating files ourselves. The color matrix method in this system can be used for low- and high-end color proofs. Each type of color proofing system—ink-jet, Fiery, Iris, Color Key, Cromalin, Matchprint, and press proof— creates a different color appearance, even if the electronic file is identical. Using the same electronic color matrix and printing it out on an ink-jet printer and a Fiery, for example, will demonstrate the massive amount of color shifting that takes place. In other words, color shifting is taking place from software application to software application, as well as from printing device to printing device, and from computer monitor to computer monitor. This is why many of these software applications and printed color matrices (in book form) do not work and why it is difficult to show a client accurate color proofs.

There is something to be said for a simple solution to a complex problem. The color matrices provided in the Acuity Color System will provide you not only with confidence in predicting the types of color that different printing devices can produce, but also the knowledge to adjust these hues on screen to match the desired color. You can print out one of the color matrices provided and hold it up to the computer screen to see how the printed color is shifting in comparison to what is being displayed on screen. Each of these matrices has the percentage builds in cyan, magenta, yellow, and black. By adjusting the electronic file's color either up or down to the color matrix, a hue match can be simulated. If, for example, you create a file for both Web and print, or just print, you should create a duplicate file. If you are interested in seeing how the color matrix will shift on press in comparison to a low-end color proof, electronic file, or both, do the same. First, you should pull either a Matchprint or press proof. After this color matrix proof has been pulled, a low-end color matrix can be printed out. On a duplicate electronic file, you can then make color adjustments based on the high-end color matrix proof. In other words, you will create two files that differ only in their color builds. One file will be used for press and the other as a client proof. These color matrices act as color test strips to anticipate and simulate final color appearance.

Figure 2
Illustrator Robert Meganck

Figure 2 (a–c) This series depicts a superior color palette that can be easily produced through four-color process printing.

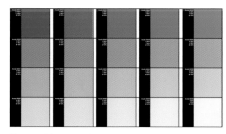

Diagram 2 The Acuity color matrix demonstrates some of the green hues found within the system.

Diagram 3 As shown in figures 2, the greens, blue-green, blue-purple, and reddish-purple are captured within this matrix, making it easy to create an accurate client comprehensive and color prepress proof.

	type				
2	type	C79	M68	Y67	K90
	bgd	C79	M68	Y34	K0
2	type	C38	M33	Y42	K0
	bgd	C79	M68	Y67	K90
2	type	C79	M68	Y34	K0
	bgd	C38	M33	Y42	K0
2	type	C31	M1	Y38	K0
	bgd	C76	M41	Y75	K31
2	type	C76	M41	Y75	K31
	bgd	C31	M1	Y38	K0
2	type	C8	M12	Y45	K14
	bgd	C76	M61	Y11	K37
2	type	C76	M61	Y11	K37
	bgd	C65	M53	Y39	K13
2	type	C65	M53	Y39	K13
	bgd	C8	M12	Y45	K14

Figure 3
Art Director Lanny Sommese
Illustrator/Designer Lanny Sommese

A four-color (CMYK) process can simulate up to 60 percent of the PANTONE color formula guide for both coated and uncoated papers. The PANTONE solid to process guide swatch book shows us which colors can be simulated using the CMYK primaries, cyan, magenta, yellow, and black. Using this swatch book to verify which spot colors can be simulated, you can create color matrices in Adobe Photoshop to duplicate the overprinting of two, three, four, and more colors. Adobe Photoshop allows you to simulate overprinting for all spot colors. However, accurate color appearance can be simulated up to only 60 percent utilizing the CMYK primaries. Adobe Photoshop also has the ability to overprint spot colors from any ink-matching system, including Toyo and TRUMATCH, and the overprinting ability to mix and match these systems. If you are considering mixing and matching between color systems through overprinting, you should pull a high-end Matchprint or press proof. The application program QuarkXPress can be used to verify whether a spot color is within the CMYK process color spectrum. (See Chapter 6, Color Correcting Images for Press.)

Using a low-end printer, you can produce a fairly accurate PANTONE color simulation of two spot colors overprinting if they are within the range of the CMYK process

Figure 3 Two spot colors are utilized to create the color palette within the duotone. If the spot colors are outside the CMYK spectrum, massive color shifting would occur; in this example they fall within the CMYK spectrum.

Diagram 4 The spot hue in this example falls within the CMYK spectrum. The horizontal stripes are created in 20% increments from 20–80% of color.

Diagram 5 Again, the spot hue used falls within the CMYK spectrum. The vertical stripes are created in 20% increments from 20–100% of color. In both diagram 4 and 5, color tinting is utilized.

3 type C0 M0 Y0 K0
bgd C86 M44 Y31 K51

3 type C86 M44 Y31 K51
bgd C27 M2 Y98 K1

3 type C27 M2 Y98 K1
bgd C0 M0 Y0 K0

BG Background color C70 M0 Y100 K0 20%

and specified from the PANTONE solid to
process guide swatch book. You can then
make adjustments on the electronic file,
utilizing the color matrices used to simulate
overprinting for the client proof to verify
them. (To view overprinting spot colors
that fall outside of the CMYK process color
spectrum on-screen, see Chapter 6, Creating
Duotones Outside CMYK Color Gamma.)

Figure 4
Studio Underware
Art Director/Designer Bas Jacobs

Figure 4 The Illustrator has
created an easily reproduced
graphic. Screen tints of red
and black are effectively used
to eliminate color shifting
when trapping. Poor trapping
management is most evident
in commercial silk screening.
The trap required for silk
screening is far greater than
commercial offset, and is
easily detected by the eye
if poorly managed. Trapping
is where two or more hues
overprint to create a seemingly
in-register document.

Diagram 6 Diagrams 4 and 5
are combined to overprint,
creating additional hues. Color
tinting is also utilized within
the overprinting process.

4	type **C16** **M84** **Y100** **K5** bgd **C22** **M16** **Y22** **K0**	4	type **C64** **M50** **Y70** **K44** bgd **C3** **M33** **Y5** **K0**
4	type **C3** **M33** **Y5** **K0** bgd **C16** **M84** **Y100** **K5**		
4	type **C22** **M16** **Y22** **K0** bgd **C64** **M50** **Y70** **K44**		

Figure 5
Art Director/Designer Art Chantry

Color Sinking and Overprinting

Setting up a document to color sink the hues on-screen to a printout is easy. The document will simulate overprinting for client proofs, and setting up an electronic file for press to allow overprinting.

1. Open the document and make a duplicate copy so that both documents are on the screen together.

2. Choose the color matrices that are color appropriate for the document from the Acuity Color System, and open the color matrix document. If you are using two spot colors, create a color matrix (see Building a Spot Color Matrix for Overprinting).

3. Print out the color matrices appropriate to the working document.

4. From the printout, choose the hues that represent the colors on screen.

5. Make the necessary color adjustments on the duplicate document by plugging in the new CMYK color builds. (The color builds in the original will no longer match the color builds in the duplicate document—they will look very different.)

Figure 5 A superior use of overprinting, which also occurs in the black areas to create subtle variations within the hue.

a

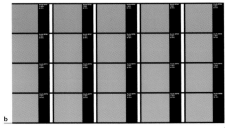

b

Diagram 7 (a–e) Follow these steps for building a spot color matrix for overprinting.

Image before adjustment on computer srceen (step 1).

Open color matrix from CD (step 2).

	type	C1	M0	Y15	K0
	bgd	C49	M0	Y50	K0

	type	C69	M64	Y70	K81
5	bgd	C1	M0	Y15	K0

	type	C2	M97	Y100	K1
	bgd	C69	M64	Y70	K81

	type	C49	M0	Y50	K0
	bgd	C2	M97	Y100	K1

BG	Background color	C0	M80	Y0	K0	100%

6. Print out the duplicate document. It should closely match the original working file on-screen. (Note, repeat this process every time the original document is printed to another device or different paper is used: changing the printing device from an ink-jet printer to an Iris, or changing the paper stock from uncoated to coated will alter the color appearance.)

Building a Spot Color Matrix for Overprinting

Another way of generating secondary colors and their tints is to create a color matrix of each primary hue with 5-percent increments, from 0–100 percent. This method can also be used to create a press proof for monotones, duotones, tritones, and four-color process images. To create the press proof all you need to know is where and on what printer the color proof will be pulled. Always print the color matrix and images on the same paper as intended for the final proof. If you are using duotones and tritones, include a sample strip from each on the document as well. The strip should be from an area on the image that shows full color and tonal range. It is a good idea to have examples of one image set up three or four times with different color densities: in this way you are assured that one of the sample strips will be correct.

1. Using Photoshop, set up a document at 72dpi.

2. Use the guidelines to create vertical and horizontal strips, 1 x 10in (2.54 x 25.4cm), on two layers.

3. Using the rectangular marquee tool and the Fill setting under Edit in the main menu, fill the vertical strips with the primary colors. Each time you create and fill one of the vertical strips, change the opacity setting within the Fill dialog box. Start with 5 percent and move up in 5-percent increments to 100 percent.

4. Repeat the process for the other color on another layer, making sure you change the direction of the strips from vertical to horizontal.

5. Once you have completed the hues and tints, use the Multiply feature in the Layers dialog box and delete the unwanted layers. Within the Layers dialog box you can turn the multiply feature quickly on and off to see different color effects. Do not use the Multiply feature in the Fill dialog box.

6. Flatten the document by selecting Flatten Image under Layer in the main menu, and print it out.

Figure 6
Art Director/Designer Akio Okumura

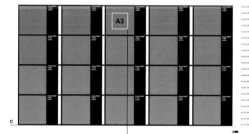

Print out color matrix from CD (step 3), then choose hues from matrix (step 4).

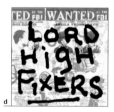

Adjusted image on srceen (step 5).

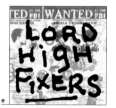

Color printout after making adjustment to document (step 6).

Figure 6 For overprinting, pure and semipure colors will create the widest spectrum of hues, including light to dark.

	type C99	M42	Y83	K28		type C2	M2	Y94	K0
	bgd C90	M53	Y0	K0		bgd C2	M96	Y93	K0
	type C99	M95	Y16	K3		type C99	M42	Y83	K28
	bgd C2	M2	Y94	K0		bgd C90	M53	Y0	K0
	type C2	M96	Y93	K0					
	bgd C99	M95	Y16	K3					

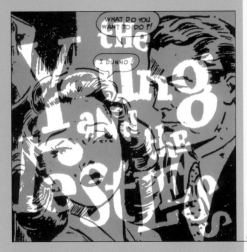

Figure 7
Art Director/Designer Art Chantry

Setting up Proofs and Mechanicals for Overprinting

A client proof should not be taken to press. It should be used only to show the client accurate color appearance. For those graphic designers educated precomputer, the process of producing a client proof and an electronic mechanical for press will be much easier to comprehend. It is very similar to the way in which proofs and traditional mechanicals were produced for press in the past. The concept is basically the same—only the tools have changed.

Often, with programs used for press purposes, overprinting, or the simulation of overprinting, is not available. Being able to see what you are designing is critical. The system outlined below allows you to preview what these colors will look like when overprinting in any application software program, and to set up a separate electronic mechanical for press. More importantly, it allows you to show your clients what the printed sample will look like.

Several simple rules guide the effective creation of a client proof and an electronic mechanical for press.

Rule 1:

The electronic client proof should never be taken to a service bureau or printing firm when film is going to be produced for the job. This will add confusion.

Rule 2:

A color printout of the client proof should be provided to the service bureau or printing firm along with the electronic file for press.

Rule 3:

To show accurate overprinting of spot colors, the individual spot hues must be within the CMYK color spectrum. Use the PANTONE solid to process guide to verify which PANTONE colors can be reproduced using CMYK primaries.

Rule 4:

Keep the written instructions to the printer or service bureau simple and clear. In this case less is more.

Figure 7 (a and b) In 7a, the artwork was created using a solid red field with type knockouts/reversals so that the underlying blue image is revealed. Where the human figures are colored, a muddy black overprinting occurs at 100% of both colors.

In 7b, a gross screen pattern is used in the overprinting artwork to create a highly textured environment that is seemingly disfigured and distressed. This emotional quality is further amplified through the overprinting process.

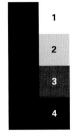

A B
Diagram 8 An example of the film separations needed to create each color in figure 7b. A will overprint on B.

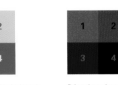

Electronic mechanical made from yellow and cyan.
bgd 1 **Y**100
bgd 2 **C**20 **Y**100
bgd 3 **C**70 **Y**100
bgd 4 **C**100 **Y**100

type 1 **C**100 **Y**100
type 2 **C**100 **Y**100
type 3 **Y**100
type 4 **Y**100

Printed result and client proof.
bgd 1 100% spot 1
bgd 2 20% spot 2; 100% spot 1
bgd 3 70% spot 2; 100% spot 1
bgd 4 100% spot 2; 100% spot 1

type 1 100% spot 2; 100% spot 1
type 2 100% spot 2; 100% spot 1
type 3 100% spot 1
type 4 100% spot 1

100% spot color 1

100% spot color 2

The two spot colors, at 100% with no overprinting.

type C69 M29 Y0 K0
bgd C0 M78 Y100 K0

type C0 M78 Y100 K0
bgd C69 M29 Y0 K0

7a type C0 M0 Y0 K0
bgd C85 M45 Y100 K53

7b type C73 M41 Y55 K18
bgd C22 M98 Y100 K14

7b type C22 M98 Y100 K14
bgd C5 M0 Y95 K0

7b type C5 M0 Y95 K0
bgd C73 M41 Y55 K18

BG Background color C68 M16 Y0 K0 20%

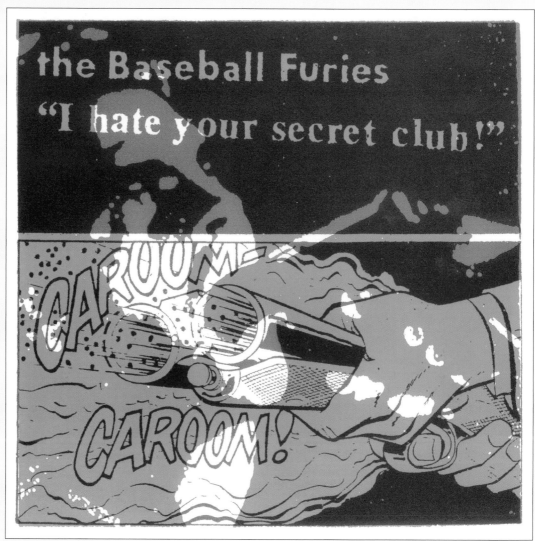

Figure 8
Art Director/Designer Art Chantry

Figure 8 An excellent
illustration of overprinting,
utilizing cyan and magenta.
These two colors are pure
and will yield a large spectrum
of hues that fall within the
CMYK gamma.

	type	C68	M16	Y1	K0
	bgd	C0	M90	Y0	K0
	type	C91	M85	Y0	K0
	bgd	C68	M16	Y1	K0
	type	C0	M90	Y0	K0
	bgd	C91	M85	Y0	K0

DOCUMENTS NORTHWEST
The PONCHO Series

ART CHANTRY

July 15-November 21, 1993
Seattle Art Museum

Figure 9
Art Director/Designer Art Chantry

Setting up Client Proofs for Overprinting

This process allows you to create a document that simulates two overprinting spot colors for client approval only. If this document were taken to press, four pieces of film would be RIPed (Raster Image Processor), and the job would no longer be considered two-color. Follow the same steps to produce a client proof using three and four spot-color builds.

1. Choose the spot colors desired from the PANTONE solid to process guide.

2. Create the spot color matrix as described previously. Apply the Multiply feature in the Layers dialog box in Adobe Photoshop once the matrix is created. This allows you to visually verify how the colors will overprint. If you omit this, Photoshop will not accurately simulate the over-printing of two spot colors.

3. Print out the color matrix and select the colors you desire from the printed spot color matrix, making sure you skip at least two or three squares between the colors to be used. Do not pick colors that are side by side as their color value differential will not be sufficient for hue difference to be detected. If the design calls for a pie chart, choose colors that are three or four squares apart in any direction.

Figure 9 This artwork was created using the four-color process primaries in their pure state. The occurrence of new hues only occurs where overprinting takes place.

a

b

c

d

Diagram 9 (a–d)
These four diagrams illustrate how documents built in the four-color process primaries can be altered to print in any spot hues. Three spot hues are shown in 9a–c; in 9d, all three spot hues from 9a–c are overprinted to create a new color palette.

type **C4** **M0** **Y55** **K0**
bgd **C0** **M36** **Y1** **K0**

type **C30** **M0** **Y0** **K0**
bgd **C4** **M0** **Y55** **K0**

type **C0** **M36** **Y1** **K0**
bgd **C30** **M0** **Y0** **K0**

BG Background color **C49** **M2** **Y100 K0** 50%

4. In Adobe Photoshop, use the eyedrop tool to click on each color chosen. Write down the CMYK percentages.

5. Choose the software application desired for the print job. Any software application program can be used.

6. Under the color feature found within your chosen software application, plug in the CMYK percentages for each color.

7. Use these percentages to name each new color, for example, "C 20 M 80 Y 5 K 3," and type in the color builds to create the new color.

8. In the application chosen, create the design using only the colors that are derived from the spot color matrix to allow the client proof to simulate the overprinting of two spot colors.

9. For monotones and duotones, produce photographs with one or both spot colors at 100 percent.

10. After the monotones and duotones have been created, copy these files in duplicate and save them as CMYK documents. Place these duplicate CMYK documents in the above QuarkXPress file for position only (FPO).

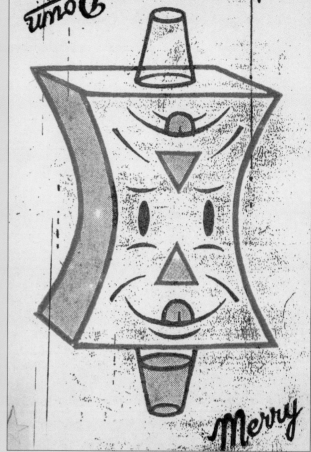

Figure 11
Creative Director David Dye
Typographers David Wakefield and Mike Pratley

Figure 10
Art Director/Designer Art Chantry

Figure 10 In this example two spot hues are utilized— a rubine red and a teal green— to create a purple when overprinting. Depending upon which color is laid down first, the purple will appear with a bluish or reddish tint.

Figure 11 The three hues utilized in this poster overprint to create additional colors.

| | type C0 | M0 | Y0 | K0 |
| 10 | bgd C73 | M93 | Y0 | K0 |

| | type C73 | M93 | Y0 | K0 |
| 10 | bgd C91 | M0 | Y35 | K0 |

| | type C91 | M0 | Y35 | K0 |
| 10 | bgd C0 | M91 | Y0 | K0 |

| | type C0 | M91 | Y0 | K0 |
| 10 | bgd C0 | M0 | Y0 | K0 |

| | type C88 | M45 | Y22 | K2 |
| 11 | bgd C6 | M98 | Y72 | K1 |

| | type C9 | M17 | Y31 | K0 |
| 11 | bgd C70 | M70 | Y64 | K80 |

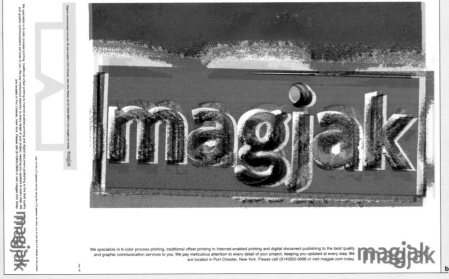

Figure 12
Art Director John T. Drew
Designer Gloria Shen

Overprinting Spot Colors for Press

In the mid-1980s it was commonplace to create traditional mechanicals for press. The traditional mechanical was constructed with illustration board, photo stats, typesetting stats, and rubylith and/or amberlith overlays. The black base plate was always placed on the illustration board, and the consecutive cyan, magenta, and yellow plates were produced through rubylith, amberlith, and/or acetate overlays. All written indication was placed on a tissue overlay instructing the strippers (the individuals who create film composites by cutting them apart and stripping them together prior to platemaking) on the types of colors being utilized, percentages of color, screen frequency, and any other information that needed to be communicated.

Today, most of this information is automatically composed and specified. However, software applications for press are not advanced enough to allow for duplicate overprinting, which would allow designers to see what is taking place on the computer screen. In order to create software applications that would accommodate visualization of all spot color overprinting and their tints, millions of colors would have to be created and specified. This would increase the memory of an application program beyond its practical use.

Figure 12 (a and b) In both examples the overprinting is intentionally out of register, creating a 3-D color effect when using 3-D glasses. The colored gels that are inserted into the glasses must be of the same color as the two most prominent hues utilized within the composition.

Diagram 10 (a–e)
Examples of spot color (SC) matrices using tints and overprinting are shown in 10a–c.

1. SC 1 20%
2. SC 1 80%
3. SC 2 20%
4. SC 2 100%
5. SC 1 20%; SC 2 60%
6. SC 1 80%; SC 2 60%
7. SC 1 40%; SC 2 100%
8. SC 1 80%; SC 2 100%

The spot color opacity is stepped down in 20% increments, creating tinted hues.

| 12 | type C1 M95 Y2 K0 | | 12 | type C0 M0 Y0 K0 | | 12 | type C38 M83 Y0 K0 | | BG | Background color C48 M86 Y0 K0 20% |
|---|---|---|---|---|---|---|---|
| | bgd C4 M0 Y92 K0 | | | bgd C94 M52 Y0 K0 | | | bgd C0 M0 Y0 K0 | | |

type C4 M0 Y92 K0 type C94 M52 Y0 K0
bgd C0 M0 Y0 K0 bgd C0 M100 Y0 K0

12 type C0 M0 Y0 K0 type C0 M100 Y0 K0
bgd C1 M95 Y2 K0 bgd C38 M83 Y0 K0

Up until the end of the 1980s, the overprinting of two spot colors was commonplace. Today, this lost art can be revitalized through the creation of an electronic file specifically as a mechanical for press. Using either the magenta and yellow or the cyan and yellow plates, any software application can create the desired overprinting mechanical. Cyan and yellow offer the greatest difference in color appearance; greens indicate where the two spot colors will overprint. By using only two of the four process colors, the job will RIP on two pieces of film. To set up a two-color overprinting mechanical for press, follow the steps below.

1. Create the client proof as indicated in steps 1 through 10 above (Setting Up Client Proofs for Overprinting). This proof needs to be complete and signed off by the client before you can start the electronic mechanical.

2. Using the spot color matrix created, indicate the screen percentages of each color build. These percentages should give only the amount used from each spot color. For example, PANTONE 185 10 percent and PANTONE 259 85 percent make up one overprinting color. Do not write down the CMYK builds of each color.

3. Once you have written down the overprinting colors and their corresponding screen percentages (PANTONE 185 10 percent and PANTONE 259 85 percent), open up the client proof.

4. Save the client proof as a duplicate copy, and save the file. Make sure you mark the file clearly for press.

5. Working with the duplicate copy, open up the Color dialog box. Some programs may require you to go through the main menu to edit and create new or edited colors; these will appear in the Color dialog box once you have saved them.

6. On a piece of paper, indicate which spot color is to be substituted with yellow and which with cyan. (It does not matter which is replaced with which.)

7. Replace each color that was created within the client proof to simulate spot color overprinting with cyan, yellow, and combinations of the two, with the correct screen percentages for the spot color builds. The electronic mechanical should now have a color palette made only from cyan and its tints, yellow and its tints, and screen percentages of the two, creating different values of green.

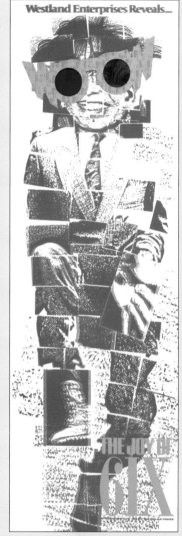

Figure 13
Studio Bremmer & Goris
Creative Director Dennis Goris
Designers Camilla Capozzi and John T. Drew

Figure 13 This artwork was created utilizing xerography. The artwork of the human figure was placed on the cyan and magenta channels. In certain areas, especially the front hand and foot, the image was pulled out of register to a greater degree, making these areas pop forward viewed through 3-D glasses.

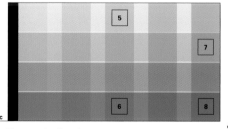

The spot colors found in a and b are overprinted, creating additional hues.

Electronic mechanical made from yellow and magenta. To create an overprinting mechanical, two of the three four-color primaries should be used. This will allow for up to three spot hues.

Printed result and client proof.

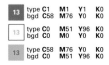

13	type	C1	M1	Y1	K0
	bgd	C58	M76	Y0	K0
13	type	C0	M51	Y96	K0
	bgd	C0	M0	Y0	K0
13	type	C58	M76	Y0	K0
	bgd	C0	M51	Y96	K0

Figure 14
Art Director John T. Drew
Designer Rendi Kusnadi Suzana

8. Print out the electronic mechanical, with crop marks, for viewing. A low-end ink-jet printer is sufficient for this task.

9. At the bottom of the printout write, as appropriate, "yellow prints as PANTONE 185 and cyan prints as PANTONE 259." The stripper will scratch out the yellow and cyan names on the film work and replace them with PANTONE 185 and PANTONE 259.

10. Write down any other indication to be communicated to the printer, and the file is ready to go to press.

11. Take the printouts of both the client proof and the electronic mechanical to press. Mark the client proof to indicate that it is a facsimile of what the printed job should look like.

Quality of Color Proofs

The following color proofing systems are ranked by quality from low to high. A crude breakdown of their expense is also given. Most often quality relates to expense. The color proofing systems outlined are commonly used within graphic design. With color proofing systems, quality is related to how well a color system can match specified colors, including spot colors.

Fiery

A low-end color proof, digitally printed. This type of proofing system is not created using film and is meant to yield a crude estimation of color appearance. A Fiery is mostly used for client proofs and for working layouts. Since a Fiery is produced through digital means (an electromagnetic heat fusion process of colored pigments), the color proof can be unreliable for typographic composition, photographs, color, and line work. The cost of a Fiery is minimal. They can be acquired at most photocopy stores, service bureaus, and printers.

Figure 14 This poster produces a 3-D color effect when utilizing 3-D glasses. Cyan and magenta gels must be inserted into the glasses in order for this to work.

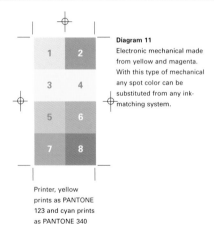

Diagram 11
Electronic mechanical made from yellow and magenta. With this type of mechanical any spot color can be substituted from any ink-matching system.

Printer, yellow prints as PANTONE 123 and cyan prints as PANTONE 340

Ink-jet

A low-end color proof, digitally printed. This type of color proofing system is used to obtain a crude estimation of color appearance, and for client proofs and working layouts. Some ink-jet color proofs have better color appearance than others, depending upon the manufacturer, the quality of equipment, and the amount of ink color primaries used to create the full color spectrum. Ink-jet color proofing systems are unreliable for typographic composition, photographs, color, and line work. They have a random mezzotint pattern to create continuous tone. The cost of an ink-jet color proof is minimal; it is generally the least expensive of all color proofing systems.

Figure 15
Art Director John T. Drew
Designer Eric Nagashima

Figure 15 This example demonstrates a 3-D color effect within the hand and lightning bolts. The further the image is pulled out of register the greater the effect, until the illusion is optically destroyed.

15	type	C75	M67	Y67	K90
	bgd	C0	M100	Y100	K20

15	type	C91	M90	Y0	K6
	bgd	C0	M35	Y100	K0

15	type	C0	M100	Y100	K20
	bgd	C75	M67	Y67	K90

15	type	C0	M35	Y100	K0
	bgd	C91	M90	Y0	K6

Figure 16
Art Director Theron Moore
Designer Tanya Ortega

Iris

A low-end color proof, digitally printed. This type of proofing system has a better color appearance than a Fiery or ink-jet, but does not show dot generation (it has continuous tone like a photograph). The dyes are highly light sensitive and fade rapidly in sunlight. Iris proofs are meant for client proofs and for working layouts. Unlike any other color proofing systems, an Iris is preferred for proofs with artwork that is meant to be displayed on a computer screen. The color spectrum is greater than most other printed color proofing systems, allowing for a higher color gamma. However, an Iris can be unreliable for typographic composition, photographs, and line work. However, an Iris proof is usually more expensive than a Fiery or an ink-jet, but the cost is still minimal.

Blueline

Produced by film output, a blueline is a highly accurate proof for typographic composition, sharpness of photographs, registration, and line work. Since a blueline is produced by the job's actual film, the halftone screens are accurate as well. However, bluelines depict all information through tints of blue so they are unreliable for color proofing. This type of color proofing system is highly sensitive to light; after viewing, a blueline should be placed back into a folder for protection. Because of this, most printers substitute digital "bluelines," which are not made from the plates. Digital bluelines are essentially color prints and are only meant for checking imposition. Although the cost of a traditional blueline is minimal, they do cost more than Fiery, ink-jet, or Iris proofs.

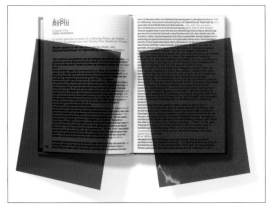

Figure 17
Studio Thonik

Figure 16 To design this poster, chromatic color matrices were created to verify the hue position. To color proof the poster for press a color key would be needed.

Figure 17 Green and red gels are utilized to create the 3-D effect on the page. Green and red ink are used to create the text, ensuring the illusion is successful.

Diagram 12 This highly dynamic book cover is a one-color job. The paper used creates the white hue, and the tones of gray are created through screen percentages. In this case a blueline would be sufficient for the job—an in-register document.
Designer Ned Drew

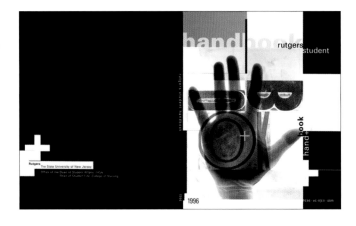

| | type C72 M47 Y51 K36 |
| | bgd C13 M88 Y71 K3 |

| | type C13 M88 Y71 K3 |
| | bgd C72 M47 Y51 K36 |

| 16 | type C49 M12 Y77 K2 |
| | bgd C5 M0 Y78 K0 |

| 16 | type C5 M0 Y78 K0 |
| | bgd C49 M12 Y77 K2 |

| 17 | type C7 M5 Y6 K0 |
| | bgd C62 M98 Y95 K27 |

| 17 | type C62 M98 Y95 K27 |
| | bgd C98 M37 Y98 K4 |

| 17 | type C98 M37 Y98 K4 |
| | bgd C7 M5 Y6 K0 |

| BG | Background color C4 M2 Y96 K0 10% |

Color Key

Produced by film output, Color Key proofs are as accurate as bluelines for typographic composition, sharpness of photographs, registration, halftone screens, and line work. This type of color proofing system yields fairly accurate color appearance for four-color process jobs, but it does not depict spot colors well. Color Keys also have a hard time with accurate color appearance of purples. Each piece of film—cyan, magenta, yellow, and black—is overlaid on clear acetate, in register. A Color Key is more expensive than a blueline, but the cost is still minimal.

Matchprint

Produced by film output, Matchprint proofs give an accurate color appearance of four-color process, and a limited range of spot colors such as those from the PANTONE color formula guide. This type of color proofing system is an in-register composite and is accurate for typographic composition, sharpness of photographs, registration, halftone screens, four-color process color, limited PANTONE colors, and line work. The Matchprint is moderate in cost and is a very useful color proofing device.

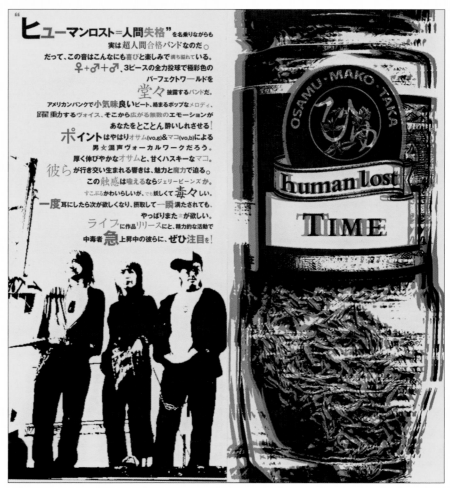

Figure 18
Art Director/Designer Yokoyama Yoshie

Figure 18 The bottle is intentionally placed out of register, ensuring that when viewed through 3-D glasses, it will pop off the page.

Diagram 13 Right: An iris could be used to check color for the working layout, but a blueline should also be pulled to verify position.
Art Director Ned Drew,
Designer Rick Bargmann

Diagram 14 Left: For fine detail, as in this illustration, a matchprint is recommended.
Illustrator Robert Meganck

18	type	**C5**	M98	Y34	K0
	bgd	**C4**	M2	Y96	K0
18	type	**C4**	M2	Y96	K0
	bgd	**C66**	M65	Y72	K81
18	type	**C66**	M65	Y72	K81
	bgd	**C5**	M98	Y34	K0

Figure 19
Art Director/Designer Art Chantry

Creo Veris Proof

A high-end color proof, digitally printed. While not created using film, the Creo Veris proofing system can be used for in-register composition. It is accurate for typographic composition, sharpness of photographs, registration, four-color process, spot colors, and limited use of metallic inks. The Creo Veris proof is similar to the Kodak Approval proof, but it uses an ink-jet delivery system, which makes it more economical.

Kodak Approval
Color Proofing System

Produced by film output, this system gives an accurate color appearance for four-color process, spot colors, and metallic inks. The Kodak Approval system uses rolls of donor film to create spot colors and metallic inks. Donor film is a color-coated, polyester film which, when exposed to lasers, transfers an image onto the stock, in register, and can overprint. Typically, these additional films are orange, green, and silver. In combination they do a decent job matching metallic colors, but the system falls short in matching the intensity of Day-Glo colors. Kodak Approval proofs use mylar laminated to the stock of choice. The process is similar to that used for a Matchprint or Cromalin. The Kodak Approval system is moderate in cost and is a very useful color proofing device.

Figure 19 Overprinting is utilized in the image areas. A Kodak Approval color system is an excellent choice to proof the artwork. The area holding "12" is a metallic ink.

Diagram 15 Color toning is used to a superior level here. This strategy decreases simultaneous contrast, cools the green, and makes the foreground image pop. In such a case, a Creo Veris Proof is recommended. If the design utilized spot colors, a Kodak Approval color proofing system would be best.
Designer Haleh Bayat

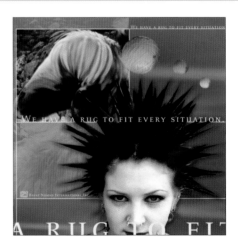

19	type C78 M59 Y61 K53	type C52 M14 Y23 K0
	bgd C9 M45 Y20 K0	bgd C31 M29 Y50 K1

type C31 M29 Y50 K1
bgd C52 M14 Y23 K0

19 type C9 M45 Y20 K0
bgd C78 M59 Y61 K53

BG Background color C0 M83 Y0 K0 50%

Creo Digital Matchprint

A high-end color proof, digitally printed. The Creo Digital Matchprint delivers the same quality as a Kodak Approval proof and outperforms the Creo Veris proof. The Creo Digital Matchprint system is moderate in cost, falling somewhere between a Creo Veris and a Kodak Approval proof.

Cromalin

Produced by film output and similar to a Matchprint. Cromalin, however, can reproduce accurate color appearance of PANTONE colors. This type of color proofing system is an in-register composite and is accurate for typographic composition, sharpness of photographs, registration, halftone screens, four-color process color, PANTONE color, and line work. A Cromalin is moderate in cost and is highly useful for color proofing.

Press Proof

Produced by film and printed on an actual press (usually a small press or older model). A press proof is a highly accurate color proof. This type of color proofing system uses the actual inks specified for the job and depicts accurate typographic composition, sharpness of photographs, registration, halftone screens, four-color process color, PANTONE color, dot gain, and line work. A press proof is expensive, which means it is commonly used for jobs with large printing budgets.

a

b

c

Figure 20
Art Director Sarah A. Meyer
Designer Leny C. Evangelista

Diagram 16 An example of color toning. In the central part of the composition, green and red are intermingled, helping to create a kinetic composition. Shading is utilized within the green, reducing and eliminating simultaneous contrast. All colors used in this design fall within the four-color process spectrum, and therefore a Creo Digital Matchprint or Cromalin is not needed. **Designer** Haleh Bayat

Figure 20 (a–c)
Many prepress issues are being utilized: simultaneous contrast, fake-duotone, coarse screen patterns, overprinting, intentionally creating an object out of register, and die cuts.

	type						type						type				
20	type	C76	M22	Y0	K0	20	type	C100	M50	Y0	K0	20	type	C0	M59	Y0	K0
	bgd	C0	M0	Y25	K20		bgd	C0	M66	Y100	K0		bgd	C85	M0	Y0	K0
20	type	C0	M0	Y25	K20	20	type	C1	M1	Y1	K0	20	type	C85	M0	Y0	K0
	bgd	C76	M22	Y0	K0		bgd	C100	M50	Y0	K0		bgd	C0	M0	Y0	K0
20	type	C100	M50	Y0	K0		type	C0	M0	Y0	K0	20	type	C0	M0	Y0	K0
	bgd	C1	M1	Y1	K0		bgd	C0	M59	Y0	K0		bgd	C0	M59	Y0	K0

6 Color Prepress and Printing

In the late 1980s, the design industries saw a massive technological transformation that, within less than a decade, had revolutionized the way in which design was thought about and created. In the past, many of the prepress issues were tasked out to different departments and special-effect houses. Today designers are responsible for more and thus need to possess a broader and more in-depth understanding of color management issues. These issues can have a profound affect on the way in which we create design and ultimately translate messages.

Managing the use of color in different media and platforms is becoming more and more routine. Understanding how color changes and is applied, not only from application to application, but from one environment to another, and one medium to another, is necessary to understand how prepress color issues are handled and applied within graphic design. This chapter explores many of these issues, giving designers tremendous color flexibility on a day-to-day basis.

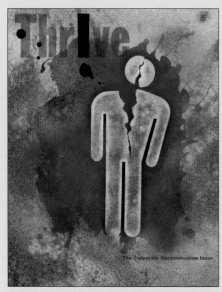

Figure 1
Art Director/Designer Theron Moore

Dot Gain

Hues, shapes, and depths have the potential to radically change color perception of 2-D static forms. When dealing with the static printed form, either by overprinting flat color fields, textures, tints, and shades, or utilizing photographs, illustrations, or continuous-tone drawings, dot gain must be taken into consideration in order to control the overall color appearance.

Dot gain on press is caused by ink absorption. When ink is imprinted on paper, depending upon the type of paper (uncoated, coated, clay-coated, etc.), the ink is absorbed like water into a sponge. Dot gain happens with all papers to some degree; typically, uncoated paper has the highest absorption rate. When dealing with photographs, images, illustrations, drawings, graphite rubbings, etc., a halftone screen is commonly used to simulate continuous tone. If, for example, the print job calls for process colors on an uncoated paper stock, the absorption rate will be high, and if it is not managed, this will drastically alter the color appearance. Printing on uncoated paper versus coated paper, clay-coated paper, matte finished paper, etc., will alter color appearance for monotones, duotones, tritones, four-color photographs, illustrations, and hues at any percent of color.

Most paper companies (Simpson Paper, Neenah Paper, Beckett Paper, etc.) and their distributors make paper samples available to any professional whose intent is to use the paper for commercial printing. An easy test to determine the absorption rate of paper is to place the head of a black permanent marker (for example, a fine point marker) on the paper for 4 or 5 seconds. Repeat this exercise on different types of uncoated and coated paper to obtain a visual read of the absorption rate for each.

The absorption rate is critical in determining how you should go about color correcting any continuous halftone image, color tint field, or color shade field for press. If the paper chosen has a high absorption rate, the dark areas should be color corrected 3–6 percent lighter than normal. The higher the paper's absorption rate, the lighter the darker areas need to be. This phenomenon applies to illustrations, monotones, duotones, fake duotones, and tritones.

Dot gain can be caused in prepress operations by overexposing the film or the metal plates for press, but this is rare. Overexposing the film is unlikely, unless the chemicals used to create the film or plate are out of balance. When making metal plates for press, most printers are

Figure 1 Used effectively, image manipulation will take into account the dot gain that results from rudimentary printing on inexpensive paper and therefore will yield high-quality results, as above.

a

b

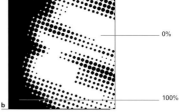

0%

100%

Diagram 1 (a and b) The image above is an enlargement of the flower to the left and is printed on coated paper. It shows the clarity and richness of each screened dot with very little overlap between dots. The image to the right (1b), printed on uncoated stock, shows many dots bleeding into their neighbors.

For coated paper, the dark area of a photo should not exceed 98% and the lightest area should have no less than 2% or 3% of color. For uncoated paper these percentages need to be adjusted according to the absorption rate. (See diagram 2.)

| | type | C80 | M46 | Y17 | K13 | | type | C33 | M80 | Y78 | K57 | | type | C1 | M28 | Y87 | K0 | | BG | Background color | C42 | M93 | Y16 | K1 | 20% |
|---|
| | bgd | C1 | M28 | Y87 | K0 | | bgd | C8 | M90 | Y100 | K1 | | bgd | C0 | M0 | Y0 | K100 | | | | | | | | |
| | type | C80 | M46 | Y13 | K17 | | type | C1 | M28 | Y87 | K0 | | | | | | | | | | | | | | |
| | bgd | C33 | M80 | Y78 | K57 | | bgd | C27 | M93 | Y94 | K35 | | | | | | | | | | | | | | |
| | type | C27 | M93 | Y94 | K35 | | type | C8 | M90 | Y100 | K1 | | | | | | | | | | | | | | |
| | bgd | C5 | M72 | Y99 | K1 | | bgd | C33 | M80 | Y78 | K57 | | | | | | | | | | | | | | |

very careful in the production process, making dot gain highly unlikely. Visible dot gain usually happens while on press, and it is the press person's responsibility to bring the job into balance. Most press persons use densitometers to determine and regulate the density or amount of color laid down on press. With this said, color appearance still shifts. A press check by the designer is always prudent.

If a color correction is not done properly, the image may appear to have dot gain. (Dark areas within the photograph will fill in to a solid color, causing a loss in detail.) Color correcting images properly is the responsibility of the designer, unless the designer is paying the printer to make corrections. If there are any questions about the image adjustments necessary for the paper specified, call the printer to determine the proper setting.

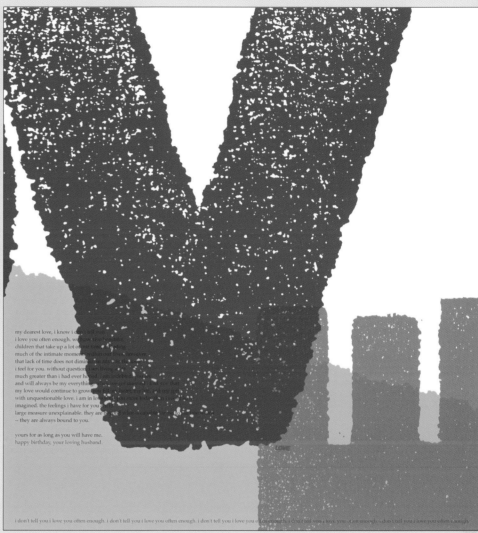

Figure 2
Art Director/Designer John T. Drew

1 second

5 seconds

a

1 second

5 seconds

b

Diagram 2 (a and b) An easy test to determine the absorption rate of paper is to place the head of a black permanent marker on different paper stock for 4–5 seconds. Diagram 2a gives a visual read of the absorption rate for coated paper, while 2b shows the absorption rate for uncoated paper.

Notice that both dots on the uncoated paper have unclean edges, but the bottom dot has an exaggerated quality due to the fast absorption of the ink into the paper.

Figure 2 In this piece, dot gain is used as a positive rather than a negative attribute, enhancing the grainy quality of the image.

type C0 M95 Y100 K0
bgd C33 M98 Y77 K46

type C0 M0 Y0 K0
bgd C0 M95 Y100 K0

type C33 M98 Y77 K46
bgd C0 M0 Y0 K0

type C0 M30 Y100 K0
bgd C0 M75 Y100 K0

type C0 M75 Y100 K0
bgd C30 M100 Y100 K0

type C30 M100 Y0 K0
bgd C0 M30 Y100 K0

type C0 M87 Y100 K0
bgd C30 M100 Y0 K0

type C30 M100 Y100 K0
bgd C0 M87 Y100 K0

a

b

Figure 3
Art Director/Designer Sang-Soo Ahn

Undercolor Removal

Undercolor removal (UCR) is the process of removing cyan, magenta, and yellow from the shadow areas of a four-color process image and replacing those colors with black. Most often this process is conducted in the prepress operation, and designers have no idea it has happened. However, you should understand this process in order to color correct an image properly, to cut down on dot gain. For a four-color process image, keeping 300 percent of total ink coverage as a maximum is a good rule to follow. In order to meet this, you cannot use all four process colors together, at 100 percent of color: the total would be 400 percent. If the 300 percent rule is followed, it will cut down on ink buildup, and reduce dot gain, and filling in.

Adobe Photoshop is an excellent program for accomplishing UCR. Use the Channels feature in Photoshop, found under Window in the main menu, in combination with the Adjustment features found under Image. Channel Mixing can be found under Image/Adjustments. Each channel has a source channel scroll bar that allows you to increase or decrease, in percentages, the amount of ink flow. To use a source channel for, let us say cyan, make sure that the cyan output channel is selected. The

output channels are found at the top of the dialog box. To use the color replacement feature in Photoshop, scroll down under Image to Adjustments, and select the area that you wish to adjust with the eyedrop tool. At the top of the Replace Color dialog box you will find the Fuzziness scroll bar. Moving it left or right will allow you to adjust the selected area. There are three other scroll bars in this dialog box: Hue, Saturation, and Lightness, and you adjust them in the same fashion as the Fuzziness bar to achieve the desired effect. You can verify that the above percentages have been met through the Information dialog box.

The color field should be adjusted down an extra 3–6 percent when using flat color tint fields with small type, or flat color shade fields with small type on uncoated paper stock. For example, in anticipation of dot gain, a 20-percent color field with small, 100-percent black text type should be adjusted down to 17 percent. With highly absorbent paper, an additional 3–6 percent should be removed to compensate for dot gain on press. This also holds true for ghosted images (images used at a very low opacity setting, typically 10–20 percent).

When dealing with graphic armatures, line work, and small typography, color removal must be considered in order to

Figure 3 (a and b) These posters are excellent examples of the use of duotones. The conversion of the image from a two-color duotone to a four-color, press-ready image for this book resulted in a black that was greater than 300%. The combination of cyan, magenta, and black created a warm build of black that was 362%—62% over the recommended amount. To create a four-color, press-ready image, the yellow and magenta channel had to be reduced and the black increased. It is recommended that all duotones and tritones be checked during calibration for four-color process.

Diagram 3 These areas of the duotone were a 362% build of cyan, magenta, and black after the original duotone was converted to four-color process for this book.

| 3a | type C97 M88 Y72 K62 |
| | bgd C95 M8 Y1 K0 |

| 3a | type C11 M9 Y8 K0 |
| | bgd C97 M88 Y72 K62 |

| 3a | type C95 M8 Y1 K0 |
| | bgd C11 M9 Y8 K0 |

| 3b | type C67 M68 Y74 K20 |
| | bgd C33 M51 Y87 K0 |

| 3b | type C10 M9 Y7 K0 |
| | bgd C67 M68 Y74 K20 |

| 3b | type C33 M51 Y87 K0 |
| | bgd C10 M9 Y7 K0 |

| BG | Background color C53 M0 Y19 K0 20% |

create a healthy electronic mechanical for press. Rule lines that are hairline—0.25 or 0.5—should be constructed from one PANTONE spot color or two of the four-color process colors. Using more than two colors for fine line work or small typography can cause a registration nightmare on press, especially when using lower screened frequencies (65–133lpi). When print is out of register, it can have an unpleasant effect on the hues, shapes, and depth of color appearance of an object.

Figure 4
Art Director/Designer Brian Cantley

Figure 4 This poster is comprised of many graphic armatures, lines, and type. Each makes use of a simplified color build or a knockout for easy registration on press.

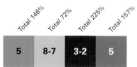

Total 146%	Total 72%	Total 225%	Total 157%
5	8-7	3-2	5

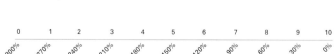

0	1	2	3	4	5	6	7	8	9	10
300%	270%	240%	210%	180%	150%	120%	90%	60%	30%	0%

Opaque = 300% (0) of ink coverage (100% cyan, 100% magenta, and 100% yellow) or 100% black
Transparent = 0% (10) of ink coverage

Diagram 4 Relative transparency ratings of color in relation to the percent of each build. Notice that at 300% the transparency is 0, or completely opaque. Anything over 300% will leave excess ink on the press, causing dot gain and a blurry image, as well as possible offsetting.

In contrast, it can be assumed that anything under 30% will significantly show through the substrate.

| 4 | type **C62** **M51** **Y49** **K63** |
| | bgd **C53** **M15** **Y81** **K8** |

| 4 | type **C84** **M39** **Y2** **K1** |
| | bgd **C53** **M0** **Y19** **K0** |

| 4 | type **C53** **M15** **Y81** **K8** |
| | bgd **C62** **M51** **Y49** **K63** |

| 4 | type **C53** **M0** **Y19** **K0** |
| | bgd **C84** **M39** **Y2** **K1** |

Figure 5
Illustrator Robert Meganck

Pixels, Lines, and Dots per Inch

Pixels per inch (ppi), lines per inch (lpi), and dots per inch (dpi) can all affect color appearance. The number of pixels per inch affects the tonal range, pixel depth, and color shape. For press an image, regardless of its kind, must have at least 266ppi at the size the image is used. For example, an image in Photoshop at 4 x 4in (10.16 x 10.16cm) with 300ppi, to be used at 8 x 8in (20.32 x 20.32cm) equates to an 8 x 8in (20.32 x 20.32cm) image with 150ppi. If this image were used for press, the insufficient ppi would adversely affect both the tonal range and the shape of the hues: there would not be enough pixels to capture the entire tonal range inherent in the original object, and the shape of the colors would be adversely affected by the visible appearance of jagged square shapes.

Several types of scanner are currently on the market. The most commonly used within the design and architectural fields are slide scanners, flatbed scanners (low- and high-end), and drum scanners. (These scanners are listed in order of the image quality they produce.) Slide and flatbed scanners have the ability to both scan in the true dpi, and interpolate data. Interpolation programs are a feature offered with most low-end scanners: they "guess" where more information should be placed within a given image. Flatbed scanners for print-production purposes should have the ability to scan in at 1,200dpi, uninterpolated. The ability to scan in artwork uninterpolated at either medium-range dpi (1,200) or at high-range dpi (2,400 and higher) leads to truer color appearance. A drum scanner is the highest quality scanner on the market today. These scan in images on a round sphere, so cannot scan in images that aren't flat. The ability to scan images at a medium to high range coupled with a high-bit color depth (42- to 48-bit color) allows the scanner to detect millions of colors. Eight-bit color equates to 256 shades of color, 16-bit to 65,000 shades of color, 24-bit 16,000,000 shades of color, and so on. (Humans have the ability to distinguish 700 million colors.)

Lines per inch and dots per inch can affect the tonal range of color as well as the shape and depth of the object. Lines per inch is the measurement of screen frequency. Typically, this ranges from 55–200lpi. The lower the frequency, the coarser the tonal range will appear. Within the newspaper industry 55lpi is common, 65–75lpi is generally used in commercial silk screening, and 133–150lpi is typical for offset printing. However, quality offset lithography printers can generally hold 175–200lpi.

Figure 5 The illustration above was scanned on a drum scanner and saved in 16-bit color. This allows for a medium range of color possibilities. 16-bit color equates to 65,000 shades of the 700 million colors the human eye can distinguish.

Diagram 5 There are many screens that can divide an image into different patterns. Although a straightline screen is the most common, it may not be the most effective for the content being communicated. Here are a few of the choices available.

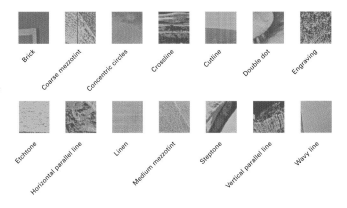

Brick Coarse mezzotint Concentric circles Crossline Cutline Double dot Engraving

Etchtone Horizontal parallel line Linen Medium mezzotint Steptone Vertical parallel line Wavy line

Lines per inch can also affect the shape
and depth of color within an image. Since
lpi has the ability to determine how course
or fine an object will appear, it also has the
ability to influence shape. The lower the
line frequency, the coarser the appearance
of the object. For example, scanning in
a photograph of a coffee cup at 1,200dpi
and assigning the image a 55-line screen
frequency will make the image of the coffee
cup appear coarse.

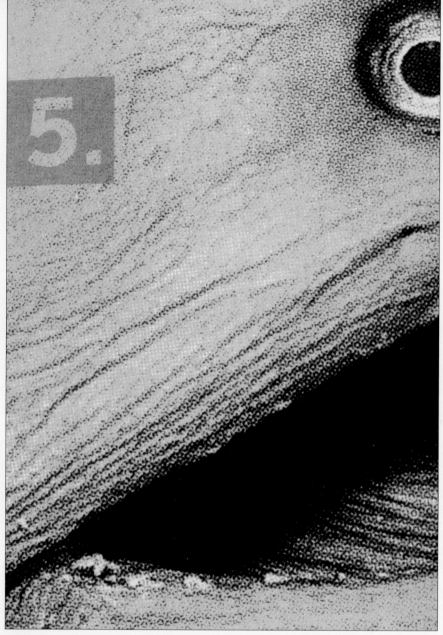

Figure 6
Studio Underware
Designers Bas Jacobs and Den Haag

Figure 6 This image is an
exceptional use of a coarse
screen frequency. The low
frequency flattens the range
of color and the dimensionality
of the image.

6	type	**C**75	**M**67	**Y**67	**K**88
	bgd	**C**27	**M**13	**Y**93	**K**0

6	type	**C**27	**M**13	**Y**93	**K**0
	bgd	**C**75	**M**67	**Y**67	**K**88

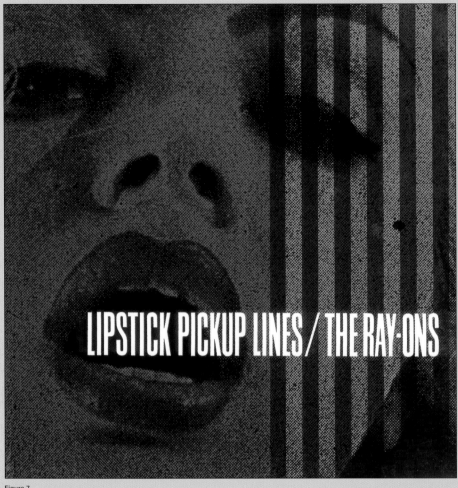

A coarse screen frequency of 55–75lpi influences color depth. In print-based graphics, the lower the line frequency, the more information or data in color tonal range is lost. This destruction of information tends to flatten images, due to the loss in color depth. There are many different types of halftone screens (round, square, oval, brick, cross line, cut line, double dot, engraving, etched tone, fine grain, linen, mezzotint, parallel line, horizontal parallel line, stepped tone, wave line, etc.). Each type of screen, together with its lpi measure, influences color tonal range, shape, and color depth. In order to get the appropriate effect, the ratio of ppi to lpi must be 2:1. For example, if the ppi is 300, the lpi must be 150, and if the ppi is 266, the lpi must be 133. The ratio of dpi to lpi must also be 2:1.

Figure 7
Art Director/Designer Art Chantry

Figure 7 The coarse line screen, in addition to the choice of screen pattern, dramatically alters this image. As technology has developed, line screens have become more refined. Therefore, using a lower frequency will date an image.

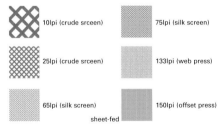

10lpi (crude srceen)

25lpi (crude srceen)

65lpi (silk screen)
sheet-fed

75lpi (silk screen)

133lpi (web press)

150lpi (offset press)

Diagram 6 Each red box represents a varying screen frequency in lines per inch, from 10lpi to 150lpi. The lower the screen frequency, the coarser the tonal range will appear.

| 7 | type | **C1** | **M0** | **Y1** | **K0** |
| | bgd | **C13** | **M97** | **Y100** | **K4** |

| 7 | type | **C78** | **M29** | **Y7** | **K0** |
| | bgd | **C1** | **M0** | **Y1** | **K0** |

| 7 | type | **C13** | **M97** | **Y100** | **K4** |
| | bgd | **C90** | **M90** | **Y25** | **K12** |

| 7 | type | **C90** | **M90** | **Y25** | **K12** |
| | bgd | **C78** | **M29** | **Y7** | **K0** |

| BG | Background color | **C90** | **M90** | **Y25** | **K12** | 20% |

Bit Depth Range and Raw Formatting

For color, the most common bit depth range is from 1–64. However, when dealing with photographs, the two most common settings are 8-bit and 16-bit. Eight-bit color gives a color value range of 256 colors per pixel; 16-bit color gives a range of roughly 65,000 colors per pixel. In both RGB and CMYK mode the channels play an important part in color appearance. From a printer's point of view, channels are the color separations that represent the inks used in printing a job, and in this case are cyan, magenta, yellow, and black. When these four channels are combined they are called a composite. The total possible values are multiplied by the number of channels; the equation becomes the color value range per pixel, per channel. With every increase in the number of bits, and of channels, the color appearance, including the tonal range of a photograph or image, is massively improved.

When taking digital images, it is best to shoot in raw format. With Photoshop CS, raw-formatted photographs can be downloaded easily. Such photographs offer the highest resolution and pixel depth (16-bit). For example, a digital camera that can capture 6.3 megapixels is capable of creating an image that, in raw form and at 16-bit

color, has a pixel dimension of 144 megabytes (MB), a pixel width of 6,144, a pixel height 4,096, a document width of 20.48in (52.02cm), and a document height of 13.653in (34.68cm), at 150lpi and 300dpi (sheet-fed offset printing). For web press (133lpi), the document size would be 23.098 x 15.393in (58.67 x 39.09cm), at 266dpi. This is quite remarkable considering a 35mm camera has the capability of shooting up to 11 x 14in (27.94 x 35.56cm)—though that is pushing the limits of the film size.

Raw images contain the actual information captured by the electronic sensors within a digital camera and are not filtered or processed by any in-camera software. This allows for a greater range in size and better quality for color management.

Figure 8
Art Director John Gall
Designer John Gall and Ned Drew

Diagram 7 Bit depth is determined by powers of two. The following chart gives examples of incremental bit depth and the resultant color range per pixel. ——————

8-bit color	2^8	= 256
16-bit color	2^{16}	= 65,336
32-bit color	2^{32}	= 16,777,216

Figure 8 The harmonious relationship that is created through the use of color is an excellent example of analogous color schemes represented in 8-bit color.

8	type	C38	M91	Y87	K61
	bgd	C11	M15	Y39	K0
8	type	C11	M15	Y39	K0
	bgd	C24	M49	Y76	K5
8	type	C24	M49	Y76	K5
	bgd	C38	M91	Y87	K61

Figure 9
Art Director/Designer Ganta Uchikiba

Printing Order

In four-color process printing, offset lithography, or web press, the typical printing order of the color primaries is black, cyan, magenta, then yellow. The yellow primary is commonly printed last for color purposes. For print jobs that use spot colors, it is generally the darker of the two hues that is printed last. However, the order of printing can be changed in order to achieve certain color effects, or for better trapping. Trapping is when one plate (color) is choked or spread so that a small amount of ink is overlapping an adjacent hue. This is achieved through film or digital methods and transferred to plate or digital printing. Choking (down) or spreading (out) a color creates a slight overlap of adjacent hues so that a print job looks perfect. Dark trapping involves reversing the order of cyan and magenta, a process that improves image quality, because the trap cannot be detected by the eye. These effects typically transpire in a visible color tint of the hue that was printed last. Depending upon the colors utilized, this effect can be slight or drastic. For example, printing black on top of yellow will create a neutral black, but printing yellow on top of black will create a warm black with a slight tint of yellow. Another example is printing 100 percent cyan over 100 percent magenta, which

creates purple with a bluish tint. Reversing the order of printing creates purple with a reddish tint.

The electronic mechanical will often have to be constructed differently when changing the designated ink order for printing. For example, when printing small yellow type on a black background, the mechanical will be set up in the traditional manner. However, to create yellow type on a warm black background with a yellow tint, the mechanical will need to be constructed differently. Either the black ink will need to incorporate a large percentage of yellow (50–100 percent, customizing the color), or the black plate will need a type reversal, and the yellow plate will need a solid overprint covering the black plate. The first option involves a change to normal printing procedure and will create a more visible color tint. With this said, the scenarios above can be designated for a change in printing order. Both mechanicals are set up properly to accommodate this experience because the trap is eliminated or virtually undetected.

The printing order of inks is often defined because the print job tends to trap better with the darkest color printed last. However, in two-color jobs it is sometimes a toss-up as to which ink should be the hue that traps

Figure 9 Careful use of printing order and trapping is essential in bringing out the iridescent quality of the gold type above.

Diagram 8 (a and b) A change in printing order on a two-color job comprised of magenta and cyan. In 8a the magenta is printed over the cyan; in 8b the cyan is laid over the magenta. In most cases, the image will subtly shift to the hue of the last printed color.

Diagram 9 (a–d) Right: A wide variety of choke and spread settings. Notice that as type is choked, the hairlines of the letterface become more compressed and therefore may loose some legibility 9b. In contrast, type that is spread may become thicker than was intended.

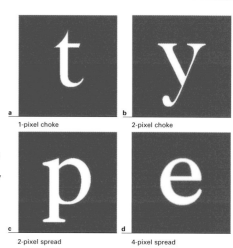

1-pixel choke 2-pixel choke

2-pixel spread 4-pixel spread

9 type **C**33 **M**45 **Y**97 **K**22
 bgd **C**0 **M**0 **Y**0 **K**100

 type **C**0 **M**0 **Y**0 **K**100
 bgd **C**62 **M**49 **Y**49 **K**48

9 type **C**62 **M**49 **Y**49 **K**48
 bgd **C**33 **M**45 **Y**97 **K**22

BG Background color **C**33 **M**45 **Y**97 **K**22 20%

because the print job will not be adversely affected. In these cases, changing the printing order may create a printing effect whereby the colors being utilized create a more pleasant hue experience.

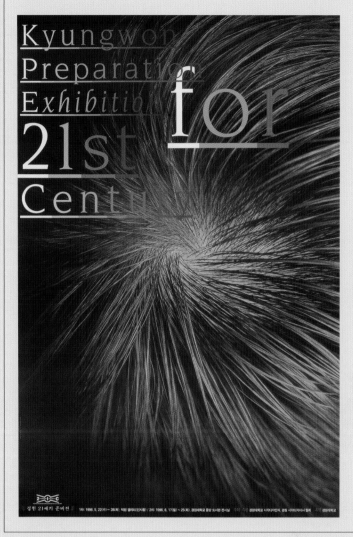

Figure 10
Art Director/Designer Gi-Heun Suh

Figure 10 The gradation of gray hues in this poster is emphasized in the typography. Each letterform appears to emerge from the background.

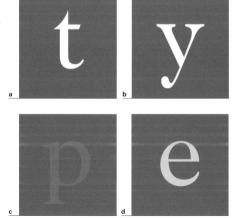

Diagram 10 (a–d) Left: Optimal trapping conditions would be to balance the choke and spread of an image so that each will be minimally compromised. Generally, the background is choked down while the foreground, in this case type, is spread out. Type that is filled with 100% of a color that is built into the background will not need to be choked or spread. For example, yellow type on a red background (10d) will not need to be altered because the red has yellow in it.

<table>
<tr><td>10</td><td>type C36 M31 Y45 K10
bgd C64 M48 Y56 K66</td></tr>
<tr><td>10</td><td>type C64 M48 Y56 K66
bgd C36 M31 Y45 K10</td></tr>
<tr><td>10</td><td>type C64 M48 Y56 K66
bgd C47 M33 Y34 K12</td></tr>
</table>

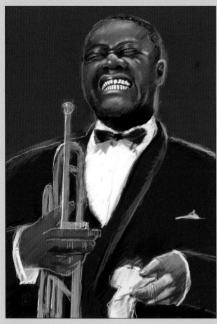

Figure 11
Illustrator Robert Meganck

Color Correcting Images for Press

To color correct images for press, whether four-color, grayscale, monotones, duotones, fake duotones, or tritones, the tonal values from light to dark must be set up correctly. For press there are six major concerns when dealing with color correcting. The first is the quality of the original image. The second is the quality of the scanned image. The third is ensuring proper contrast from light to dark within the photograph. Without this the image will look flat. Typically, a lack of contrast is caused by either the overall image being too light, too dark, or too even (a lack of lights and darks). In four-color photographs, when images appear flat, the color primaries throughout the overall image tend to be relatively proportionate. The fourth concern is to avoid the light areas dropping out within the photograph, and the fifth is to prevent the dark areas filling in (dot gain), both of which cause a loss in detail and an improper tonal range from light to dark. The sixth concern is compensating for the printing process, including the paper being utilized. With duotones, fake duotones, and tritones there is also usually an additional seventh factor: maintaining tonal range when overprinting takes place.

The quality of the original image is the primary criterion that determines whether it will print well. "What you start with is what you get." An image that is flat and out of focus will never yield a high-quality image. The image in question must be in focus, properly color balanced, and have the proper tonal range from light to dark. This includes black-and-white photographs. At this stage in their development, 35mm slide scanners are not recommended for press. They usually don't capture enough dpi for use at sizes larger than 2 x 2in (5.08 x 5.08cm). When using a flatbed scanner, the flatbed should capture 1,200 dpi uninterpolated or higher, and the image should be at least 4 x 6in (10.16 x 15.24cm). The larger the original image, the better the quality from flatbed scanners.

Having the right tool to color correct photographs is paramount, and there is no better application program for this than Adobe Photoshop. Once you have scanned the image and saved it in the right color mode (RGB, CMYK, or grayscale), you should determine the proper contrast. There are several ways to achieve this through Photoshop. The first step is to try using the Auto-contrast and Auto-level features under Image in the main menu. Fifty percent of the time, this feature will properly orient the image for Web-based

Figure 11 It is just as important to properly color correct an illustration for press as it is a photograph. Similar hues, such as Armstrong's right hand and the background, will be jeopardized without correct calibration, and will decrease the depth of field.

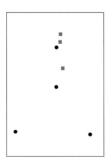

● Highlight areas (2–3% of color)
■ Shadow areas (98% of black and no greater than 300% of color)

Diagram 11 Left: This diagram depicts the shadow and highlight areas in the illustration above. Although areas of the illustration may appear to be white, the percent of color never reaches zero. Likewise, the shadow areas never exceed the recommended 300%.

production and motion graphics. For press, however, dropout and dot gain must be taken into account. If these automated features do not properly color correct the image for press, open the Information dialog box under Windows in the main menu of Photoshop. The Information dialog box allows you to read the color builds found within the image at any given point. For press, the highlights and lowlights/shadow areas within the image should be properly determined, and their builds should be retrieved. The general rule for highlighted areas is no less than 2–3 percent of color information for each channel, totaling no less than 8 percent. (Color information is the amount of image data found on each channel—use the Information dialog box under Window in the main menu to retrieve this information.) This will alleviate most of the dropout on press. On press, 2–3 percent typically translates to 0 percent color information. In other words, if the image is not properly adjusted for press, a 5 percent highlight area will appear on press anywhere from 0–2 percent, resulting in the dropout of a considerably large tonal area.

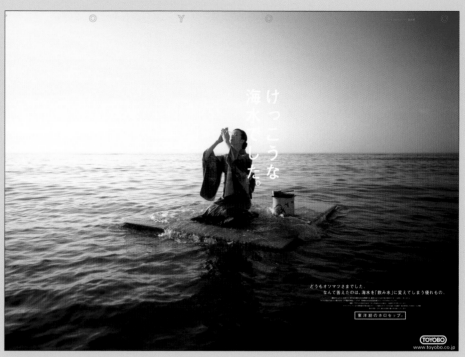

Figure 12
Studio Katachi
Creative Director Hiroshi Akai
Art Director Kunikazu Hoshiba and Akira Sanjobs
Designer Kunikazu Hoshiba

Figure 12 The photograph in this piece utilizes the prescribed range of color build. Only the typography drops out to the white of the paper (0%), bringing it to what appears to be a layer on top of the image.

● Highlight areas (2–3% of color)
■ Shadow areas (98% of black and no greater than 300% of color)

Diagram 12 Left: The shadow and highlight areas of the photograph, not the typography, are depicted in this diagram.

12	type	C44	M33	Y96	K38	
	bgd	C35	M15	Y6	K1	
12	type	C67	M51	Y48	K84	
	bgd	C44	M33	Y96	K38	
12	type	C35	M15	Y6	K1	
	bgd	C67	M51	Y48	K84	

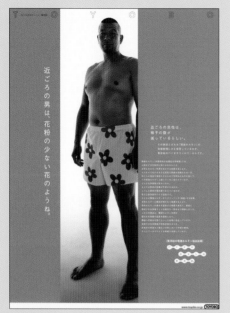

Figure 13
Studio Katachi
Creative Director Hiroshi Akai
Art Director Kunikazu Hoshiba and Akira Sanjoba
Designer Kunikazu Hoshiba

For press, the general rule for dark areas is no more than 98 percent color information. By properly adjusting the contrast to achieve this percentage, dot gain will be counteracted on most coated and less absorbent papers. If you are using a highly absorbent paper, a maximum of 94–97 percent is recommended: on absorbent papers, these areas will completely fill, creating a solid, 100-percent color field. If you cannot meet these general rules for press through the automated features mentioned above, you will need to adjust the Brightness and Contrast feature under Image in the main menu of Photoshop. Using this feature, along with the Information dialog box, will ensure that the image has the proper contrast and color for press.

Duotones, Fake Duotones, and Tritones

For duotones, fake duotones, and tritones, a few more steps must be taken in order to properly color balance and color correct images. Prior to the mid-1980s, duotones were created with two separate pieces of film, one for each color. Each piece was taken from the original image and exposed to light differently to create the base art. In Adobe Photoshop this is no longer the case. A duotone is created from one piece of film or one channel and split onto two pieces of

film for press. Therefore, color correcting a duotone, fake duotone, or tritone in Adobe Printer creates visual verification problems. In other words, when using two spot colors, including black and another, what appears on the computer screen is not what will appear on press.

Verifying Spot Colors

You can use several methods to create a document, all of which allow for visual verification when color correcting a duotone, fake duotone, tritone, or setup for press. The first is to refer to a color guide. PANTONE offers a duotones guide for both coated and uncoated colors—the PANTONE Studio Edition Duotone Guide. Each duotone color combination offers four distinct, curved setups for black and another spot color, and the guide offers a comprehensive compilation of 11,328 setups, with an explanation of how to work with duotone curves in Photoshop. This information is excellent when you are working with duotones created with black and another color. However, many duotones are created with two spot colors, such as PANTONE 102 and PANTONE 2415.

Both PANTONE hues—102 and 2415—fall within the CMYK color gamma. The method listed below works only with spot colors that fall within the CMYK color gamma.

Figure 13 Depth of field and coolness is increased in this image with the use of a duotone made up of black and a hint of blue.

a

b

c

Diagram 13 (a–c) This fake duotone (13a) is created using two spot colors that fall inside the CMYK color gamma. In the new PANTONE® formula guide printer's edition, the spot hues that are achievable in four-color process are indicated.

Images 13b and 13c create the composite duotone in 13a. The curve setting for the color in 13b is 0:100% and for the color in 13c, 100:100%. By setting the curve in this manner, a solid color field of yellow is created behind the flower.

13	type	C4	M2	Y3	K0
	bgd	C3	M89	Y4	K0
13	type	C3	M89	Y4	K0
	bgd	C59	M48	Y47	K48
13	type	C59	M48	Y47	K48
	bgd	C4	M2	Y3	K0

BG Background color　C3　M89　Y4　K0　30%

(A method for dealing with spot hues that cannot be matched by the four-color process is described later in this chapter.) There are two ways in which to verify whether a spot color falls within the CMYK gamma. The easiest is to check in one of the color guides that display which spot colors meet this requirement. PANTONE's solid to process guide is such a book.

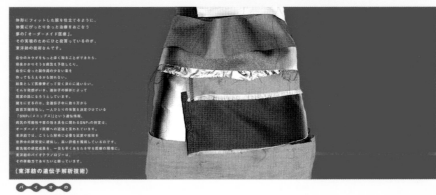

Figure 14
Studio Katachi
Creative Director Hiroshi Akai
Art Director Kunikazu Hoshiba and Akira Sanjoba
Designer Kunikazu Hoshiba

Figure 14 All but the test tubes in the woman's hands are comprised of tints of black on a masked red background. The liquid in the test tube is a duotone of red and black, providing stark contrast with the woman, and harmony with the red background.

14	type	C0	M0	Y0	K79
	bgd	C3	M3	Y3	K0
	type	C0	M98	Y78	K0
	bgd	C0	M0	Y0	K79
14	type	C3	M3	Y3	K0
	bgd	C0	M98	Y78	K0

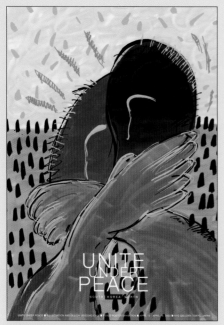

Figure 15
Art Director/Designer Inyoung Choi

A less expensive way to visually verify if a spot color falls within the CMYK gamma is to use the QuarkXPress Colors features under Edit in the main menu. This cannot be done with other common software programs used in the design field—as QuarkXPress is specifically designed for print production, it offers a color palette unlike any other software program. Using the Colors features in QuarkXPress, you can simulate any solid-to-process guide for any color-matching system, including PANTONE, Toyo, TRUMATCH, and Focoltone.

1. Open the default colors dialog box by clicking on Colors under Edit in the main menu.

2. Within this dialog box click on New, choose the spot color to be verified, and click OK. This will return you to the default colors dialog box.

3. Choose Edit within this. This will return you to the Edit Colors dialog box.

4. Choose the CMYK mode under Model. The spot color along with the four-color process equivalent will appear in the New and Original color swatch section within this dialog box, allowing for visual verification. If the two colors match,

the spot color can be created within the CMYK gamma. If the two colors do not match, then the method listed below will not give an accurate color appearance. In this case, the method for dealing with spot colors that fall outside of the CMYK gamma should be used (see page 186).

Quite often in print-based graphics, duotones are used and converted to the CMYK mode. This is usually done to decrease the amount of inks specified for a particular job. For example, instead of running a six-color job—two spot colors used with a four-color process—the job can be reduced to four colors. In such cases, if the spot colors specified fall outside of the CMYK gamma, the duotones will more than likely be out of color balance and flat. A designer choosing to create a duotone knowing that it will be converted to the CMYK mode should select colors that fall within the CMYK gamma.

Creating Duotones Within CMYK Color Gamma
When you create duotones with two spot colors other than black, you need to follow the method below in order to create an accurate color appearance for final output. The PANTONE Studio Edition duotone curves can also be used with any image in Photoshop by loading the setting.

Figure 15 This poster makes use of the wide range of color possibilities available in four-color process printing to communicate a sense of unity across diversity.

1. Create a duotone using the spot colors, for example 102 and 2415, in Photoshop.

2. Open up the original grayscale image and create a monotone using 102.

3. Create a 2415 monotone using the same grayscale image as for Step 2.

4. Copy each monotone into a new CMYK document in Photoshop. There should be two layers, each having a monotone image and a background layer (white).

5. Click on layer 2 to make it active, then apply Multiply under Normal in the Layers dialog box. This allows you to see how the two spot colors are overprinting in Photoshop in process color. At this point a difference in color between the Photoshop duotone and the hybrid facsimile just created should be discernible. Check any PANTONE coated or uncoated spot colors against the

Figure 16
Art Director/Designer Myung-Sik Rhoo

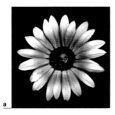

a b c d

Diagram 14 (a–d) Traditional duotones are created from one grayscale image (14a). The image is then separated into two spot-color channels (14b and 14c) which are overprinted to create the final composite duotone (14d). This duotone is achieved through the default settings in Photoshop.

Figure 16 This poster uses a narrow color field effectively. The poster appears to have layers of depth and the eye seems to spin like the world because our mind's eye perceives motion as the oriented moving slits. This, in combination with the planes of color, forces a shift in perspective from foreground to background.

16 type C97 M93 Y88 K57 / bgd C42 M33 Y36 K1
16 type C42 M33 Y36 K1 / bgd C97 M93 Y88 K57
16 type C0 M0 Y0 K0 / bgd C55 M22 Y12 K0
16 type C55 M22 Y12 K0 / bgd C0 M0 Y0 K0

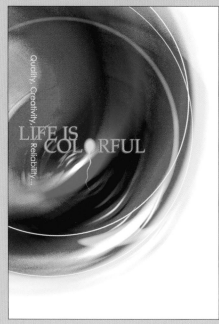

Figure 17
Art Director John T. Drew
Designer Sisi Xu

PANTONE solid to process guide to see if they match, or use the QuarkXPress color method stated above. The duotone facsimile created in the CMYK mode is more color accurate than the Photoshop duotone and can be used as a guide to color correct the Photoshop duotone image for press. (The CMYK duotone facsimile is created from two grayscale images unlike its Photoshop counterpart, thus creating a color facsimile closer to what will appear on press.)

6. If the spot colors match the CMYK color gamma, color correct each layer in the Curves dialog box, under Image in the main menu of Photoshop, and save both curves settings. Keep the image in CMYK mode and don't add any channels.

7. Click back on the Photoshop duotone and reopen the duotone setting under Image in the main menu.

8. Click on each duotone Curve setting individually. The duotones matrix will appear.

9. Load the curves setting saved for each color. The duotone will now be properly color corrected.

Creating Duotones Outside CMYK Color Gamma

When creating a duotone outside the CMYK color gamma, you need to set up the computer monitor differently so that it holds, or emits, only the colors that are specified for creating the duotone. A large percentage of spot colors are outside the CMYK color gamma. The primaries that make up these colors have a higher chroma rating than those that can be created through process colors. Therefore, the computer monitor color primaries need to be changed to accurately reflect the chroma value of each individual duotone. Two of the CMYK color primaries within Photoshop must be altered each time a duotone is created, as outlined below.

1. Open a grayscale image or convert a CMYK image to grayscale.

2. Convert the grayscale image to the duotone setting under Image in the main menu of Photoshop.

3. Select the Duotone mode in the Duotone Options dialog box.

4. Select the two spot colors to create the duotone. Do not adjust the curve settings.

Figure 17 This poster uses the pure printing colors to highlight the capabilities and quality one can achieve from the traditional four-color printing process.

a b

Diagram 15 (a and b) Creative control of the highlight and shadow dots can be accessed through Photoshop curves. The curves in 15a have been manipulated whereas 15b uses the default settings.

17	type C0 M0 Y0 K0 / bgd C0 M100 Y0 K0
17	type C100 M100 Y0 K0 / bgd C100 M0 Y0 K0
17	type C0 M100 Y0 K0 / bgd C100 M100 Y0 K0
17	type C100 M0 Y0 K0 / bgd C0 M0 Y0 K0
BG	Background color C7 M71 Y6 K6 50%

5. After selecting the two spot hues, click back on each color, then click on Picker and write down the individual L*a*b values for each spot color.

6. Click on the overprinting in the bottom of the Duotone Options dialog box.

7. Click on the color swatch found in the Overprinting dialog box, then click on the Picker and write down the L*a*b values of the overprinting color.

8. Open the duotone.

9. Under File in the main menu, scroll down to Color Settings and select the CMYK setup.

10. Under the CMYK Setup dialog box, select Custom within the Ink Colors slot. (For each Photoshop version, acquiring the Ink Colors dialog box is somewhat different. It is usually found under Preferences or Color Setup under File in the main menu of Photoshop.)

11. Click on the L*a*b coordinates at the bottom left of the dialog box. The L*a*b setting must be activated in order for this process to work.

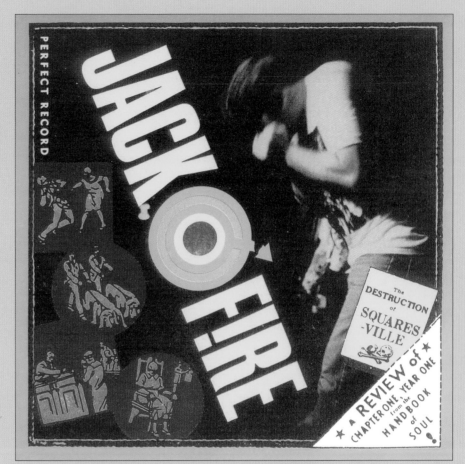

Figure 18
Art Director/Designer Art Chantry

Figure 18 The high contrast of the fake duotones above lend vibrancy to the album cover.

18	type **C6**	**M0**	**Y100**	**K0**
	bgd **C7**	**M71**	**Y6**	**K6**

18	type **C7**	**M71**	**Y6**	**K6**
	bgd **C84**	**M53**	**Y66**	**K50**

18	type **C84**	**M53**	**Y66**	**K50**
	bgd **C6**	**M0**	**Y100**	**K0**

Figure 19
Art Director/Designer Art Chantry

12. In the Ink Colors dialog box, enter the L*a*b values for the first duotone color in the three cyan slots.

13. Enter the second duotone color in the three magenta slots.

14. Enter the overprinting duotone color in the three cyan/magenta slots.

15. Click OK in the Ink Colors dialog box.

16. Save the ink color settings by clicking on Save in the CMYK Setup dialog box, then click OK.

17. Open the original grayscale image, copy it to the clipboard, then close the grayscale image.

18. Open a new CMYK document in Photoshop. Copying the original image on the clipboard will prompt Photoshop to automatically create a document the size of the original grayscale image.

19. Paste the original grayscale image into the cyan and magenta channels.

20. Select and delete any information on the yellow and black channels in the document. Do not delete the channels— erase the information on them.

21. Click on the composite CMYK channel to view the facsimile duotone. If the spot colors chosen are outside of the CMYK color gamma the Photoshop duotone, already open on the computer screen, and the facsimile duotone color composite should look dramatically different. The facsimile duotone is an accurate color representation for press.

22. Within the facsimile duotone, click on the cyan channel and open the Curves dialog box.

23. Adjust the curve setting and save it to the appropriate folder.

24. Once the cyan channel curve setting has been saved click OK.

25. Repeat steps 22–24 for the magenta channel.

26. Within the Photoshop duotone, load the curve settings for each spot color and save the document. The duotone is now mechanically ready for press.

Pantone has done an outstanding job in compiling 11,328 different duotone curve settings for use with its colors. These curve settings can also be used by loading the desired settings in steps 23 and 26.

Figure 19 In this tritone, a flat field of yellow is flooded onto the background to create orange and green. The line pattern is then knocked out of cyan and magenta to reveal yellow. In this example, the additional knock out of white type adds a layer of complexity.

a

Duotone

b

Cyan channel

c

Magenta channel

Diagram 16 (a–e) Spot colors are often outside the CMYK color gamma, however, duotones created with spot colors can be designed in a CMYK document. The advantage is that the channels can be directly accessed in a CMYK document. This diagram depicts the information that is on each channel (16b–e) to create the duotone in 16a. Notice that some channels carry 0% information.

19	type C0 M0 Y0 K0 bgd C0 M36 Y100 K0	
19	type C0 M36 Y100 K0 bgd C0 M0 Y0 K0	
19	type C49 M2 Y100 K0 bgd C2 M11 Y99 K0	

19	type C2 M11 Y99 K0 bgd C49 M2 Y100 K0

BG	Background color	C2	M11	Y99	K0	50%

Furthermore, the settings can be used
with other ink-matching systems, such
as TRUMATCH, Focoltone, and Toyo. To
use these curves effectively, select colors
that are similar in value and chroma. The
hue does not need to match. By altering
the two hues that create the duotone, the
secondary and tertiary colors, and their
corresponding tints, will be different.

Figure 20
Art Director/Designer Art Chantry

d — Yellow channel e — Black channel

Figure 20 Flooding the
background with one color
is the most traditional and
respected method of creating
a fake duotone.

20	type	C40	M94	Y69	K60
	bgd	C0	M0	Y0	K0

20	type	C7	M79	Y69	K1
	bgd	C40	M94	Y69	K60

20	type	C0	M0	Y0	K0
	bgd	C7	M79	Y69	K1

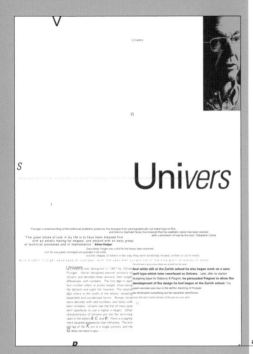

Figure 21
Designer Carol Sogard

Creating Duotones for Overprinting Electronic Mechanicals

If you are creating a document in which you want to overprint two spot colors, the electronic mechanical needs to be set up differently from the document for the client proof. For example, to create a brochure using two spot colors that will overprint, including large display type, flat color fields, 0.5–1.0pt rules, and duotones, the document must be set up properly. Chapter 5 explains how to create a document that will overprint in any application program. Adding to this, you can create highly effective Photoshop duotones using cyan and yellow, which you can then import into the two-color overprinting brochure.

The method described for creating duotones outside the CMYK color gamma can be used to create a document that will overprint. However, an additional Photoshop duotone must be created using the CMYK process colors cyan and yellow. In other words, three duotones need to be created for this process. The first is a Photoshop duotone utilizing the actual spot colors, the second is the facsimile duotone to verify how the colors will react to one another on press, and the third is the mechanical duotone made from cyan and yellow. After you have created the basic cyan and yellow duotone, load the curve settings, save the document,

and import the cyan and yellow duotone into the application used to produce the overprinting electronic mechanical. The procedure for creating tritones is the same, but with the addition of the magenta plate for the third color.

Creating Fake Duotones

For fake duotones only one curve setting needs to be saved, not the solid color. Under Duotones in Photoshop, set the curve setting for the spot color solid. In the duotones matrix set the "0" setting at 100 and the "100" setting at 100. This will ensure that the second color of the duotone prints 100 percent of color. When creating fake duotones, the darker of the two halves should always be the continuous-tone image. The process for color verification and mechanical preparation is as described above.

Figures 21 (a and b) and 22
The color palette and duotones unify these posters. Used well, minimal color will add to the composition and create a sense of wayfinding through a series of information.

Diagram 17 In this diagram the type size is 5pt and the typeface is Univers Bold 65. For silk-screen printing, the type size must be a minimum of 9pt, and the typeface must be monoweight, with no serifs.

Diagram 18 To insure a good four-color press run, knockouts should be simple so that they include as few of the process colors as posssible. In this example, yellow and magenta are used, and the color/type registration is only held in the magenta plate. Process yellow is at 100% of color for both hues.

Diagram 19 In this example, the type is 30% of the background color red. Registration is necessary because the type and background color is made from yellow and magenta.

| 21 | type **C**60 **M**51 **Y**49 **K**62 |
| | bgd **C**0 **M**0 **Y**0 **K**0 |

| 21 | type **C**49 **M**10 **Y**25 **K**3 |
| | bgd **C**60 **M**51 **Y**49 **K**62 |

| 21 | type **C**0 **M**0 **Y**0 **K**0 |
| | bgd **C**49 **M**10 **Y**25 **K**3 |

| BG | Background color **C**49 **M**10 **Y**25 **K**3 10% |

Type Reversals and Knockouts with Solids, Tints, and Shades

When setting up a document for press, the little formal details are the elements that cause printers fits. They are most often also the elements overlooked by designers, and tend to create readability, legibility, and registration problems. Some simple rules, when applied properly, can facilitate the process of setting up the mechanical for press.

Type Reversals

Reverse type is when type is dropped out to the color of the paper from a solid color. Type reversals can also be dropped out of color tints in shades. For example, a type reversal with a color tint or a solid orange on white paper will more than likely not be legible because either the color tint or the solid orange does not have a 40-percent differential from the white paper. Each paper stock has a brightness rating or color value number that can easily be obtained from a paper representative or a paper swatch.

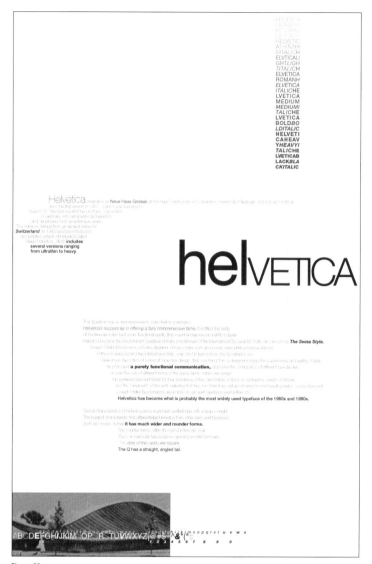

Figure 22
Art Directors Carol Sogard and Raymond Morales
Designer Carol Sogard

Diagram 20 In this example, 15% black is added to both the type and background colors to aid in registration (100% magenta, 100% yellow, and 15% black).

M plate Y plate K plate

The three small squares are a breakdown of how the composite, large square, is made and printed.

	type				
22	type	C60	M51	Y49	K62
	bgd	C0	M0	Y0	K0
22	type	C49	M10	Y25	K3
	bgd	C60	M51	Y49	K62
22	type	C0	M0	Y0	K0
	bgd	C49	M10	Y25	K3

Figure 23
Art Director/Designer Carol Sogard

The color in which the type reverses is also an issue with type reversals. There is usually not a problem if the color is pure, semipure, or a spot color, but there can be a problem mechanically when dealing with four- and six-color processes. If the color in which the type reversal is to take place is made from all four six process primaries, it will be very difficult to hold the job in register on press, especially with small type. The solid color background in which a type reversal takes place should not be made from more than two of the process primaries. This may seem limited, but with the addition of color tinting there are thousands of colors to choose from. If color shading (the addition of black) is desired, one of two strategies can be employed in order to create a proper electronic mechanical. If there are already two colors making up the solid background, then color shading should be applied uniformly to both the background and the reversed type. In this case the type is no longer a reversal, but rather, a type knockout, and registration is still held to only two plates. Because black is uniformly applied, registration is not a problem. The second strategy is to eliminate one of the two colors and replace the second color with the shading addition of black.

Type Knockouts

Type knockouts are when type is cut out of a background color and replaced with another hue. For example, white type on a red background is a type reversal (white being the color of the paper), where purple type on a red background would involve a knockout. This example is one that is easy to hold on press. As each color, purple and red, is built from 100 percent magenta, there are no registration issues with this plate, only with the cyan and yellow plates. The two-color rule should also be applied in these scenarios, using pure and semipure colors. If the background color is so dirty or muddy that a large percentage of black is being utilized (giving a color value of 0–20 percent), you can construct a decent trap to negate the two-color rule, allowing all process primaries to be utilized.

When using small text type with tints and shades, the most typical scenario is black type on a background that has 80–100-percent color value. Black has a color value rating, in printed form, of 10–15 percent, creating a color value differential of no less than 65 percent. This scenario is always a safe bet because it eliminates registration problems, and legibility issues are not a concern. The rule to apply when using a solid color, other than black, on a tinted background is to keep the color value

Figure 23 This pattern uses the most traditional knockout in which the type is reversed to the white of the substrate.

23	type	**C0**	**M61**	**Y39**	**K30**			23	type	**C0**	**M23**	**Y76**	**K0**
	bgd	**C0**	**M23**	**Y76**	**K0**				bgd	**C34**	**M27**	**Y51**	**K0**

23	type	**C34**	**M27**	**Y51**	**K0**
	bgd	**C0**	**M0**	**Y0**	**K0**

23	type	**C0**	**M0**	**Y0**	**K0**
	bgd	**C0**	**M61**	**Y39**	**K30**

BG	Background color	**C34**	**M27**	**Y51**	**K0**	50%

differential to a minimum of 40 percent,
but this may not eliminate registration
problems. To guard against both legibility
and registration problems, the background
color should always have a color value
rating of 80 percent or higher, and the
type color should always have a rating of
20 percent or less. This creates a 60-percent
color value differential, which eliminates
registration problems. The type color will
be so dirty that it can be overprinted with
little adverse effect.

Building colors that are made up from more
than two primaries can lead to registration
problems on press. You should always take
this into consideration when deciding which
colors are going to be placed where on the
electronic mechanical. Most often, simple
adjustments to the electronic mechanical
will make the press person's job much easier
and eliminate costly mistakes.

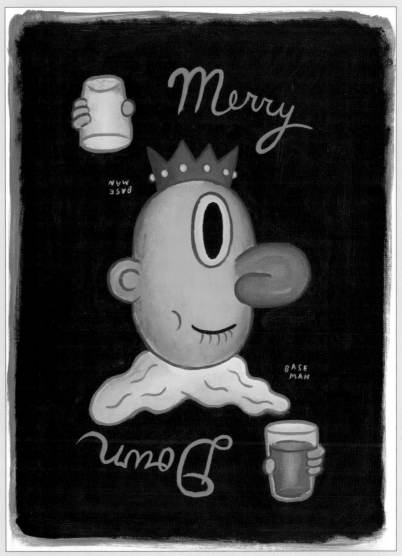

Figure 24
Creative Director David Dye
Typographers David Wakefield and Mike Pratley

Figure 24 Complex
illustrations or simple graphics
undergo similar printing
technology. The effectiveness
of their communication is
dependent on adherence to
the techniques proven to
achieve quality.

24	type	C0	M71	Y32	K0
	bgd	C86	M79	Y82	K75

24	type	C84	M58	Y14	K2
	bgd	C25	M12	Y33	K0

24	type	C86	M79	Y82	K75
	bgd	C0	M71	Y32	K0

24	type	C25	M12	Y33	K0
	bgd	C84	M58	Y14	K2

7 Behavioral Effects of Color

Physical, psychological and/or learned behavioral attributes
can be assigned to all colors. Depending upon the culture in
which an individual is raised, different colors will convey a certain
meaning. With this in mind, we have limited our discussion here
to Western cultures. Within the fields of design, the physical and
psychological effects of color have not been widely taught. More
often than not, designers are taught to tell people how they should
feel about art, including color, regardless of any scientific basis.

Throughout history, humans have assigned meaning to color,
both consciously and unconsciously, in order to understand and
define the environment around them. Modern medical science
has been actively pursuing the understanding of physical,
psychological, and/or learned behavioral effects associated with
color for more than a century. Anthropologists and historians
have also been studying the effects of color on human endeavors.
To ignore this wealth of color information is to overlook the most
powerful communicative tool designers have.

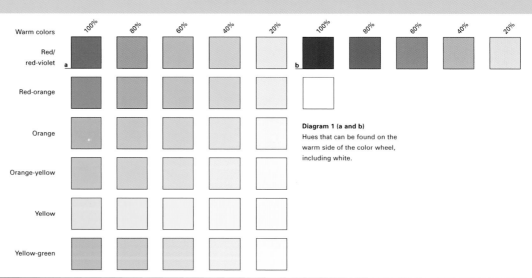

Figure 1
Art Director/Designer Hiroyuki Matsuishi

Micro Color Responses

Color affects humans physically because of its psychological associations. These effects can be classified according to two general categories of color—warm and cool. Three basic responses to color are associated with human behavior: motor, glandular, and conscious. Each of these responses holds clues to human reactions. Muscular contraction or relaxation as a response to color is referred to as a motor response. With a glandular response, particular glands in the body are activated, which prompts a chemical secretion that brings about a specific change in the body. With a conscious response, the activation is in the brain, and the viewer is immediately aware of the response. Warm colors possess a longer wavelength than cool colors. In general, warm colors (red, red-orange, orange, orange-yellow, and white) elicit a response of warmth and hardness, whereas cool colors (blue, blue-green, and green) tend to elicit a response of cold and scattered or diffuse space. Both warm and cool colors evoke a conscious response. (There is evidence to support that this may be a learned cultural response.)

Figure 1 The delicate, furry lines, and the absence of facial detail reinforce the psychological effects associated with the hue chosen for the background (gentle, good spirit, soft, fuzzy, delicate, undetermined, obscure, and unclear). Both the drawing and the choice of hue reflect the demeanor of the animal and its future.

Warm colors	100%	80%	60%	40%	20%	100%	80%	60%	40%	20%
Red/ red-violet	a					b				
Red-orange										
Orange										
Orange-yellow										
Yellow										
Yellow-green										

Diagram 1 (a and b)
Hues that can be found on the warm side of the color wheel, including white.

1	type **C1** **M0** **Y0** **K0**	
	bgd **C0** **M50** **Y51** **K0**	
1	type **C0** **M50** **Y51** **K0**	
	bgd **C1** **M0** **Y0** **K0**	

BG Background color **C0** **M50** **Y51** **K0** 80%

Motor and Glandular Responses

An individual placed in a high-chroma red room will experience, for a short period, accelerated heart rate, and an increase in blood pressure, pulse rate, respiration rate, and muscle reaction rate. This is a motor response. Low-chroma greens and blues cause the opposite effect, slowing down muscle reaction time, calming nerves, and generally relaxing the body. However, this response can be counteracted if the chroma level of secondary and primary greens and blues is intensified. Both of these color categories, warm and cool, also trigger galvanic skin responses. The skin's response, its resistance to color, indicates the immediate emotional reaction of an individual to color. The higher the chroma rating in both categories, the greater the motor response induced.

Psychological Responses

The psychological effects of any color can be altered by changing its chroma, tinting, purity, saturation, shading, and texture rating. For example, the intensity or chroma of a color is significant in triggering arousal or excitement irrespective of hue. The perception and interpretation of color is very complex and can be altered by properties not normally associated with color, for example, silhouette/form, depth, and motion of an object. The psychological interpretation of color is not a precise language, but in general, along with all other factors associated with visual communication, color can be used to shape visual messages.

There is some evidence to support that for children, grades 1 through 6 (4–10 years of age), blues and reds are highly desirable colors. In general, red is preferred over blue in grades 1 through 3, but blue is preferred over red in grades 3 through 6. Color preference is also gender related: boys

Figure 2
Art Director/Designer Koshi Ogawa

Figure 2 The broad, simplistic strokes coupled with the high-chroma blue background create a powerful, lively, electric, energetic, dynamic, and strong composition.

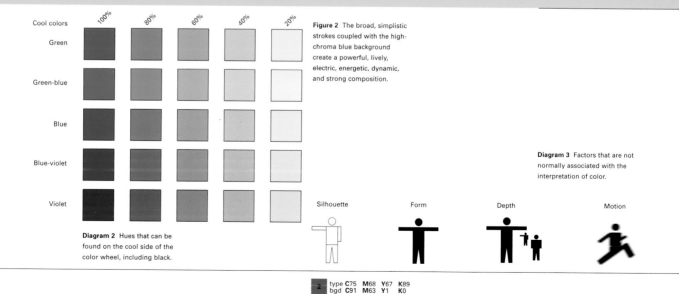

Diagram 2 Hues that can be found on the cool side of the color wheel, including black.

Diagram 3 Factors that are not normally associated with the interpretation of color.

Figure 3
Art Director/Designer Hiroshi Mitsuishi

prefer (in order of preference) blue, red, green, violet, orange, and yellow; girls prefer blue, green, orange, violet, red, yellow, and white. High-chroma primary and secondary colors are preferred by all schoolchildren over muddy and neutral gray colors. Saturated reds and blues are preferred over shades and tints of reds and blues. When children enter their teens, warm colors are still preferred over cool, but as they grow, their color preference develops with them. Children less than a year old have no color preference, supporting the statement that the emotive responses to colors are cultural, and that we often have a physical response opposite to what is culturally learned. Adult men prefer blue, violet, and green, whereas adult women prefer red, orange, and yellow. For both men and women, color value differential is paramount in the preference of color combination —the more contrast, the more pleasing the combination. However, compositional balance also plays an important role in influencing a pleasing color value differential (CVD). The greater the CVD, the greater the kinetic energy within the composition.

The appearance of color can also influence the perception of taste. Color taste preferences and color associations are influential in the success or failure of a product, an important consideration in food packaging. In general, yellow and yellow-green have a low appetite rating, whereas orange, red, white, and pink foods are perceived as being sweeter. In a study conducted with wines, white and pink were perceived to be sweeter than wines colored yellow, brownish, or purple, regardless of actual taste. Foods not conforming to preconceived ideas tend to be rejected. For example, any natural food dyed an unnatural color will be rejected by most consumers. White foods and white packaging are seldom chosen. Foods and food packaging in the blue-green family need to be handled with care. Blue-green is typically associated with mold and mildew. Nature does not create many edible foods that are colored a high-chroma blue, light blue, or blue-green, and therefore most consumers find blue food unnatural; it elicits a strong negative response correlating to an appetite suppressant. There may be a self-preservation correlation associated with blue and blackish-purple foods—many poisonous fruits and berries have these hues.

Red and orange fruit juices are perceived to be sweeter than juices of other colors. If food coloring is added to juices to intensify the chroma, the juices are perceived as sweeter, regardless of actual

Figure 3 (a and b)
The two liquor bottles above were designed to create a dignified tone through the use of hue choice both within and on the bottle. The chosen hue has an excellent rating for packaging.

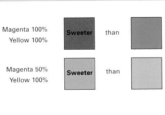

Magenta 100% Sweeter than
Yellow 100%

Magenta 50% Sweeter than
Yellow 100%

Diagram 4 The higher the chroma color, the sweeter the perception.

Diagram 5 Poisonous fruits and berries are typically these colors.

3a	type C0 M4 Y60 K0	3b	type C0 M12 Y60 K0		BG	Background color	C54 M25 Y19 K8	50%
	bgd C23 M36 Y77 K24		bgd C21 M33 Y62 K16					
3a	type C13 M71 Y96 K23	3b	type C33 M26 Y3 K0					
	bgd C0 M4 Y60 K0		bgd C0 M12 Y60 K0					
	type C23 M36 Y77 K24	3b	type C21 M33 Y62 K16					
	bgd C13 M71 Y96 K23		bgd C33 M26 Y3 K0					

taste. With baked goods (breads, cereals, and nuts), a medium golden-brown is expected by consumers, and many of these products have golden-brown labels and packages as well.

Not everyone responds to color in the same way. There is evidence to support that, depending upon a person's innate personality, a color may produce an effect opposite to the typical stimulus response. A person who is more naturally introverted may not feel comfortable in an environment of high chroma, and this may induce a reaction opposite to what normally happens. The same can be said for someone who is excitable; placing such an individual in a room decorated with low-chroma hues will serve only to make them uncomfortable. For interior and environmental graphic designers, understanding the personality traits of the individual is critical for success. In other words, both the culture and the individual within the culture must be taken into consideration. Having the client answer a series of questions designed to profile his or her personality traits will help you uncover a suitable solution.

It is said that color influences the perception of noise, temperature, weight, time, and volume. Color can change not only the mood of a person within a given environment, it can also alter their perception of space. For example, cool and dark colors, regardless of hue, can make a room seem smaller; warm and light colors produce the opposite effect. Color may also influence the perception of time. A 1975 study conducted by Dr. Goldstein indicated that individuals placed under red light tended to overestimate time, whereas those placed under green or blue light underestimated it. The relationship of light/color to humans is a very complex and powerful one. Designers may tailor color to evoke a more meaningful response. However, when this is not possible, for example, with design for the masses, understanding the cultural norms of the intended audience is paramount in creating an effective design solution. Regardless of whether a particular color has psychological associations for the audience or whether the response is simply learned, there is a wealth of responsive color information that can govern informational color palettes.

Figure 4
Art Director/Designer Koshi Ogawa

Figure 4 The high-chroma red family has negative associations—brutal, war, tension, and hatred—that in this case reinforces the concept within the illustration.

	type C0	M0	Y0	K0		type C93	M79	Y35	K23
4	bgd C93	M79	Y35	K23	4	bgd C0	M0	Y0	K0
4	type C75	M68	Y67	K88					
	bgd C31	M90	Y71	K29					
4	type C31	M90	Y71	K29					
	bgd C75	M68	Y67	K88					

Figure 5
Designer Babette Mayor

Macro Color
Associations

Color must be placed in context in order to understand the implications associated with its meaning. Other factors that influence a color's associative interpretation are form/silhouette, motion, and depth. These four factors—hue association, form/silhouette, motion, and depth—create a complete mental picture, one that can be amplified, de-emphasized, associated with, or learned. In very general terms, each of the above factors, including color, can be broken apart and used separately to convey messages and prompt emotions, associative responses, and/or learned behavior.

Figure 5 A surrealistic photograph that emits a paradox of emotions.

	type C58 M61 Y65 K44		type C2 M0 Y0 K0
	bgd C5 M100 Y100 K1	5	bgd C85 M63 Y0 K0

	type C85 M63 Y0 K0
5	bgd C2 M0 Y0 K0

	type C5 M100 Y100 K1
	bgd C58 M61 Y65 K44

BG	Background color	C85 M63 Y0 K0 20%

	High-chroma red family	**Dark red family** (burgundy, brick-red)	
positive associative responses	Surging, brilliant, intense, energizing, sexy, dramatic, stimulating, fervid, active, cheer, joy, fun, aggressive, hope, powerful, hotness, excitability, solid, aggression, provocative, strength, virility, masculinity, dynamism, imposing, dignity, benevolence, charm, warm, overflowing, ardent, power, not dissipating, irresistible, extrovert, saints, patriots, compassion, counteraction, comedy, vigor, severe, traditional, fire, opaque, dry, hot, heat, blood, Christmas, Fourth of July, St. Valentine's Day, Mother's Day, flag, passionate, excitement, happiness, love, school, dignity, charm, graciousness	Rich, elegant, refined, taste, expensive, mature, earthy, strong, warm, country, serious, important, passive, grown, ripe, developed, experience, sincere, earnest, selective, exquisite, wealthy, worldly, significant	Positive associative responses
negative associative responses	Brutal, war, restless, tension, sinners, communists, anarchists, hate, melancholia, anger, falling profits, red herring, fire, intense, opaque, dry, heat, blood, danger, Christmas, Fourth of July, St. Valentine's Day, Mother's Day, flag, rage, fierceness, rapacity, pain, hunger, revolt, aggression	Serious, problematic, passive, doubtful, ambiguous, uncertain, submissive, inactive, grave	Negative associative responses
appetite rating for package design	Excellent	Poor	Appetite rating
associative taste	Very sweet	No associative taste	Taste
	(6) 000/100/100/000	(7) 010/100/095/000	

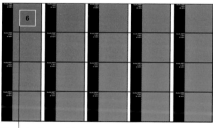

Chosen hue from matrix for the high-chroma red family.

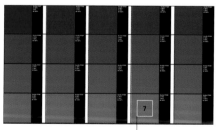

Chosen hue from matrix for the dark red family.

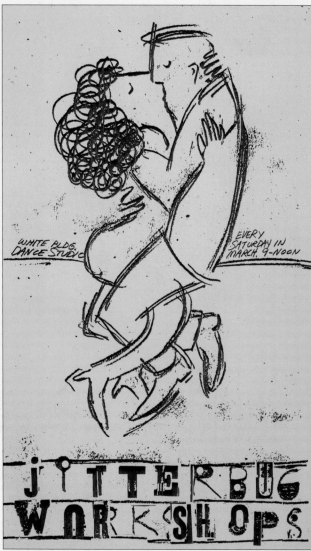

Figure 6
Art Director/Designer/Illustrator Lanny Sommese

Figure 6 A sentimental
favorite, the Jitter Bug poster
displays an excellent use
of color.

Earth-tone red family

positive associative responses	Warmhearted, rural, rustic, earthy, warm, wholesome, country, welcome, good, healthy, fit, sound
negative associative responses	Earthy, country, rural, rustic
appetite rating for package design	Poor
associative taste	No associative taste

(8) 040/075/075/000

Chosen hue from matrix for
the earth-tone red family.

6	type **C47 M91 Y53 K49** bgd **C4 M45 Y0 K0**	BG	Background color C0 M28 Y7 K0 50%
6	type **C4 M45 Y0 K0** bgd **C47 M91 Y53 K49**		

Mid-range pink-red family	High-chroma pink family	Pastel pink family	
Restrained, toned down, soft, subdued, quiet, sentimental, sober, tame, domestic	Stimulating, aggressive, genial, exciting, happy, high, fun, excitement, attention-grabbing, promising, color of love, energetic, youthful, spirited, fun, trendy, wild, bright, hot, high-energy, sensual, cheer, joy	Soft, sweet, tender, cute, comfortable, snug, rarefied, delicate, female babies, cozy, subtle, animated, energetic, joyful, beautiful, expressive, emotional, shy, romantic, feminine, gentle, affectionate, intimate, active, guileful	Positive associative responses
Subdued, quiet, domestic, toned down, tame, soft	Girlish, lusty, infant, young, callow, immature	Weak, fragile, wavering, unsure, stereotyped response for female baby, delicate, feeble, frail	Negative associative responses
Good	Excellent	Excellent	Appetite rating
Sweet	Very sweet	Sweet	Taste
(9) 000/065/000/000	(10) 000/100/000/000	(11) 000/025/000/000	

Chosen hue from matrix for the high-chroma pink family.

Chosen hue from matrix for the pastel pink family.

Chosen hue from matrix for the mid-range pink-red family.

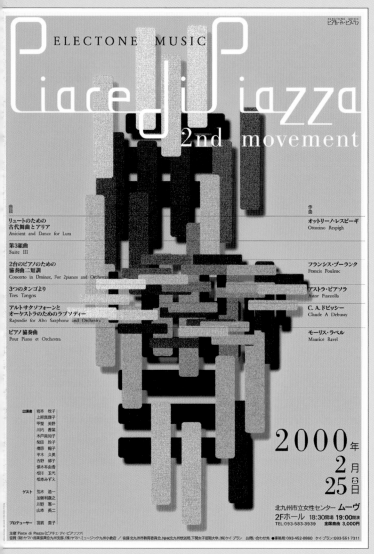

Figure 7
Designer Hiroyuki Matsuishi

High-chroma orange family

positive *associative responses*	Producing, healing, tasty, growing, fire, warm, cleanliness, cheerfulness, masculine, fearlessness, curiosity, antithesis, thought, whimsical, childlike, happy, vital, sunset, harvest, autumn, hot, juicy, tangy, energizing, gregarious, friendly, loud, radiant, communication, wholehearted, receptive, intimate, comedy, pride, ambitious, joy, happy, dramatic, cheerful, lively, exciting, bright, luminous, metallic, Halloween, Thanksgiving, jovial, energetic, hilarity, exuberance, satiety, cheer, joy, fun, stimulating, aggressive, happiness, school, youth, strength, impetuosity
negative *associative responses*	Danger, hot, loud, fire, forceful, pain, restlessness, antithesis, gloom
appetite rating *for package design*	Excellent
associative taste	Very sweet

(12) 000/075/100/000

Figure 7 This dark and powerful design invites viewing, through the use of an orange background. A 3-D illusion arises from an effective use of black tinting to create different tones of gray.

Chosen hue from matrix for the high-chroma orange family.

Chosen hue from matrix for the high-chroma yellow-orange family.

7	type C13 M2 Y3 K29 bgd C2 M1 Y1 K98	**7**	type C2 M1 Y1 K98 bgd C13 M2 Y3 K29	
7	type C4 M5 Y8 K71 bgd C0 M43 Y97 K2			
7	type C0 M43 Y97 K2 bgd C4 M5 Y8 K71			

BG Background color C0 M43 Y97 K2 50%

Mid-range orange family	Dark orange family	High-chroma yellow-orange family	
Gentle, entice, good spirits, glad, nurturing, soft, fuzzy, delicious, fruity, sweet, inviting, mellow, ripened, livable, cheerful	Exhilarating, inspiring, stirring, stimulating, moving, provoking, most exciting, passive	Enterprise, drive, target, goal, luxuriance, cheer, joy, fun, excitement, stimulating, aggressive, powerful, energy, splendid, warmth, delight, glow, pleasant, agreeable, cheerful, energetic, healthy	Positive associative responses
Unclear, obscure, undetermined	Passive, submissive, idle, quiet, inactive, resigned, yielding	Pride, pushy, target	Negative associative responses
Good to excellent	Poor	Excellent	Appetite rating
Sweet	No associative taste	Very sweet	Taste
(13) 000/050/070/000	(14) 015/075/090/000	(15) 000/020/100/000	

Chosen hue from matrix for
the mid-range orange family

Chosen hue from matrix for
the dark orange family.

Figure 8
Art Director/Designer Art Chantry

Pastel yellow family

positive *associative responses*	Pleasant, sunshine, glad, compassionate, tender, kindhearted, cheerful, happy, soft, sunny, warm, sweet, extrovert, good smell
negative *associative responses*	Bland, mild, subdued, foolish, simple, silly, softhearted, cowered
appetite rating *for package design*	Poor to good
associative taste	Sweet

(16) 000/000/025/000

Figure 8 The youthful energy
found in this illustration is
carried out through the use
of line work and color. This
cheerful and exhilarating
design evokes the feeling
of being on holiday.

Chosen hue from matrix for
the pastel yellow family.

8	type C55 M53 Y100 K42 bgd C20 M40 Y84 K2	8	type C16 M72 Y64 K3 bgd C55 M53 Y100 K42
8	type C20 M40 Y84 K2 bgd C3 M10 Y91 K0		
8	type C3 M10 Y91 K0 bgd C16 M72 Y64 K3		

| BG | Background color | C3 | M10 | Y91 | K0 | 50% |

Golden-yellow/beige family	Dark yellow family	High-chroma yellow family	
Dignified, pleasant, autumn, flowers, harvest, rich, sun, exalted idea, splendid, warm, wheat, comforting, sun-baked, buttery, classic, sandy, earthy, natural, soft, new idea	Flavorsome, long, active, appetizing, thirst	Anticipation, agreeable, pleasant, welcome, vigorous, noble, youthful, speed, movement, enlighten, sunshine, cheerful, friendly, hot, luminous, energy, intuition, magnanimity, intellect, loudest, brightest, vivacious, extrovert, comedy, celestial, favorable, biological, safety, warmth, joy, spontaneity, active, projective, aspiring, investigatory, original, expectant, varied, exhilaration, spring, summer, incandescent, radiant, inspiring, vital, celestial, high spirited, health, fun, excitement, stimulating, aggressive, honesty, happiness, strength, life, brilliant, admixture, picture, great density of light, substantial, real, satisfying, intrigue	Positive associative responses
Bland, smooth, mild, flat	Shame, disgust, unease, palatable, sicken, tension	Loudest, lacks weight and substance, scoundrel, coward, caution, yellow journalism, sickness, dense, deceit, treachery, yellow dog, yellow streak, incandescent, envy, jealousy	Negative associative responses
Excellent (for baked goods) Good to excellent (for products other than baked goods)	Good	Good	Appetite rating
No associative taste	Semisweet	Very sweet	Taste
(17) 000/010/060/000	(18) 000/000/075/020	(19) 000/000/100/000	

Chosen hue from matrix for the golden-yellow/beige family.

Chosen hue from matrix for the dark yellow family.

Chosen hue from matrix for the high-chroma yellow family.

Figure 9
Studio Underware
Art Director/Designer Bas Jacobs

OSSEOINTEGRATION:
40 YEARS AND BEYOND
techniques of the new millennium.

Torsten Jemt, DDS, PhD

December 10, 2002
Chicago, IL

Brånemark System®

Nobel Biocare

Figure 10
Art Director/Designer Linda Y. Henmi

High-chroma yellow-green family

positive *associative responses*	Lemony, tart, fruity, acidic, sharp, bold, trendy, strength, sunlight, biology
negative *associative responses*	Sickly, slimy, most tranquilizing, tacky, acidic, gaudy, tart, disagreeable, shame, disgust, unease, bankrupt
appetite rating *for package design*	Excellent (for products other than meats) Poor (for meats)
associative taste	Very sweet, lemony

(20) 015/000/100/000

Figure 9 The gritty feel of the typography is enhanced by the use of the acidic high-chroma green-yellow.

Figure 10 The implant is imbued with the sense of strength associated with a high-chroma yellow-green hue.

| 9 | type | C31 | M0 | Y100 | K0 |
| | bgd | C75 | M68 | Y67 | K90 |

| 9 | type | C75 | M68 | Y67 | K90 |
| | bgd | C12 | M11 | Y8 | K0 |

| 9 | type | C12 | M11 | Y8 | K0 |
| | bgd | C31 | M0 | Y100 | K0 |

| 10 | type | C20 | M0 | Y100 | K100 |
| | bgd | C20 | M0 | Y100 | K0 |

| 10 | type | C20 | M0 | Y100 | K0 |
| | bgd | C2 | M0 | Y11 | K0 |

| 10 | type | C2 | M0 | Y11 | K0 |
| | bgd | C20 | M0 | Y100 | K100 |

| **BG** | Background color | C20 | M0 | Y100 | K0 | 30% |

High-chroma green-yellow family	Pastel green family	High-chroma green family	
New growth, lemony, tart, fruity, acidic	Empathy, innate, complete, calm, quiet, soothing, natural, sympathy, compassion	Life, use, motion, ebbing of life, springtime, infancy, wilderness, hope, peace, plenty, mature growth, fresh, grass, Irish, lively, spring, foliage, outdoorsy, sympathy, adaptability, quiet, undemanding, soft, not angular, pacific, not nervous, tranquil, thinking, concentration, meditation, cool, abundance, healthy, hope, fertile, sea, fields, greenbacks, clean, moist, nature, water, clear, St. Patrick's Day, refreshing, peaceful, nascent, calm, security, peace, mountains, lakes	Positive associative responses
Acidic, bitter, sour	Calm, quiet, silence, stillness, inactive, idle	Sympathy, no direction, no expression, middle-of-the-road, soft, not muscular, jealousy, inexperienced worker, greenhorn, disease, terror, guilt, ghastliness, envy, radioactive	Negative associative responses
Excellent (for products other than meats) Poor (for meats)	Excellent (for products other than meats or baked goods) Poor to average (for meats and baked goods)	Excellent (for products other than meats) Very poor (for meats)	Appetite rating
No associative taste	No associative taste	No associative taste	Taste
(21) 040/000/100/000	(22) 035/000/050/000	(23) 100/000/100/000	

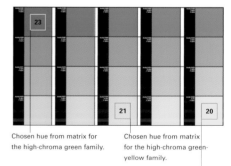

Chosen hue from matrix for the pastel green family.

Chosen hue from matrix for the high-chroma green family.

Chosen hue from matrix for the high-chroma green-yellow family.

Chosen hue from matrix for the high-chroma yellow-green family.

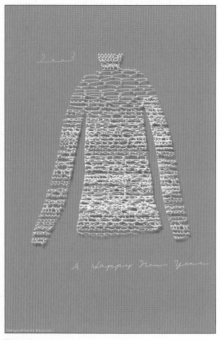

Figure 11
Designer Hiroyuki Matsuishi

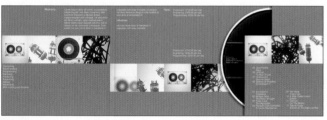

Figure 12
Studio Sauce
Creative Directors Adam Softley and Shane Mizon

Dark green family

positive *associative responses*	Nature, mountains, lakes, natural, mature growth, versatility, traditional, money, trustworthy, refreshing, cool, naturalness, restful, stately, forest, healthiness, quiet, woodsy, ingenuity
negative *associative responses*	Restful, quiet
appetite rating *for package design*	Good (for products other than meats) Poor (for meats)
associative taste	No associative taste

(24) 070/000/070/070

Figure 11 The symmetrical balance of the poster, the texture of the fabric, and the background hue chosen convey a sense of the natural.

Figure 12 The classic feel found in this CD package is conveyed through the use of color and form. This family of colors has an excellent rating for package design.

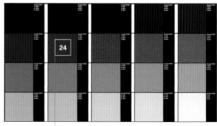

Chosen hue from matrix for
the dark green family.

11	type **C3** **M0** **Y5** **K4** bgd **C25** **M0** **Y43** **K43**		12	type **C8** **M13** **Y34** **K1** bgd **C40** **M30** **Y55** **K20**
11	type **C25** **M0** **Y43** **K43** bgd **C3** **M0** **Y5** **K4**		12	type **C40** **M30** **Y55** **K20** bgd **C54** **M62** **Y62** **K81**
			12	type **C54** **M62** **Y62** **K81** bgd **C8** **M13** **Y34** **K1**

BG Background color **C25** **M0** **Y43** **K43** 10%

Mid-green family	Blue-green family	High-chroma purple family	
Warlike, forces, military, camouflaged, safari, classic	Pristine, pure, serious, cleanliness, incorruptible, pensive, tranquillity, lively, mellow, cheerful, clarity, certainty, firm, consistent, great strength, inner coolness, lakes, flattering	Celibacy, rage, deep, nostalgia, memories, power, spirituality, infinity, dignified, sublimation, meditative, mystical, coolness, night, conservative, thought, royalty, nobility, subduing, athletic, important, soft, atmospheric, mist, Easter	Positive associative responses
Military, camouflaged, drab, warlike, forces, combative, militant	Irritable, disagreeable, peeve	Conservative, melancholia, priggishness, darkness, shadow, mourning, pompous, loneliness, desperation, sadness	Negative associative responses
Excellent (for products other than meats) Poor (for meats)	Excellent (for products other than meats) Very poor (for meats)	Excellent (for products other than food) Poor (for food)	Appetite rating
No associative taste	No associative taste	No associative taste	Taste
(25) 050/000/070/000	(26) 095/045/060/000	(27) 090/090/000/000	

Chosen hue from matrix for the mid-green family.

Chosen hue from matrix for the blue-green family.

Chosen hue from matrix for the high-chroma purple family.

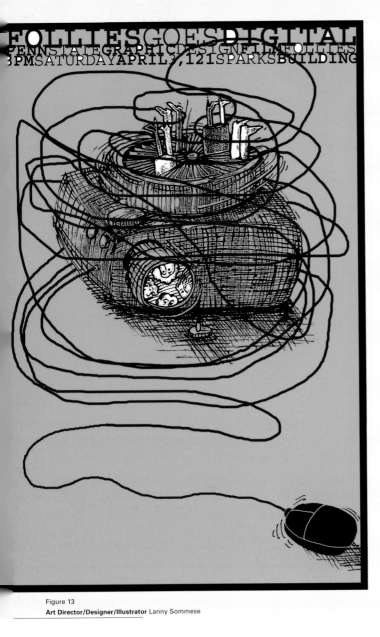

Figure 13
Art Director/Designer/Illustrator Lanny Sommese

Figure 13 The meaning of this
illustration is accentuated by
the association with fragility of
the mid-range red-purple hue.

High-chroma red-purple family

positive *associative responses*	Sweet taste, subtle, restlessness, prolongs life, feminine elegance, tender longing, romanticism, exciting, sensual, flamboyant, creative, unique, sophisticated
negative *associative responses*	Subtle, flamboyant, unquiet, rest
appetite rating *for package design*	Excellent (for products other than food) Good to excellent (for food)
associative taste	No associative taste

(28) 055/100/000/000

28

Chosen hue from matrix
for the high-chroma red-
purple family.

13	type C73 M58 Y77 K79 bgd C23 M47 Y0 K0			
13	type C0 M0 Y0 K0 bgd C73 M58 Y77 K79			
13	type C23 M47 Y0 K0 bgd C0 M0 Y0 K0			

BG Background color C23 M47 Y0 K0 20%

Mid-range red-purple family	High-chroma blue-purple family	Pastel blue family	
Charming, elegant, select, refined, subtle, nostalgic, delicate, floral, sweet scent, sweet taste	Meditative, restlessness, expensive, regal, classic, powerful, tender, longing, elegant, mystical, spiritual, futuristic, fantasy	Pleasure, peace, calm, quiet, hygienic, peaceful, refreshing, clean, cool, water, heavenly, constant, faithful, true, dependable, happy, tranquil, glory, good, devoted to noble ideas	Positive associative responses
Picky, breakable, frail, fragile	Tragedy, restlessness, misadventure, mishap, misfortune	Calm, quiet, peaceful, empty, restful, indifferent, blurry	Negative associative responses
Good	Excellent (for products other than food) Poor (for food)	Excellent (for products other than food) Poor (for naturally colored foods) Good (for artificially colored foods)	Appetite rating
Sweet	No associative taste	No associative taste	Taste
(29) 030/050/000/000	(30) 100/095/000/000	(31) 050/015/000/000	

Chosen hue from matrix for the mid-range red-purple family.

Chosen hue from matrix for the high-chroma blue-purple family.

Chosen hue from matrix for the pastel blue family.

Figure 14
Designer Koshi Ogawa

Figure 14 A high-chroma
blue is an excellent choice
to communicate the concept
of an insane and fearful
relationship/existence.

High-chroma blue family

positive *associative responses*	Dignity, spaciousness, sobriety, calm, height, lively, pleasing, rich, levels, vertical, honesty, strength, work, upward, deep, feminine, relaxed, mature, classy, expensive, unique, electric, energetic, vibrant, flags, stirring, happy, dramatic, recalls childhood, inner life, seized by love, not violent, quiet, cold, wet, reposed, blue bloods, once in a blue moon, bolt from the blue, flute, stringed instrument, mercury, clear, cool, transparent, introspective, summer, water, sky, ice, service, subduing, contemplative, sober, calm, security, peace, thought-provoking, serenity
negative *associative responses*	Mournful, feeling blue, the blues, insane, mental depression, blue Monday, transparent, recessive, distant, melancholy, gloom, fearfulness, furtiveness, sadness, work, solemn, shadows, empty
appetite rating *for package design*	Poor to good
associative taste	No associative taste

(32) 095/020/000/000

Chosen hue from matrix for
the high-chroma blue family.

Dark blue family	High-chroma blue-green family	Earth tone family	
Serene, quiet, authoritative, credible, devotion, security, service, nautical, solemnity, gravity, great religious feeling, basic, confident, classic, conservative, strong, dependable, traditional, uniforms, professional	New, further, young, forward, ocean, tropical, jewelry, pristine, cool, fresh, liquid, refreshing, healing, wholesome, pure, recent, young	Rustics, delicious, deep, rich, warm, folksy, rooted, life, work, wholesome, sheltering, masculine, woodsy, warm, durable, secure, earth, dirt, strength	Positive associative responses
Authoritative, gloom, conservative, traditional, uniforms, serene, quiet, solemnity, irrationality	Inexperienced, raw, rude, unseasoned	Folksy, woodsy, rustics, dirt, work	Negative associative responses
Excellent (for products other than meats) Poor (for meats)	Excellent (for products other than meats) Poor (for meats)	Excellent (for baked goods, coffee, chocolate, and candy) Good (for most other products; in some cases will have negative connotations)	Appetite rating
No associative taste	No associative taste	No associative taste	Taste
(33) 095/080/000/020	(34) 090/050/055/000	(35) 005/080/080/080	

Chosen hue from matrix for the dark blue family.

Chosen hue from matrix for the high-chroma blue-green family.

Chosen hue from matrix for the earth tone family.

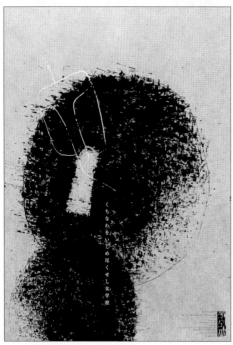

Figure 15
Designer Hiroyuki Ueno

Figure 16
Designer Inyoung Choi

	White
positive *associative responses*	Light, cool, snow, cleanliness, purity, clean, sterling, innocent, silent, inexplicable, normality, life, work, school, emptiness, infinity, refreshing, antiseptic, perfect balance, zeal, bright, glistening, awareness, pleasure, cold, clean, spiritual, Mother's Day, flag, frank, youthful, brightness of spirit
negative *associative responses*	Innocent, lightweight, inaccessible, silent, emptiness, fear, work, sadness
appetite rating *for package design*	Excellent
associative taste	No associative taste
	(36) 000/000/000/000

Figure 15 The expressively strong graphic is accentuated by the neutral gray instilling a quiet and classic overtone.

Figure 16 The typography is imbued with the hue black to engender a relationship between the statement made and the powerful graphics.

36

Chosen hue for white.

| 15 | type **C0** **M0** **Y0** **K100**
bgd **C0** **M0** **Y0** **K38** |
| 15 | type **C0** **M0** **Y0** **K38**
bgd **C0** **M0** **Y0** **K100** |

16	type **C0** **M0** **Y0** **K2** bgd **C0** **M0** **Y0** **K89**
16	type **C0** **M0** **Y0** **K89** bgd **C0** **M0** **Y0** **K36**
16	type **C0** **M0** **Y0** **K36** bgd **C0** **M0** **Y0** **K2**

BG Background color **C0** **M0** **Y0** **K36** 20%

Black	Dark gray family	Neutral gray family	
Winter, percussion, spatial, powerful, elegant, mysterious, heavy, basic, neutral, night, life, school, cold classic, strong, expensive, magical, invulnerable, prestigious, sober without peculairity, distant, noble, blindness, piano	Wise, cultured, professional, classic, expensive, sophisticated, solid, enduring, mature	Quality, quiet, classic, inertia, ashes, passion, practical, timeless, old age, cunning, cool, sober, corporate	**Positive associative responses**
Dark, heavy, death, despair, void, eternal, silence, no future, powerful, mysterious, nightmare, rigid, distant, negative, evil, blackmail, blackball, blacklist, gloom, hatred, malice, anger, fear, black magic, emptiness, mourning, funeral, omnious, deathly, depressing, negation of spirit, blindness	Expensive, costly, complex, complicated, disenchanted, disillusioned, debase	Quiet, ghostly, egoism, depression, indifference, autonomous, nothing, neutral, indecision, lack of energy, tragedy, selfishness, deceit	**Negative associative responses**
Excellent	Excellent (for products other than food) Poor (for food)	Poor to good	**Appetite rating**
No associative taste	No associative taste	No associative taste	**Taste**
(37) 000/000/100/100	(38) 000/000/005/090	(39) 000/000/000/050	

Chosen hue from matrix
for black.

Chosen hue from matrix for
the dark gray family.

Chosen hue from matrix for
the neutral gray family.

positive
associative responses

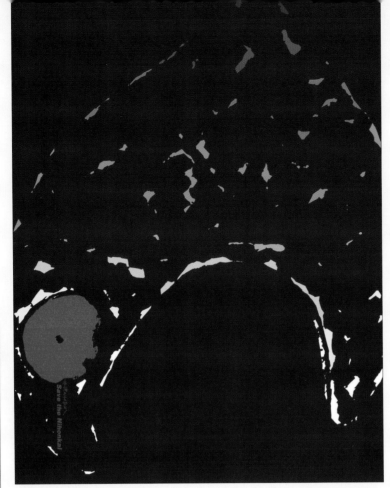

negative
associative responses

appetite rating
for package design

associative taste

Figure 18
Designer Koshi Ogawa

Figure 17
Art Director/Designer Linda Y. Henmi

Figure 17 The use of a
dark, muddy gray creates
an overtone that is related
to quality, that is timeless
and classic, and a practical
solution to a serious problem.

Figure 18 The direction of the
graphic and the use of a dark,
muddy gray solicits a response
from the viewer that reinforces
the idea of a fish sinking.

17	type **C**49 **M**39 **Y**100 **K**16	bgd **C**75 **M**68 **Y**67 **K**90
17	type **C**75 **M**68 **Y**67 **K**90	bgd **C**10 **M**7 **Y**20 **K**0
17	type **C**10 **M**7 **Y**20 **K**0	bgd **C**49 **M**39 **Y**100 **K**16

18	type **C**31 **M**24 **Y**25 **K**0	bgd **C**69 **M**64 **Y**61 **K**56
18	type **C**0 **M**94 **Y**82 **K**0	bgd **C**31 **M**24 **Y**25 **K**0
18	type **C**69 **M**64 **Y**61 **K**56	bgd **C**0 **M**94 **Y**82 **K**0

BG Background color **C**31 **M**24 **Y**25 **K**0 20%

Muddy gray family	Silver family	Gold family	
Quality, basic, classic, practical, timeless, natural	Futuristic, cool, expensive, money, valuable, classic	Warm, opulent, expensive, radiant, valuable, prestigious	Positive associative responses
Pragmatic, sober, utilitarian, old, bottom, primitive, elemental	Costly, expensive	Lavish, costly, expensive	Negative associative responses
Poor	Excellent	Excellent	Appetite rating
No associative taste	No associative taste	No associative taste	Taste
(39) 000/000/055/085	(40) 000/000/000/040	(41) 025/025/100/000	

Chosen hue from matrix for the muddy gray family.

Chosen hue from matrix for the silver family.

Chosen hue from matrix for the gold family.

Acknowledgments

We would like to thank all those who have contributed to and made this book possible. So many people have shown generosity and insight that it is impossible to list them all here. Our deepest gratitude to each and every one.

John DeMao, Rob Carter, Ben Day, John Malinoski, Mary McLaughlin, and Virginia Commonwealth University. Jerry Samuelson, John Randolph Carter (master poet), and California State University, Fullerton. Babette Mayor, Karen Hanna, and California State Polytechnic University, Pomona. Mike Garrin and Judy Theuerkauf at PANTONE for encouragement and support. Christine Pickett, for providing the fundamentals, and The University of Utah, Technology Transfer Office. The International Council of Graphic Design Associations (ICOGRADA), Design and Art Direction (D&AD), Society for Environmental Graphic Design (SEGD), and American Institute of Graphic Arts (AIGA). Inyoung Choi and Jianming Xing (computer programmer extraordinaire). Don Beery, Bill Drew, and Col. Mark C. Bane. Rebekah Roose, Carlo Irigyen, Tanya Ortega, and Saied Farisi for unlimited design support. Faviola Fernandez, Anna Choi, Vicki Guo, Maggie Yu, Nayla Ahmed Al-Mulla, Ai Yoshida, and all students who have inspired us to think differently. To the "hardworking" folks at RotoVision, especially Lindy Dunlop and Luke Herriott. And above all, our families, for understanding in a time that always seems compressed.

BG Background color **C**20 **M**0 **Y**100 **K**0 100%

Contributors

Bremmer & Gorris bremmer@goris.com

Carter WongTomlin info@carterwongtomlin.com

Carlo Irigoyen los105@juno.com

Imagination, Ltd. www.imagination.com

Katachi, Co. Ltd. inadome@katachi.jp

Magnetic North moragH@magneticN.co.uk

ModernArts www.modern-arts.com

Pentagram www.pentagram.com, email@pentagram.com.uk

RGD smilergd@bom3.vsnl.net.in

Underware, Bas Jacobs bas@underware.nl

Sang-Soo Ahn

Haleh Bayat halehb@hotmail.com

Paul Belford www.amvbbdo.com

Brian Cantley bcantley@fullerton.edu

Art Chantry achantry@goinet.com

Inyoung Choi aychoi@hanyang.ac.kr

Halim Choueiry hchoueiry@qf.org.qa

Concrete Pictures info@concretepictures.com

Ned Drew ndrew@andromeda.rutgers.edu

David Dye dave@cddlondon.com

Tom Engeman tomeengeman@verizon.net

Leny C. Evangelista jinx13174@yahoo.com

Saied Farisi farisi@ureach.com

Danielle Foushée danielle@daniellefoushee.com

Mihoko Hachiuma creer@mocha.ocn.ne.jp

Ben Hannam bhannam@qf.org.qa

Iwao Hashimoto gloomyhand@hotmail.com

Linda Y. Henmi lhenmi@yahoo.com

Shun Kawakami shun@artless.gr.jp

Sang-Rak Kim

Jenni Kolsky Goldman www.JenniGoldman.com

Rendi Suzana Kusnadi

Rosie Lee www.rosilees.co.uk

Clinton MacKenzie macmatters@aol.com

Brenda McManus bmcmanus21@yahoo.com

John Malinoski jmalinos@mail2.vcu.edu

Peter Martin pmartin@qf.org.qa

Hiroyuki Matsuishi matsuishi@aqua.ocn.ne.jp

Babette Mayor brmayor@csupomona.edu

Robert Meganck robert@communicationdesign.com

Paul Middlebrook paul@du-o.co.uk

Hiroshi Mitsuishi mitsuishi-h@mail.dnp.co.jp

Theron Moore theronrmoore@hotmail.com

Raymond Morales moralesraymond@msn.com

Eric Nagashima djnaga03@hotmail.com

Koshi Ogawa koshi_ogawa@off-beat.co.jp

Akio Okumura oku@okumura-akio.com

Tanya Ortega tana_tega@hotmail.com

Pornprapha Phatanateacha pphatanateacha@hotmail.com

Leo Popovic leo.popovic@gmail.com

RGD, Rubia Gupta smilergd@vsnl.com

Myung-Sik Rhoo

Aidan Rowe arowe@surrart.ac.uk

Gloria Shen meiya1314@aol.com

Jannuzzi Smith email@jannuzzismith.com

Adam Softley adamsoftley@btconnect.com

Carol Sogard c.sogard@art.utah.edu

Lanny Sommese lxs14@email.psu.edu

Myung Jin Song msong@wexarts.org

Gi-Heun Suh

Byoung Il Sun

Thonik studio@thonik.nl

Ganta Uchikiba ganta@grounder.jp

Hiroyuki Ueno ueno-des@tateyama.or.jp

Sisi Xu ssxu60@yahoo.com

Yokoyama Yoshie yoko@alfaeyes.com

John T. Drew, *Associate Professor*
Department of Visual Art
California State University, Fullerton
P.O. Box 6850
Fullerton, CA 92834
Phone: +1 714 278 4657
Fax: +1 714 278 3005
jdrew@fullerton.edu

Sarah A. Meyer, *Assistant Professor*
Department of Art
California State Polytechic University, Pomona
3801 West Temple Avenue,
Pomona, CA 91768
Phone: +1 909 869 2077
Fax: +1 909 869 4939
sameyer@csupomona.edu

John T. Drew is currently an Associate Professor at California State University, Fullerton, and a Visiting Professor at Virginia Commonwealth University, Qatar. He has taught at The University of Utah, and Virginia Commonwealth University, Richmond in the Graphic Design and Visual Communication areas. He is the author of *Acuity 1.0* and *The Effects of Distance, Typographic Form, Color, and Motion On Visual Acuity*, an environmental design application program and companion book. Professor Drew is a coeditor of *Design Education In Progress: Process and Methodology*, Volumes 1, 2, and 3. His design work can be seen in *Working with Computer Type 3: Color & Type, Typographic Specimens: The Great Typefaces*, and *Graphic Design: A Career Guide and Education Directory*, published by The American Institute of Graphic Arts. He has written for *Messages, AIArchitect's, ACSAnews, Design Education in Progress: Process and Methodology, Revival of The Fittest: Digital Versions of Classic Typefaces*, and *Why Design?: The Proceedings for The Hanyang International Design Conference*. Professor Drew is also a Society for Environmental Graphic Design Education Foundation Grant recipient, and holds a patent with the United States Patent Office. His work has been recognized by AIGA, and The Society for Technical Communication. He is an honorary member of the Brand Design Association of Korea.

Sarah A. Meyer is an Assistant Professor at California State Polytechnic University, Pomona, and a Visiting Professor at Virginia Commonwealth University, Qatar. She has taught at The University of Utah, and Virginia Commonwealth University, Richmond in the Graphic Design and Visual Communication areas. Professor Meyer is a coeditor of *Design Education In Progress: Process and Methodology*, Volume 3. She has written for the *Design Management Journal, Revival of the Fittest: Digital Versions of Classic Typefaces, Design Education in Progress: Process and Methodology*, and *Why Design?: The Proceeding for The Hanyang International Design Conference*. Her design work can be seen in *Working with Computer Type 3: Color & Type*, and *United Designs*, Hanyang University. Professor Meyer has been recognized by The Society for Technical Communications and the Art Directors Club. She is an honorary member of the Brand Design Association of Korea.

Index